D0165322

PAINTING WOMEN

How did women work as artists during the nineteenth century, and how did they represent femininity? Challenging the myth of Victorian women as passive 'Angels of the Hearth', *Painting Women* shows Victorian women artists as producers, spectators and purchasers of women's art throughout the nineteenth century, illuminating the work of artists rarely included in text books on Victorian art.

Uncovering a rich feminine culture of the time, Deborah Cherry explores how women managed households and businesses in a social structure shaped by sexual difference, and, drawing on letters, diaries, autobiographies and contemporary papers, she discusses the ways in which women trained as artists, exhibited and sold their works, and participated in the Victorian art world. Women's visual representations varied widely – from studies of motherhood, afternoon tea or the white wedding, to paintings of domestic servants, governesses or seamstresses, from scenes of landscape to depictions of history. By examining the ways in which women networked and formed distinct cultural discourses, *Painting Women* evokes a powerful sense of women's pleasures in, and support of, women's culture. It argues for the location of women artists and their work not as exceptions in a male-dominated culture but as an integral part of a period of massive historical change. It also breaks new ground in linking women producers and consumers and in advancing the debates of feminine spectatorship in the field of vision.

Deborah Cherry teaches art history at Manchester University. In 1987 she curated the first major exhibition on Victorian women artists for Rochdale Art Gallery. She also co-curated the exhibitions *The Edwardian Era* (Barbican Art Gallery, London, 1987) and *Treatise on the Sublime* (California State University, 1990) with Jane Beckett of the University of East Anglia.

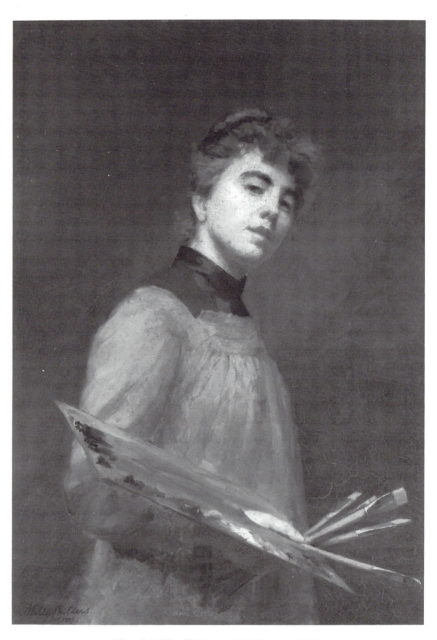

Plate 1 Milly Childers, *Self-Portrait*, 1889.

PAINTING WOMEN

Victorian women artists

Deborah Cherry

London and New York

First published 1993
by Routledge
11 New Fetter Lane, London EC4P 4EE

Simultaneously published in the USA and Canada
by Routledge Inc.
29 West 35th Street, New York, NY 10001

© 1993 Deborah Cherry
The author asserts the moral right to be identified as
the author of this work.
Set in 10/12 pt Times Linotronic 300
by Florencetype Ltd, Kewstoke, Avon
Printed in England by Biddles Ltd., Guildford, Surrey

All rights reserved. No part of this book may be reprinted or
reproduced or utilized in any form or by any electronic, mechanical,
or other means, now known or hereafter invented, including
photocopying and recording, or in any information storage or
retrieval system, without permission in writing from the publishers.

British Library Cataloguing in Publication Data
Cherry, Deborah
Painting Women: Victorian Women Artists
I. Title
709.22

Library of Congress Cataloging-in-Publication Data
Cherry, Deborah.
Painting women: Victorian women artists / Deborah Cherry.
p. cm.
Includes bibliographic references and index.
1. Women painters – Great Britain – Biography – History and
criticism. 2. Painting, Victorian – Great Britain. 3. Painting,
British. 4. Women in art. I. Title.
ND467.C45 1993
759.2′082–dc20 92–36713

ISBN 0-415-06052-4. – ISBN 0-415-06053-2

A mon amie

CONTENTS

PLATES

(Frontispiece, and between pages 64–5, 109–10, 163–4, 214–15)

Oil on canvas, oval, 814 × 700 mm., Royal Collection, St James's Palace, Her Majesty the Queen.

12 Elizabeth Siddall, *Self-Portrait*, 1853–4.
Oil on canvas, circular, 230 mm. diameter, private collection.

13 Emily Mary Osborn, *Barbara Leigh Smith Bodichon*, probably before 1891.
Oil on canvas, 1180 × 960 mm., The Mistress and Fellows, Girton College, Cambridge.

14 Henrietta Ward, *'God Save the Queen'*, Royal Academy, 1857.
Present location unknown; engraved *Art Journal* 1864.

15 Charlotte Bosanquet, *Drawing Room at Meesdenbury, March 1843*.
Watercolour and pencil on paper, 259 × 348 mm., Ashmolean Museum, Oxford.

16 Lucette Barker, *Laura Taylor and her son Wycliffe*, 1859.
Watercolour and pencil on paper, 337 × 224 mm., Ann Thornton.

17 Jane Bowkett, *Preparing Tea*, 1860s.
Painting lost at sea; photograph courtesy of Christopher Wood.

18 Jane Bowkett, *An Afternoon in the Nursery*, 1860s.
Present location unknown; photograph courtesy of Christopher Wood.

19 Louise Jopling, *Weary Waiting*, Royal Academy, 1877.
Oil on canvas, 1092 × 838 mm., reproduced by kind permission of Sotheby's, London.

20 Maud Hall Neale, *Two Women in an Aesthetic Interior*, 1880s.
Oil on canvas, 445 × 560 mm., reproduced by kind permission of Sotheby's, London.

21 Alice Walker, *Wounded Feelings*, 1861, British Institution, London, 1862.
Oil on canvas, 1016 × 762 mm., The Forbes Magazine Collection, New York.

22 Edith Hayllar, *Feeding the Swans*, 1889.
Oil on canvas, 914 × 711 mm., photograph courtesy of Sotheby's, London.

23 Jessica Hayllar, *Fresh from the Altar*, Royal Academy, 1890.
Oil on canvas, 533 × 800 mm., photograph courtesy of Christie's, London.

24 Lucette Barker, *Lavender Sweep, Wycliffe and 'Liebe nurse'*, c. 1864.
Watercolour on paper, 233 × 316 mm., Ann Thornton.

25 Joanna Boyce, *Peep-bo*, Royal Academy, 1861.
Painting destroyed in 1939–45 war; photograph taken in 1925, private collection.

26 Rebecca Solomon, *A Young Teacher*, Winter Exhibition, London, 1861.
Oil on canvas, 600 × 450 mm., private collection.

27 Anna Blunden, *'For Only One Short Hour'*, Society of British Artists, London, 1854.
Oil on canvas, 470 × 380 mm., Christopher Wood, London.
28 Rebecca Solomon, *The Governess*, Royal Academy, 1854.
Oil on canvas, 660 × 864 mm., photograph courtesy of Sotheby's Inc., New York.
29 Elizabeth Siddall, *Pippa Passes*, 1854.
Ink on paper, 122 × 89 mm., private collection.
30 Joanna Mary Boyce Wells, *Gretchen*, 1861.
Oil on canvas, 724 × 432 mm., The Tate Gallery, London.
31 Rosa Brett, *Study of a Turnip Field, Barns and Houses*, after 1863.
Oil on panel, 153 × 228 mm., private collection.
32 Ellen Gosse, *Torcross, Devon*, c. 1875–9.
Oil on canvas, 222 × 161 mm., ex-collection of Kathleen Fisher, Hastings, present location unknown.
33 Alice Havers, *The End of Her Journey*, Royal Academy, 1877.
Oil on canvas, 1118 × 1803 mm., Rochdale Art Gallery.
34 Alice Havers, *The Belle of the Village*, Royal Academy, 1885.
Oil on canvas, 1016 × 1956 mm., Sefton Libraries and Arts Services, Atkinson Art Gallery, Southport.
35 Helen Allingham, *Near Witley, Surrey*.
Watercolour on paper, 480 × 375 mm., photograph courtesy of Christie's, London.
36 Elizabeth Armstrong Forbes, *School is Out*, Royal Academy, 1889.
Oil on canvas, 1066 × 1460 mm., Penzance Art Gallery and District Museum.
37 Elizabeth Siddall, *The Lady of Shalott*, 1853.
Pen, ink and pencil on paper, 165 × 223 mm., J. S. Maas.
38 Henrietta Ward, *'Queen Mary quitted Stirling Castle . . .'*, Royal Academy, 1864.
Present location unknown; engraved *Art Journal* 1864.
39 Rebecca Solomon, *Fugitive Royalists*, also known as *The Claim for Shelter*, Royal Academy, 1862.
Present location unknown; engraved *Art Journal* 1869.
40 Julia Margaret Cameron, *Mnemosyne*, 1868.
Photograph, 300 × 240 mm., reproduced by kind permission of Sotheby's, London.
41 Marie Spartali, *The Lady Prays Desire*, Dudley Gallery, London, 1867.
Watercolour on paper, 420 × 310 mm., reproduced by kind permission of Sotheby's, London.
42 Marie Spartali, *Fiammetta Singing*, Grosvenor Gallery, London, 1879.
Watercolour and bodycolour on paper, 762 × 1016 mm., Pre-Raphaelite Inc.

43 Evelyn de Morgan, *Aurora Triumphans*, Grosvenor Gallery, 1886. Oil on canvas heightened with gold, 1165 × 1720 mm., Russell Cotes Art Gallery and Museum, Bournemouth.

44 Henrietta Rae, *Psyche at the Throne of Venus*, Royal Academy, 1894. Oil on canvas, 1930 × 3048 mm., present location unknown, reproduced in *Royal Academy Pictures* 1894.

45 Anna Lea Merritt, *War*, Royal Academy, 1883. Oil on canvas, 1015 × 1395 mm., Bury Art Gallery.

46 Frances Macdonald, *Ill Omen*, 1893. Watercolour on paper, 518 × 427 mm., University of Glasgow, Hunterian Art Gallery, Mackintosh Collection.

47 Susan Isabel Dacre, *Lydia Becker*, 1886. Oil on canvas, 665 × 523 mm., Manchester City Art Galleries, presented by the National Union of Women's Suffrage Societies, Manchester branch, 1920.

ACKNOWLEDGEMENTS

One of the pleasures of researching this book has been meeting and corresponding with people who have generously shared information, ideas and works by women artists. I am indebted to many working in galleries, museums, libraries and archives; the help which they have given in making works available and in providing documentation is fully acknowledged in the notes. I would like to thank all those who have shared their collections with me, especially Ann Christopherson and Ann Thornton.

Over the years the project has been discussed with friends and students on both sides of the Atlantic. Ziggi Alexander, Lucy Bland, Cheryl Buckley, Susan Casteras, Elizabeth Cowie, Leonore Davidoff, Carol Duncan, Bridget Elliott, Nicholas Green, Catherine Hall, Lubaina Himid, Jan Marsh, Frank Mort, Lynda Nead, Pamela Gerrish Nunn, Kate Perry, Marcia Pointon, Griselda Pollock, Shari Rigmaiden, Maud Sulter, Lisa Tickner, Rozina Visram, Susanna Wade-Martins and Lynne Walker have commented on ideas or sections of the manuscript or provided the framework for thinking women's history and cultural production. My warmest thanks go to Jane Beckett for her critical discussion of the research and its contexts. Jill Morgan commissioned the exhibition and catalogue of 1987, also entitled *Painting Women*. Margie Christian, Sarah Colegrave, Lydia Cresswell-Jones, Julian Hartnoll, Gregory Page-Turner, Lynda Packard, Sarah Wimbush and Christopher Wood provided invaluable assistance with illustrations. Rebecca Barden and Moira Taylor of Routledge and Janet Tyrrell with her painstaking editorial skills have turned a possibility into a reality. Permission to quote from manuscript material has been granted by the Syndics of Cambridge University Library, the John Rylands University Library of Manchester, the Tennyson Research Centre at Lincoln and the University of Iowa Library.

The author and publisher are grateful to all those individuals and organisations who have granted permission to reproduce works of art. Every effort has been made to obtain permission to use copyright material but if for any reason a request has not been received the copyright holder should contact the publisher.

INTRODUCTION
What's the difference,
or why look at women's art?

A spring morning in Rochdale. The paintings and drawings have arrived. Some are already in place; others are stacked against the walls. They look well in the late Victorian art gallery, purpose-built for this northern mill-town. As the day continues one or two late arrivals complete the total – eighty works in all. Large oils in weighty frames have escaped from basements, attic stores and dark corridors where they have languished unregarded for half a century or more. Albums of watercolours have been sent from collections where they have been treasured by women kin. On the far wall is a self-portrait of a woman in a brilliant red painting smock holding palette and brushes (plate 1). With its dramatic presentation and its skilful references to the art of the past, this painting testifies to the presence and identity of women as producers of culture and meaning in nineteenth-century Britain. The woman's gaze is direct and unflinching, a steady regard of those who are watching her, of we who stand in the place of the women who went to art galleries, visited artists' studios, wrote art criticism for a living, bought pictures.[1]

As I walk through three spacious galleries filled with paintings, water-colours, drawings, sketches and studies, all by women, I am struck by the *difference* which is purposefully created here. This exhibition of women's works painted between 1840 and 1900 is an unusual event, a rare occasion. But this is a heterogeneous collection of diverse works which vary in scale, medium, technique, conception, purpose. What are the differences, then, of women's works? And how have they been differently perceived, treated and located in the institutions of culture and the histories of art? *Painting Women* is in part a search for answers to these questions. Its title, which it shares with the exhibition, signals two strands of inquiry – an investigation into the lives of women who worked as painters in the second half of the nineteenth century and an examination of the pictures which they made of and about women.

Hundreds of women worked for their living as painters and hundreds more painted or drew as a recreational activity. Every year the professional oil painter prepared at least one major work for exhibition in her local

1

town or in a London gallery, its production requiring numerous figure, drapery and compositional studies. In addition she would complete several smaller pictures for exhibition and sale as well as attending to commissioned works; her income from picture sales might be supplemented by illustrations for magazines and novels. Watercolourists relied on a much higher turn-out, at least until the later decades when watercolours were produced on the size and scale of oils. Professional women painters worked in most areas of art production; they provided historical subjects, depictions of contemporary life, animal pictures and still life as well as rural, urban and seaside scenes. While their activity and productivity have exceeded the boundaries of modern scholarship, this plenitude can be located and framed by feminist studies.

Feminist interventions into the history of art have not been satisfied with the simple addition of women artists into existing accounts. The inscription of women's cultural production into the history of art has necessitated profound challenges to the very foundations of the discipline, not only to its scholarly activities and curatorial procedures, but also to its public diffusion through magazine articles and exhibitions. As Rozsika Parker and Griselda Pollock indicated over ten years ago, there is something fundamentally wrong with an enterprise which persistently silences and stereotypes women artists and their works. At the end of *Old Mistresses: Women, Art and Ideology* they concluded:

> We can now recognise the reasons for and political importance of the persistent feminine stereotype within the structure of art history's ideological practices. In this stereotype women are presented negatively, as lacking in creativity, with nothing significant to contribute, and as having no influence on the course of art Women's practice in art has never been absolutely forbidden, discouraged or refused, but rather contained and limited in its function as the means by which masculinity gains and sustains its supremacy in the important sphere of cultural production.[2]

Feminism's varied and diverse encounters with art history have challenged its established procedures and agendas, contradicted its dearest values, and questioned consensual definitions of art and the artist. Recognising that the production of knowledge is intimately related to the workings of power, feminist studies have concentrated on documenting the lives and works of women artists and analysing the meanings of representations of femininity in the broader fields of social relations.

Painting Women has been produced at the interface of several feminist strategies. The exhibition of 1987 participated in the projects to recover women's history and cultural artefacts in museums and galleries which were initiated from the later 1970s. One of the meeting points for these initiatives was Women, Heritage and Museums, which targeted three areas

for action: the recognition of women as makers of culture, the represen-
tation of women in museum displays and the representation of women in a
profession which had strictly demarcated arenas of expertise and advance-
ment for men and women. At the same time a policy of 'equality and
quality' was developed at Rochdale Art Gallery to showcase Black artists
and to foreground women artists, past and present. These concerns,
initiated by Jill Morgan and more recently developed by Lubaina Himid
and by Maud Sulter, have stood in contrast to the lack of such commitment
in other British galleries where, 'against the grain' as it were, historical
shows of women artists have occasionally been organised. The first histori-
cal exhibition of women artists which I saw in Britain was curated by
Norma Watt from the permanent collections of the Castle Museum in
Norwich in 1978: it was exhilarating.

Gallery-based initiatives, at least in Britain, have often been fugitive,
documented by little more than a photocopied handlist or a slender
catalogue. Substantial cataloguing of the wealth of visual material by
women artists in provincial galleries has not been a priority. Feminist
pressures have had an impact on two national museums: the holdings of
women's works in the National Museums on Merseyside have been docu-
mented by Jane Sellars while Maud Sulter has made a selection of those in
the Tate Gallery.[3] The nearest equivalent to the majestic collection
Women Artists, 1550–1950, curated by Linda Nochlin and Ann Sutherland
Harris in 1976, or the 'hidden museum' assembled from works by women
in Berlin's collections in 1987, both of which were accompanied by detailed
scholarly catalogues, was the *Women's Art Show, 1550–1970*, presented at
Nottingham in 1982, a survey drawn from British collections which in-
cluded a section on Victorian art.[4]

Plentiful in the nineteenth century, women's works have not always had
the good fortune to survive, or even survive intact, into the twentieth
century. There has been little impetus for the conservation of women's
paintings, drawings and sculpture, or for the acquisition of women's art by
national collections. Women's art is rarely 'saved for the nation'; it is
infrequently at stake in disputes about export. Purchasing policies have
been erratic at best. As Maud Sulter commented in her catalogue *Echo:
Works by Women Artists, 1850–1940*, selected from the Tate Gallery:

> The white male Eurocentric nature of most of the works in the Tate
> collection stands in stark contrast to the works by women artists.
> These are few in number and even more randomly representative of
> their oeuvres than those of male artists. Such problems are exacer-
> bated in the case of Black artists. In order for the Collection to be
> fully representative, works by women and Black artists must be
> increased by more than mere token gestures, and that must include
> the work of the greatest anachronism in European thought – the

Blackwomanartist What works by Blackwomen will there be when they come to curate *Echo: Works by Women Artists, 1940–2030?*[5]

If arts funding and administration, war, changing tastes and long periods when Victorian paintings were distinctly unfashionable have all contributed to the disappearance and disregard of women's art, so too have the serious under-provision and (active) discouragement of scholarly investigation. Grant-awarding bodies and art history departments have not fostered research into a subject which is rarely included in undergraduate programmes, either as a free-standing course or written in as a major component. Even today, the study of women artists is often viewed as unacademic and unworthy of interest or at best incorporated to reinforce prevailing notions of artistic value which rest on women's secondary status. Feminist scholarship can easily be re-read to insist that women artists are, after all, another diversion from the real business of masculine canonisation. While many will agree that 'we don't need another hero',[6] traditionalist, social history and modernist versions of art history continue to fabricate a proliferating range of masculine 'greats'. The tireless promotion of masculine genius in art history comfortably accompanies the concepts of *patrimony* utilised in museums, galleries and the heritage industry. *Matrimony*, after all, has quite other meanings.

Feminist initiatives in art galleries have drawn on and contributed to feminism's interventions in the academic domain. Lisa Tickner has rightly indicated that there are many feminisms which have diversely engaged with and changed the scholarly practices of art history. Both Lisa Tickner and Griselda Pollock have wisely counselled against a 'feminist art history', not only because feminism cannot be added onto or into art history since it calls for a dismantling of the existing structures and categories of art historical knowledge, but equally because feminism is not a unitary category or single perspective. Feminism is composed of a diversity of women's movements, discourses and politics which extend far beyond the academy.[7]

In Britain, Europe and North America a rich texturing of feminist debate has been produced in relation to visual imagery addressing a wide range of artefacts from popular to high culture, and generating strongly contradictory analyses founded on widely divergent principles and politics.[8] The massive task of researching women artists, reclaiming their historical presence and documenting their output has begun. *Women Artists, 1550–1950* represented a high point of scholarly documentation in its collation of individuals and selection of typical works. This broad survey of women artists over several historical periods and from several different societies, characteristic of a prominent strand of North American scholarship, has continued in several publications including the most recent,

4

Whitney Chadwick's *Women, Art and Society*.[9] In this approach women artists and their works are inserted into already defined movements and styles, so yielding a sort of parallel 'story of art' illustrated by women artists. In this integrative approach women artists are occasionally presented as pioneers but more usually they are regarded as characteristic of a particular school, a point of view well exemplified by the comprehensive account of *Women Artists and the Pre-Raphaelite Movement*.[10] This perspective, which combines the biographical and the stylistic, has been complemented by the publication of monographs on, among others, Berthe Morisot, Rosa Bonheur, Georgia O'Keeffe, Gwen John and Frida Kahlo. These studies of feminist heroines represent powerful ripostes to Linda Nochlin's rhetorical question of 1971, 'Why have there been no great women artists?'[11] Here are the greats, the big names, all larger than life. Narratives of an individual's struggle and achievement have manufactured what art history has so substantially denied for women artists – an artistic subject. These biographics construct recognisable personalities whose works are interpreted as personal vision. Given the persistent individualism of art history, the monographic tendency has been understandably strong; it inscribes the names of the nameless and rescues the forgotten from oblivion.

But while it is essential for feminism to inscribe women artists into history, there is a need for caution in deploying the tools which have contributed to women's omission and negation. Has the manufacture of 'heroines' tokenised the few against the many? Women of colour have not figured prominently in this rush to rediscovery. Lubaina Himid has drawn attention to the ways in which Black women artists are currently being represented:

> Art history means being written about in books or at the very least well respected art journals. Art historians do not visit the 'studio' until they have seen the exhibition. Art books are expensive to produce and bought by the few. The black woman artist is not a very safe bet for profit, as she does not have many solo shows. The same art history, at least in terms of the historian's reputation, is also made in the art journal. In Britain there are perhaps ten art journals, . . . thus far no one is risking their reputation on a black woman artist. No one who teaches in an art history department, that is, no one who writes books, or footnotes us *en masse*, that is. We cannot rely on newspapers or style magazines, we are not musicians after all. We can insist on catalogues when we do show work and we can expect the odd 250 words in a listings' publication.[12]

A unitary category – 'woman artist' – can easily marginalise the contributions and innovations of Black women while claiming to survey the whole, target the representative, or focus on the exceptional. Women's art

history cannot afford to neglect the presence of women of colour or Jewish women. In nineteenth-century Britain, for a variety of historical reasons, an increasing number of Jewish women artists can be documented and Asian women artists are recorded; it is undoubtedly the case that women of African descent, not as yet identified, were working as artists. The social construction of race, class, dis/ability and sexuality shaped the practice and production of all women artists in this society. In writing the histories of white middle-class women, whose social positioning has to a certain extent privileged them in historical records, it is important to acknowledge that we are dealing with specific communities and local stories, particularities and not the generality of women. As Ziggi Alexander has observed in her discussion of the fragmentary nature of the archives and the absence of academic scholarship on Black women in Britain, 'what is recorded, pre-served or printed depends largely on the interest, politics and prejudices of those who control and determine what is of historical value'.[13]

Addressing the formation of historical records in the past and in the present is necessarily central to a feminist politics of knowledge. The very materials at the historian's disposal are far from neutral. The historical archive is a fissured, fragmentary monument to the past, shaped in and by historically specific relations between power and knowledge which have determined who is recorded, when, where and how.[14] Far from simply containing information or relaying facts, surviving documentation as much as contemporary historical inquiry can be located within the exercise of power. From the late eighteenth century onwards a proliferating mass of documentation claimed to record the population and to classify its constituent individuals. Ranging from statistical surveys, state records such as the census, parliamentary papers, street directories, medical histories and the reports of philanthropic societies, these publications were part of the complex practices of surveillance and regulation which Michel Foucault has identified as characteristic of bourgeois social formations of western Europe in the nineteenth century. According to Foucault, individuals were brought to visibility within relations of power/knowledge which shaped that visibility.[15] The insights of Michel Foucault into what he termed 'the disciplinary society' as well as his theories of discourse and power, visibility and surveillance have had a powerful impact on feminist, historical and visual studies. His work has transformed the understanding of the ways in which the individual was manufactured as a discursive category in the nineteenth century and of representation as a process in which social meanings were inscribed.

In this 'privileged period of individualisation' the 'author' was consti-tuted as an organising category of discourse.[16] Paralleling the rise of the case study in nineteenth-century medicine and life sciences, the author became the focus of interest, the pivot around which information was accumulated and classified. Foucault's theory has been incisively put to

work in the analysis of art history's institutional and discursive production of the masculine artistic subject.[17] To draw on Foucault's theories for a feminist analysis is to rework them, to go beyond them. If Foucault alerts us to the ways in which the individual author or artist became a discursive category, feminist analysis of authorship has indicated that women were authored in significantly different ways to men in the nineteenth century. The very materials, therefore, on which *Painting Women* draws are not transparent records detailing the lives and describing the works of Victorian women artists. Rather they are saturated in and structured by historical conditions and discourses.

The artist biography which emerged in the 1880s as a two-volume, lavishly illustrated compilation of life and letters constituted an artistic subject for the works of art which were, in turn, attributed to a knowable individual whose unique personality was revealed in his correspondence and expressed in his art. New forms of art journalism, such as the illustrated monograph, feature article and interview – along with the wide circulation of photographic *cartes-de-visite* – assisted the production of knowledge about these artistic persons. Whereas numerous texts specified male artists, few full-length studies were published about individual women artists before 1914, and substantial biographical treatment was generally reserved for those who were married to artists. To account for the representation of women artists in the developing literatures of art is to investigate middle-class women's differential access and entry to the modes of auto/biographical writing. Valerie Sanders has indicated that men's life-stories traced the organic growth of the subject and the development of an intellectual position, often in a narrative of struggle against and triumph over adversity; self-help stories were the most concentrated and popular versions of this tendency. By contrast women's auto/biographies tended to avoid a linear outline of personal growth in favour of a series of anecdotes, portrait vignettes and reminiscences.[18] Given the prevalence of this pattern, the representation of professional activity required a careful negotiation of the codes of propriety which shielded the feminine subject from public scrutiny. When composing the 'personal recollections' of the scientist Mary Somerville, her daughter contended that 'the life of a woman entirely devoted to her family duties and to scientific pursuits affords little scope for a biography'.[19] Time and again, the writers of magazine articles and short biographical entries on women artists claimed that there was little or nothing to tell. In her massive compilation of 1876, *English Female Artists*, Ellen Clayton commented on Susan Elizabeth Gay with tantalising brevity that 'like most lady artists Miss Gay has led a tranquil, uneventful life, absorbed in artistic, literary and scientific subjects of study'.[20] Ellen Clayton admitted that she had nothing to record about the personal circumstances of Annie Feray Mutrie and Martha Darley Mutrie, two sisters famous for their flower-paintings: 'these ladies have invariably

declined from feelings of delicacy, to make any particulars of their life public'.[21] Although these entries, like the emerging literatures of feminist biography and self-help, borrowed the format of the masculine life-story to detail struggles against adversity (most often parental opposition) and to chronicle the favourable and difficult circumstances of becoming and being an English Female Artist, they did not, except on a few occasions, chart the development of an artistic credo or an intellectual position.[22]

Faced with these biographical strategies for veiling the feminine subject, how is the historian to proceed? Other difficulties are encountered when dealing with exhibition catalogues, art reviews, street directories or public records, the kinds of nineteenth-century documentation which were formed in relation to, and are now accessed through, the name of the individual. In the course of a lifetime a woman who married would be known by at least two patronymics; a listing in an exhibition catalogue and an entry in the census may not coincide. How can we be sure different names will point to the same historical individual? How do we manage the relations between the spinster name, the married name and the author-name? And how do we negotiate the different registers of historical statement, each with their own conditions of production and address, in which these various names circulated? Disparate scraps of discontinuous information garnered from different sources will not yield the definitive history of an individual, nor will they constitute a unified artistic subject. Furthermore, recent psychoanalytic and post-structuralist theories have emphasised that subjectivity is a process. Neither a state which is finally achieved, nor an entity which can be seized whole from its historical traces, nor the unique essence of a person, subjectivity is fragmentary, contradictory, and mediated in many ways. These theoretical articulations have thrown into question the individuating impulses of art history and literary criticism and cast doubt on the project of assembling a biographical subject from diverse and often contradictory materials. Nevertheless, feminist concerns with women artists can hardly sustain 'the death of the author' or be in/different to the question 'What matter who's speaking?'[23]

Nineteenth century biographies established modes of representing women artists which have persisted, and indeed prevailed, into the twentieth century. Victorian narratives of struggle in adversity have been reworked in accounts of obstacles, impediments and discrimination. Against these narratives of individual difficulties or institutional inequalities, feminist art historians working in the 'social history of art' have studied the broader conditions of artistic production, forging an analysis which breaks with artistic activity as a personal event in favour of a detailed investigation of the specific ways in which women were located *as women* in the institutions, discourses, social and economic practices in and by which high cultural artefacts were made and viewed. To delineate the specific circumstances in which women artists trained, in which they

exhibited and sold their pictures or ran their businesses in nineteenth-century Britain, is to map a social structure organised by and constantly productive of sexual difference – from the family to the workplace, from the art school to the associations of artists, from legal statutes concerning the corporate and personal control of income and property to the modest practices of civil society such as taking afternoon tea. It is to explore identity, desire and pleasure as they were varyingly constituted for feminine subjects. It is to investigate the contradictory definitions of women artists in the struggles of the bourgeoisie for moral authority, professional status and hegemonic power.

One of the strands running through *Painting Women* is the definition of, and the attendant struggles over, professionalism, a new identity in nineteenth-century Britain. New institutions and languages were formed for the middle-class occupations which emerged alongside the older professions of the law, medicine and the church. Formal organisations set up outside the home controlled access and entry, provided specialist training and regulated professional practice. Professionalism was most vociferously claimed as masculine by the upper strata of middle-class men. In the language and institutions of art, femininity was positioned as the very antithesis of the professional artist, as amateur, a definition secured by the inclusion in middle-class women's education of the domestic practice of drawing and watercolours as an accomplishment, a component of femininity. Women who worked as artists challenged the exclusivity of masculine claims to professionalism: neither their location in the profession of art nor their activities in a capitalist economy coincided with those of bourgeois men. Shaped in and by the social formation of sexual difference women forged feminine professional identities and differentiated ways of working. Today the category of amateur is still mobilised against women artists. It is often alleged that women, particularly those who marry, do not practise art seriously and are not financially independent. As a category of value amateur is mobilised against women's art to secure masculine definitions of the artist and the professional.

In recent years social historians have moved away from the theories of sexual division which were developed to provide a structure which could explain the relative position of middle-class women in the Victorian period. Following the nineteenth-century ideology of the 'separate spheres', accounts were given of a social order with oppositional gender roles and separate social spaces for the sexes: men occupied the public world of business and government and women inhabited the private world of home.[24] However, definitions of masculinity and femininity were by no means consistent and middle-class men and women were not so evenly placed in Victorian society. The ideology of the 'separate spheres' may seem to concord with the institutional treatment of women – their exclusion from societies of artists or the separate curricula, teaching rooms

and hours for women students. But sexual division does not easily account for the increasing numbers of women who worked as artists – alone, in business with their husbands, in partnership with another woman. Theories of sexual difference have emphasised the unfixed, uneven and shifting nature of psychic processes and discursive practices in and by which differences between masculinity and femininity are constituted.[25] Such theories have assisted in thinking how distinctions between masculinity and femininity were managed historically across a multiplicity of sites and practices. Griselda Pollock has defined what she has called the 'spaces of femininity' as those social and psychic terrains which were sexed and classed,[26] while Lynne Walker's pioneering research on women and architecture fractures assumptions that middle-class versions of masculinity and femininity were organised on a diametric opposition of public and private spaces.[27]

Even though femininity was often represented as the unitary, homologous polarity of masculinity, femininity in the second half of the nineteenth century was far from being a unitary category or universal condition inhabited by all women in the same way. A woman's position in and understanding of (her) femininity could alter profoundly in the course of the year or the passage of a lifetime. Femininities were socially, psychically and historically formed; they changed and developed over a half-century fissured by massive social and economic changes. Crises in the state and in society provoked from the 1880s onwards coincided with the emergence of discourses on the modern. As Jane Beckett has cogently argued, these transformations profoundly restructured artistic practice and identities for the 'modern' woman.[28]

Since the nineteenth century, sex and class have been recognised as major determinants of women's art practice, Ellen Clayton noting in 1876 that many middle-class women took up art in order to support themselves financially.[29] Other factors were equally important: race, religion, politics and dis/ability all affected how and whether a woman became a professional artist and the kind of practice she established. Theories of sexual difference, while insisting on process and instability, can inscribe fixed categories and polarities. Thinking of difference as alterity or otherness has assisted in catching the shifting interplay of the discourses of race, class and sexual difference. For Rosemary Hennessy and Rajeswari Mohan the theorisation of alterity must be historically and materially grounded. Far from being trans-cultural, 'alterity is continually re-articulated in terms dictated by its economic and political conditions of emergence'. They elaborate:

> The periodically recurring crises which marked the second half of the nineteenth century signalled the re-articulation of alterity as previously prevalent ideologies of otherness disintegrated against the

force of contradictions accompanying the global shift to monopoly capitalism. This shift required a redefinition of alterity around the issue of discipline to help produce the good subject under the emergent conditions of production, exchange and consumption and to serve as the ideological foundation for new laws marking increased state control over the family, sexuality and labour in both the colonies and the metropole.[30]

Their investigation of the historical re-articulation of alterity accompanied a global analysis of the reordering of feminine sexuality and the recategorisation of 'woman' in the relations of production and in written and visual representations. The historical formations of discourses of alterity have also been investigated by Anita Levy. In her study of the writing of class, race and gender in nineteenth-century England she has shown how, in fiction and non-fiction, a category of the 'other woman' was constituted and circulated in order to collapse and negate the differences of other women and to promote a normativity of white bourgeois masculinity.[31] In both these studies difference is not envisaged as a polarity of absolutes but viewed as an ensemble of historically produced discourses which work with and against each other.

What is at issue here is the conceptualisation of power. Feminist theory has worked with and adapted several models of power relations. One account considers power to be distributed into two blocs dividing the powerful and the powerless. Theories of patriarchy, sexual division and sexual difference in marxist and psychoanalytic formulations have tended to propose a binary fissuring of masculinity and femininity. Other formulations have argued that power is distributed more complexly and more unevenly throughout the social formation. Attempts have been made to resolve a marxist emphasis on class relations with a feminist emphasis on gender relations, to forge an alliance between theories of capitalism and patriarchy.[32] Black women historians such as Hazel V. Carby have rightly insisted on the simultaneity of race, sexual and class differences and the necessity of analysing the interconnections between capitalism, patriarchy and racism.[33]

Foucault's theories of knowledge and power have been highly debated by feminists. For some, Foucault's proposition of the disciplinary society with its mechanisms of surveillance proliferates the categorisation and regulation of women: visibility is a trap and representation by others women's only condition of existence. Such readings have emphasised the production of dominant discourses, their anchoring and circulation by dominant institutions. But Foucault's writings offer other possibilities for a theory of power which is not structured on an opposition of dominance and subordination, or the powerful or the powerless, but is conceptualised as a tense and unstable network of oppositions and resistances, supported

by a multiplicity of discursive knowledges and social institutions.[34] Post-structuralist theory enables a move away from the model of Victorian Britain as a male-dominated society or oppressive patriarchy: patriarchal discourses may be viewed as specific historical statements which attained hegemonic status in circulation with and against other discourses; they were not coincident with women nor were they the only definitions of femininity. Moving away from an account of patriarchy as the predominant social force and insisting on the productivities of the discourses of difference centres women in their multiplicities as producers of discourses and signification without recourse to essentialism. Femininities and identities may be perceived as discursively constituted, governed by specific forms of power and anchored by a range of competing institutions, including those formed by and for women.

Foucault's writings have informed feminist analyses of visual images as productive in social definitions and power relations. In Britain, Lynda Nead, Lisa Tickner and Griselda Pollock have argued that visual representation is a social practice with its own historically specific codes, procedures and forms of address, the meanings of which were generated in and by its discursive intersections with other arenas of social knowledge such as law, medicine, education, religion, politics or philanthropy.[35] Their discussions of the visual representations of femininity draw on Foucault's theory that sexuality was not so much repressed in the nineteenth century as 'put into discourse', while following Lucy Bland's observation that an opposition between masculinity and femininity has been one of the main structuring polarities of this discursivity.[36] This theory of visual representation shatters the concept of a picture as a discrete object with its own essential or internal meanings. It contradicts the notion of art as personal expression and challenges the interpretation of Victorian paintings as social documents which transparently mirrored Victorian life. Far from neutrally recording a pre-existent reality, Victorian paintings represented social relations from particular and often highly contradictory points of view.

Situating works by women artists in the arena of social debate as representations which echo and rework other representations, written and visual, springs the trap of interpreting women's art as the expression of femininity, perceived as either personal to the artist or collective to women as a whole. It also works against over-simplistic comparisons between women's art and men's art, an insistence which relies on essentialist absolutes of sexual division to inscribe women's secondary status. Trinh T. Minh-ha has observed in *Woman, Native, Other* that such parallels do not advance feminist thinking but remain within existing paradigms of knowledge; 'the constant need to refer to the 'male model' for comparisons unavoidably maintains the subject under tutelage.'[37] Neither women nor men artists in the nineteenth century comprised undifferentiated groups. Neither can we identify a unitary *woman's* perspective, a way of looking or

picturing which was shared by all women. Rather we can identify the heterogeneity of women's visual representations, their divergent ways of making pictures and producing signs, and the contending meanings which were generated for these works by their contemporary audiences.

In the space of a few months a painting could be seen in an artist's studio, in a London gallery, in a provincial exhibition, in a dealer's showroom, in the house or building of its purchaser; it might be viewed as a print or as an illustration in a magazine. Various readings would be made by diverse viewers. Was the image read differently if the spectator was a woman or a man? Did visual and written texts by women offer differentiated positions for feminine or masculine readers/viewers? Did the feminine gaze operate in the same field of vision as the masculine gaze? How did women's social experiences and knowledge affect their expectations of high culture or their perceptions of visual representations of womanhood? The sexual politics of vision and spectatorship, recently added to the agenda of feminist studies of visual culture, allow us to reinstate women spectators, consider women's varied expectations and gratifications and address the formation of feminine and feminist visual pleasures.

In debating images of women feminists have utilised psychoanalytic theory, discourse analysis, marxism and theories of difference. For her analysis of 'woman as sign', published in *m/f* in 1978, Elizabeth Cowie turned to structural anthropology, structural linguistics and Lacanian psychoanalysis. Breaking with debates about positive and negative images of women and with discussions of stereotypes, Elizabeth Cowie interrogated the relations between representation and signification. In an examination of kinship structures, she differentiated between the women who were physically transferred between males and the sign woman which was thereby produced and exchanged. She thus drove a wedge between woman as an individual or member of a social group and woman as a sign whose meaning was not reducible to, equatable with or derived from women. The sign woman, she argued, does not reflect any pre-existing historical individual nor is it determined by the condition of women in society. Rather, as signs are only intelligible in the systems of signification in which they occur, the sign woman acquires meaning from its production and exchange in a specified system. The meanings of the sign woman, therefore, derive not from the social group women but from the system in which the sign woman is generated and circulated, in this case kinship. Elizabeth Cowie considered that woman as sign did not signify women but functioned as 'the signifier of difference in relation to men'. She concluded:

> It is therefore possible to see 'woman' not as a given, biologically or psychologically, but as a category produced in signifying practices
> To talk of 'woman as sign' in exchange systems is no longer to talk of woman as the signified, but of a different signified, that of:

establishment/re-establishment of kinship structures or culture. The form of the sign – the signifier in linguistic terms – may empirically be woman, but the signified is not 'woman'.[38]

This analysis has profound effects for the historical study of women artists and for the analysis of visual images of women. Her theorisation enables a clear demarcation to be made between a historical woman and the visual and written representations of her. As 'Woman as sign in Pre-Raphaelite literature' proposed, the historical individual Elizabeth Siddall could be differentiated from the sign 'Siddal' which circulated in the patriarchal discourses of art history to signify not woman but masculine creativity. It is this signification which determines the prevailing representation of Elizabeth Siddall not as a woman artist but as the model, muse and mistress of Dante Gabriel Rossetti.[39]

'Woman as sign in Pre-Raphaelite literature' was written as a feminist intervention into art history, as part of the will to discover how and why women artists were marginalised in the literatures of art. But the article did not investigate the feminist significations for the sign 'Siddall', a powerful and seductive signifier in another order of pleasure and desire which then spoke from the margins, at conferences, in unpublished manuscripts and theses. Overly concerned, perhaps, with patriarchal discourse, 'Woman as sign in Pre-Raphaelite literature' did not assess the feminine or feminist desires invested in the sign 'Siddall', the circulation and exchange of the sign woman between women, in feminist discourse. It did not acknowledge the desires and subjectivities which have been so eloquently spoken by Teresa de Lauretis in her assessment of feminism as 'a radical re-writing, as well as a re-reading of the dominant forms of western culture; a re-writing which effectively inscribes the presence of a different, and gendered, social subject'.[40]

Elizabeth Cowie's founding theory can be put to work in the study of works by women artists and the meanings which were constituted for them by contemporary viewers. Elizabeth Cowie's theory of woman as sign facilitates a consideration of the contending signifying systems in which the sign woman was circulated with widely differing significations. Her analysis facilitates an examination of the different communities of women who produced and exchanged woman as sign. The social ordering of sexual difference generated particular spaces and contexts in which women, joined by interests of kin and friendship, class and culture exchanged the sign woman – from the sexually specific zones of the middle-class residence to women's restaurants or the institutions of women's colleges, clubs, organisations and societies. Woman as a visual sign was produced and exchanged between women in a range of ways from appraising glances at each other's appearance to viewing high cultural images of women or exchanging portraits of female friends or relatives.

To explore these possibilities, *Painting Women* takes as its four central themes, production, representation, spectatorship and signification. Part One, entitled 'Women painting', is concerned with the conditions in which women became and worked as artists. Entry into professional practice was often a family matter: daughters were trained alongside sons to work in the family business. As adults their practice was often sustained by a companionate marriage to and working partnership with a male artist. An upbringing or marriage outside the artistic community did not necessarily encourage a woman's career. Chapter two considers women artists who elected spinsterhood, the companionship of a sister or the partnership of a woman friend. Chapters three and four are concerned with the ways in which sexual difference was institutionalised in art schools and art criticism as well as the professional associations and informal groups of artists: women were either entirely excluded or consigned to a separate curriculum or separate category. Running counter to these patriarchal strategies were women's discourses and alternatives: the societies of women artists, publications on women artists, campaigns against the Royal Academy. Chapter five discusses changing professional identities, involvement in socialism and participation in the women's movements of the period. The last chapter in this section explores the ways in which women artists ran their businesses and cultivated their clients, drawing attention to the ways in which women and women's organisations supported women's cultural production.

A discussion of feminine spectatorship introduces Part Two. 'Women painting women' is concerned with women's diverse representations of femininity across a half-century of profound historical change. Given the wide range of work produced and the many themes and subjects taken by women during this period, this section focuses on four different categories of representation, drawing attention to the heterogeneous nature of women's image. Chapter seven addresses the ways in which women defined domesticity, that ideological and social terrain central to the construction of bourgeois femininity. The following chapter considers visual images of women workers – from the governess defined on the borders of middle-class respectability to the prostitute located as a social outcast. Chapter nine investigates the relationships between art and tourism, a context which fostered the perception of the countryside in pictorial terms and women's representations of rural scenes. The final chapter discusses women artists working in the most prestigious categories of art; accounting for the rebuttals they encountered initiates an investigation of the collisions between sexually differentiated versions of culture and contending significations of the sign woman.

Painting Women is about women painters and their representations of femininity. Women artists are not assigned to the margins of a dominant patriarchal culture, but rather they are located as participating in, drawing

on and shaping a wide range of cultural practices and social definitions. If we return to the question of the difference of women's art, these differences are many: to write the histories of women artists in Britain in the second half of the nineteenth century is to embark on an analysis of the heterogeneity of femininity in a social formation shaped by contending social, economic and political forces. There is no single women's perspective or women's culture which we can comfortably predict in advance.

To write an account of women artists in nineteenth-century Britain is also to write a history of the present, for the present. The theoretical and historical models which we use in researching and reassembling the fragments of the past are informed by our concepts of the present, our hopes for the future. Writing and reading history is about here and now, about the production and exchange of meanings. And why look at women's art? In foregrounding women artists and their representations of femininity we review the past in a different way, wise in looking *other*-wise.

Part I
WOMEN PAINTING

1

FAMILY BUSINESS

> In most instances women have been led to the cultivation of art
> through the choice of parents or brothers. While nothing has been
> more common than to see young men embrace the profession [of art]
> against the wishes of their families, and in the face of difficulties, the
> example of a woman thus deciding for herself is extremely rare.[1]

In 1859, in the first book published in England on women artists, Elizabeth
Ellet correctly assessed the importance of the family as a social institution
in shaping women's desires and aspirations. In the commercial, manufac-
turing and professional families of nineteenth-century Britain, bourgeois
femininity was consensually defined in relation to home and family, and
middle-class girls and women were not expected to work for a living: paid
productive labour and professional practice were appointed to their male
relatives. Women who were ambitious to train and practise as artists often
spoke of their determination to forge a path against parental desires or,
more rarely, against a husband's wishes. Economic pressures however
often made it necessary, especially in families in the lower middle classes,
for women to work. From the 1840s to the 1870s the collapse of the family
business or death of the male provider was frequently given as the motivat-
ing force for a woman's decision to become a professional artist. In other
instances the strategic support of male or female kin was enabling, as it was
in the families of artists. Particularly before 1870, and in a period when
artists as an occupational group struggled for the status of respectable
professionals, the distinctive organisation of artist-families facilitated
women working in the family business. Daughters grew up in the expec-
tation that they would contribute to the enterprise, sisters formed pro-
ductive alliances, and wives often entered painting partnerships with artist-
husbands. And in the later nineteenth century, when broader social and
economic changes encouraged vocational training and paid work for
middle-class women, familial contexts remained important for women
artists.

Throughout the nineteenth century women practised as artists in a social

19

formation which constructed certain choices for them *as women*. They negotiated, often on a daily basis, between a career and marriage, business and household management, between the practice of art and their responsibilities to their home, husband and children. Shaped by changing historical circumstances, the organisation of families, marriages and partnerships varied widely, as did women's experiences, expectations and pleasures in relation to a career and a home life, their definitions of domesticity or professional practice. If for some the two were in conflict, for others they were woven together in productive and enjoyable ways. Feminine identities were complexly formed, both in relation and in resistance to hegemonic notions of bourgeois femininity. Subjectivities as much as familial, marital and friendship relations or business arrangements were structured in and formative of the social ordering of sexual difference.

DAUGHTERS IN ARTIST-FAMILIES

Across the period 1780 to 1850 distinctive middle-class identities were secured through the alliance of kinship and capital. Business ventures were consolidated through familial training and extended by marriage to draw in new sources of capital, expertise and personnel while retaining family control. As Leonore Davidoff and Catherine Hall have argued in their monumental study of the formation of the middle classes during these transitional decades, sexual difference was organised in and by kinship positions, legal contracts and differentiated practices governing the corporate and personal control of capital and income, and a network of social, occupational, political and religious associations. The concurrent separation of work and home located women in relation to domesticity and dependence, and masculinity in relation to occupations and organisations located outside the home.[2]

From the later eighteenth century the practice of art was similarly shaped by kinship links, intermarriage, familial training and an increasing professionalisation. Artist dynasties assisted in the formation of an occupational group with strong familial and professional ties. But although artist-families were part of the distinctive social formation of the middle classes they did not extend business enterprise or economic power in quite the same way as the kinship links of commercial and manufacturing families. They differed profoundly in that daughters, as well as sons, were trained to become artists, to contribute financially to the family enterprise or to become independent practitioners through the sales of their work. As Eloise Stannard, a member of a large artist-family, testified in her later years, 'there was imposed on her the necessity of contributing what she could to the family exchequer [Her father] Alfred Stannard, who, though something of an artist, was also a business man, saw that she was kept well employed.'[3] Another artist-father, Ford Madox Brown, frankly

admitted that when his own income fluctuated that of his children was most useful: 'Lucy, Cathy and Nolly [Oliver] selling four pictures for small sums have helped to keep things square.'[4]

Lessons from family members – fathers, brothers, uncles, aunts, mothers – were often augmented, especially before 1860, with instruction from established artists who were friends of the family. In the family context women gained access to tuition, materials and work-space; they would be given advice on exhibitions, commissions, sales, markets and clients. Most importantly they were encouraged to develop a professional attitude in contradistinction to the amateur practice which signified dependent domesticity. Artist-families provided material and psychic spaces for middle-class girls to grow into professional artists. For some this development was accompanied by the expectation that they would become self-supporting, economically and socially. As Louise Rayner asserted, she 'took up drawing with a sort of independent feeling that she, as well as the rest of the family, should have to make her own way in the world'.[5]

But artist-families did not treat daughters and sons in the same ways and they offered women sexually differentiated professional identities. Daughters and wives not infrequently worked in categories of art which occupied a lower status in the artistic hierarchy to those practised by the male members of the dynasty. Sisters would be given a different art education to brothers and required to undertake domestic as well as art work. Familial demands and household management could easily displace painting. Agnes Rose Bouvier was trained at home by her father and elder brothers. She quickly established a career and exhibition record. But when her parents became ill the responsibilities of housekeeping fell to her and she painted only occasionally, 'at intervals snatched from domestic duties'.[6]

Beginning in the family, boys' art education was increasingly conducted outside the home in institutions which provided the specialist training and life-classes deemed necessary for professional practice. By contrast women's training, certainly up to the 1870s, tended to remain within the older apprenticeship model inherited from the eighteenth century, with its training by example and studio assistance. Working as pupils of and assistants to their relatives, girls' training was regulated neither by the statutes which governed art schools nor by the contracts of formal apprenticeship. Training in the family varied considerably; little is known of the timetables or curricula. Louise Rayner who studied with her father, taking additional lessons from his professional acquaintances, stated that 'she never went through any regular course of instruction'. She added that 'few daughters of artists ever receive timed "lessons" '.[7] Ellen Stone apparently absorbed artistic training without formal instruction at home,[8] whereas instruction from her father, Frank Stone, paved the way for her brother Marcus Stone's admission to the Royal Academy schools.

Similarly Eliza Goodall was tutored by her father while her brothers were dispatched to the Royal Academy. Some women picked up techniques and skills while working as studio assistants: Grace Cruickshank learnt her trade as a miniature painter when sketching in backgrounds, draperies and accessories for her father, Frederick Cruickshank.[9] Lucy and Catherine Madox Brown assisted their father with preparatory work and by making the copies and replicas which were necessary to boost his income; in return he organised formal classes for them and his women pupils.[10] In the later decades of the nineteenth century when institutional provision for women art students increased, familial training for women artists continued. In the 1870s and early 1880s Edith, Jessica, Mary and Kate Hayllar trained with their father who preferred to tutor his daughters at home, although the Royal Academy schools which he had attended were now open to women. Drawing, painting and perspective classes were held from 10 a.m. to 4 p.m., with clay modelling, etching and mezzotint engraving in the evening.[11]

Kinship networks were often extensive between women artists, organised matrilineally with daughters named after women kin following mothers or aunts into the practice of art. Outside as well as inside artist-families, mothers encouraged daughters to become artists, often giving them their earliest lessons. Aunts offered role-models, sisters worked together, sisters-in-law shared work-spaces. Throughout the century there were many instances of daughters following their mothers' example: Mary Backhouse, the daughter of Margaret Backhouse; Maude Naftel, the daughter of Isabel Naftel; Alberta Brown, the daughter of Eleanor Brown; Sylvia Gosse, daughter of Ellen Gosse; Theresa ·Thornycroft and Helen Thornycroft, daughters of the sculptor Mary Thornycroft.[12] When Mary Harrison took up art to support her family she trained her daughters, Maria and Harriet, in her own specialisation of flower painting.[13] Jessie Macgregor was initally taught by her mother who belonged to a large artist-family in which women of several generations trained as artists.[14]

Kinship patterns were particularly strong among watercolourists, still-life painters and landscape painters. Jane, Barbara, Margaret, Anne, Charlotte, and Elizabeth Nasmyth became landscape painters like their father and brothers. Caroline Williams and Kate Gilbert were members of the extensive Williams family of painters.[15] Louise, Rose, Margaret, Nancy and Frances Rayner were the daughters of Samuel Rayner, an architectural watercolourist; their mother 'was admired for her beautiful engravings on black marble'.[16] With training from their father supplemented by tuition from prominent male artists, the sisters set up independent art practices, Rose specialising in figural subjects, Nancy, Louise, Frances and Margaret opting for architectural views. The three daughters of Thomas Rosenberg, a watercolourist and drawing master in Bath, all became still-life painters. Initially trained by her father, Mary extended the

family business by marrying a prominent artist in the same field, William Duffield; moving to London, the couple founded a successful business partnership. Ellen and Frances established themselves as painters of fruit and flowers, Frances maintaining her career after marriage. Their nieces, Ethel Jenner Rosenberg and Gertrude Mary Rosenberg, continued the family tradition of watercolour painting.[17]

From the later eighteenth century the art circles of provincial towns were often bound together by kinship. In Norwich familial networks helped to construct a distinctive cultural identity for the urban bourgeoisie against the landed aristocracy of the county. The practice and positions of women artists in the artist-families of Norwich were structured in difference to their male kin. While men painted landscape and architecture and dominated the city's cultural institutions, women artists often specialised in still life and were not leading figures in its art world. Emily Crome, daughter of John Crome, painted flowers and still life and worked as a teacher. Emma Sillett was the daughter and pupil of James Sillett, a landscape watercolourist and, unusually for Norwich, a painter of still life who trained his daughter and several other women, including Mary Ann Kettner and Miss Fitch, in still-life painting.[18] In the Stannard family, linked by marriage to other artist-families in Norwich, women produced still life while their male relatives – the fathers who trained them, their brothers, husbands, uncles and cousins – painted landscapes and marine pictures. Eloise Harriet Stannard (plate 2) worked as a still-life painter as did her sister-in-law, Anna Maria Hodgson Stannard; her aunt, Emily Coppin Stannard; and her cousin, Emily Stannard (Appendix 1). In the later nineteenth century women such as Gertrude Offord, Ethel Buckingham and Fanny Jane Bayfield dominated still-life painting, while Emma Sandys, again from a Norwich artist-family, was among those to make a local reputation for figure subjects.[19] But women artists were rarely prominent in art societies of the city and they were marginalised in the literatures and exhibitions of the 'Norwich School'. From the 1860s to the early 1900s the concept of the 'Norwich School' was assiduously promoted by the local bourgeoisie, confirmed by their collections and donations to the Castle Museum and endorsed by the historical exhibitions of the Norfolk and Norwich Art Circle. Artists, art institutions and collectors constructed rurality as the central interest of the 'Norwich School', a view which accorded well with the shift from manufacturing to tourism as the city's main industry.[20] In focusing on landscape and architectural painting this formulation of the 'Norwich School' bypassed the diverse cultural production in the city in the closing decades of the century, a diversity largely produced by women.

In an interview with Eloise Stannard it was reported that,

in spite of a heart weakness from which she suffered in early womanhood, there was imposed on her the necessity of contributing what

23

she could to the family exchequer. Being unable by reason of her health to study landscape in the open, she concentrated herself on paintable things that were best capable of being treated indoors.[21]

The passage works together several contradictions. As an artist Eloise Stannard was expected to earn a living but as a woman she was asymmetrically positioned in the production of art. Her art practice was not attributed to the workings of sexual difference but to her own physical frailty, in itself a sign of bourgeois femininity.

There are numerous examples of the sisters or daughters of artist-families taking up still life while male kin painted landscape: Mary, Florence, Ellen and Norah Vernon, daughters of a landscape painter, William H. Vernon; Mary Scott, a painter of fruit subjects who was the daughter of William Scott and sister of John Henderson Scott, both landscape painters.[22] In the Rosenberg family of Bath the daughters specialised in fruit and flowers while the son George Rosenberg painted landscape as well as still life. Mary Harrison trained her daughters in flower painting, whereas her son George Henry produced watercolours of landscape and figure subjects. On other occasions the link was made through marriage: Florence Thomas, a still-life painter, married Alfred Williams of the extensive artist-family. At the end of the century, and in a family in which her father was a minister and her mother a watercolourist, Katherine Cameron (plate 3) established a reputation for flower painting while her brother David Young Cameron became well-known for his landscapes.[23]

Time and again in the biographies of women artists the choice of still-life painting in preference to landscape was attributed to a woman artist's ill health. In her two-volume compilation *English Female Artists*, published in 1876, Ellen Clayton recounted several life-stories in which landscape was forsaken for still life. She reported of Emma Walter that 'when a young girl [her] health was not sufficiently robust to admit of her going out to sketch or to study landscape'.[24] And she commented of Agnes MacWhirter,

> her health became so delicate that the doctors would not allow her to sit in the open air to sketch. She was obliged to give up her favourite landscapes and oil pictures, in which she had been so successful, and take up watercolour studies of still life. All the medical men who have seen her express an opinion that sitting out in the raw air so much as she did when sketching from nature has resulted in the breaking up of her health.[25]

The polarity, health/ill health, was one of the principal regulators of sexual and class difference. The discursive construction of the sickening feminine body ascribed to nature what was socially produced. Beliefs about middle-class women's incapacity for sustained physical or mental activity were

reinforced by tight corseting and restrictive clothing. By the mid-century a cult of feminine invalidism encouraged the perception of delicacy of mind and body as indices of bourgeois femininity. In turn this delicacy of bodily and mental constitution was given as an argument against middle-class women's professional work, vocational training and higher education as well as outdoor pursuits such as landscape painting and sketching. Egalitarian feminists of the 1850s staunchly resisted these constructions in bourgeois femininity, advocating not only education and employment but reformed dress and walking and sketching out of doors (plate 4).

In art criticism still-life paintings by women were perceived as expressions of innate femininity. But weighty cultural discourses anchored claims such as that made by the influential *Art Journal* in 1868 that 'fruits and flowers seem by divine appointment the property of ladies'.[26] In academic discourses on art, still life was dismissed as 'mere imitation'. Viewed as a decorative art based on manual dexterity not intellectual content, this lowly genre was considered suitable for women artists. But in the discussions which took place in the mid-nineteenth century around the appropriate forms of visual culture for 'the national school of art', still life was admired for its high finish, its attention to detail and most of all for its 'truth to nature'. Condensing a plethora of aesthetic and moral meanings, this phrase was widely used in the 1850s to construct particular bourgeois values in and for high culture. Works by two of the most noted flower painters, Annie Feray Mutrie and Martha Darley Mutrie, were commended for their botanical accuracy as much as for their aesthetic properties. For several different reasons, still-life painting became an artistic category in which women gained considerable critical acclaim, their success being facilitated by the frequent elisions between flowers and femininity which were made in a variety of ways in the literatures of art, books of household management and women's diaries.[27]

In the later decades of the nineteenth century artist-families fostered the careers of women figure painters. Living and working with her father James Gow and her brother Andrew Carrick Gow, both history painters, Mary Gow contributed figure subjects to the family enterprise until her father's death in 1885. Similarly Margaret Dicksee, living in the family home and working in the family business until her father's death in 1895, produced historical subjects which were dispatched along with those by her brothers, uncle and father to the Royal Academy.[28] Although artist-families profoundly affected the category of art in which a woman practised, there was generally an assumption that a daughter would become an artist and contribute to the family business. This expectation did not prevail widely among commercial, manufacturing and professional groups and a daughter in these families had first to contend with parental views on whether the professional practice of art was a suitable occupation for a bourgeois young woman.

25

DAUGHTERS IN COMMERCIAL AND PROFESSIONAL
FAMILIES

Daughters of merchants, manufacturers, lawyers, civil servants, doctors, bankers, writers and politicians became artists. Financial necessity was frequently given as the reason for taking up art professionally. Fanny Corbaux resolved on a career as an artist when her father became unable to support his family.[29] Ellen Clayton noted of Mary Tovey that 'like many others [she was] obliged to depend on her art for her fortune', and she reported of Annie Dixon that 'family affairs rendered it necessary that early in life Miss Dixon make her own way in the world'.[30] Without this economic drive, women in prosperous middle-class families often testified to opposition from parents who had neither desires nor expectations for working daughters. The amateur practice of watercolours was regarded as an accomplishment but specialist training and professional practice conflicted with the ideals of feminine respectability which, particularly before 1870, were centred on domesticity. While displeasure might be articulated by a mother or a father, transitions to professional training and practice could be facilited by a mother's unfulfilled wish to have been an artist or by the example of a brother or female relative already working as an artist. The entries in Ellen Clayton's *English Female Artists* of 1876, based on artists' statements, often reported prohibition leading to reluctant consent. In their stories of how daughters battled against parental hostility or slowly gained permission to attend art school, and in their narratives of how the death of a father or failure of the family business necessitated women putting their artistic skills to professional use, the entries reworked familiar formats of biographies of Victorian men, offering their readers role-models, inspirational examples and useful strategies.

Religion was a major factor in shaping the lives of Victorian women. Whereas Evangelicalism was highly influential in forming the domestic ideologies of the first half of the nineteenth century,[31] Quakerism and Unitarianism were significant in facilitating professional art practice for women. In the 1840s the close alliances between Quaker and Unitarian families generated a network of young women with shared aspirations and linked them to an older generation of women who had campaigned in the 1820s and 1830s for education, employment and an intellectual life for middle-class women.

Anna Mary Howitt was one of several women raised to an independent livelihood in a Quaker family in the 1840s. When the Howitts resigned their membership of the Religious Society of Friends in 1847 they allied themselves with Unitarianism, similarly committed to women's education and emancipation. Anna Mary Howitt was expected to work and contribute to the family business of cultural production headed by her energetic parents, the writers William and Mary Howitt. While her sister Margaret

became a translator, Anna Mary trained as an artist. She went on continental tours with her parents, attended Henry Sass's art school in London in the mid-1840s and studied independently in Munich from 1850 to 1852. Encouraged to paint and to write, Anna Mary Howitt was given her own workroom in the family home although her mother, a prolific author and editor, had no work-space of her own. When Anna Mary was in Munich her mother worked in this room, edited her daughter's articles for publication and dispatched them to magazines.[32] Passionately fond of Anna Mary, whom she named after her sister and herself, Mary Howitt's letters were filled with her longing for this daughter, likening herself to Ceres mourning the departed Proserpine.[33] Reunited in 1852, mother and daughters lived together in North London, 'busily occupied in writing, painting and studying'.[34] Mary Howitt wrote to her husband, then in Australia with their sons,

> Sometimes Annie and I sit together in the same room, each at our table, for an hour or two, never speaking. Then we say, 'How quiet and pleasant it is, and what a holy and soothing influence there is in blessed work!'[35]

Mary Howitt's pleasure in her daughters was matched by her practical help and constant encouragement.

The Howitts were part of a circle of intellectuals, politicians, writers and artists who were interested in radical politics and progressive causes. But in the 1840s not all the parents in this group countenanced their daughters' ambitions for vocational training and paid work. Octavia Hill's mother, a noted educational reformer, refused to allow her daughter to accept the offer of free tuition made by Margaret Gillies, the portraitist of this group. Octavia Hill was channelled instead into philanthropy.[36] Eliza Fox battled with her father, William Johnson Fox, a Unitarian minister who became a politician and well-known supporter of working-class education and suffrage. In favour of a rational education for girls, he supplied Eliza with books and art materials, sternly opposing her wishes to become a professional artist. She persevered, studying on her own, and eventually persuaded her father to allow her to attend Sass's art school which she attended regularly from c. 1844 to 1847 with Anna Mary Howitt.[37] Eliza Fox established a career with subject pictures and portraits, working at home in 'a little studio' with a sitter's chair, while acting as her father's housekeeper and hostess.[38]

Eliza Fox's opposition to her father drew on the interlocking discourses of radical politics, civil rights, feminism and Unitarianism which in the 1840s offered middle-class women not only access to formal education but most importantly a language in which to develop resistant subject positions and in which to voice demands for equality of opportunity.[39] She was supported by older women such as Harriet Martineau, whose portrait she

painted;[40] Eliza Flower, the composer who lived with W.J. Fox and who, until her death in 1846, tried against his will to sustain an independent career as a music teacher; Sarah Flower Adams, an Owenite feminist; Margaret Gillies, known for her encouragement of young women artists; and Harriet Taylor.[41] Moreover, by the mid-1840s Eliza had become close friends with Anna Mary Howitt and Barbara Bodichon, two young women who shared her commitment to the serious pursuit of art and to a feminist politics of equality.

Barbara Bodichon was the daughter of a wealthy Unitarian politician Benjamin Leigh Smith, who gave her an allowance and considerable independence. Her maternal aunt, Dorothy Longden, introduced her to radical politics and her paternal aunt, Julia Smith, took charge of her education, going with her to Bedford College, one of the first higher education colleges for women, where Barbara augmented private lessons in watercolour with study in the art classes.[42] Although she had a substantial allowance from her father, Barbara Bodichon worked and exhibited as a landscape watercolourist. For her, as for her two friends, professional practice as an artist was part of an emerging egalitarian feminist politics.

Links between a career in art and an interest in egalitarian feminism were certainly fostered by progressive attitudes to women's education, work and independence in Quaker families. *Recollections of a Spinster Aunt* provides a fascinating account of a girl growing up in the Quaker family of a London doctor. This collection of letters from the 1840s to the 1870s and interspersed narratives was undoubedly written by the artist Sophia Beale. With her sister Ellen she attended Queen's College and Leigh's private art school while copying works in the collections of the National Gallery and the British Museum. In the later 1850s and early 1860s the sisters enjoyed considerable freedom to walk unchaperoned around London, going to and from art school and museums. Their pleasures included eating baked potatoes from a stall in Charing Cross Road on a cold night. Aware of the possible improprieties of this activity, Sophia Beale commented, 'a little mild Bohemianism does no one any harm',[43] thus re-defining and feminising a term already in use for masculine artistic identity.

When their stepmother joined the household, the sisters were given their own recreation room, a social space of intense delight.

> After painting at the studio, or the Galleries, we return here and bring our friends to partake of a dish of tea We are not beholden to the domestic authorities as we make our own tea in our own pot, boiling our own kettle on our own hearth, and we toast our own muffins at our own fire.[44]

Like many young women they particularly disliked the regime of the bourgeois household where, in the words of the 16-year-old Evelyn de

Morgan, 'breakfast, as usual, lasted a century'.[45] It was at these teas that the sisters and their women friends plotted how to 'force open the doors of the R.A. for women students and women Academicians', and aired their hopes for women university students and women's clubs.[46] The daughters of this household were given considerable encouragement to follow their chosen paths and they were allotted their own space at home. Sophia had her own workroom in which she painted from paid models. In such propitious circumstances it is not surprising that she established a career as a writer and painter.[47]

Unitarian connections remained significant in the second half of the century. Helen Allingham's path to becoming an artist netted together a Unitarian background, women kin of two generations working as artists, and a precipitating factor which shaped the decisions of many women, the death of her father.[48] Both her parents, Alexander Paterson and Mary Herford, came from Unitarian families. Her paternal grandfather and several members of her mother's family were Unitarian ministers. In addition the Patersons and the Herfords were linked by kinship and friendship to prominent Unitarian families such as the Martineaus, Parkes and Gaskells. Helen's maternal grandmother Sarah Smith Herford had founded the Unitarian school for girls in Cheshire at which Helen was educated and she had also earned a living as an artist. Although Mary Herford had given up her artistic ambitions when she married, her sister, Laura Herford, became the first woman student at the Royal Academy and she set up an artistic practice in London. After the death of Alexander Paterson in 1862 and the consequent loss of income from his thriving medical practice, it became essential for Helen, as well as for her brothers, to be trained to be self-supporting. With the encouragement of her Paterson aunts, well connected in Birmingham non-conformist and radical circles, Helen was sent to the city's School of Design where she won several awards.[49] At the successful completion of her training she attended the Female School of Art in London in 1866 in preparation for her admission to the Royal Academy schools the following year. In London she was chaperoned by Eliza Parkes, the mother of Bessie Rayner Parkes, and by her maternal aunt. Laura Herford provided support, securing useful introductions to leading engravers who provided work which not only paid for Helen's lodgings but which laid the foundations for an extremely successful career as a graphic artist, marked by her appointment as staff illustrator and reporter to *The Graphic* in 1870, a post which she held until her marriage in 1874. Her earnings helped to support her mother and they financed the art training of her younger sister Caroline, whose career as a watercolourist she warmly encouraged.

Middle-class family organisation varied widely, shaped as much by race and religion as by class and sexual difference. Kinship linked the Jewish communities in Britain, cementing business, professional and cultural

alliances. Rebecca Solomon's position as a woman artist was located in the interlocking networks of the Jewish community in London in the 1850s and 1860s, the construction of Jewish womanhood and her class position. Of Ashkenazi origin, the Solomon family settled in Britain at the end of the eighteenth century. Rebecca's father inherited a thriving hatting business which he diversified in the 1840s. It has been suggested that Meyer Solomon's economic security contributed to his willingness to permit his two sons to train at the Royal Academy Schools and his daughter to attend the Spitalfields School of Design near the family home in east London.[50] It is also likely that her mother, Catherine Levy, an amateur artist, particularly encouraged Rebecca Solomon to make the transition to professional activity. Monica Bohm-Duchen has emphasised the importance of Rebecca Solomon's family context, in which 'artistic ambition and Jewish feminine respectability could co-exist'.[51] Drawing attention to the significance of Anglo-Jewry from the 1830s, not only economically but in the arts, she has concluded,

> the nineteenth-century Solomon family was thus a family with dual allegiances; on the one hand loyal to its Jewish roots and on the other anxious to succeed in English gentile society – which meant, for the most part, discarding outward signs at least of Jewishness.[52]

Presumably with parental consent, Rebecca Solomon left the family home in the early 1850s to live with her brothers and to establish her career as an artist. Her elder brother Abraham presided over a household which observed the Jewish calendar and dietary laws and Rebecca took responsibility for the religious education of her younger brother Simeon. Abraham Solomon provided tuition and commissions for copying; and presumably he advised on sales and exhibitions.[53] Rebecca Solomon may well have followed the example of her elder brother who based his success on contemporary themes without specific reference to Jewish customs or rituals. In the 1850s she exhibited modern-life subjects (plate 28), taking up history paintings at the end of the decade, a move made by several women artists of her generation. After Abraham Solomon's death in 1862 the household was disbanded. Rebecca Solomon lived for a decade with her brother Simeon, after which she lived alone.[54] For Jewish women artists, more numerous in the later decades of the century, the professional practice of art took place in a cultural context shaped by a greater visibility of Jewish public figures and art collectors and the active participation of Jewish women such as Lady Blanche Lindsay in cultural management.[55]

For a young woman facing opposition to her ambition to become an artist, support from a member of the family would be of strategic importance. Several women testified to the encouragement given them by their mothers. Emily Mary Osborn recollected that her mother had had 'a great love of painting and . . . had wished in vain to study art professionally'.[56]

Maternal approval successfully countered the opposition of her father, a clergyman, who nevertheless only allowed his daughter to attend formal lessons in art intermittently. Having been her first art teacher, her mother continued to encourage her professional practice. After her mother's death in 1868 Emily Mary Osborn gave up painting for some time, revealing the closeness and importance of this relationship.[57]

By contrast Joanna Boyce found her best ally in her father, who, until his death in 1853, chaperoned her to lectures, galleries and collections. She lived at home, working in her own painting room, studying intermittently at London art schools, networking with other young women artists and negotiating her mother's censure of her art career.[58] Joanna's determination may well have influenced the decision of her brother, George Price Boyce, to abandon architecture for watercolour painting; he introduced her to art circles, offered encouragement and doubtless provided practical advice.[59] But when he was ill it was Joanna who left her art classes to nurse him.

Having an artist brother was both a help and a hindrance. As in the example of Rebecca Solomon, a brother's choice of career could benefit his sister. On the other hand, brothers seem to have been particularly demanding. In the 1850s Rosa Brett assisted her brother John Brett in return for art tuition. She helped him with his pupils, packed his pictures for him and worked on his canvases, her painting being passed off as his. As the only daughter in a family of boys she managed the family home in Maidstone, did some of the housework, entertained her mother and sat by when her brother Arthur practised his music. Over these years she also worked hard as an artist, sketching and painting. Her diaries and letters reveal an arduous routine combining the practice of art with domestic and familial responsibilities which often led to chronic illness.[60] When she first contributed one of her own works to the Royal Academy exhibition in 1858 she sent it with the pseudonym 'Rosarius' to distance herself from her brother, by then renowned as a landscape painter and championed by Ruskin. Similarly, Helen Angell, the daughter of a doctor, was trained by her brother William Coleman; in return she assisted him with his decorative work for Minton's pottery.[61] She established an independent identity as an artist (plate 31).

In the second half of the century, women's practice of art was increasingly defined in terms of respectability. These discourses predisposed parents to sanction a daughter's desires for a career in art. Some middle-class parents, however, still opposed or discouraged this choice. Louisa Starr, the daughter of a London banker, 'won the reluctant consent of her parents to study art'.[62] Maternal displeasure was recorded in the biographies of several women artists. Ellen Clayton's entry on Augusta Walker, daughter of a wealthy doctor in Dublin, noted that 'it was with difficulty that her mother was reconciled to her wish of becoming an artist, but she

eventually yielded, though it was an outrage to cherished ideas'.[63] Evelyn de Morgan met strong opposition in her family. Her father was a London lawyer and Queen's Council. Her mother, who was connected familially to the upper classes, contended that paid work for women was not only unfeminine but petit bourgeois and she dismissed her brother, the painter John Spencer Stanhope, as an eccentric. Confronted with Evelyn's determination she is reputed to have said, 'I want a daughter not an artist.'[64] Evelyn was trained in the rituals of gentility. She complained bitterly in her diary of the tedium of meals, drawing-room conversation and visiting; she deplored the constant changes of dress and chafed at her 'enforced idleness'. She refused to be presented at Court, declaring 'no one shall drag me out with a halter round my neck to sell me'.[65] Drawing lessons were allowed but, according to her younger sister and biographer, one master 'was secretly given instructions to tell her she had no artistic talent' and another was ordered to restrict her to fruit and flowers. She worked on her own, locking herself in her room and hiding her materials. In 1872 she reflected on this situation in her journal:

> 17 today, that is to say 17 years wasted; three parts at least wasted in eating, dawdling and flittering time away. . . . Art is eternal, but life is short, and each minute idly spent will rise, swelled to whole months and years, and hound me in my grave. This year every imaginable obstacle has been put in my way, but slowly and tediously I am mastering them all. Now I *must* do something – I will work till I do something.[66]

The diary centres an author–character, unifying in its textual work the fragments and contradictions in which subjectivity was forged. A coherent sense of self was constituted in the narrative of personal struggle against adverse circumstances and massive obstacles, a self-representation in which a resistant and oppositional subject position was formed. The following year Evelyn persuaded her parents to let her attend classes at the Slade School of Art. After two years she made a decisive break, leaving the Slade to study in Italy. But it was not until the death of her father and the consequent break-up of the family home with her mother's departure for Yorkshire that Evelyn established an independent life in London. Like other young women of her generation she faced a new set of choices – spinsterhood, partnership with a woman, marriage (perhaps to an artist) – each of which would vary the relations between femininity, sexuality, identity and art practice.

MARRIAGE

The social institution of marriage as a relation of emotional and economic dependency came into being with the transitions to a bourgeois social

formation in which the family became central to the organisation of capital, identity and sexuality. Social structures of sexual difference positioned married women in relation to their husbands, household management and motherhood. Widely held beliefs that a married woman's highest pleasures resided in giving up her own concerns or her independence for the care of others prompted many women to relinquish a painting career when they married, or to change its direction in order to accommodate the interests of husband and family. But marital relationships took many forms in the Victorian period, and in companionate marriages, particularly those in which wife and husband worked together in the family business of cultural production (literature or art), a married woman was constituted an active agent in a partnership which for men and women united kinship and capital, paid productive labour and home life.

The marriage patterns of women artists were closely related to their familial origins. Throughout the nineteenth century women artists married practising artists, professional men, intellectuals, traders or minor civil servants. Women artists variously negotiated the social structures of sexual difference which positioned them as wives, mothers and hostesses. If some continued to work and exhibit, for others art practice took a secondary place in lives primarily organised around home, husband and children. Marriage to an artist facilitated women's art practice when there was an understanding that a woman would continue her practice and more especially that she would enter a business partnership with her husband. Joanna Boyce, Henrietta Ward, Jane Bowkett, Laura Alma-Tadema, Sophie Anderson, Elizabeth Forbes, Alice Havers, Marianne Stokes and Henrietta Rae were among those who formed these painting partnerships. But for others marriage to an artist could play havoc with a woman's artistic career. Georgiana Macdonald studied at the South Kensington schools in the later 1850s but after her marriage to Edward Burne-Jones in 1860 she recalled that 'I stopped, as so many women do, well on this side of tolerable skill, daunted by the path which has to be followed absolutely alone if the end is to be reached.'[67] Eliza Goodall was among those who relinquished a professional career on marriage.[68] Eleanor Brown's progress was deflected by her husband's illness.[69] Those who continued confessed to a sense of being torn between domestic matters and a career. Louisa Starr, a successful history painter and society portrait painter, who did not marry until she was 37, considered,

> We women are heavily handicapped in Art, as in all else, by the fact
> of our womanhood and its duties, and I hold that when a woman has
> a profession, it means in most cases that she has two professions.[70]

Women artists who had established an independent life and career often perceived marriage as an erosion or renunciation of their autonomy. Joanna Boyce, Mary Severn and Ellen Gosse all expressed a disinclination

for matrimony on these terms. Louise Jopling's letter, written in 1873 after the death of her first husband from whom she had legally separated, is shot through with interwoven strands of pleasure, desire and identity.

> As to marrying again, I shall do so only when I have no longer the power, as I have now, of earning my own bread. I have tasted for too long a time, and have too keen a relish for the bread of independence to ever exchange it for the kickshaws of dependence [B]y marrying again . . . I should be loading my self with extra duties, and all these duties would be as iron bars to my success. If I married a man, do you not think he would require some of my time, some of my thoughts? God knows, I have enough to think of as it is. With children coming every second year, where would be my time or strength for work? . . . No; I am perfectly happy with my work, my children and the love of my sisters Were I alone, and childless, it would be different perhaps; but with my boy and girl I can never be lonely.[71]

Louise Jopling drew on the language of duty and dependency in which middle-class women often conceptualised marriage and wifehood in order to construct a contrast with her own elected pleasures of children, women kin and paid work. But her choices were made against the grain and she quickly came to perceive that her position as an artist and her respectability as a middle-class woman could only be sustained by a second marriage, this time to an artist and arts administrator, Joseph Jopling. She was convinced that 'the best thing I can do for my reputation's sake, and my boy's, is to marry again'.[72]

ARTIST-MARRIAGES

Kinship and business relations in the artist-families of still-life painters, landscapists and watercolourists were particularly strengthened by marriage. The union of Isabel Oakley and Paul Naftel created a veritable dynasty which was continued by their children. Watercolour landscapists Emma Eburne and William Oliver formed a working partnership. After Anne Fayermann married Valentine Bartholomew she added flower painting, his speciality, to her repertory.[73]

Artist-marriages also extended the networks of women kin working together. Jane Maria Bowkett and her sisters Eliza, Leila and Jessie all became artists,[74] although according to Jane 'the family home was entirely devoid of pictures'.[75] The daughters of Jane Watkinson of Stepney and Thomas Bowkett, a surgeon active in Chartism and radical politics in East London, were evidently expected to work. Jane and Eliza trained at one of the London Schools of Design where Jane won prizes and medals. Beginning their careers in the early 1860s the two sisters continued to work

closely together for several years after Jane's wedding in 1862 to Charles Stuart. Jane Bowkett married into an artist-family: her husband was a painter, as were his father and his brother. In 1862 she moved into the Stuart family home in Stepney which served as the business premises for her mother-in-law Amelia Stuart, a genre painter; her sister-in-law Theresa Stuart, a still-life painter; and perhaps her husband's aunt, Miss G.E. Stuart, a painter of fruit subjects.

In 1866 Jane moved to Gravesend with her husband and children as well as his parents and sister, Theresa. In these years of almost constant pregnancy and the death of three childen she maintained a prolific exhibition record except in 1871–2 when her mother died. After her father's death in 1874 she and her husband returned to London, settling in neighbourhoods made fashionable by prosperous artists. The move coincided with a change from modern-life painting to historical and literary subjects which commanded higher prices. In 1885 the couple moved from Melbury Road in Kensington to West Hampstead where they built a large studio to accommodate her husband's vast landscapes and her larger works, although at this date she stopped exhibiting. Her eldest daughter Leila Bowkett, named after her sister, became an artist, setting up her practice with her mother's younger sisters, Jessie and Leila, both painters in Acton, west London.

When marriage to an artist made it possible for a woman to continue to work and exhibit professionally, the daily routines of husband and wife would be structured differently, with the woman taking responsibility for household management and child-care.

In 1848 Henrietta Ward married her teacher Edward Matthew Ward, a painter for whom she had modelled. She came from an extensive artist-family: her great-uncle was George Henry Morland; her grandfather, the painter James Ward; and her father was a portrait painter and engraver. Henrietta was given her first lessons by her mother, Mary Webb, a miniature painter who pursued her career through her daughter's childhood and adolescence, exhibiting her work at the Royal Academy up to 1849. Henrietta Ward gave up painting for a short period after her marriage but quickly resumed, attending Sass's art classes and sending her first oil painting to the Royal Academy in 1850. In the 1850s she and her husband both worked at home, each in their own studio. They rose early, worked from 6 a.m. until breakfast at 8.30, after which Henrietta went to the kitchen to order dinner, then visited her children in the nursery and the schoolroom, before returning to her studio. But as she recollected, she was not infrequently interrupted by her children or 'an alarmed servant coming to tell me of some small domestic tragedy; some knotty point that could only be solved by the mistress of the house'.[76]

As a middle-class woman Henrietta was responsible for the running of a large household which included several domestic servants, a cook, nursery-

maids and a governess, whose work was indispensable to her own. In this and the following decade when she was contributing a major painting to the Royal Academy every year she gave birth to eight children, supervised their education and trained several of her daughters, Eva, Flora, Beatrice and Enid, as artists.[77] Her reminiscences, written as were many women's in a vein of light humour, include amusing anecdotes of her daughters working beside her on the lower portions of her canvases and an account of one occasion on which they rubbed out one of her paintings.

By contrast, Edward was not involved in his children's upbringing or the running of the household. After breakfast he read the newspaper, then retired to his studio, from which he banned the children unless they were modelling for him. As Henrietta observed, her husband was 'immersed in his own artistic problems, quite to the exclusion of the whole world'.[78] His isolation from daily worries and his ordered working day, even his evening entertainments which varied from a walk with Henrietta to a party which she hosted, were organised by his wife. In turn her art practice was supported by a companionate marriage and shared enterprise. Henrietta drew up their accounts and she seems to have managed the business. In the 1850s husband and wife worked in different areas of art practice. However, in the following decade Henrietta, for reasons which are explored in Part II, took up history painting (see plates 14 and 38). Although critics constantly set up comparisons between their historical subjects, it seems likely that the couple, like many other painting partnerships, pitched for the same market without adversely competing with each other. Husband and wife did not promote a corporate identity but sustained independent careers while contributing to a joint income.

In 1857 Joanna Boyce, by then well established as an artist and art critic, married the portrait painter Henry Tanworth Wells. Enjoying her 'intense love of independence', she was extremely reluctant to become engaged to him, writing, 'I have so long taught myself to look on engagement and marriage as things to be dreaded and avoided.'[79] In 1858, however, she wrote to a woman friend, 'letting you know how happy I am in my married life and how thankful I am to God for having overruled my wicked selfish purposes as he has'.[80] Like many bourgeois women, Joanna framed her experience of marriage in explicitly religious terms as submission to a higher authority. As an artist her married years were productive: she turned visits to Surrey into landscape settings for her pictures, used her children and household servants as models (plate 25) and exhibited regularly. After Joanna's death from puerperal fever in 1861 Elizabeth Siddall commented, 'It will be a fearful blow to her husband for she must have been the head of the firm and most useful to him.'[83]

Numerous artist-marriages were arranged as business enterprises with both partners contributing through sales and commissions. In some cases, such as that of Louise Jopling, the woman artist was the mainstay of the

business; in the years of her second marriage to Joseph Jopling, she was the principal income-generator. She found this responsibility weighty and stressful, necessitating constant production, regular sales and a continual search for commissions and clients. In 1879, despite her own illness and that of her son Percy, she produced eighteen works. The following year she wrote despairingly,

> I cannot help wondering sometimes what would become of the entire family if I were to succumb and be unable to work any more. As it is, forcing myself to work when I was not fit to do so has, I think, injured my reputation . . . this last attack has made me feel very wretched, and I fear that my work is bound to suffer.[82]

The marriage of Evelyn Pickering to the art potter William de Morgan in 1887 cemented an alliance already made with a joint exhibition of pots and paintings in 1884. Evelyn de Morgan contributed substantial emotional support and financial assistance, partly derived from her success as a painter, to her husband's pottery business until its demise in 1907.[83] Joint ventures were not uncommon. The painting partnership of Elizabeth and her husband Stanhope Forbes included the founding of an art school in Newlyn at which both taught. In the case of Henrietta Rae and Ernest Normand a friendly rivalry, fuelled by critical comparison, developed between the two partners living in the same house and then working in the same studio on similar massive history paintings. In 1889 Henrietta Rae commented that she was activated as an artist by 'a resolute will and laudable ambition . . . that would not let her like to see even her husband get too far ahead of her in art'.[84] On other occasions a husband's sales and prestige far outweighed those of a wife. Lawrence Alma-Tadema's neo-classical paintings for instance generated a greater income than Laura Alma-Tadema's small-scale Dutch interiors.

While all these varying forms of partnerships between husband and wife participated in the common middle-class practices of cementing business interests through marriage, they differed sharply from the organisation of many commercial, manufacturing and professional firms by uniting men and women as active partners in the enterprise. The social order of sexual difference was not therefore constituted in a rigid division demarcating the spheres of men and women, but nuanced and rearranged to encompass the formation of commercial practices in which women artists contributed substantially as income generators and were publicly recognised as paid workers.

For a woman to sustain an art practice after marriage it was essential that she had some sort of work-space, whether this was her own, shared with her husband, or simply an easel set up in the corner of a room. Henrietta Rae and her husband Ernest Normand initially worked together, but after a move in 1893 to Norwood they worked separately, Henrietta Rae

commissioning an enormous studio to accommodate her largest and most ambitious work, *Psyche at the Throne of Venus* (RA 1894) (plate 44).[85] Spatial provision undoubtedly affected the categories of art in which women worked. Without considerable studio space, it was not possible for women to paint the kinds of art on which an academic reputation depended. Reciprocally the space of production structured women's identity, shaping the ways in which they considered themselves to be artists. In the later nineteenth century highly successful male artists worked in vast studios in palatial residences which indexed not only status, wealth and success but came to signify artistic masculinity. The locations of picture making as much as access to models and materials, time and concentration were thus part of the ways in which femininity was sustained in a position of difference.

Tantalising questions about the organisation of painting partnerships remain as yet unanswered. It is not known how decisions were made or how the daily business of a joint enterprise was undertaken in a social formation which structured asymmetrical relations for men and women to capital and income, space and time. Who chose and purchased artists' materials, who hired models, who negotiated with clients, and to what effects? What exchanges took place in a shared studio between father and daughter, husband and wife? What differences could be charted between married women working in artistic partnerships and those running their own businesses?

MARRIAGE OUTSIDE THE ARTIST COMMUNITY

Women artists often married lawyers, civil servants, administrators, business men, writers and intellectuals. Having trained and practised as professional artists women often experienced tensions between maintaining their career and the demands of husbands, children, household management and hostessing. They resolved these conflicts in desire in varying ways: by giving up professional practice entirely, by sketching occasionally, by lessening their artistic productivity, or by changing the direction of their career. Some opted to marry in their late twenties, like Helen Angell who sustained a distinguished career as a flower painter after her marriage to a postmaster for south-west London.[86]

Given the prevalent expectations that wives of professional men did not work, several women artists expressed a decided disinclination to marry, preferring familial ties and an independent career. Mary Severn was trained by her father the artist Joseph Severn, and by his friend George Richmond. In the 1850s she established a thriving practice in watercolour portraits (plate 5). She worked hard, contributing substantially to the household income as her father's practice of history painting steadily declined. In 1853, when he fled to France to escape his creditors, the family

temporarily disbanded, reassembling in a house taken in Mary's name. Her clients came from the royal family, court circles, the aristocracy and the wealthier middle classes, her mother mobilising her family connections. Mary often travelled to her clients; when she visited Eton to paint school-leaving portraits she was chaperoned by her sister Eleanor. By 1858 she had displaced her father as the main earner.[87]

Mary Severn evidently enjoyed her family life. In the autumn of 1852 when she was staying in Ireland to carry out portrait commissions, she wrote of her home in London, 'Such a little originality is delightful now and then. I long for the Denbigh Terrace irregularities. I think out of the way living is after all the most interesting – at all events we have variety.'[88] Her pleasure resided in a household routine ordered around artistic productivity, perceived as irregular only against the formality of her clients' households.

Mary Severn's identity as a respectable professional woman was essential for her dealings with her clients, for staying at their residences, and for drawing them and their children, relationships all governed by propriety and decorum. But this identity was held in tension with ideals of domestic femininity and it was to these ideals which Charles Newton appealed in proposing marriage to her. Her initial unwillingness was based on her sense of responsibility to her family, her pleasure in their company and her desire to be self-supporting. She came in contact with Newton, a classical scholar, when she was commissioned to provide drawings of sculptures at the British Museum. Newton's courtship was accompanied by censure of her professional practice, criticism of her work and that of her teacher. Mary began to consider her family and her working life to be idiosyncratic and she seems to have lost confidence in her abilities as an artist.[89] When Newton relinquished his post of British Consul in Rome he offered it to her father, Joseph Severn, who welcomed the status and income as well as the opportunity to return to the city where he had lived in the 1820s and 1830s. With her siblings grown up and her father secure, Mary had no grounds for declining Newton, particularly after he was appointed Keeper of Classical Antiquities at the British Museum.

After her marriage in 1861 Mary abandoned her practice of watercolour and chalk portraiture, taking up oil painting, in which she had been trained but had not practised professionally. She successfully exhibited several oils, including her self-portrait, shown at the Royal Academy in 1863 (plate 6). From 1858 she produced drawings which were used as illustrations to Newton's lectures and publications, archaeological studies which were valued less for their artistic merit than for their correctness. Mary accompanied her husband on his excavations, making drawings and studies for him.[90] She died of measles in Rhodes in 1866.

In her obituaries the restructuring of her art practice during her married life was ascribed to wifely devotion.

After her marriage Mrs Newton became even a more devoted and conscientious labourer in her art than before. Following her husband's studies with the double interest of a devoted wife and an enthusiastic artist . . . Mrs Newton executed on a large scale a considerable number of drawings from the finest antique sculptures and vase paintings of the Museum as illustrations of her husband's lectures.[91]

The selflessness expected of bourgeois femininity was elided with a form of visual imagery, archaeological drawing, in which the marks and name of the producer are considerably less important than what is represented and the status of the 'discoverer'. Newton's renown as an archaeologist rested on the lectures and publications enlivened by his wife's drawings. The profound changes wrought in the artist's life after her marriage cannot be attributed simply to an expression of her femininity, nor to the oppressive patriarchal domination of one sex over the other. Rather they took place within that web of psychic and social relationships which instituted sexual difference and constituted pleasure for a married woman in relation to her husband. By contrast, in Victorian Britain husbands were not expected to rearrange their activities or reconstitute their sense of self on marriage; on the contrary, they expected their wives to adapt to them and to cater to their desires.

Mary Severn was one of several women artists to marry a writer or an intellectual. Emilia Dilke's first marriage to an Oxford scholar similarly reshaped her work. Having trained at the South Kensington school in the later 1850s and tentatively begun her exhibiting career at the Society of Female Artists, she contributed to the decoration of Wallington Hall in Northumberland, the home of her friend Lady Pauline Trevelyan.[92] But after her marriage in 1861 she did not develop her career as an artist. By the end of the decade, however, she had established herself as a prominent art critic and she was to become an eminent art historian.[93] Likewise, neither Lucy Madox Brown who married art writer William Michael Rossetti, nor Catherine Madox Brown who married music critic Franz Hueffer, continued a career in art. By contrast, Helen Allingham was amongst those whose art practice flourished in her married years, her husband, the writer William Allingham, noting that 'she is especially pleased with the prospect of going on with her art, not only without hindrance, but with every encouragement from her husband'. He continued, 'We have a great many friends in common and trust under Heaven to be in every way good to each other and to keep our friends.'[94] Giving up her post as an illustrator on *The Graphic*, probably thought inappropriate for a married woman, Helen Allingham made a successful transition from illustration to watercolour painting.

There was a marked pattern of marriage by women artists into what has

been called the 'intellectual aristocracy',[95] a network of scholars, writers and public administrators. If, as Leonore Davidoff has indicated, this group produced 'so many politically and economically pioneering women',[96] uneven relations of sexual difference were tangled through these interrelated families which functioned largely as a system of masculine preferment, channelling men into the civil service, colonial administration and the professions, paid posts which also allowed them to work as writers and critics, even artists. For women artists married into this network there were tensions between their art work and the social and household management which supported the public careers and patronage systems of their husbands. The contrasts between two sisters exemplify the different paths of marriage to an artist and marriage to an intellectual.

Ellen Gosse and Laura Alma-Tadema were the daughters of a London homoeopath. While their elder sister Emily Williams trained as a painter with John Brett,[97] Ellen attended Ford Madox Brown's classes and Laura studied with Lawrence Alma-Tadema, a Dutchman recently settled in Britain, whom Laura married in 1871.[98] This same year Ellen began exhibiting her work. She had her own studio in the house she shared with her widowed sister Emily, one of her brothers, and her aunt. In 1874 her aunt wrote of

> Miss Nellie's determination of will, she having willed that she will not marry, but prosecute her art with all her might, for since she has no fortune, she wishes to be indebted to no one for a livelihood, but work herself into fortune.[99]

The letter was written to Edmund Gosse whose proposals of marriage Ellen had refused, but whose suit was favoured by her aunt. By the end of the year Ellen had, according to Gosse, 'suddenly capitulated and without terms', for, he claimed, 'she is so anxious *to think of me* in the future rather than herself'.[100] After their marriage in 1875 Edmund Gosse worked as a civil servant while gaining a reputation as a literary critic and poet. Ellen ran the household, kept their accounts (keenly aware of the need to collect payments outstanding for Gosse's work and to secure remunerative commissions) and looked after their three children (Philip, Tessa and Sylvia). When she was away from home – on holiday with the children, visiting his parents, or nursing Gosse's father in his terminal illness – her husband would write to her with a barrage of questions such as,

> Please let me know by return of post: –
> 1 Where are my white flannel trousers and shirts?
> 2 Have I a decent pair of tennis shoes?[101]

He would confess his dependence on her: 'Whenever you are away, I become immediately conscious of my utter helplessness without you, and how essential to my daily comfort your strength and knowledge and

experience are.' She was, he admitted, his general provider: 'It is so dreadfully fatiguing to have you away. You are so terribly indispensable, hands and brains and everything to your poor E.'[102] But it was on these visits away from home that she painted landscapes (plate 32). When circumstances permitted she worked hard, noting in her diary for 1887 that she had painted continuously for seven hours.[103] She exhibited occasionally from 1878 to 1890 after which date she wrote travel pieces and nonsense verse, contributed art reviews to the *Saturday Review*, *Century* and *Academy*, children's stories to *St Nicholas* and published articles in *St James Gazette*. In 1893 she wrote deprecatingly that she had been sent a copy of *Art and Handicraft in the Woman's Building* of the World's Columbian Exposition in Chicago 'as I happen to be a woman and was once a sort of artist'.[104]

In 1874 Ellen exchanged her independence for marriage, children, a moderate output of paintings and a modest exhibition record, not establishing herself as a journalist until her children grew older. Her sister was more productive.[105] Nevertheless Laura Alma-Tadema's relativity to her husband was constituted by the disposition of space in their London residences. At Townshend House, lavishly decorated in the 1870s with columns, stained glass, carvings and painted ceilings, Laura Alma-Tadema occupied a suite of three small rooms on the ground floor whereas her husband's studio, adjacent to the first-floor drawing-room and decorated in a neo-classical style with a painted ceiling, created the appropriately palatial setting for his scenes of Ancient Greece and Rome.[106] Furnished with numerous photographs of Lawrence Alma-Tadema's works and portraits of Laura Alma-Tadema which registered her presence as image rather than as image-maker,[107] their magnificent residence was the *mise en scène* for Lawrence Alma-Tadema's artistic style and products. As one contemporary visitor noted,

> The artist lives his whole life under his own roof, and every room bears witness to his presence Townshend House is the entire scene of Mr Alma-Tadema's toil, happiness and triumph, and is . . . an epitome of his history.[108]

Seventeen Grove End Road, St John's Wood was extended and remodelled in the mid-1880s to Lawrence Alma-Tadema's specifications. Laura was apportioned a small apartment, while her husband designed for himself a vast semicircular domed studio which served as the setting for his art and for the couple's lavish entertaining. Their weekly calendar now included Monday afternoon studio showings, Tuesday evening dinners and concerts and studio visits on Sundays. Admission to these events was by invitation only and the guest lists of patrons, dealers, critics and friends were often composed by Lawrence Alma-Tadema himself.[109] Laura Alma-Tadema skilfuly moved between her activities as hostess, household

manager and artist. She made her reputation with scenes of women and children at home which, while they drew their inspiration from seventeenth-century Dutch pictures, could be compared to the collection of Dutch furniture and decorative objects, given to her by her husband, which graced her apartments and her paintings.[110]

For young women of the second half of the nineteenth century there were many ways of accommodating marriage, motherhood and artistic production. Elizabeth Thompson's wealthy parents provided continual encouragement and material resources: private education, art training, European travel and art study, assistance with models and props, a London studio and, when she needed it for *The 28th Regiment at Quatre Bras* (1875), a field in which to paint. After her marriage in 1879 to a soldier, Sir William Butler, she combined an extremely successful career as a military painter with her role as an army hostess.[111]

For some women such as Anna Maria Charretie[112] and Mary Harrison, widowhood precipitated a decision to take up art professionally. Mary Duffield was among those who continued the art business, in this case watercolours, after the death of her husband. Anna Lea Merritt and Helen Allingham were both intensely productive as widows, the latter leaving an estate of some £25,000 at her death in 1926.[113] By contrast, widowhood could prompt a change of direction. After the death of her husband in 1879 Henrietta Ward reorganised her business practice and opened an art school, exhibiting her works only occasionally.[114]

For a woman artist marriage could further her career, or halt it. It could initiate changes in her practice, lessening her output or her exhibition record, or initiate a new course. Without full catalogues raisonnés of individual artist's work it is not yet possible to chart in detail the asymmetries between men and women with regard to working practices, exhibition records, sales, commissions and an overall corpus of work. What is certain is that married women were positioned, and indeed perceived themselves, in sexually specific relationships to household management, social calendars and child-care: for them, desire and pleasure were constituted around these areas of social life as much as around artistic production. Within the diversity of conjugal relationships, companionate marriages allied to joint business ventures certainly facilitated the professional practice of women artists.

At the turn of the nineteenth century Anna Lea Merritt, who had been widowed for over two decades and, as she admitted, had 'lived by my brush' for twenty-seven years, wittily reflected on marriage and the unevenness of this social institution.

The chief obstacle to a woman's success is that she can never have a wife. Just reflect what a wife does for an artist,
 Darns the stockings;

Keeps his house;
Writes his letters;
Visits for his benefit;
Wards off intruders;
Is personally suggestive of beautiful pictures;
Always an encouraging and partial critic.

It is exceedingly difficult to be an artist without this time-saving help. A husband would be quite useless. He would never do any of these disagreeable things.[115]

2

SPINSTERS AND FRIENDS

Spinsterhood was chosen by many women artists in the nineteenth century. There was considerable diversity in this construction of feminine sexuality. Some women lived alone; some remained as adult women in the parental home, especially when this was the premises of the family business of picture-making, while others set up house with brothers. Throughout the period women formed partnerships with women friends and kin, particularly sisters.

Spinsterhood, celibacy and women-partnerships were positive identities for middle-class women. Writing in the 1860s, the writer Frances Power Cobbe, partner of the sculptor Mary Constance Lloyd, characterised the spinster 'as an exceedingly cheery personage, running about untrammelled by husband or children'.[1] The writer Harriet Martineau stated in her *Autobiography* that she was 'thankful for not having married My business in life has been to think and learn, and to speak out with absolute freedom what I have thought and learned. The freedom is itself a positive and never failing enjoyment to me.'[2] As Harriet Martineau indicated, these freedoms enabled spinsters to pursue careers, establish their own priorities and set their own agendas and they wrote of their energy and their pleasures in being self-determined and self-supporting.

Spinsterhood increasingly entered public discourse in the later decades of the nineteenth century.[3] Broad patterns of social and economic change distributed more middle-class women into paid employment and by the 1880s the single woman was commended as 'a new, sturdy and vigorous type . . . neither the exalted ascetic nor the nerveless inactive creature of former days'.[4] Invested with a strong moral force, spinsterhood and celibacy were advocated as the grounds on which women participated in the public world and proposed in feminist discourse as the highest forms of womanhood:

The higher a woman's nature is, the more likely it is that she will prefer rather to forgo marriage altogether, than surrender herself to a union that would sink her below her own ideal.[5]

45

In electing spinsterhood women artists not only chose independence, but they harnessed their art practice to those moral principles of feminine purity which were perceived as unique to their class and their sexuality.

Close relationships between women kin often lasted a lifetime. Sisters who had trained alongside one another lived together as adults, continuing their careers as professional artists. There are several examples of sisters producing comparable art-work, both aiming for a similar market. Martha Darley Mutrie and Annie Feray Mutrie moved from Manchester to London in 1854 where they both established successful practices as flower painters. Fanny and Louisa Corbaux, Sarah and Elizabeth Setchell, Alice and Emma Squire, Alice and Cordelia Walker were among the many teams of sisters sharing homes and working lives in London. Clara and Ellen Montalba worked together in Venice, sending work back to exhibitions in Britain.[6] Myra and Kate Bunce studied together at the Birmingham School of Art, living at home in Edgbaston, a leafy suburb of Birmingham, with their parents, Rebecca Ann Cheesewright and John Thackray Bunce, the latter a leading Birmingham liberal and editor of the *Birmingham Daily Post*. Kate Bunce embarked on her career as a painter in the later 1880s, exhibiting in London and Birmingham and often using her sister as a model. Myra produced watercolours but concentrated on decorative metalwork, designing frames inset with precious stones to house paintings by Kate. Both Anglicans, their work was inspired by, and their practice gained commissions from, the High Church revivalist movement of the later nineteenth century. They worked together on religious works, triptychs and reredos, jointly producing an altarpiece in memory of their parents and their sister Edith for the parish church at their father's family home in Longworth in Oxfordshire, the centre of the Anglican Lux Mundi group.[7]

Sister-partnerships linked emotional bonds with the practicalities of running a business. When faced with the necessity of being self-supporting, Margaret Gillies and her sister, the writer Mary Gillies, moved from Edinburgh to London, living and working together from the 1820s until Mary's death in 1870.[8] Mary undertook the commercial transactions for Margaret's portraits, settling the prices and dealing with purchasers. In 1839 when her sister was away Margaret Gillies herself informed a client of 'what she [Mary] would have said for me'.[9] Recent research on women artists in Glasgow in the 1890s has documented the numerous teams of sisters such as Frances and Margaret Macdonald or Margaret and Mary Gilmour who set up design studios together and the many sister-partnerships which, as in the examples of Dorothy and Olive Carleton Smyth, or Hannah, Helen and Constance Walton, united work in the fine and decorative arts.[10]

In families in which there was some expectation or agreement that daughters would pursue careers as artists, adult women remained in the

parental home, living and working there. Eliza Fox and Anna Mary Howitt were among those with their own work-spaces in their parents' houses. This pattern was common for the adult daughters of artist-families. Louise, Nancy and Rose Rayner, Frances and Evelyn Redgrave, Mary Gow and Margaret Dicksee were among those who took up practice in the family business and lodged at its headquarters. Living and working at home was highly productive for the four Hayllar sisters (plate 7). When their mother died in 1899 and the tenancy of Castle Priory was relinquished, only Jessica continued painting, setting up house with her father. Kate turned to nursing and Edith, like Mary, gave up her career on marriage.[11] Others, like Rebecca Solomon and Flora Macdonald Reid, lived with artist-brothers.

For some women an independent and productive life entailed a break with the family and a move away from parents and family. For some this break was brought about by circumstance and for others it was an elected necessity. When her mother disbanded the family house in London, Evelyn de Morgan left 'to live in rooms adjacent to a studio'.[12] Her sister and biographer characterised the ten years before her marriage in 1887 as 'years of loneliness, and work, of hardship and poverty' but 'years too of happy aspiration and achievement'.[13] An independent life, living in rented accommodation and supporting themselves on earned income, became an increasingly familiar pattern for single middle-class women in the last quarter of the nineteenth century, bringing relative economic hardship for some.[14] Spinsters moved in and out of cheap lodging-houses; they often shared accommodation or studio-space. When Edith Courtauld left her parental home in the early 1870s she rented a house which she shared with a woman friend.[15]

Spinsters, unlike married women, had absolute control over their own money from their earnings or from a parental allowance or family inheritance. Having secured their autonomy and set up a business, profits would be ploughed back in the building of a studio. Emily Mary Osborn financed her studio from a commission for a portrait of Mrs Sturgis and her children, shown at the Royal Academy in 1855, for 200 guineas.[16] Jessie Macgregor commissioned her own studio in the 1870s.[17]

Feminist historians have drawn attention to the prominence of spinsters in the women's movements of the nineteenth century.[18] From the 1840s onwards feminist politics was an important strand in the professional practice of art by women, and artists were among the independent women whose networks formed the movement's strong alliances. Links between the personal and the political structured the early organisation of egalitarian feminism. By the later 1840s a group of young women including Barbara Bodichon, Anna Mary Howitt, Eliza Fox and Bessie Rayner Parkes had established ties of friendship linked by emotional bonds, professional commitment to cultural production and political commitment

to equal rights for women. Their rituals of friendship included communal study, the constant exchange of letters, discussions of shared aspirations, holidays together, walking and sketching excursions. The four are depicted in Barbara Bodichon's drawing *Ye newe generation* (plate 4). Their serious work as artists and writers and their understanding of feminism were developed by these passionate friendships. Bessie Rayner Parkes's collection, *Poems*, of 1856 was dedicated to Barbara while the first poem, entitled 'The World of Art', was inscribed to Anna Mary.[19] Anna Mary gave lessons in oil painting to Barbara, whom she considered 'my beloved friend . . . the sister of my heart'.[20] Friendship also generated several unfulfilled plans for women's communities. In Munich in 1850 Anna Mary, Barbara and Jane Benham discussed a project for communal living and working in 'a beautiful sisterhood in Art, of which we have all dreamed long, and by which association we might be enabled to do noble things'.[21] An inner sisterhood of women artists would be accompanied by an outer sisterhood of women workers, 'all striving after a pure moral life, but belonging to any profession, any pursuit'.[22] Anna Mary's novella 'Sisters in Art', serialised in 1852, elaborated a plan for a women's art college as an 'offering to ART and WOMAN'S CULTURE',[23] together with a scheme for women friends living and working together, 'sisters in love and unity – as SISTERS IN ART'.[24]

By the 1880s extensive networks of spinsters existed, particularly in larger cities and in 'artistic' areas of north and west London. They commissioned, bought or rented purpose-built artists' studios and socialised in a largely female community. By the early 1900s a circle of women artists in which spinsters such as Emily Ford predominated had become established in Chelsea. Drawn together by proximity, friendship, women's suffrage and the practice of art, the group was centred on Mary Lowndes, the principal designer for the Artists' Suffrage League and partner in the stained-glass studio of Lowndes and Drury, and her lifelong companion Barbara Forbes.[25]

EXCURSIONS ABROAD

With their particular 'freedom of locomotion'[26] spinsters travelled extensively in Britain and Europe, unchaperoned or accompanied by women friends or kin.

From the 1850s to the 1870s spinsters from Britain joined the large community of independent women settled in Rome which was well-known and well-publicised in feminist networks in Britain from the mid-century.[27] For Augusta Walker, settling there in the early 1870s realised 'the dream of my childhood'. She wrote of 'that strange and subtle charm which can only be felt – not understood or explained – it seems to me as if life would not be life anywhere else'.[28] For an artist the pleasures of Rome were its

museums, collections, studios, and society of British and American writers, artists and collectors. But for a woman these attractions augmented those sexually specific pleasures of taking a place in an extensive community of women writers, artists, actresses and singers whose professional and domestic lives were linked by friendship, interdependence and woman-centred social codes and spaces.

Spinsters also travelled to Paris, particularly from the mid-century onwards, to attend the ateliers and 'ladies' classes', pursue their studies and launch a career. They worked together, shared models and apartments. Sophia Beale's letters are full of spirited descriptions of her visits to Paris between 1869 and 1872, detailing her social and domestic arrangements and her adventures travelling alone. In 1869 she rented a room and a separate studio, taking her meals alone and unchaperoned in restaurants. She financed her visit and her tuition at Chaplin's atelier by acting as a supervisor at M. Bertin's studio three days a week. The following year she journeyed alone on the boat train and slept in the Ladies' Waiting Room when she arrived in Paris at 5.30 a.m. In 1872 she travelled with women friends and they rented a flat together.[29] The letters are shot through with the distinctive characteristics of spinsters' life-styles: independence, financial autonomy, the freedom to travel, an enjoyment of the public spaces of the city, and the companionship of women friends.

This pattern of work, friendship and shared lives was well established by the mid-1880s when Dinah Muloch Craik wrote an article on a group of British and American women artists in Paris who studied together at the same atelier and lived in rented rooms in the same house. The author emphasised that it was necessary to break with the conventions of bourgeois femininity when establishing an independent working life. The young women, she wrote, 'did not look particularly tidy, having on their working clothes – an apron and sleeves grimed with chalk, charcoal and paint – but all looked intelligent, busy and happy'.[30] The women shared aspirations to exhibit in the Salon as much as they shared walks, talks and teas; they modelled for each other and gave constructive criticism of work in hand. As one of them affirmed, 'companionship is one of the pleasantest bits of our student life'.[31] Within this circle there were close friendships: 'one pair might almost rival the Ladies of Llangollen. For seven years they have never been separated, and seem quite indispensable to each other.'[32]

FRIENDS AND COMPANIONS

Women's friendships were of central importance to women's lives in the nineteenth century. The social structuring of sexual difference generated emotionally charged relationships between women. Publicly represented in biographies, autobiographies, memoirs, fiction and high culture, women's friendships were the subject of letters, poems and drawings exchanged

between women. These relationships have often remained 'hidden from history', as Carroll Smith-Rosenberg has written:

> The female friendship of the nineteenth century, the long-lived, intimate, loving friendship between two women, is an excellent example of the type of historical phenomenon that most historians know something about, few have thought much about, and virtually no one has written about These relationships ranged from the supportive love of sisters, through the enthusiasms of adolescent girls, to sensual avowals of love between mature women.[33]

Many women organised their lives around an emotional bond to a woman friend or relative. As Ellen Clayton noted of the artist Augusta Walker,

> It is impossible to avoid noticing her [cousin Frances], as any sketch of Augusta Walker would be incomplete without including one who has been from time to time her constant friend and companion.[34]

Having gained the reluctant consent of her mother to study art in London, Augusta Walker was sent from Ireland to live with her cousin Frances while she studied at South Kensington schools and at Heatherley's in the early 1860s. The two women quickly formed an intense friendship and they published their jointly authored stories under various pseudonyms.

> Augusta found what she had struggled for so long in vain – liberty; and in the first encounter of that delight, she passed the very happiest hours in her life. A singular and romantically interesting friendship existed between the girl-cousins. Every thought was shared by a magnetic influence beyond their control.[35]

Similar close friendships included those between the artists Annie Robinson (later Swynnerton) and Susan Isabel Dacre in the 1870s and 1880s, between Helen Paxton Brown and Jessie M. King which flourished from 1898 to 1907 when the latter married, or between Emily Mary Osborn and 'her great friend Miss Dunn', with whom she lived.[36] Domesticity was redefined by independent women for whom setting up house was often the basis for a working partnership uniting two different careers.[37] As Martha Vicinus has indicated, these relationships combined emotional commitment, shared political interests, feminist campaigning and professional activity. In her path-breaking studies of independent women she has concluded that 'during the last thirty years of the nineteenth century women's friendships became more intense and all-encompassing: love absorbed the burdens of pioneering work . . . a woman of this generation was able to live independently with a special [woman] friend, devoting herself completely to her career and her relationship.'[38]

'A MON AMIE': SIGNS OF FRIENDSHIP

Women's friendships were represented in visual culture from subject paintings of Ruth and Naomi,[39] to numerous exhibited portraits of women by their friends, companions and sisters. Annie Swynnerton's portrait of Susan Isabel Dacre was shown at the Royal Academy in 1880 (plate 8). The two women were friends in Manchester, joint founders of the Manchester Society for Women Painters in 1879 and campaigners for women's suffrage. As artists they worked together in Rome, Paris and London, sharing lives and studios until Annie Robinson's marriage in 1883.[40] The portrait is inscribed 'A mon amie [to my friend] / S. Isabel Dacre' and signed 'Annie L. Robinson/ 1880'. This recording of the name of the beloved along with the name of the artist, as much as the actual gift of the painting to the sitter, marks the portrait as both the token and the sign of friendship.[41]

The painting was produced within the codes and rituals structuring women's romantic friendships which included the frequent reciprocation of letters and presents, the dedication of poems, and gifts of portrait drawings of the beloved, self-portraits and photographs.[42] Making and exchanging portraits were important indicators of closeness and affection: Annie Swynnerton gave her portrait to the sitter. Lucette Barker filled her albums with drawings of women friends and kin; when she met the writer Margaret Gatty in 1846 she presented her with a large chalk portrait drawing of herself as a token of friendship.[43] Charlotte Brontë made drawings of her close friend Ellen Nussey to whom she regularly wrote long, passionate letters.[44] Mary Severn sketched Gertrude Jekyll, her friend and travelling companion, when the two women accompanied Charles Newton on his archaeological expeditions.[45]

In women's friendships particular significance was attached not just to the portrait but especially to the face. Women friends did not necessarily assess one another in terms of conventional standards of elegance or fashionability. As Geraldine Jewsbury wrote of the actress Charlotte Cushman, who became a central figure in the women's community in Rome:

> I suppose Miss Cushman was not handsome, but the beautiful, true, and firm gray eyes gave me the impression of beauty, and supplied the lack of it, if it were lacking. To me she always looked beautiful.[46]

The delineation of the face recorded the actual appearance of the woman friend while indexing the inner beauty of the beloved and that moral purity which was believed to set women's friendships apart from and raise them above other relationships. The face of the beloved thus became the locus of pleasure, and its visual representation was the site and sight of desire which registered the special values of women's friendships.

In Annie Swynnerton's portrait (plate 8) Susan Dacre's face is pictured in terms of its its unevenness, its unlikeness to contemporary standards of feminine beauty. Deep shadows under her eyes, a large nose, full lips, asymmetrical eyes, wisps of hair escaping over her forehead comprise the depiction of her face while a loose, enveloping cloak entirely conceals the contours of her body. This dark fabric and a plain, monochromatic background throw the pale face with its shy, slightly anxious expression into sharp relief. Lighting, composition and colouring, the gravity of tone and presentation as well as the academic handling of paint emphasise the face as the central focus of the picture.

The portrait does not engage with the protocols of society portraiture or the codes for the depiction of fashionable women. The figure is portrayed without the svelte lines of fashionable styling which disposed the body into serpentine curves and which were accentuated by elaborate trimmings. The paint surface has none of the rich facture of the artist's commissioned portrait of Florence Hawkesley, Mrs Musgrave, of 1883 where the creamy texture of paint renders the substantiality of decorative ruffles on the sitter's dress which offset her profiled face.[47] Annie Swynnerton's portrait of Susan Isabel Dacre challenges the predominant regimes of representation and signification which from the 1860s increasingly produced woman as the visual sign of masculine desire. Here woman is not constituted as the sign of difference to masculinity, as in patriarchal systems of meaning.

The portrait of Susan Isabel Dacre reworked the representation of woman to articulate the pleasures and desires invested in women's friendships. In its making, representation, and inscriptions the portrait was an actual token of affection and a visual sign exchanged between two women. The painting was produced within, and was part of, the rituals of women's friendships and it signified the reciprocities and proximities of these passionate relationships between women. These exchanges between two friends, between sitter and artist, took place and meanings within the broader contexts of the formation of the women's movements and the networks of matronage and the foundation of women's societies and colleges. Across all these sites women produced and exchanged the visual sign woman to forge new meanings about womanhood and the relationships between women within the communities and institutions of women which proliferated in the later nineteenth century.[48]

3

AN EDUCATION
IN DIFFERENCE OR AN
IN/DIFFERENT EDUCATION?

Art training for women

INSTITUT(IONALIS)ING DIFFERENCE

Art institutions in the nineteenth century were organised in terms of sexual difference: the arrangements of art schools and of societies of artists distinguished between men and women. Some institutions excluded women, others limited their numbers or restricted their access to membership or training. Women artists were located in asymmetrical and unequal relations to art education, art administration and professional status.

Art schools and societies were part of the national and regional networks of political, religious, occupational and cultural associations which linked the disparate groups of the bourgeoisie. Professionalism was produced as masculine by the formation of organisations which trained and preferred men to assume positions of power in civic and public administration, from the running of the Empire to the management of cities and the direction of libraries, museums, art galleries and education. But these masculine identities were contested by middle-class women who forged languages and spaces in which to intervene in public discourse. Relations of civic power were reshaped by middle-class women's membership of school boards, their participation in municipal events, their work as Poor Law guardians, social workers and factory inspectors, and, at the cultural level, by the public careers, exhibition records and critical successes of women artists. The institutions of art, like those of other occupations, proved resistant to the training and recognition of *professional* women artists. Artists' societies and art schools characterised women as special, separate and not infrequently as amateur. Women students were refused admission, assigned to special classes or debarred from the life-class, while women artists were often placed in separate categories or excluded from membership of the artists' societies. Against this extended and diffused regime of patriarchal power women organised their own art classes, founded their

own societies of women artists and campaigned for admission to art schools and access to the full curriculum.

The history of women's art education has often been presented as a narrative of decreasing discrimination and increasing opportunities.[1] This story has usually been framed around women's exclusion from the Royal Academy schools and from the life-class, considered to be the high point of academic training and the basis for the most valued forms of art. These narratives are too familiar to need rehearsing once again. What is of interest here is the continual reshaping of sexual difference in the institutions of art education and the strategies of women's resistance.

Distinctions and inequalities between men and women were variously managed in admissions policies, teaching contracts, building layout, curricula, facilities, timetabling and charges. While the Royal Academy schools (which excluded women until 1860) provided free tuition, the private schools on which many women depended required the payment of fees.

More significant were the differences in the duration of men and women's art education. In contrast to the continuity of art education experienced by young men graduating from paternal guidance to formal training, a process which facilitated a smooth transition to professional practice, women's art training was often fragmentary, patched together by attending several classes, or by switching schools in search of better instruction. The pattern of Helen Allingham's art education was not untypical: she studied first at the Birmingham School of Design, then attended the Female School of Art preparatory to her acceptance at the Royal Academy schools in 1868; disappointed by the lack of provision there for women she left, enrolling at the Slade where she studied life-drawing.[2] Women's art education would be interrupted by domestic duties or cut short by family responsibilities. Several women testified to the frustrations generated by parental opposition. Edith Courtauld, daughter of a wealthy Unitarian textile manufacturer sympathetic to women's education, was given a studio and art materials but no formal training. She embarked on vast history paintings or 'passed despairing hours crouched on the floor, face turned towards the wall, weeping tears of anguish and mortification'.[3]

Women's struggles for art education contested patriarchal control over the making and definition of high culture founded on the production and exchange of the sign woman and the generation and preferment of patriarchal sets of significations for this sign.[4] The representation of the feminine body was one of the most contested sites of power/knowledge. The classification of the female nude as the highest form of academic art and later as one of the principal signs of modernity contributed to the social regulation of the feminine body sustained across multiple points of discourse and institutional practice.

Women artists' views on life-drawing varied widely, inflected by their

definitions of femininity and respectability. In the 1850s women artists ambitious for professional success attended the lectures on anatomy for artists by John Marshall, studied life-drawing in private art schools or at the classes organised by Eliza Fox, and launched a campaign against the Royal Academy's exclusion of women students. But at the same moment another advocate of professional work for women, the novelist and writer Dinah Muloch Craik, wrote of 'the not-unnatural repugnance that is felt to women's drawing from 'the life', attending anatomical dissections'.[5] Twenty years later, when life-drawing was more widely available, Ellen Clayton remarked, 'Perhaps there is no more vexed subject, or one more difficult of satisfactory solution, than this matter of drawing from the life by ladies studying figure painting.'[6] Class is clearly an issue here since Ellen Clayton registers a concern about the activities of bourgeois women. Life-drawing was perceived in relation to definitions of purity and respectability, terms which were produced as much around class, culture and morality as definitions of femininity. The struggles by women for access to life-drawing thus represented not only women's rights to that specialist training which underwrote professional success but more importantly they registered a challenge to the predominant regimes of representation and signification: the life-class embodied the contests around woman as sign. In the 1880s and 1890s those women artists who staked their careers on their rendition of the female nude, that double sign of academic achievement and of women's subordination in patriarchal culture, encountered intense hostility from the critical establishment. When, for example, Henrietta Rae exhibited *Psyche at the Throne of Venus* at the Royal Academy of 1894 (plate 44), the painting was said to be technically incompetent. Furthermore, the artist herself was accused of moral impropriety for her rendition of fourteen nude and semi-draped female figures. These criticisms, which were not uncommon, undercut women artists' professional status and the stance of purity on which middle-class women based their participation in the public world.

THE CAMPAIGN AGAINST THE ROYAL ACADEMY

Eliza Fox ran art classes for women from the late 1840s. They were organised on co-operative lines, the participants sharing the expenses. Having attended Sass's art school from *c.* 1844 to 1847, Eliza Fox initially gave instruction, but later she simply arranged the sessions, usually held in the library of the house she shared with her father.[7] Attended by Anna Mary Howitt, Barbara Bodichon, Laura Herford and many others, Eliza Fox's classes became a meeting-place for egalitarian feminists and a springboard for the campaign against the Royal Academy. Linked by professional interest and a network of friendship, this group of women organised the first feminist campaign for art education for women.

Women's dissatisfaction with the Royal Academy, which excluded women from its membership throughout the century and until 1860 from its schools, was first articulated in the later 1840s. Henrietta Ward and Fanny Corbaux were among the women artists who made their presence known by attending the Royal Academy public lectures.[8] Anna Mary Howitt recounted:

> Did I tell you I went one night to hear Leslie. Lecture at the Royal Academy. Oh! how terribly did I long to be a man so as to paint there. When I saw in the first room all the students' easels standing about – lots of canvasses and easels against the walls, and here and there a grand 'old master' standing around, a perfect atmosphere of inspiration, and then passed on into the second room hung round with the Academicians' inaugural pictures, one seemed stepping into a freer, larger, and more earnest artistic world – a world, alas! which one's *woman*hood debars one from enjoying – Oh, I felt quite sick at heart – all one's attempts and struggles seemed so pitiful and vain – . . . I felt quite *angry* at being a woman, it seemed to me *such a mistake*, but Eliza Fox, a thousand times worse [than] I, said, 'nay, rather be angry with men for not admitting women to the enjoyments of this world, and instead of lamenting that we *are* women let us earnestly strive after a nobler state of things, let us strive to be among those women who shall first open the Academy's doors to their fellow aspirants – that would be a noble mission, would it not?[9]

Her letter, written to Barbara Bodichon in about 1848, articulated both a sense of injustice at this institutional ordering of sexual difference and a politics of action. 'Woman's mission to women', which usually referenced middle-class women's rescue work of prostitutes, was here radically redefined away from philanthropy to feminism to forge a strategy for engaging women in a campaign for equal rights. The public petition for women's admission to the Royal Academy schools, launched some ten years later, was a part of the egalitarian feminist campaigns for women's education, paid work and professional status. Laura Herford's success in becoming enrolled in 1860 as the first woman student at the Royal Academy schools paralleled the determination of Elizabeth Garrett Anderson to become a doctor and the beginning of her training, in similarly disadvantaged ways, at Middlesex Hospital.[10]

For nearly 100 years from its foundation in 1768 no women students were admitted to the Royal Academy schools. As this institution admitted, its training was an essential stepping-stone to professional success:

> Most artists practising and exhibiting in the present day have been students in the Royal Academy . . . at present full three fourths of the Members of the Academy have been trained in these schools.[11]

By the spring of 1859 women were ready and their actions demonstrate the strength and organisational skills of egalitarian feminism at this date. In March 1859 several letters by individual women were printed in the *Athenaeum*.[12] The following month thirty-eight women published a petition which was printed in the *Athenaeum* and the *English Woman's Journal*, featured in the *Art Journal* and dispatched to the Academicians (appendix 2).[13] Taking advantage of the Royal Academy's imminent move to larger premises at Burlington House (its present-day location off Piccadilly), the campaign took issue with the claims made by Lord Lyndhurst that its schools were open to 'all her Majesty's subjects', while drawing on and contributing to contemporary criticism of its elitism. Prominent women intellectuals lent public support: Anna Jameson signed the petition and, like Harriet Martineau, she publicised the issues.[14]

Laura Herford's enrolment in 1860 has often been attributed to her personal initiative in sending in drawings signed only with her initials. But the admission of women was the direct outcome of feminist pressure which was maintained as the Academy restricted the numbers of women students and their access to the curriculum. When the Royal Academy halted the admission of women in 1863, women students at other London art schools challenged this decision and it was overturned in 1867.[15] Women continually protested about the inequality of training and facilities for women students who were admitted to the Antique school to draw from casts of classical sculptures and to the Painting School for the study of the draped model,[16] but excluded entirely from the life-class. As Jessie Macgregor, the prize-winning student of 1872, testified in later life,

> in those days *none* of the advantages in figure study, now freely open to students of both sexes, were open to us – so that I was under great disabilities compared with my fellow competitors.[17]

Throughout the 1870s and 1880s women students at the Royal Academy petitioned in vain for their own life-classes.[18] In her column in the *Illustrated London News* Florence Fenwick Miller drew public attention to their 'constant quiet agitation' and the Royal Academy's counter-threats of expulsion.[19] The art critic Emilia Dilke clashed with Frederic Leighton over student grants to enable women students to study the life-model.[20] It was not until 1893 that provision was made for women to study a partially draped model in a separate class.[21] By this date academic procedures and the prestige of the Academy were in decline and life-classes for women students were more widely available in public and private schools throughout the country.

DIMENSIONS OF SPACE:
DIFFERENCES OF SEX AND CLASS

In 1878 Amy Leigh Smith was advised to study at the Slade School of Art rather than the National Art Training Schools in South Kensington on the grounds that, 'the teaching is much more what you want You want to be an artist not a designer, don't you?'[22] The comment was significant, for art schools participated in the complex social regulation of class distinctions as well as sexual differences. Not only were the architectural spaces, timetables and classes in the art schools differently organised for men and women students, but art education differentiated between art and design along the lines of class. The Slade School of Art, founded in 1871 as an independent art school, was considered to offer the best fine art training for women in the later nineteenth century. Women studied with men at the preliminary level and had access to the study of the life-model. In 1883 Charlotte Weeks praised it:

> Here for the first time in England, indeed in Europe, a public Fine Art School was thrown open to male and female students on precisely the same terms, and giving to both sexes fair and equal opportunities.[23]

In its training of women as fine artists the Slade differed profoundly from the national network of Schools of Design founded in the 1830s to raise the standards of British design and primarily aimed at a working-class entry. A Female School of Design was established in London in October 1842. Anthea Callan has documented the ways in which the Female School was caught between the contradictory demands of its male administrators and its women students and teachers.[24] The first Superintendent was a well-known painter, Fanny McIan, who strongly supported women's professional training and financial independence, stating her 'conviction of the importance of this establishment . . . in its affording the means of respectable subsistence to a most interesting portion of society, the educated women of the middle-classes'.[25] The school flourished in its early years, but after 1848 policy changes increasingly discouraged the fine-art training which attracted middle-class women, deprived the school of facilities, eroded Fanny McIan's powers of decision-making and relocated the school to premises on the Strand, an area considered unsuitable for middle-class women. In 1852 Eliza Turck was 'vainly trying to satisfy a wholesome appetite for study with dry bones'.[26] The same year the school was moved once again, this time to the more respectable Gower Street, and, following a decision to capitalise on middle-class women, fine-art training was provided and the school prospered once again, becoming known as the Female School of Art. Although totally deprived of its funding when

it was cut loose from the national network in 1859, the school survived, setting up in Queen Square as an independent fine art school for women; its overcrowded classes provided a useful route for admission to the Royal Academy schools.

After a major reorganisation in 1857, the National Art Training Schools at South Kensington and the regional art schools primarily provided training for designers and art teachers with some classes aimed at income-generating middle-class amateurs. For women living in a provincial town the local art school was often the only option. Attending Nottingham Art School from 1890 to 1894, Laura Knight recollected her intense frustration at the separate classes for women, the lack of life-drawing and the endless copying of casts.[27] Art schools in Birmingham and Glasgow offered far better facilities.[28] Under the direction of Fra Newbery the Glasgow School of Art adopted a progressive approach to equal opportunities. After his appointment in 1885 amateurs were sternly discouraged and the course was reorganised to provide a basic introduction followed by a specialisation in fine or applied arts, a system which produced a city of distinguished women painters and designers.[29]

Private art schools and lessons from established artists comprised the two main options in art education for women before 1860. By contrast, male students tended to graduate from either or both to formal training at the Royal Academy. From the 1840s women attended the school run by Francis Cary,[30] and also enrolled in the mixed and separate classes at Dickenson's Academy, which became Leigh's art school and later Heatherley's. Joanna Boyce's art training, pieced together across several schools and family interruptions, was not uncharacteristic of young women artists at the mid-century. She studied at Cary's in the summer of 1849, giving up for several months to nurse her brother and returning to the school for three days a week in November. In 1852 she switched to the rival establishment, Leigh's, once again attending three days a week, while in the same year attending John Marshall's lectures on Anatomy for Artists. In her diary for April 1853 she noted, 'Commenced at Mr Leigh's. Paid for 12 lessons.'[31]

Leigh's offered a wide range of classes, and probably provided separate life-drawing classes for women in the 1850s.[32] Students were encouraged to study Leigh's own history paintings and anatomical drawings, to draw from his collection of casts and to make use of his collection of costumes and accessories. The school was run on the lines of a French atelier with independent study complemented by occasional criticism. In the later 1850s Sophia Beale, then a student there, wrote of

the wondrous 'High Art' pictures all over the house – in the rooms and on the staircases; and what a wonderful house it was! Not too clean and woefully hugger-mugger As to instruction we did

very much what we liked with little correction and much talk and theory.[33]

Leigh and his successor Heatherley seem to have done much to support and encourage women artists whose recollections often give lively vignettes of the school.[34]

Private art schools flourished in Britain in the 1880s and 1890s; some provided serious professional training, often on the lines of a French atelier; several specialised in particular kinds of art; others, like Arthur Cope's, attended by the young Vanessa Bell, prepared men and women for admission to the Royal Academy. Private schools were usually strictly segregated, timetabling men's and women's sessions at different hours and providing separate life-classes. But if art classes for women proliferated, vocational training did not, for many schools offered art as an accomplishment targeting a titled and royal clientele. Hubert Herkomer's school at Bushey in Hertfordshire was one of the few establishments which completely rejected the lucrative amateur contingent to provide rigorous professional training with open-air study and separate life-classes for men and women. But sexual difference skewed the admissions policy: the school excluded married women, widows, and single women over twenty-eight years of age.[35]

STUDENTS AND TEACHERS

Women's access to art education was structured by inequalities of racial and sexual difference. There has been an unspoken assumption that students in art schools of nineteenth-century Britain tended to be white. Research on the presence of women artists of colour is under way as is the documentation of Jewish women artists.[36] Rozina Visram has drawn attention to the increasing numbers of male and female Indian students who came to Britain in the later nineteenth century.[37] From 1892 to 1895 Dhumbai F. Banajee visited western Europe, attending Herkomer's school and studying in Paris and Holland before she returned to the subcontinent.[38] Although it was claimed at the time that she was the first Indian woman to come to England to study art, Dhumbai Banajee may well have been one of several women whose presence was recorded in Britain only as a name in a register, journal or official document.[39] Dynamics of race shaped the experiences of south Asian students in Britain, separated by thousands of miles from family and friends and often living on insufficient funds. Whether they were welcomed, tolerated or rejected by their contemporaries, as Rozina Visram has pointed out 'racial prejudice confronted them all'.[40]

Little is known of the relations between students in nineteenth-century art schools. Supportive friendships certainly developed. Eliza Fox recalled

the pleasures of studying daily with Anna Mary Howitt at Sass's art school.[41] Ellen Clayton recorded an amusing anecdote of women students going on strike for three weeks in protest against Augusta Walker's expulsion from the South Kensington school for whistling. When Augusta Walker left, one of her women classmates accompanied her to another school.[42] But if separate classes generated intense loyalties, they also produced considerable irritation. Laura Knight considered herself the only serious woman student at Nottingham Art School in the early 1890s.[43]

In mixed classes men and women jostled for space and the best positions. The patriarchal order of Victorian society gave men distinct advantages in these situations, since the codes of bourgeois masculinity included an authoritarian attitude as well as a patronising chivalry towards middle-class women. By the 1890s the behaviour of male art students, particularly those at the Slade School of Art, was increasingly bohemian and antisocial,[44] more sharply differentiated from the deferential and modest deportment expected of bourgeois women in public. But even before this date male students' behaviour could be aggressive, even violent. Jessie Macgregor recollected the aftermath of her winning the Gold Medal for history painting in 1872:

> I was under great disabilities compared with my fellow competitors. Perhaps it was this that made the men students so enraged (as they were) at the success of 'a chit of a girl' as I was called; feeling was so high that in their wrath the students smashed a cast that night.[45]

Once admitted to formal art training, women students at the Royal Academy and the Slade School of Art were frequently among the prize-winners.[46]

Women students were generally taught by men older than themselves. Then, as now, patriarchal power was inscribed in this hierarchical relationship. G.D. Leslie, an instructor at the Royal Academy schools in the later decades of the century, recollected,

> It is very pleasant work teaching girls, especially pretty ones, who somehow always seemed to make the best students It is certainly remarkable that the prettier the girl the better the study.[47]

Pleasure, desire and power traversed this circuit of instruction, differentially shaped for woman students whose attitudes to their male teachers have been little researched. When Anna Lea took lessons from Henry Merritt, a painter and picture restorer whom she later married, she sensed 'every impulse I had previously felt driving me to become an artist was now merged in the great wish to please my *master*',[48] a term whose meaning certainly exceeded that of teacher. Male teachers undoubtedly helped their female students to counter family prejudice to professional art practice. Marie Spartali, a member of the wealthy Greek community in London,

was indebted to Ford Madox Brown, testifying that 'if it had not been for his encouragement and help she might never have summoned the courage to attempt being an artist'.[49]

In the first half of the century when personal tuition was widespread, women artists often trained with an established artist. Mary Ann Criddle learnt watercolour from Sarah Setchell, who had herself trained with one of the Sharpe sisters. In the category of still life, skills were not infrequently handed down by women. Anna Maria Fitzjames was a pupil of the respected flower painters, Anne Bartholomew and William Henry Hunt. Emma Cooper took lessons from Helen Angell.[50] Margaret Gillies provided support and tuition for several generations of younger women.[51] Joanna Samworth was inspired by the example of Barbara Bodichon.[52] At the Female School of Art, Fanny McIan's pupils presented her with an address in 1845 testifying to 'their deep sense of the benefits they receive from her instruction'.[53] Women teachers were, however, rarely employed in the national network of schools of art and design. Gertrude Offord was appointed an assistant pupil teacher at Norwich Art School from 1889 (plate 9).[54] Sexual difference was written into employment, demarcating women's low-paid, low-status work from the senior teaching and administrative posts held and controlled by men. At progressive institutions such as Glasgow School of Art, equal opportunities extended to teaching. In the applied arts, instruction was dominated by the city's leading women designers who provided important role models for the female students who became designers, craft workers, elementary teachers or instructors at the School itself.[55]

Women set up, managed and taught in many of the private art schools which flourished in the 1880s and 1890s and which were listed by Tessa Mackenzie in *The Art Schools of London* in 1895.[56] Teaching undoubtedly provided invaluable income for women artists. For Louise Jopling it provided a necessary supplement to sales of paintings;[57] for Henrietta Ward a new way of earning money after her husband's death; for Elizabeth Forbes it became part of that art partnership which she formed with her husband. Teaching enabled independence and for Maud Hurst, as for so many others in the closing decades of the nineteenth century, a self-determined life which included those visits to Paris and France which were so essential for the modern artist.[58]

PARIS AND MUNICH

From the mid-century onwards increasing numbers of women went to study in Paris. Margaret Gillies and Joanna Samworth were among the small group studying with Ary Scheffer whose religious works were greatly admired by women.[59] Joanna Samworth also enrolled at the Public Drawing School headed by Rosa Bonheur.[60] Joanna Boyce attended the

'ladies classes' at the atelier of the history painter Thomas Couture from November 1855 to February 1856.[61] From the second half of the century Paris became the centre of modernity, a newly redesigned city devoted to the enjoyment, spectacle and representation of urban pleasure. It was this modernity with its facilities for independence along with access to life-drawing in the ateliers which attracted women artists. From the 1880s art periodicals and women's magazines featured art training in the French capital, recommending *pensions*, apartments, *quartiers*, restaurants, and the club for British women artists.[62] Often written by spinsters, these articles advocated self-sufficiency, determination and serious study. At the Académie Julian (opened in 1868), women drew from the life-model alongside men until 1879 when separate studios were established and women were excluded from the cheaper sessions and charged highly inflated fees.[63] In the Parisian ateliers the rooms tended to be crowded and tuition was minimal. One woman commented that 'the artist gives us instruction; perhaps two minutes each, . . . we learn most by experience and practice, and by criticising each other's work.'[64]

Munich was also a favourite location for women artists who were wealthy enough to study abroad. In 1850 Anna Mary Howitt and Jane Benham travelled here only to discover that the Munich Academy did not admit female students. They decided to stay and worked in a studio belonging to the history painter Wilhelm von Kaulbach who occasionally commented on their work.[65] Although this disadvantageous situation persisted, women artists were attracted to this 'art-city'. Charlotte Weeks claimed in 1881 that Munich offered 'facilities for social intercourse among artists and fellow students, and for living a *garçon* life, such as can only be obtained in a place where it is a common thing for a lady to live alone in lodgings'.[66] But Elizabeth Forbes, who had trained at the progressive Art Students' League in New York, was bitterly disappointed with her five-month visit, concluding that Munich 'was not at all a place in which women stood any chance of developing their artistic powers'.[67] The art critic Harriet Ford conveyed Marianne Stokes's strictures on the teaching system there:

> Generally on the professor's part it was not altogether serious. He came, he praised, he pointed out a superficial fault or two, he went away. For the rest the student wrestled with technical problems by herself . . . the feeling of being treated with a somewhat perfunctory gentleness and condescension, not too much being demanded of her, added insult to injury.[68]

Any instruction which women gained was on an individual basis from a male artist who agreed to assist them in a private capacity. Women worked on their own or in groups outside and excluded from the facilities, classes

and formal tuition of the Munich Academy, and they financed their own studio expenses, models, materials and tuition.

In conclusion, many of the state-funded art schools of the nineteenth century exhibited a particular resistance to the vocational training of women artists, although this was partly countered in the later decades by the provision for women at the Slade School and at the Glasgow School of Art. In the market economy of the private schools, art education was on offer for those who could pay for it, but the large amateur contingent at these schools could outweigh those in search of professional training, except at schools like Herkomer's. But whatever the differences of provision, public and private schools were united in the priority they gave to organising art education in terms of sexual difference. This differentiation between artists simply on the grounds of sex was constantly put in play in the institutions and discourses of art – from the art schools which controlled professional training to the art societies which awarded professional validation and distinction.

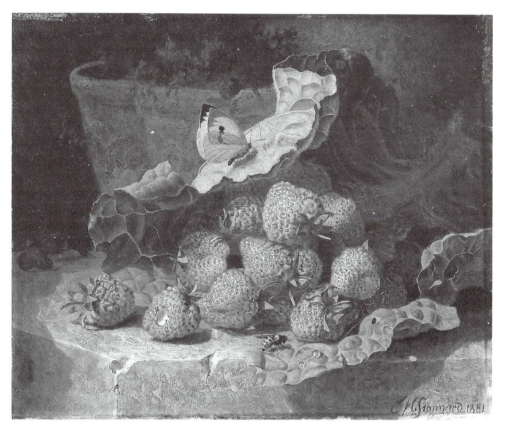

Plate 2 Eloise Stannard, *Strawberries on a cabbage leaf with a flower pot behind*, 1881.

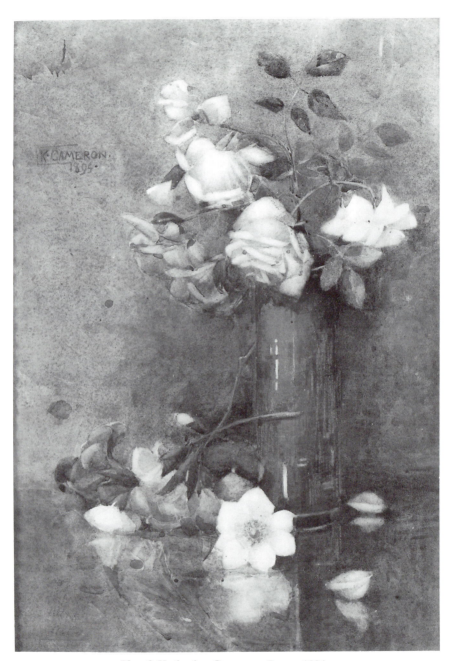

Plate 3 Katherine Cameron, *Roses*, 1894.

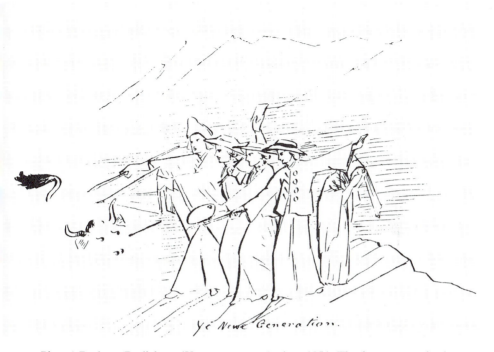

Plate 4 Barbara Bodichon, '*Ye newe generation*', *c*. 1854. The four women in the foreground are wearing loose baggy jackets, unsupported skirts and wide-brimmed hats. This kind of dress, favoured by the artist's circle of friends in the 1850s, made a statement about their feminism, and was suitable for the outdoor activities they enjoyed.

Plate 5 Mary Severn, *A woman of the Petre Dawkins family*, 1857.

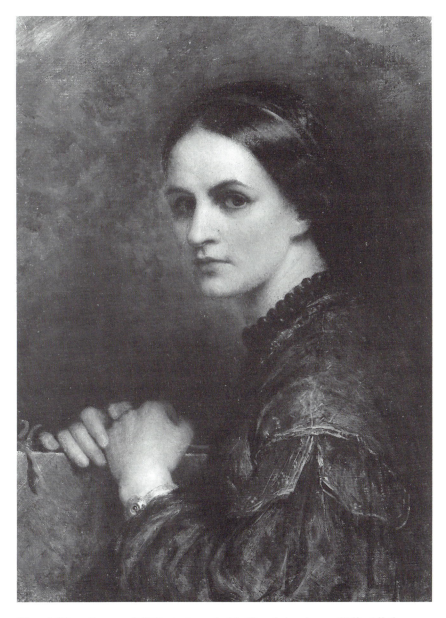

Plate 6 Mary Severn, *Self-Portrait*, probably Royal Academy, 1863. All the components of this self-portrait construct an image of an artist. The portfolio perhaps references her earlier production of portrait drawings rather than her current work in oils. Her ultramarine velvet attire, trimmed with gold tinsel braid, is a fashionable interpretation of 'artistic' dress. As in Elizabeth Siddall's *Self-Portrait* (plate 12) the figure is set against a rich dark green ground, a format revived in the 1850s in Pre-Raphaelite circles for literary and artistic sitters.

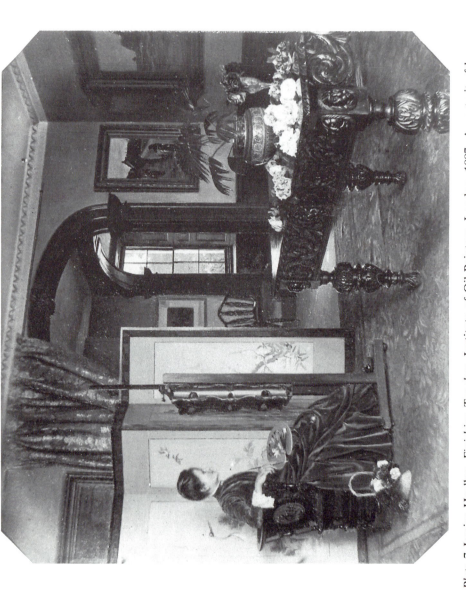

Plate 7 Jessica Hayllar, *Finishing Touches*, Institute of Oil Painters, London, 1887. A portrait of her younger sister Edith working at Castle Priory Wallingford, the family home, from 1875 to 1899.

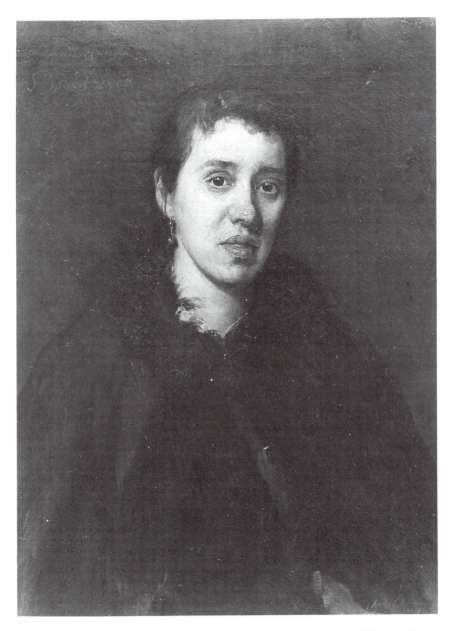

Plate 8 Annie Swynnerton, *Susan Isabel Dacre*, Royal Academy, 1880. Inscribed top left corner, 'A mon amie / S. Isabel Dacre' and lower right corner, 'Annie L. Robinson / 1880', given by Susan Isabel Dacre in 1932 to Manchester City Art Gallery.

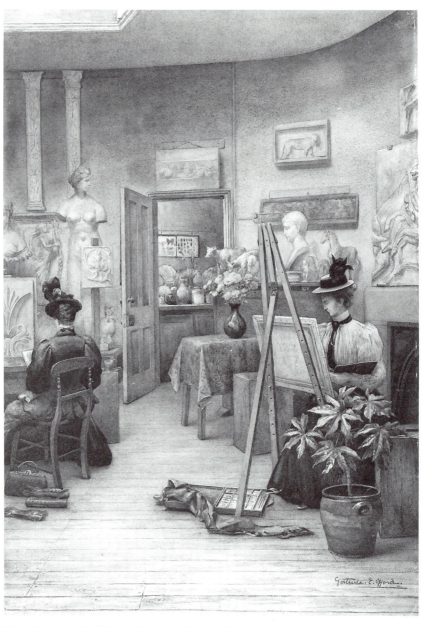

Plate 9 Gertrude Offord, *Interior of the Old School of Art, Norwich*, 1897. The artist was first a student and, from 1889, a teacher at Norwich Art School.

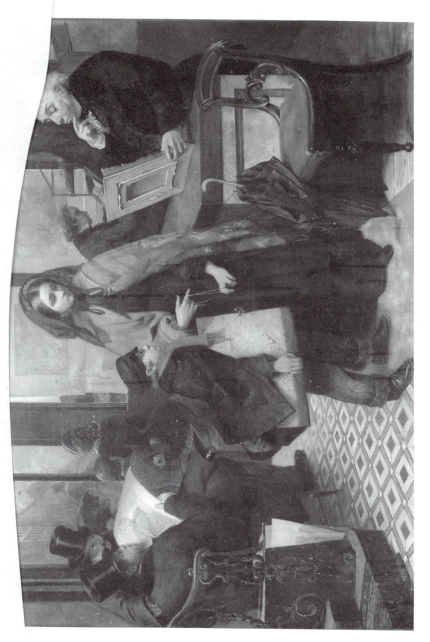

Plate 10 Gertrude Offord, *Interior of the Old School of Art, Norwich*, 1897. The artist was first a student and, from 1889, a teacher at Norwich Art School.

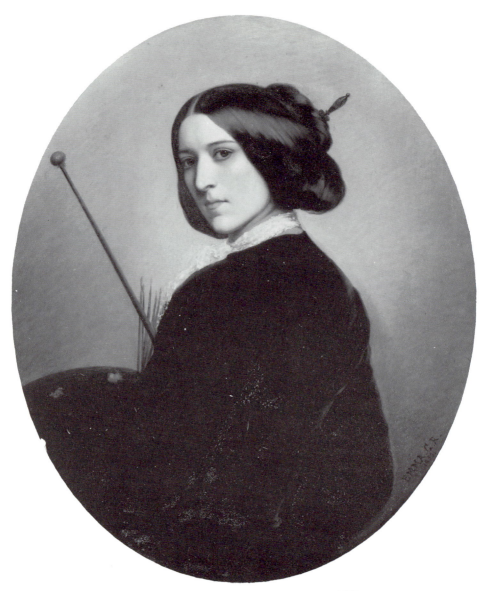

Plate 11 Emma Richards, *Self-Portrait*, 1853.

Plate 13 Emily Mary Osborn, *Barbara Leigh Smith Bodichon*, probably painted before the sitter's death in 1891.

4

ART INSTITUTIONS
AND THE DISCOURSES
OF DIFFERENCE

MOBILISING AND REFUSING SEXUAL DIFFERENCE

Sexual difference was managed in societies of artists by the exclusion or special categorisation of women. Throughout the nineteenth century the Royal Academy of Arts remained exclusively male, although there had been two women members, Angelica Kauffman and Mary Moser, at its foundation in 1768.[1] From the 1840s onwards several attempts were made to secure the election of women artists. Elizabeth Thompson (later Lady Butler) was nominated three times between 1879 and 1881.[2] Her candidacy was narrowly defeated on the grounds that members were defined as 'men of fair moral character' and that 'the letter of the law as given in Article 1 of the Instrument [of the Academy's foundation] does not provide for the election of women as members'.[3] In debarring women, the Royal Academy denied them privileged access to hanging space in its annual exhibitions and appointment to its administrative and teaching posts; even today no woman artist has yet been elected President, a position which has been accompanied by a knighthood.

This exclusion was not simply a matter of discrimination, but part of the broader field of power relations. Membership of the Royal Academy yielded distinct material benefits: as a writer in the *Examiner* commented in 1871, 'everyone well knows the money value (to mention no others) of the magic letters [RA]'.[4] Professional status was at stake: as artists, unlike doctors or lawyers, had no accreditation through a formal college or examinations, their occupational definitions were regulated by the art societies. Until the closing decades of the century the Royal Academy was highly regarded, and membership conferred distinction not only in the art world, but also in fashionable society. Without this badge of professional status, women artists did not participate widely in the decision-making processes which established professional standards and categorised exhibitable art. Lawrence Alma-Tadema, for example, was elected to the Royal Academy in 1879. In 1882 he became a member of the Royal Society of Painter-Etchers and served on the selection committees of the Society of

Cabinet Pictures in Oil and the Grosvenor Gallery, where his retrospective was held the same year. Numerous awards and honours followed, culminating in a knighthood which was celebrated with a men-only banquet.[5] It was much harder for a woman to cultivate this public identity. It was not until 1893 that Henrietta Rae 'broke the spell of masculine exclusiveness' when she joined the selection committee of the Liverpool Autumn Exhibition and acted as an adviser to the Walker Art Gallery's Purchasing Committee.[6] Women could gain hanging and administrative experience at the Society of Female Artists, but an appointment here was not considered prestigious and did not lead to solo-shows.

Although the societies of watercolourists included women, their membership was highly restricted. In the Old Water-colour Society (later Royal Water-colour Society) founded in 1804, women members were, like the associates, debarred from the financial profits and management of the society which were in the hands of a small clique of men. Whereas male associates could graduate to full membership and a share of the profits and administration, this transition was prohibited for women. However in 1850 the Society was reorganised even more rigorously when the four women members – Maria Harrison, Eliza Sharpe, Nancy Rayner and Mary Ann Criddle – were assigned honorary status, a tactic which clearly demarcated them from the twenty-six members and the seventeen associates, all of whom were men. Perhaps in response to complaints in the art press that honorary connoted amateur, the four were reclassified as 'ladies' in 1851, and in 1860 they were placed in the associate class. But while the numbers of men accepted into the society rapidly increased – by 1879 there were thirty male members and forty-one male associates – there were never more than six women associates at any one time.[7] Women were not admitted to full membership until 1890 when Helen Allingham, who had been an associate since 1875, was elected. A similar pattern developed in the New Water-colour Society (later Royal Institute of Painters in Water-colour), founded in 1832, which by the mid-century tiered its membership into full and associate classes for men with a separate classification for 'ladies'.

This treatment paralleled the special categorisation of women artists in art criticism. From the 1850s onwards women artists were grouped together and variously referred to as 'lady artist', 'female artist', 'lady member' or even 'paintress'; their varied and heterogeneous works were enfolded in a 'feminine stereotype' and interpreted as expressions of feminine refinement, delicacy and maternal sentiment.[8] This critical strategy occurred at the precise historical moment when women were increasingly numerous and visible as professional artists. At one level, their presence was contained by a classification designed to place them outside the definitions of professional practice. But the very instability of the nomenclature of the category indicates the difficulties of reducing the complexity of women's cultural production and the diversity of women

artists into a single term, while its persistent deployment registers the constant battle – in the literatures of art as in the wider areas of social practice – to secure and maintain distinctions between masculinity and femininity.

Women formulated varying strategies for dealing with their separate categorisation. Some refuted it, contending that separate classification was accompanied by unequal treatment. In *A Woman's Thoughts About Women* of 1858, the novelist Dinah Muloch Craik insisted that women's cultural work should be judged on its artistic or literary merits, not on the sex of the maker. She claimed that art was a neutral realm, not a domain governed by sexual difference.[9] Another response was to reverse the discourse, so empowering speech on and activities by women artists. The societies of women artists founded in London, Manchester and Glasgow were shot through with contradictions.

The Society of Female Artists, which became the Society of Lady Artists in 1872 and from 1899 the Society of Women Artists, was formed in London in the winter of 1856–7 and held its first exhibition in 1857.[10] Its exhibitions undoubtedly provided a venue for women artists who did not exhibit elsewhere. They offered a particularly useful forum for those embarking on a career and a much-needed additional London venue for artists such as Henrietta Ward who quickly established a pattern of sending small works, studies and sketches to the Society while dispatching their major works to the Royal Academy. While the Society undoubtedly assisted women artists by organising exhibitions, providing art classes, offering the use of its collection of properties and costumes, and selling their works (often however at very low prices), it never offered a serious challenge to the leading exhibiting venues, and some well-known women artists, such as Annie and Martha Mutrie, never exhibited there.[11]

The Society's exhibitions, which often included a mix of work by professionals and amateurs, were consistently criticised in the art press and in feminist journals. Art reviewers tended either to view the Society with patronising chivalry or to lampoon it satirically. Initially the *English Woman's Journal* welcomed the Society for helping 'to rouse the energy, concentrate the ambition and support the social relations and professional status of working women'.[12] But from 1859, when it criticised the society for failing to be the foster-mother of a noble school,[13] the *English Woman's Journal* concurred with the art reviewers, deploring the lack of technical skill, the vacuous subject-matter, low standards and absence of successful artists. Although several leading feminists such as Margaret Gillies, Eliza Fox and Barbara Bodichon were financial supporters and regular exhibitors – often sending important works – feminist papers were disappointed in the Society because its exhibitions did not demonstrate the achievement and standing of women artists and therefore did not support their campaigns for the paid work and professional recognition of middle-

class women. By the later decades of the century prominent women writers and feminist activists were ranged against the Society, Florence Fenwick-Miller commenting in 1889 in her weekly column in the *Illustrated London News*:

> the best work of the most capable women is sure to be given to the general public, and not to the more restricted circle. Just as the paintings of the foremost women artists will go to the Academy, or the Grosvenor, or the New Gallery, so the most important work of the best women writers will be sent by preference to the journals that 'everybody reads'.[14]

Her views were shared by many women who laid claim to professional status. Refuting special categorisation, they argued that their work was equal, not different, to men's and they worked to participate and intervene in the main exhibiting galleries and the papers that 'everybody reads' rather than to re-form the arenas of power/knowledge.

In the 1850s when women's membership of the watercolour societies was being curtailed and women artists located in a 'separate sphere', the Society of Female Artists activated the critical category to draw attention to women's work. But by the later decades the ideologies of the separate spheres – which made space for women artists as the representatives of bourgeois femininity – were being reshaped, as masculinity, modernity and the professional concerns of art history were inscribed in cultural discourses. The literature of art developed in new directions as sexual difference was reorganised and feminist objectives were reformulated in what has been termed a period of 'crisis' in British history.

FEMINISM AND SEXUAL DIFFERENCE 1870–1900

The period from the 1880s to the 1920s was characterised by the recomposition of British society, politics and the state, economic shifts to monopoly capitalism, the 'new imperialism', and significant challenges to the existing order from nationalist struggles in the colonies, from feminism and socialism. To characterise these massive transformations, Stuart Hall and Bill Schwarz have written of 'a crisis of hegemony in the whole social formation',[15] in which new political forces contested not only political representation but the organisation of power and the management of social definitions.

The feminist movements of the later nineteenth century were characterised by plurality and political divergence. The organisation of working-class women was transformed by the re-emergence of socialist feminism in the 1880s and by the radical suffragists, who formed an alliance across the labour and trades union movements to campaign for the vote for women not simply on the grounds of equality, but to improve their living and

working conditions.[16] Egalitarian feminism, which had launched its first campaigns for paid work, vocational training, higher education and legal reform in the 1850s and 1860s, continued to prioritise these issues. The social purity movement, initially formed to secure the repeal of the Contagious Diseases Acts, developed a powerful moral language which valorised femininity. Whereas egalitarian feminists refuted special categorisation in arguing for equality, purity feminists shifted feminist discourse and founded it on sexual difference.

In the later nineteenth century, from women's work to feminist 'speaking-out' on masculine sexuality, marriage, prostitution, venereal disease and domestic violence,[17] the patriarchal order was challenged, contested, fractured and disrupted. The decades of 'crisis' provided women with a range of languages and strategies in and with which to address their positions as cultural producers.

The institutional exclusion of women artists was maintained by formal institutions such as the Royal Academy and by informal associations such as the Langham Sketching Club which provided meetings for men only. Some organisations incorporated women in a limited way. The Society of Portrait Painters, established in London in 1891, included a few women whose membership did not grant voting rights. A successful lobby led by Louise Jopling pressurised the society to reform.[18] In Manchester women artists organised for their equal inclusion in the Manchester Academy of Fine Art. But their success was at the expense of the Manchester Society of Women Painters.

THE MANCHESTER AND GLASGOW SOCIETIES OF WOMEN ARTISTS

The Manchester Society of Women Painters was founded in 1879 by a circle of women friends: Susan Isabel Dacre was elected President, Annie Swynnerton became the Secretary, and her sister Emily Robinson acted as Treasurer.[19] Having trained at the Manchester Art School and/or studied in Europe, women artists who set up their practice in the city had no facilities for life-drawing, no specific provision for exhibiting or selling their work and few opportunities for professional advancement. The Manchester Society of Women Painters therefore organised exhibitions and life-classes and offered experience in art administration. According to the *Englishwoman's Review* the society was formed 'to provide facilities for members working together and studying from the life – there being no course open for such advantages, except by leaving Manchester'.[20] Exhibitions of members' works were held in December 1880, January 1882 – when each artist's works were hung together – and in November 1883.[21]

The Manchester Society of Women Painters made a bid for public visibility and professional recognition at a decisive moment in the city's

cultural history. A major centre of commercial and industrial growth, Manchester's cultural status was confirmed by the Art Treasures Exhibition of 1857, consolidated by the Royal Jubilee Exhibition thirty years later and enhanced by a range of local events such as the autumn shows of the Royal Manchester Institution which attracted a national participation.[22] But the city's cultural institutions, embedded in its organisation of civic power, excluded or marginalised women. The Graphic Society, founded in 1876, did not admit women. The Manchester Academy of Fine Art became the target for women artists ambitious for professional recognition, particularly after 1874 when its printed catalogues publicised the names and works of contributors; by 1882 its spring shows had become notable events in the city's cultural calendar. Although its founding constitution of 1859 stated that members could be of either sex, the Manchester Academy classified women as 'Lady Exhibitors' and debarred them from its administration.[23] In 1884, not long after the last exhibition of the Manchester Society of Women Painters, the Manchester Academy granted women full membership.

As women artists joined and were assimilated into the city's leading art society, so special provision for them ceased. No longer claiming their difference, women were nevertheless positioned in difference to Manchester's cultural managers. The City Art Gallery which opened in 1882 was curated, stocked and administered by an all-male team. Although women artists worked in the city, often however outside its most lucrative sector of portraiture, their works were not substantially represented in the City Art Gallery's founding collections.

But if women artists could not build a platform on which to demand cultural representation, they were active in the campaigns for political representation. The women's suffrage movement was particularly strong in the north-west of England. The first women's suffrage society was formed in Manchester in 1867 and its secretary, Lydia Becker, edited the *Women's Suffrage Journal* from 1870 to 1890. The Manchester suffrage society was predominantly middle-class. But in 1879 a shift took place when the society launched a campaign to enfranchise all women citizens and held meetings for working-class women. As the response was so strong, a Grand National Demonstration was held in the Free Trade Hall on 3 February 1880. Several women artists were members of the Manchester society, contributing to its funds and participating in its activities. It was in this context of shared political commitment and friendship that Susan Isabel Dacre chose to exhibit her portrait of Lydia Becker at the Manchester Academy in 1886 (plate 47).

The Glasgow Society of Lady Artists, founded in 1882 and considerably larger than the Manchester Society of Women Painters, was nurtured in a very different urban environment. It too was formed to give support to the professional activities and practice of women artists who were excluded

from the all-male Glasgow Art Club. A group of thirty-eight women organised its first exhibition in 1883.[24] Jessie M. King, Agnes Raeburn, Ann Macbeth and Katherine Cameron were among the active artist members. The Glasgow society provided life-classes, lectures, studio space, a meeting-place and social events which brought the artists together with the other women members. Expanding rapidly, it became a residential club in 1893 and, moving to new premises, the society commissioned a purpose-built gallery for its exhibitions.

The Glasgow society prospered in the 1880s and 1890s. By 1899 there were 384 members and 70 affiliates.[25] Women were a strong presence in the city as artists, designers, art teachers and purchasers, as Glasgow's affluent bourgeoisie channelled their wealth into art production and conspicuous consumption. The Glasgow society formed an invaluable alliance between artists and matrons, the wealthy women who funded and managed the society and who bought or commissioned art-work by members. This alliance was one of the society's strengths, one of the reasons for its success. As a single-sex urban institution, the society generated a strong network of women which could be activated politically, for in Glasgow, as in Manchester, there were strong links between women artists and feminism and the club became a centre for suffrage activity.[26]

WRITING WOMEN IN AND OUT OF THE LITERATURE OF ART

The Manchester and Glasgow societies of women artists mobilised the difference of women, as did publications such as Ellen Clayton's *English Female Artists* of 1876, a compilation of biographies which focused on selected women artists and the particular conditions in which they worked. This publication was produced across major shifts in the reorganisation of sexual difference which generated two divergent approaches in the writings on art by women. While Alice Meynell, Harriet Ford, Charlotte Weeks, Jane Quigley and Hélène Postlethwaite gave critical attention to women artists, other writers, like Emilia Dilke, maintained a critical distance, securing their reputations on their studies of male artists.

The problems of writing about women artists in the later nineteenth century were registered in Eve Blantyre Simpson's article on Elizabeth Forbes in *The Studio* of 1894.[27] While arguing that 'waiving all question of sex', the artist was 'one of the most promising of the younger painters', the author also engaged in special pleading on the grounds that Elizabeth Forbes's achievement had been neglected by persistent reference to her husband and by the 'false chivalry' and 'official courtesy' usually accorded to women. The sex of the artist was thus both refuted and deployed as a critical issue. Eve Blantyre Simpson wanted to promote her subject's work on its artistic merits:

the artist's work needs no apology to be advanced for the sex of the
artist. It is strong, wholesome art, able to hold its own, and deserves
the honour of being considered quite apart from its signature.

The problem was how to frame a discourse which could mobilise sexual
difference without marginalising women. To short-circuit the feminine
stereotype, critics like Eve Blantyre Simpson distinguished between pro-
ducer and product, arguing that while there was sexual discrimination
against women artists, there were no fundamental differences between art
made by women and art made by men. Both could be judged by the same
critical standard; work by women artists needed no separate, lower,
criteria.

By the 1870s many women were employed in writing art criticism,
several achieving professional success. Emilia Dilke was the art editor of
Academy magazine from 1873, a prolific art critic whose writings were
formative of aestheticism in the 1860s and 1870s, and an art historian who
produced substantial scholarly studies of French art of the eighteenth
century. A notable feminist, she campaigned for women's suffrage and was
a leader of the women's trade union movement.[28] But as a writer on art she
kept aloof from women artists.[29] This position was shared by the majority
of women art critics and art historians whose professional reputations were
based on articles, monographs and scholarly studies which often did not
address women artists or set critical or historical contexts for women's
work.[30] Their writings participated in the discipline of art history at a
crucial stage in its development, and their silence contributed to the
structural exclusions of women artists in the history of art and the public
collections of the early twentieth century.

The issues here are not those of straightforward discrimination, preju-
dice or oversight. Rather they are to do with the formation of the pro-
fessional concerns of art history as they intersected with the construction of
sexuality, changes in the position of women, and the priorities of the
women's movements in the later nineteenth century. Critics and historians
were engaged in profound struggles over language and power when they
discussed or denied the representation of women as cultural producers. For
those like Eve Blantyre Simpson, it was essential to write women artists
into the discourses of art and to discuss the unevenly weighted structures in
which art by women was produced and consumed. For others, it was
important to establish what were claimed to be professional standards of
neutrality and impartiality. But in refuting sexual difference and refusing
women artists, these writers assisted in the framing of those discourses of
art which became hegemonic in the later nineteenth century, in which
masculinity was inscribed as the central area of study and the pivotal term
of reference.

A rapid expansion of art-book publication took place in the later

nineteenth century, with the production of illustrated biographies, compilations of 'life and letters' and assessments of the English school. Women artists occasionally featured in the studies of contemporary art, but it was extremely rare for them to be accorded the full biographical account, unless married to an artist. While individual creativity was thus celebrated as masculine, women artists were grouped together in articles or books which marked them as separate and distinct; and if some redressed the balance by focusing on artists otherwise overlooked in the literature of art, other publications monotonously reiterated the feminine stereotype.[31] At the same time, male art critics often promoted their male acquaintances and relatives, establishing critical frameworks around their work. William Michael Rossetti compiled numerous volumes canonising his brother, Dante Gabriel Rossetti. Edmund Gosse specifically took up art reviewing in order to construct a new critical discourse around the sculpture of his confrère and brother-in-law Hamo Thornycroft.[32] Although William Michael Rossetti and Edmund Gosse married painters, neither provided substantial critical support for women artists; masculine interests and concerns were preferred. In these discourses around men and masculinity the sign woman artist (but not necessarily the sign woman) functioned as a significant absence. In the later nineteenth century, sexual difference was reorganised to shape those professional standards which masked patriarchal values, and it was to be refigured in the masculinist myths of modernism.

DISCOURSING ON THE MODERN

The history of English art from 1870 to 1900 has been organised in terms of art movements – Social Realism, Neo-classicism, Pre-Raphaelitism, Aestheticism: each has its chroniclers and advocates – and 'great' artists such as Whistler or Sickert. This arrangement of the history of art into contending groups or movements with their 'founding fathers' is a modernist interpretation which has been most visibly rendered in Alfred Barr's diagram of 1936 which mapped art production from 1890 to 1935. Barr's flow-chart reduced diverse social, economic and political systems, across nearly a half a century of imperialism, nationalist struggles and revolution, to a schema in which art movement follows art movement in an inexorable progression; directional arrows connect the founding fathers to modernism's climax, abstract art.[33]

This canonical tradition was founded on sexual and racial difference. As Griselda Pollock has pointed out, its masculinist myths of artistic creativity have been, and indeed still are, sustained by the absence of women as cultural producers.[34] Women artists neither figure in Barr's diagram nor do they have a substantial presence in the massive literatures of modernist art history. Charles Harrison's *English Art and Modernism, 1900–1939*, for

example, presents this period in terms of rivalries between fractious groups, each of which claimed that it superseded the others and all of which positioned themselves as modern against what they regarded as the art establishment.[35] But such accounts, in failing to locate modernism's difference as sexual difference, necessarily failed to substantially include women artists. How then are the relations between women artists and the categorisations of the modern to be interrogated? In a discussion of the historical formations of modernism, Jane Beckett has cogently argued that it 'is not that a parallel history of great women artists or modernist women artists should be written into a separate history but that the issue of the representation of women within a modernist discourse should be addressed'.[36] Analysis of the substantial presence of women artists in modernism requires a detailed consideration of the historical formation of modernist discourses. In such an analysis, notions of a linear, chronological progression to the 'modern' will necessarily be displaced by a mapping of discontinuous histories in which the artistic practices of Black women artists and the discursive representations of race will be as significant as discussions of sexual difference.

Art institutions in late nineteenth-century Britain which claimed a modern identity were founded on already existing patterns of managing sexual difference.[37] The New English Art Club was formed in 1886 to promote that kind of French painting which its members considered to be 'modern'. It modelled itself on the Parisian Salon des Refusés, positioned itself against the Royal Academy and academic art and, in common with many contemporary cultural institutions, occasionally admitted women members who were granted no part in the selection or hanging of its exhibitions. Women artists did not have an executive role in determining the modern art which the NEAC purported to represent.

The emergent literatures on the modern were organised in similar ways around absolutes of sexual difference. In *Modern Painting* George Moore alleged, 'it is just because man can raise himself above the sentimental cravings of natural affection that his art is so infinitely higher than woman's art'.[38] By contrast women's art was, he contended, saturated in woman's nature, 'more facile and fluent than man's', which accounted for their failures as artists. Moreover, women artists transgressed what Moore regarded as fixed boundaries of sexuality:

> In their own costume they have succeeded as queens, courtesans, and actresses, but in the higher arts, in painting, in music and literature, their achievements are slight indeed – best when confined to arrange- ments invented by men – amiable transpositions suitable to boudoirs and fans Women have created nothing, they have carried the art of men across their fans charmingly, with exquisite taste, delicacy,

and subtlety of feeling, and they have hideously and most mournfully parodied the art of men.[39]

Moore's wholesale dismissal of women artists was halted by an exception, a contemporary French painter who stood for true femininity:

> Mme Morisot . . . has created a style, and has done so by investing her art with all her femininity; her art is no dull parody of *ours*: it is all womanhood – sweet and gracious, tender and wistful womanhood.[40]

In his tokenism Moore deployed the feminine stereotype while his characterisation of women artists in general as transgressive was situated within the proliferation of discourse in the 1890s on deviant sexualities. Against his twin representations of femininity, Moore inscribed masculinity as the standard of cultural value and addressed a community of masculine readers.

The discourses on the modern drew on pre-existent patriarchal strategies, reworking them not simply to differentiate women artists, but to categorise them as old-fashioned, the antithesis of the modern. Women artists came to represent those kinds of art which were deemed out of date. The polarities new/old, modern/antiquated were organised in terms of sexual difference as modernism's opposition to convention was built on a polarised opposition of the sexes.

Texts on the modern, like Moore's, often validated conventional forms of femininity. They did not take on board the modern modalities of womanhood which emerged in the later nineteenth century. One of the most highly contested figures was the 'New Woman', recently characterised by the feminist historian Lucy Bland as 'a young woman from the upper or middle class concerned to reject many of the conventions of femininity and live and work on free and equal terms with the opposite sex'.[41] For feminists the New Woman's distinctive traits were her moral principle, her autonomy and her quest for personal freedom; authors of New Woman novels offered fierce critiques of masculinity and marriage. But for their male contemporaries the New Woman was a cipher for masculine desire and unregulated sexual relations: as Elaine Showalter has indicated, male novelists 'imagined a New Woman who fulfilled their own fantasies of sexual freedom'.[42]

This modern image of femininity coincided with the modernisation of urban spaces. The New Woman went to work; was economically self-supporting; lived in lodgings; travelled on public transport; socialised unchaperoned. She maintained her independence if not her equality. The rebuilding of London as a modern city from the later nineteenth century produced a new range of public spaces – from underground stations to cafés, shops, theatres, music-halls, restaurants, clubs.[43] While some of these public spaces were specifically marked for gendered occupation,

others were contested. Even a New Woman would have encountered difficulties in visiting the clubs or cafés frequented by bourgeois male artists and working-class women and maintaining her respectability, still a component in the figuration of bourgeois womanhood but consciously rejected in the construction of masculine artistic identity. But it was in these public urban spaces as much as in artists' studios that discussions on the modern took place. It would have been unlikely that women artists could have spoken as equal partners in these situations. Male bonding, homosocial co-option and polemical competitiveness worked to define some of the the territories of the modern – but not all – as masculine. Several of the art coteries formed in the early twentieth century, such as the Fitzroy St group or the Vorticist group, admitted women as hostesses, and others such as the Camden Town group excluded women entirely.[44] Thus, while modern women could lead independent lives in the modern city, they could easily be excluded from the generative sites of the 'modern' art and located in an asymmetrical relation to its production.

The Paris Art Club, the last society of women artists to be formed in the nineteenth century, laid claim to a modern and specifically Parisian identity. Training and working in Paris and the artists' colonies of northern France, women became familiar with French debates on the modern, and several skilfully manipulated those techniques and painting styles which were considered hallmarks of modernity in the 1880s and 1890s. This constituency came together in the Paris Art Club, founded in June 1898 by Maud Hurst. Unlike other women artists' societies, the Paris Art Club did not offer any facilities such as life-classes; rather it facilitated international co-operation between established artists who claimed a 'modern' identity. The Club thus countered those institutional and critical strategies which were displacing women from definitions of modernity in art. Members were required 'to have studied in Paris, to be women and do strong work'. Its declared aim was 'in every possible way [to] help forward, by "Unity Being Strength" the cause of International Women Artists'. By 1900, when the first exhibition was held in London, there were over 100 members in seventeen countries. *International Art Notes* was first issued in 1900 as the Club's magazine.[45]

In 1900 the Club evolved into the Women's International Art Club. The rule requiring Parisian study was dropped as the organisation was redefined for 'all women artists whose work attains the necessary standard of artistic merit'.[46] The claim for a place in definitions of the modern was replaced by an appeal to professional standards. Reviewing the Club's annual exhibition of 1908 Jane Quigley considered that the WIAC 'helped to improve women's standing in the art world'.[47] This modest hope was not dissimilar to contemporary opinion that the Society of Women Artists existed 'to help and encourage the art of women in all its phases'.[48]

The critical categorisation of women artists as separate and distinct first

emerged in the 1850s. It was mobilised by several groups of women before 1900 to lay claim to a collective identity and to promote the cultural presence of women. Others were opposed to any advocacy of women's difference and worked instead for inclusion and incorporation, on occasion pressurising existing institutions to change. Both approaches had their successes and failures, their advantages and their pitfalls, and both in different ways challenged the mechanisms and ordering of patriarchal power. By the turn of the century changes were under way. After 1900 women artists working in the terrain of the modern and shaping its representational strategies did not organise together as women. By contrast those who were active in and who designed for the suffrage campaigns were committed to the common cause of women. As we shall see, both positions were grounded in the professional and political identities taken up by women artists in the later nineteenth century.

PROFESSIONAL AND PUBLIC
IDENTITIES

FEMINISING PROFESSIONAL IDENTITY IN THE 1850s

In 1857 Emily Mary Osborn exhibited *Nameless and Friendless* at the
Royal Academy summer exhibition (plate 10). She strategically placed her
portrayal of a woman negotiating the sale of a painting in the escalating
public debates about women artists. Women artists' claims for public
recognition collided with hegemonic definitions of bourgeois femininity as
dependent and domestic, while their bids for professional status contested
emergent codes of masculine professionalism. *Nameless and Friendless*
engages with these contradictions, resolving them by portraying the
woman artist in the guise of the 'distressed gentlewoman', a well-known
character in fiction and paintings in the 1840s. But this is an uneasy,
unresolved representation. Inscribed at the centre of profound disputes
over the status of women as cultural producers, *Nameless and Friendless*
registers the difficulties of representing the woman artist in a newly defined
visual field which codified woman as image rather than as maker of images.
The painting was, moreover, produced at an historical moment when
cultural production and consumption were being defined in terms of
respectability and morality, pivotal terms not only in the calls for a
bourgeois vision for high culture, but also in the definitions of middle-class
femininity. In the mid-nineteenth century visual images became key sites
for a specular management of sexual difference concerned with the visible
articulations of class and culture.

Nameless and Friendless depicts a woman attired in a black dress with a
plaid over her shoulders. Accompanied by a young boy, she is waiting
while a dealer considers a small framed oil painting.[1] The composition is
organised through visual contrasts between the figures. The appearance of
the female customer leaving the shop is contrasted to that of the female
dancer imaged on the print (held by a man on the left side of the
composition) in a short-skirted, low-cut dress, her lower legs and arms
uncovered. These representations of women managed one of the central
constructions of feminine sexuality in which the polarity of pure/fallen was

78

mapped on an axis of class: the respectable bourgeois woman was positioned against and visually differentiated from the working-class prostitute.[2] The painting introduces a third figuration of femininity, the middle-class working woman who could not easily be categorised in terms of either polarity and whose respectability, the basis of her class identity and her sexuality, is at risk.

The representation of a woman artist entering a dealer's shop to engage in an economic transaction contravened widely held views on sexual difference. Bourgeois masculinity was hegemonically defined in relation to paid professional and mercantile work, government, politics, and the management of finance capital, industrial enterprises and public institutions. By contrast, bourgeois femininity was organised in the family, around marriage, domesticity, motherhood, child-care and a newly emergent ideal of home. While consensual definitions of womanhood united the diverse groupings within the bourgeoisie – from urban to rural, metropolitan to regional, professional to manufacturing, across diversities of religion, economics and politics – this uneven class formation generated contending versions of manhood and womanhood. Constructions of femininity by and for middle-class women were many, contradictory and subject to historical change. Although feminine respectability was defined in terms of dependency and feminine purity was considered to be safeguarded in the home, a widening range of urban leisure activities was developing in the 1850s and shopping excursions, for example, with the appropriate escort of a young boy, were not perceived as indecorous. There was, however, considerable discussion about women's activities as independent persons. In the 1850s a major controversy about women's autonomy, economic rights and sexuality was engaged by the moves to change the laws relating to married women's property, and to reform the divorce laws. The controversies were fuelled by the emergence of the first organised feminist campaigns for equality, education and employment.

Nameless and Friendless was produced in and referred to these debates. The depiction of a woman acting as a trader rather than a customer contravened predominant definitions of a 'lady': women's economic independence was often considered a sign of impropriety, or even sexual deviancy.[3] On the borderlines of class and at the margins of feminine respectability this image of a woman artist selling her work tested the limits of pictorial propriety and it could only be accommodated within the discursive category of the distressed gentlewoman, already widely circulated in paintings, magazine illustrations, novels, investigative journalism and philanthrophic reports on indigent governesses. From the later 1830s the distressed gentlewoman managed the contradictions between a strengthening of domestic ideology and coincident economic pressures for middle-class women to earn money: the 'needy lady' worked not because of choice but because of financial necessity brought about by the death of

the male provider on whom she had been dependent. The woman artist in *Nameless and Friendless* is represented with all the visual signs of the distressed gentlewoman – pale features, tapering hands, mourning dress and downcast glance. This category was put to work by women artists because its strong connotations of gentility worked against the claims that the 'lady' who worked lost caste, sacrificed her class position and endangered her purity. Feminine respectability, embodied in the figure of the distressed gentlewoman and at risk in the dealer's shop, was thus central to the representation of middle-class women workers.[4]

In common with her appearance elsewhere, the distressed gentlewoman invoked sympathy. The *Art Journal* elaborated a touching story around the central character of *Nameless and Friendless*:

A poor girl has painted a picture, which she offers for sale to a dealer, who, from the speaking expression of his features, is disposed to depreciate the work. It is a wet, dismal day, and she has walked far to dispose of it; and now awaits in trembling the decision of a man who is to become rich by the labours of others.[5]

This narrative was supported by a careful reading of the visual clues of clothing, facial expression, gesture and setting. The rain outside and the dripping umbrella embellish speculations on the length of her journey. From the black dress and the absence of a wedding band it is conjectured that the woman is an orphan; her stooping pose, averted glance, enveloping cloak and drab clothes are construed as marks of poverty *and* as indices of a mental state of dejection. Taking its cue from the quotation from Proverbs 10: 15 provided by the artist for the exhibition catalogue, 'The rich man's wealth is his strong city', the *Art Journal* expressed concern for the woman's plight, her destitution, her distress, all of which are heightened by the unspoken but nevertheless present risk to her respectability which the situation has provoked. The title too encourages this interpretation, signalling the artist, habited in deep mourning, as an orphan with no family or protector. It does more, however, calling up a plethora of meanings, and implying that the central figure has no guardians in this dangerous territory in which her name and her reputation are at risk – as a woman and an artist. For a woman the words name and reputation resonated in the literature of art and in the deportment books. At the outset of her career the young unknown artist had neither name nor reputation; but at the same time, for a middle-class woman the loss of either signified impropriety, deviancy and de-classing.

In *Nameless and Friendless* the representation of feminine purity is not limited to a set of attributes borne on the body of woman. The painting is about the conditions in which a bourgeois woman's respectability and career are endangered. *Nameless and Friendless* is not only a representation of woman but an address to the nature of representation itself. The

painting interrogates the relays of power in which women's self-representations are called into question and in which women are transformed into the visual spectacle of woman. The artist is centred in an exchange of looks which traverse the pictorial field from the doubtful scutiny of the dealer, the downward glance of the shopman, the stare of the man peering in at the window, the leers of the male customers who look up from their examination of the print of the dancer. Sexual difference is inscribed in an asymmetrical differencing of the gaze in which men are ascribed – and take up – the right to look, against which women are encoded for their *to-be-looked-at-ness*.[6] Cultural practices and discourses in the 1850s increasingly categorised women as a visual image, seen to be seen, as a target for aesthetic pleasure as much as a figure of moral inspiration.[7] In the circuits of spectatorial masculine desire, in the men's looking from the print of the dancer to the figure at the counter, the signification of woman shifts, from cultural producer to visual image, from desiring subject to desired object. *Nameless and Friendless* represents a contest in desire, a collision between sexually differentiated desires. The woman who dances for her living is reduced to a transitory gratification for the eye. The woman who has come to sell her work, necessary for her livelihood, becomes the target of a curious observation: conforming to the conventions of feminine modesty, the central figure looks down. Emily Mary Osborn could not depict the woman artist looking back, for as Lynda Nead has demonstrated in *Myths of Sexuality* the forthright stare and the direct glance at a male stranger were visual signs for the prostitute.[8] But if the woman artist in *Nameless and Friendless* is dispossessed of her gaze, her power to look, her vision, the woman artist who made this complex visual representation about the sexual politics of looking was not. Emily Mary Osborn turned her gaze to contemporary masculinity to track the ways in which women's respectability, independence and professional practice were being jeopardised at the moment when increasing numbers of women were producing art for a living and were exhibiting and selling their works. If the focus of the painting is the bourgeois woman who works, *Nameless and Friendless* equally takes issue with prevailing ideas about bourgeois masculinity as the chivalrous protector of women. The painting visibly demonstrates that a woman does not lose her respectability by working, but rather that it is endangered by men in the workplace: countering the frequent allegations that women were constitutionally unsuited to mental or physical activity, *Nameless and Friendless* addresses the precise ways in which working conditions militated against women's work.

Definitions of masculinity and femininity were continually produced and contested, put into play and struggled over across a range of discourses and practices including high culture. Domestic femininity was not a static condition or monolithic entity; nor was it a dominant ideology which addressed all women in the same way. The discursive processes and social

practices which preferred domestic femininity co-existed with contending constructions of femininity as independence and discourses on paid work, vocational training and professional status.

Alongside the intensification of domestic femininity in the 1830s and 1840s, middle-class women's paid work figured in the publications addressed to middle-class women in a variety of ways from discursive construction of the distressed gentlewoman to the occasional discussions of appropriate activities. Even the deportment manuals of the widely circulated writer Sarah Stickney Ellis considered paid work. In *The Women of England* she wrote of occupations 'which might be carried on without the least encroachment upon the seclusion of domestic life, and the delicacy of the female character', recommending teaching, engraving and drawing fabric patterns. She praised 'those who have had the good sense and moral courage to employ themselves in the business of their fathers and their husbands rather than to remain idle and dependent'.[9] By the end of the 1840s women writers had fashioned an image of an independent working middle-class woman. Helen, the protagonist of Anne Brontë's novel *The Tenant of Wildfell Hall* (1848), escapes from a drunken and dissipated husband and supports herself and her household by the sale of her landscape paintings to a dealer.[10] While Helen and the heroine of Dinah Muloch Craik's novel *Olive* (1850) both work at home, Olive also exhibits her paintings, so engaging with a greater public visibility.[11] Women's magazines increasingly featured fine art as a profession for women. In 1850 *Eliza Cook's Journal* claimed that

> Art offers a pleasant and a remunerative field. Landscape and portrait painting may be practised agreeably and profitably. Society has no conventional prejudice against it. A woman may be an artist and a 'lady'.[12]

This advocacy was paralleled by a growing sense of inequality of opportunity, an awareness that the professions were unjustly monopolised by men. *Eliza Cook's Journal* noted in the same article that 'from the offices of government and administration, from the courts of law and justice, and from the practice of medicine, women are . . . utterly excluded'.[13] These statements echoed comments in a letter written by the feminist Harriet Taylor in 1848. Sending her young friend, the painter Eliza Fox, one of the few copies of *The Principles of Political Equality* which identified Harriet Taylor as co-author with J.S. Mill, she wrote, 'I sent it to Miss Fox because when I knew her in her early youth she appeared to interest herself strongly in the cause to which for many years of my life and exertions [I] have been devoted, justice for women.' She continued that 'with the sole exception of artists' the only routes open to women consisted of 'poorly paid and hardly worked occupations, all the professions, mercantile clerical legal and medical, as well as all government posts being monopolised by

men'.[14] Discussion of middle-class women's work and suitable vocations was widespread from the 1840s to the later 1850s. With the emergence of the first organised campaigns for women's education, employment and legal reform the feminist input was high: there is some evidence to suggest that Emily Mary Osborn was connected to, even active in, feminist circles. Middle-class women's work was, however, broadly debated and different points of view set out in newspapers, magazines, novels and high culture. Emily Mary Osborn's *Home Thoughts* (RA 1856), depicting a severe, orderly and capable teacher in her schoolroom, provided a prelude to her portrayal of a woman artist the following year. The debates focused on the few vocations open to women and on a widening of opportunities. As Harriet Taylor recognised by the later 1840s, the occupations for middle-class women had contracted to teaching, needlework, literature and fine art while those for men had rapidly expanded.[15] In claiming professionalism as feminine, women artists were, therefore, challenging a central component of middle-class masculinity, an important marker of class status and a badge of respectability.

The forging of a feminine professional identity was sustained against the pervasive dismissal of all (or, at the least, most) women's art as amateur. By the mid-nineteenth century the amateur practice of art had been redefined as a component of bourgeois femininity. Sketching in watercolours and drawing were perceived as accomplishments, the hallmarks of a 'lady' whose gentility was confirmed by the non-commercial status of her work and its circulation to family and friends. These historical shifts were central to the formation of a masculine professional identity not only in art institutions but at the level of visual representation. For visitors to public exhibitions in the 1840s and 1850s – a constituency which included many women for whom watercolour painting and drawing were common pastimes – the most familiar image of the woman artist was a graceful female figure sketching landscape.[16] Consumers of high culture would have associated women's art with amateur sketching and would have designated this the respectable practice of art for a 'lady'.

Visual images of women artists by women artists were thus produced in and contributed to a dispersed and contradictory regime of representations of bourgeois femininity which intersected with definitions of respectability, professionalism and high culture. Self-portraits, like modern-life paintings, were engaged in articulating women's visible presence as professional practitioners and respectable women. Whereas depictions of contemporary life comprised a relatively new pictorial category, self-portraits drew on and consciously worked with older artistic conventions. In her self-portrait of 1853 Emma Richards depicts herself in a black dress, with neatly arranged hair. She holds a palette and a mahlstick, used to support the arm when painting on canvas (plate 11). A strong light illuminates clearly defined facial features. The body, twisted contra-posto, is silhouetted

against a cream background for dramatic effect. An identity as an oil painter is constructed not only by the tools and materials but through skilful references to the pictorial conventions of Renaissance and seventeenth-century art which display that learnedness necessary for the history painter. Emma Richards established a successful career with her religious pictures, several of which were acquired for the Royal Collection.[17] Two years previously she had advertised her achievements by exhibiting another self-portrait alongside *Amore in Dio*, commissioned by Prince Albert, at the Academy exhibition. In her art practice and in her self-portraiture, Emma Richards intervened in the attempts to sexually differentiate the artistic hierarchy which defined history painting and therefore religious art as a masculine activity. All the visual signs of this self-portrait (plate 11) constitute an image of a serious, respectable, practising woman artist. The portrait redefines professional identity as feminine, and reworks the social and artistic ordering of sexual difference.

Feminine respectability was signified through dress, hairstyling and deportment: while black was often favoured beyond the rituals of mourning, dark clothing was frequently preferred by working women. Elizabeth Eleanor Siddall portrayed herself in a dark gown with her hair caught loosely at the neck (plate 12). Like Emma Richards, she depicts herself looking out directly at the spectator. Respectability, which was both a focal point of class identity and a source of social tension in the upper, artisan strata of the working classes, is once again the key to women's self-portraiture.[18] Elizabeth Siddall, the daughter of a skilled tradesman, constructs a self-representation which is carefully distanced from masculine bohemia. In the early 1850s middle-class men in the Pre-Raphaelite group were promoting an image of the artist as irregular in his hours, appearance, conduct, business transactions and sexual arrangements, the very antithesis of the masculine professional identified by his thrift and punctuality, the regularity of his habits and habitat. However, their unconventionality could not be adopted by women artists for whom, unlike men, disorderly conduct or a dishevelled appearance endangered respectability and professional activity.

Elizabeth Siddall first encountered the Pre-Raphaelite Brothers when she was invited to model for them. In moving from millinery to modelling and then to the practice of art she risked her respectability, already jeopardised by the associations between needlework and prostitution. A concern with respectability underpins her self-portrait (plate 12), one of her first productions and executed in oil, unlike the rest of her work which was produced in watercolour. It was inserted into a welter of images of her dispersed across a wide range of sites from Royal Academy pictures by Walter Deverell, William Holman Hunt and John Everett Millais to the watercolours and drawings by Dante Gabriel Rossetti which circulated in the artist's studio to a closed circle of acquaintances, critics and buyers.

Rossetti's drawings are usually interpreted as the products of the male artist's intense love for his female model. But they are not about the historical individual Elizabeth Siddall, nor do they depict her particular appearance. It is possible to identify similar features and devices in Rossetti's drawings of various female models, all of which encode femininity as delicacy and dependency through the reiteration of supine pose, drooping head, lowered eyes. These drawings operated within an emergent regime of representation and signification in which woman was produced as an explicitly visual image. The drawings were thus sites for the redefinition of femininity in the social order of sexual difference in which woman as visual sign was appropriated for the masculine gaze.[19] It was in and against this regime that Elizabeth Siddall pictured herself as one who sees, and produced a range of work which was concerned with the gaze of women.

Alongside *Nameless and Friendless*, Henrietta Ward exhibited '*God Save the Queen*' at the Royal Academy of 1857 (plate 14). The picture depicts a middle-class woman teaching three children to sing the national anthem, while a nursemaid takes charge of a younger child. '*God Save the Queen*' is at once a self-portrait and a modern-life painting,[20] and as such it marks another boundary in the representation of bourgeois femininity. Like *Nameless and Friendless* (plate 10), this painting demonstrates the complex ways in which women addressed the problem of registering the category of woman artist in visual culture. For while Henrietta Ward organises feminine respectability around motherhood and patriotism, drawing on and feeding into mid-century discourses on the home as the cornerstone of empire,[21] this is also a depiction of a recognisable individual with a public identity as a professional painter.

Images dramatising the production and reception of women's art proliferated from the 1850s, simultaneously articulating women's visibility as cultural producers and dealing with the establishment responses to their presence and their works. In the 1850s these varied from patronising chivalry, gentlemanly interest, constructive criticism or dismissive politeness, to satire, hostility and rejection. For the second exhibition of the Society of Female Artists in 1858, Florence Claxton painted *Scenes from the Life of the Female Artist*:

> there is the 'ladies class', the studio, the woodland wide-awake, all the aspirations, difficulties, disappointments, which lead in time to successes. The little dog barks . . . the plaster head on the shelf winks with a certain dry amusement at its mistress, who is represented as painting a picture of the ascent to the Temple of Fame; the picture is rejected, and the disconsolate young painter is seen sitting back in comical despair, gazing at an enormous R, chalked on the back.[22]

Self-representation was not only a question of the production of an image

of an individual woman but also of the mobilising and renegotiating of the category of woman artist. In imaging themselves, women painters frequently traversed the boundaries between artistic categories of portraiture, self-portraiture and subject painting. Pictures of women artists at work were often portraits of sisters or friends. Lucy Madox Brown's *Painting* of 1869, portraying a young woman working from a model on a picture of an old woman carrying a bundle of sticks, depicted her step-sister, Catherine Madox Brown, whose watercolour portrait of her friend, the artist Ellen Gosse, was on show in the same exhibition at the Dudley Gallery.[23] *Finishing Touches* by Jessica Hayllar, shown at the Institute of Oil Painters in 1887, pictured her sister Edith Hayllar at work (plate 7). By the closing decades of the nineteenth century, women artists were a decisive and strong presence in the art world, and their numbers and productivity, work and representations far exceeded any unitary categorisation. Their publicly exhibited pictures of women artists – in the studio, at work, as portraits or self-portraits – increased dramatically, peaking from the later 1880s to the later 1890s when their visual presence was widely circulated in illustrated magazines, art journals and women's papers. But *Nameless and Friendless* remains the only known picture of a woman artist selling her work. At a decisive moment when professional respectability was being claimed as a feminine identity, *Nameless and Friendless* refashioned the codes for the representation of woman, testing the limits of pictorial propriety by depicting a middle-class woman engaging in an economic transaction as an independent, active agent. In the decade in which women's professional pursuit of art was particularly undercut by accusations of impropriety or unladylikeness, *Nameless and Friendless* mapped those social and economic relations which worked against women's independence. Most radically, *Nameless and Friendless* interrogated the ethics of aesthetics in its visualising not only the commerce of art but the trade in images of women. It brought to visibility the relays of power which shaped the sexual politics of looking and addressed the representation of the woman artist at the historical moment when women artists became decisively visible.

ARTISTIC SOCIETY AND PERSONAL STYLE, 1870–1900

From the 1870s onwards major changes took place in the social identities and professional associations of artists. Whereas at the mid-century a specifically middle-class culture was put in place with distinctive organisations, publics, purchasers and critical discourses, in the later decades of the century artists established cultural alliances with the upper classes. These alliances were marked by patterns of patronage, the creation of peers such as Baron Leighton or Baron Tennyson, new art institutions and social rituals. In all of these social practices and discourses women were located in positions of difference.

The Grosvenor Gallery, founded in 1877 by Sir Coutts and Lady Blanche Lindsay, drew together aristocrats, leaders of fashionable Society and artists who were invited to select their own contributions to its exhibitions which also included works by titled amateurs like Louisa, Marchioness of Waterford. Departing from the contemporary convention of floor-to-ceiling hanging, paintings were spaciously presented in rooms furnished with marble columns, Ionic pilasters salvaged from the Opera House in Paris, silk-damask and velvet wall-coverings, painted decorations, rugs, china, potted plants, occasional tables and small chairs. As the critic Agnes Atkinson remarked in the *Portfolio*, 'This is no public picture exhibition, but rather a patrician's private gallery shown by courtesy of its owner.'[24] The Grosvenor Gallery created and catered for a particular life-style. Blanche Lindsay, a painter and writer and one of several Jewish women prominent in the cultural elite of London in the later nineteenth century, financed the Grosvenor Gallery and managed its social affairs at which she appeared in draped aesthetic dresses.[25] Its Sunday afternoon parties were included on the Society calendar and, along with visits to the studios of fashionable artists, were among the events attended by the Prince and Princess of Wales.[26] As Leonore Davidoff has indicated, artists remained in a client relationship to their wealthy patrons who 'found sorties to St John's Wood an enjoyable change from the usual social activity'.[27]

From the 1870s onwards establishment artists lived and worked in well-to-do areas of north and west London, often commissioning architect-designed residences and studios. In common with the dwellings of other affluent professionals, artist-houses were magnificent in design and scale, the settings for a life-style characterised by opulence, grandeur and display.[28] The artist-house was the place of artistic production and the venue for those social events which were so important in cultivating fashionable society whose own social events took place 'at home'.[29] As successful artists now worked at their residences, rather than in rented rooms, the studio became the centrepiece of the artist-house. According to one contemporary commentator, 'On Studio Sunday the studios are transformed with eastern carpets and Indian matting, rugs, flowers and works on easels.'[30] Drawings and photographs in the numerous articles and publications on artists' houses featured these apartments, occasionally including a glimpse of the artist *himself*, the epitome of bourgeois respectability in his sober suit.[31] These vast domains were not private work-rooms – indeed any hints of the processes of painting were erased – but showcases for a life-style with its own social events, styles of dress and decoration. The artist-house was less a space of domestic femininity and more the sign and visible manifestation of artistic masculinity.

Artistic society was structured in sexual difference. In the artist-house of a painting partnership such as the Alma-Tademas, the woman artist's

rooms were smaller and less palatial than her husband's. Social hierarchies in this community were organised on the axis of sex, as knighthoods became the reward for and mark of establishment success, a distinction unavailable to middle-class women except through marriage, as in the cases of Lady Laura Alma-Tadema, Lady Georgiana Burne-Jones, or Elizabeth Thompson, Lady Butler. Moreover, the social management of artistic society, like its fashionable counterpart, was the responsibility of upper- and middle-class women who managed the complex arrangements for partying, viewing, sales and commissions now that business was conducted 'at home'. Lady Linton, the wife of the President of the Royal Institute of Water-colour Painters, arranged a weekly event for 'friends' to view 'anything freshly finished in the studio'.[32] To further their own careers as professional artists and to construct the social spaces in which clients were secured, women artists engaged in skilful management of the codes of fashionable femininity. Distancing themselves from the titled amateurs, professional women represented themselves as hostesses and as practising artists. These roles were augmented when the woman artist was married to and modelled for an artist. Marian Huxley, Mrs John Collier, appeared at her husband's studio showings as artist, hostess and the model for his works.[33]

The frequent comparisons between the physical appearance of women artists and the images of women in high culture were facilitated by their modelling for well-known male artists, by the development of what can be termed 'personal style', and by changes in cultural discourses in which from the 1860s woman figured as image, as a locus for aesthetic pleasure rather than the bearer of a moral meaning or narrative. All these issues were condensed in the following account of the artist Marie Spartali at the Royal Academy private view in 1889, written by Florence Fenwick-Miller for her 'Ladies Column' in the *Illustrated London News*.[34]

> Another beautiful and picture-like head is Mrs Stillman's, so familiar in Mr Burne-Jones' pictures; she looks at the Academy like a figure from one of that artist's canvasses, as she stands clad in a black and gold matelasse cloak reaching to her feet in straight folds, her hair gathered in a great mass at the back of her head and held up by a comb, and a wreath of green leaves on her brow . . .[35]

Marie Spartali was often recognised and written about as the model for Burne-Jones. Her face and figure were elided with his pictures of women exhibited not at the Royal Academy but alongside her own at the Grosvenor and New Galleries. But Marie Spartali's appearance far more closely resembled her own paintings, and Florence Fenwick-Miller's description parallels the central figure in the artist's large watercolour *Messer Ansaldo Showing Madonna Dionora his Enchanted Garden*, shown that year at the New Gallery.[36]

Deliberately cultivating an appearance which contravened fashionable lines and cut, Marie Spartali developed a personal style which, in its combination of elements drawn from Renaissance art and its references to contemporary high culture, demarked her as an artistic person, a leading member of artistic society. Personal style in dress was generally composed from aesthetic dresses which in their colours, textures and looser lines rejected the shapes, fabrics and tight corseting of high fashion.[37] In Glasgow, where the decorative arts were dominated by women practitioners, personal style was constituted in dresses designed and embroidered by women artists themselves; Jessie Newbery and Ann Macbeth thus wore their own art works.[38] Personal style was organised on and carried by the feminine body. As high culture and aesthetic pleasure were increasingly structured around the visual spectacle of femininity, women artists in artistic society fashioned themselves as aesthetic objects, rearranging their appearance as spectacle and drawing on and feeding into high-cultural imagery. Personal style also extended to interior design, hence the importance attached to the decoration of the Grosvenor Gallery, the artist-house or Kate Cranston's tea-rooms in Glasgow. Artistic taste was marked out by distinctive kinds of dress and interior decoration, which in their rejection of mass production differentiated artistic persons from ordinary individuals. Prevalent from the 1880s onwards, personal style coincided with the proliferation of consumer markets in luxury goods and the rapid expansion of those urban social pleasures which transformed the city into the locus of pleasure, leisure, spectacle and consumption.

Dress and appearance became critically important for middle-class women engaging a public visibility through a career and/or their participation in the women's movements. Those who took up public speaking for the suffrage movement in the later 1860s and early 1870s considered that 'quiet black dresses' connoted respectability,[39] and some like Millicent Garrett Fawcett and Lydia Becker wore perpetual mourning (plate 47). Plain costumes adopted by women school teachers as a badge of professionalism were favoured by many feminists by the 1890s.[40] Some women artists may well have taken up Rational dress, with its divided skirt, rejection of corseting and feminist associations.[41] Aesthetic dress undoubtedly offered a combination of personal style and professional identity for many women artists (plate 13). Some of their contemporaries, however, considered fashionable dress was best suited to public activity: Florence Fenwick-Miller was among those who viewed Marie Spartali's attire as 'a happy eccentricity'.[42]

Louise Jopling was frequently commended in the Ladies Column for her dress, her professional attitude and her social success: 'her studio parties are always interesting and she knows so many people who are always somebody in literature and art.'[43] From the later 1870s Louise Jopling gave previews and evening parties, first in Kensington and then in her Chelsea

studio designed by William Burges, who specialised in creating distinctive forms of architecture and interiors for artists. In these decades she painted portraits of titled sitters, wealthy financiers and actresses.[44]

Cultivation of these clients and the negotiations of the cross-class relations on which her business depended required specific forms of dress and polite behaviour. Louise Jopling presented herself – in appearance and demeanour – as an utterly respectable but nevertheless stylish professional woman. She cultivated her social skills and composed her costumes with care, for the feminine body, its apparel and disposition, bore the burden of successful career management. An image of stylishness was purveyed in the numerous cartoons and sketches of Louise Jopling as well as in the formal portraits of her by Whistler and Millais. In her own self-portrait, dating from the mid-1880s, she depicts herself in a simple but striking red and yellow dress, holding brushes and palette.[45] It would be over-simplistic to interpret this self-portrait as the artist's authentic image of herself; indeed the varying representations of Louise Jopling indicate the multiplicity and fracturings of identity and they put in play the masquerade of femininity.[46]

The diversity of artistic identities constructed by and for women artists in the later nineteenth century was registered in the increasingly numerous self-portraits and portraits that were exhibited and/or reproduced. Some women artists were pictured in day wear, others in work-clothes. Millie Childers not only portrayed herself in a smock and holding palette and brushes, but drew on Renaissance and post-Renaissance portrait conventions to articulate an artistic identity in her *Self-Portrait* (plate 1).[47] Hélène Postlethwaite's biographical sketches of 'Some Noted Women Artists' of 1895 were accompanied by illustrations, mostly self-portraits.[48] Only the portraitist Mary Waller showed herself at work, standing before her easel. The spinster Flora Reid is clearly recognisable as a 'New Woman' in her baggy jacket, crisp collar and bow tie. Anna Lea Merritt's appearance is stark and severe with her hair scraped back and wire-framed spactacles perched on her nose. Mary Waller's face is tired, with deep pouches beneath her eyes. Marianne Stokes's disarray, her hair escaping to frame her irregular features, contrasted to the modishness of Jessie Macgregor, the only artist to portray herself as youthful and conventionally pretty. Two artists were portrayed by their husbands, Marie Seymour Lucas and Henrietta Rae. The latter's features are schematised into regular symmetry and, against the self-portraits in which the artist looks out directly, Henrietta Rae's unseeing eyes gaze beyond the spectator; her husband's signature is stamped upon her shoulder.

As images which circulated in the public realm and whose meanings extended beyond the documentation of facial features, self-portraits claimed a visible presence for women artists and, importantly, they returned this definition to their gaze. These self-representations were

produced at the intersections between bourgeois respectability and professional identity, participating in the ceaseless redefinitions of femininity across multiple points of discourse and social practice. Colliding definitions of the woman artist contended for preference in the late nineteenth century, put into play and given visual form by portraits and self-portraits which were the sites where formations of subjectivity, sexuality, class and politics overlapped.

SOCIALISM

Cultural politics took a central place in the socialist movement of the later nineteenth century.[49] Most of the women artists involved in late-nineteenth-century socialism worked as designers. May Morris, for example, was an active member of the Socialist League and embroidered many of its banners.[50] Emily Susan Ford was one of the few women painters whose links to the socialist movement have been identified. In common with several other women artists of progressive tendencies she came from a Quaker family. Her mother, Hannah Pease, was active in the anti-slavery and social purity movements and a supporter of women's education and women's suffrage. She encouraged her three daughters, Isabella, Bessie and Emily Ford, to make independent lives shaped by political activity and moral principle. While Isabella Ford became a prominent socialist campaigner for the rights of working women, Emily studied at the Slade School of Art in London from 1875 and established a career as a painter.[51]

Developing their ideas in relation to the socialist debates of the 1880s, Isabella, Emily and Bessie Ford took issue with the goals of egalitarian feminism which had formed as an organised movement in the 1850s. They did not envisage the women's movement as a struggle for equal rights for middle-class women. Rather they perceived the oppression of women in a wider system of social and political relationships which were determined by the economic inequalities of the capitalist system. The three sisters were in contact with the movement for independent labour politics in Leeds and they may have met members of the Leeds Socialist League as early as 1887. They were active in the labour unrest in Leeds in 1888 and 1889, supporting the campaigns of women workers. Like her mother, Emily Ford became a member of the Ladies National Association, initially formed to combat the Contagious Diseases Acts. She produced a portrait drawing of Josephine Butler, the LNA's leader and her mother's friend.[52] Emily Ford was a stalwart supporter of women's suffrage, speaking at meetings, designing a membership card for the Leeds Suffrage Society of which she was Vice-President and producing campaign materials for the Artists' Suffrage League whose Deputy Chair she became.[53] Dividing her time between Leeds and London her receptions included politicians, writers,

musicians, artists, actors and social workers, a constituency very different from the devotees of fashionable society. In the early years of this century her Chelsea studio was known as 'a meeting ground for people who did things'.[54]

Although Emily Ford was probably not involved in the labour movement after 1889, her participation in socialism paved the way for her activity in the suffrage movement and shaped the direction of her art. Socialist politics undoubtedly informed her rejection of nineteenth-century materialism, which in turn contributed to her interest in spirituality, expressed in her allegorical subjects. After a conversion to Anglicanism her major commissions were for religious paintings for churches and private chapels. Emily Ford accounted for the changes in her art practice:

> In the conceptions of my student days, the etchings and peasant subjects – I sought to discover the meaning of life in humanity alone. In a later series – 'Coming of Night', 'Life', 'Dawn', 'Ascension of Souls' etc, I strove to express it by symbolism of the life of the soul.[55]

The artist's language and her subject matter drew on and participated in the symbolist movement of the later nineteenth century to articulate a rejection of capitalism in favour of spiritual, and specifically Christian, values. Similar tendencies are to be found in the works of her close friend, Evelyn de Morgan, whose paintings in the later 1880s and 1890s, with their themes such as *Earthbound* of 1897 or *The Worship of Mammon* of 1909, criticised the exclusive pursuit of individual wealth.[56] Evelyn de Morgan was certainly friendly with May Morris, who admired her paintings.[57]

WOMEN'S MOVEMENTS

Women artists participated in the women's movements of the nineteenth century. They were particularly active in egalitarian feminism which campaigned from the 1850s for equal rights, higher education, paid work and legal reform.[58] Barbara Bodichon, Anna Mary Howitt and Eliza Fox were among those who campaigned from 1854 to 1857 for changes in the Married Women's Property Acts which until the later decades of the century gave a husband complete control over his wife's property and income. Networking with young and older women, the three friends canvassed support and signatures for the parliamentary petition drafted by Barbara Bodichon.[59] Reform was argued for on the grounds that women artists and writers as 'professional women [were] earning large incomes by the pursuit of the arts'.[60] In their own lives their careers as artists were intertwined with their activities as feminists. Eliza Fox ran art classes for women. Anna Mary Howitt contributed to the *English Woman's Journal*, the egalitarian feminist magazine published from 1858 to 1864, as did Barbara Bodichon, one of its main financial backers. In the 1860s Barbara Bodichon became a

public speaker for women's suffrage and a prominent educationalist, highly involved in the founding and early years of Girton College, Cambridge (plate 13). Egalitarian feminism became more widespread among women artists in the following decade. Susan Gay admitted that she took 'the greatest interest in all that may aid the advancement of women' and Emma Cooper testified to 'the warmest interest in the higher education of women, and in the welfare of her sex'.[61]

Women artists contributed to the campaigns for votes for women, who were not enfranchised in Britain until 1918 and 1928. As respectable professionals, women artists embodied many of the arguments for the greater public activity and responsibility of women. From the launch of the suffrage campaign in the 1860s they joined suffrage societies, gave money, spoke at meetings, turned their studios and dwellings into campaign centres, and signed petitions. Margaret Gillies, who had been connected to Owenite socialism in the 1830s and 1840s, was credited as being one of the first signatories of a petition for women's suffrage.[62] Her public support for the suffrage movement in the 1870s was shared by younger women such as Helen Allingham and Henrietta Ward; the latter became a member of the Central Committee of the National Society for Women's Suffrage and was firmly convinced that the vote for women 'would be *most desirable* for women in my own profession'.[63]

Petitions of signatures were favoured by the nineteenth-century women's suffrage movement and those of the 1880s and 1890s were signed by many women artists. Nearly 100 women artists and musicians signed the massive *Declaration in Favour of Women's Suffrage* of 1889. Charlotte Babb, Sophia Beale, Lucy Madox Brown, Emma Cooper, Susan Isabel Dacre, Margaret Dicksee, Maud Earl, Emily Ford, Lillie Stacpoole Haycraft, Louise Jopling, Jessie Toler Kingsley, Jessie Macgregor, Evelyn de Morgan, Emily Mary Osborn, Constance Phillott, Louisa Starr, Annie Swynnerton, Eliza Turck, Mary Waller and Henrietta Ward, were among the 2,000 signatories.[64] This declaration countered *An Appeal Against Female Suffrage* issued the previous month; the only woman artist to endorse this document was Laura Alma-Tadema.[65] An 1897 listing of supporters of women's suffrage which gave the names of seventy-six women artists included many of those listed above, adding Helen Allingham, Elizabeth Forbes, Mary Gow, Kate Perugini, Henrietta Rae and Elizabeth Thompson, Lady Butler.[66]

As male suffrage had initially been granted on the basis of property ownership, this qualification was highlighted in *The Letter from Ladies to Members of Parliament* of June 1884 sent by women landowners, professionals teachers, farmers, merchants, manufacturers, shopkeepers, industrialists, and artists including Barbara Bodichon, Margaret Gillies, Louise Jopling, Clara Montalba, Ellen Montalba and Henrietta Ward.[67] Among the signatories of the *Women Householders' Declaration* of 1889–

90 were the artists Charlotte Babb, Sophia Beale, Susan Isabel Dacre, Emily Ford, Mary Lloyd and Henrietta Ward, all widows or spinsters who owned property in their own right.[68] Charlotte Babb, a London-based painter of mythological and modern-life scenes, initiated a campaign for no taxation without representation in 1871 which was based on her social and economic status as a property owner.[69] Arguing that without political representation there was no requirement for independent women to pay tax, she maintained her stance for thirteen years although her goods, furniture and engravings were often distrained in payment. As a young woman Charlotte Babb campaigned for the admission of women to the Royal Academy schools, becoming one of the first to attend.[70] In later life she had no faith in the constitutionalism of the nineteenth-century women's suffrage movement, convinced that militancy was necessary to secure women's rights. She became a supporter of the Women's Social and Political Union (founded in 1903) and its 'fighting contingent'.[71]

After 1900 there was a radical break in the history of the relations between women artists and the women's movements. In the nineteenth century women artists participated in the movement as professional women, working largely in the campaigns for education, employment and suffrage. Nineteenth-century societies of women artists in London, Manchester and Glasgow fostered professional advancement and individual attainment as well as drawing attention to women artists as a group. But with the founding of the Artists' Suffrage League in 1907 and the Suffrage Atelier in the following year, women worked together for the cause as artists, designing and producing materials for campaigns and demonstrations. As Lisa Tickner has argued, women's suffrage became a professional and political activity.[72] Some women artists experienced tensions between their work as painters or designers and their commitment to the movement. Mary Lowndes, a stained-glass artist and co-founder of Lowndes and Drury who produced numerous designs for the Artists' Suffrage League, stated in 1911 that she and Barbara Forbes were unable to find time to organise the Women's Coronation Procession: 'I do not know any one else in the Artists' League who will give up their home and all their work for some weeks.'[73] Others abandoned professional practice to work for the movement, Sylvia Pankhurst becoming the principal designer of the Women's Social and Political Union, while Georgina Brackenbury, Maria Brackenbury, Helen Fraser and Louise Jopling set aside their careers.[74]

In 1909 the *Englishwoman's Review* considered the intense interest in the suffrage movement among women artists, remarking with astonishment that artists, individualists by temperament and activity, now found collectivity and the cause more absorbing.[75] The article indicated the major shift which had taken place in the relations between women artists and feminism. In the nineteenth century the individual and professional

achievements of women artists were promoted to fuel the campaigns for women's greater participation in the public world of work and politics. In the early twentieth century women artists worked together for the promotion of women's suffrage. Across the profound differences in strategy and objectives among the campaigners and across the diversities of visual languages between the artists, women forged a cultural politics which united new forms of visual representation to the struggles for political representation.

6

MAKING A LIVING

During the nineteenth century artists' incomes were drawn from a variety of sources: sales at exhibitions or from the studio, direct commissions from private clients, illustrated papers, civic institutions, the Crown or the state, financial arrangements with art dealers which might include the sale of prints or copyright. Artists' earnings were augmented by writing articles, producing illustrations for magazine or book publishers and working as teachers. Detailed research on artists' account books, prices and incomes has yet to be undertaken, but preliminary investigation suggests that the 'economics of taste' were structured in sexual difference and that women artists were positioned asymmetrically and unequally in relation to income levels, profits, supplementary earnings and finance capital.

Relations between artists and clients were mediated by art dealing, critical commentary, art organisations and cultural managers. Regular production and frequent exhibition of work were essential, while contributions to a range of exhibitions spread the possibility of critical notice on which a reputation as well as sales and commissions depended. At the mid-century women artists ambitious for professional success sent their major works to the Royal Academy, reserving smaller studies and sketches for other London venues, including the Society of Female Artists, none of which at this date rivalled the Royal Academy for its prestige or the attention its exhibitions attracted. Joanna Boyce was among those whose works were not well treated by this august institution. Her history painting, *Rowena Offering the Wassail Bowl to Vortigern*, was declined in 1856 as was her modern-life painting *'No joy the blowing season brings'* three years later, while *The Child's Crusade* was hung out of sight in 1860.[1] Her experiences seem to have been not uncommon for young artists whose exhibits would be disadvantaged by the Royal Academy's preference for works by its members. In stark contrast, however, Elizabeth Thompson (later Lady Butler)'s *Calling the Roll after an Engagement, Crimea* (*The Roll Call*) (RA 1874) was one of the three most successful and popular Academy pictures of the century. Previous submissions, however, had proved vexatious: 'first year, rejected with a rent in the canvas; second

year, rejected without a rent; third year, skyed'.[2] Works rejected by one hanging committee could be dispatched to another venue. On one occasion at least this benefited the artist. Anna Mary Howitt launched her exhibition career in 1854 with *Margaret Returning from the Fountain*. When the picture was returned by one London exhibition gallery, Anna Mary Howitt sent it to another, the National Institution, where it was bought at the private view and attracted considerable critical notice not only as 'the gem of the Portland Gallery' but as the painting rejected by the British Institution.[3] From the later 1870s, when galleries, exhibitions and dealers proliferated, women artists exhibited their works even more widely, sending them to the larger provincial exhibitions such as the Liverpool Autumn Exhibitions as well as to the local societies such as the Norwich Art Circle.[4]

As has been indicated, new definitions of 'professional' were required to encompass women artists and the sexually differentiated ways in which they conducted their careers and businesses. According to one contemporary commentator it was the acceptance of a commission and her participation in the market of sale and exhibition which marked a woman artist's professional practice of art.[5] Women artists were contradictorily inserted into the economic system of the nineteenth century, given consensual definitions of bourgeois femininity as dependent. Moreover, before the reform of the laws relating to the property of married women, only a marriage settlement in equity gave wives control over their personal property, earnings, investments, household furniture and stock-in-trade. The marriage settlement between Barbara Leigh Smith and Eugene Bodichon, filed in 1857, set aside an income to be paid 'notwithstanding coverture' and 'for her separate use, independently and exclusive of the said Eugene Bodichon and of his debts, control, interference and engagements', and it protected her property, rent and stocks.[6] Without this legal contract a married woman's art-work could be at risk; when Louise Jopling's first husband Frank Romer left her, he threatened to seize her pictures as his possessions or claim their monetary value. The Married Women's Property Act of 1882 gave married women the same rights as spinsters and widows but, although the law of coverture was overturned, women were not granted legal status as persons.[7]

At present remarkably little is known about the relations between women artists and those who purchased or collected their work, the ways in which women artists negotiated sales, secured commissions or cultivated their clients. There is only scanty documentation on the business transactions of undoubtedly successful artists such as Henrietta Ward who produced, exhibited and presumably sold at least one major work a year. In the middle and lower ranges of the market, women artists seem to have established parity with their male contemporaries, and made modestly prosperous livings. Emily Mary Osborn's sale in 1856 of her portrait of *Mrs Sturgis and Children* for 200 guineas (£210), and in the following year her

sale of *Nameless and Friendless* (plate 10) for £250 compares favourably with recent estimates of £150–£200 as the average annual income for merchants, lawyers and clerks in the middle decades of the nineteenth century.[8] In the upper reaches of the market, however, works by women artists did not command high prices even when they produced paintings which were large in scale and conception. Sophie Anderson's *Elaine* was priced at £420 when shown at the Liverpool Autumn Exhibition of 1870, and Elizabeth Thompson's *The 28th Regiment at Quatre Bras* of 1875 was sold, with copyright, for £1,126. These sums were substantially lower than comparable works by their male colleagues.[9]

As Emily Mary Osborn's *Nameless and Friendless* of 1857 indicated, art dealers were becoming a significant presence in the second half of the century; they were often crucial to an artist's fortunes. Art dealers had 'stables' of artists whose work they commissioned, assiduously promoted and sold to clients, often at highly inflated prices. The bulk of this trade was between men, dealers like Gambart often favouring members and associates of the Royal Academy. Frederic Leighton confessed that his election to Associate in 1864 'was not a great honour now – but it has material advantages as you see in the case of Gambart'.[10] When this dealer bought Leighton's *Dante at Verona* for £1,050, the artist invested the money in railway stock.[11] Lucrative deals like this strengthened masculine privilege in the worlds of art and capital. Profits from paintings and investments were turned into lavish artist-houses, key components in the display of masculine artistic identity in the later nineteenth century. Although Gambart managed Rose Bonheur, like most dealers he toke- nised women and staged his spectacular successes for male artists.

The Fine Art Society both created and capitalised on successful women, taking up Elizabeth Thompson, Helen Allingham and Kate Greenaway. Following the sensation caused by *The Roll Call* at the Royal Academy in 1874, Elizabeth Thompson was courted by the dealership with the result that *Balaclava* was exhibited at the Fine Art Society in 1876, four major works were shown there the following year and the Fine Art Society handled the engravings after her works.[12] But if dealers brought riches and renown, there were disadvantages: showing at the Fine Art Society may well have contributed to the defeat of Elizabeth Thompson's bid for election as Associate of the Royal Academy in 1879. From the mid-1880s the Fine Art Society packaged Helen Allingham as the painter of country scenes and Surrey cottages. Commissions for exhibitions on these themes assisted in shifting the artist's practice in these directions.[13] By this date there was a marked tendency for London dealer-galleries to stage solo- shows around marketable collections. Emily Mary Osborn negotiated two shows with Goupils, *The Norfolk Broads* in 1886 and *The Bure Valley* the following year. Mary Burton's watercolours of Japan were exhibited at the Clifford Gallery in 1895 and 1896, followed by her views of Scotland in

1897. Maud Earl's 'Canine Celebrities' shown at Graves's were popularised through the company's engravings. But women artists rarely benefited from major retrospectives of their work, such as those organised for Lawrence Alma-Tadema, Rossetti or Millais, events which, together with the illustrated biographies, feature articles, and curatorial procedures of the newly founded provincial galleries, created and conserved a documented *oeuvre* for individual male artists and constituted the artistic subject as decisively masculine.

Women artists could find stalwart supporters among male art collectors. C. J. Mitchell purchased Emily Mary Osborn's *Pickles and Preserves* in 1854 'as an encouragement to the artist to go on', while his brother William Mitchell commissioned the portrait of Mrs Sturgis and her children.[14] This patronage was continued with portraits of Mrs C. J. Mitchell (RA 1857) and Percy Mitchell (RA 1866). Charles Prater owned several works by women artists, notably Rebecca Solomon's *Peg Woffington's Visit to Triplet* (RA 1860) and Margaret Gillies's *Vivia Perpetua* of 1859.[15] Correspondence from Rebecca Solomon to one of her clients, George Powell, reveals that she encountered the artist's all too common difficulties of extracting promised payments.[16] William Imrie of Liverpool commissioned eight paintings from Evelyn de Morgan including *Flora* (1894) and *Helen of Troy* (1898).[17] George McCulloch's substantial collection contained Henrietta Rae's *Psyche Before the Throne of Venus* (RA 1894, plate 44) and several works by Marianne Stokes. Recent research on the larger private collections assembled by male collectors has however indicated a fairly widespread pattern of minimal acquisition of works by women artists. If Charles Galloway supported the young Elizabeth Thompson, his collection, like those of other northern manufacturers who came to prominence as art collectors in the second half of the nineteenth century, such as Thomas Fairbairn, Thomas Plint or Robert Heape, only occasionally included works by women artists.[18]

Surviving documentation on women artists' business transactions does not always represent the artist's point of view, as is the case with the arrangements between Elizabeth Siddall and her purchasers. In 1855 she struck a deal with John Ruskin for £150 per annum, in return for all the works which she produced up to that value. Pressure may have been exerted by D. G. Rossetti who perceived that Ruskin was 'likely to be of great use to me personally (for the use to her is also use to me)'.[19] Ruskin was one of the most powerful cultural managers of the 1850s, his influence pervading the literatures and economics of art. The support he gave to Elizabeth Siddall differed profoundly from the practical, financial and critical assistance which he extended to male artists such as D. G. Rossetti or John Brett – he took the latter on European tours to paint landscape and created his reputation. The sexual politics of Ruskin's position were registered in letters to Ellen Heaton which discussed the possibility of a future

purchase of a work by Elizabeth Siddall: 'There's no hurry as she doesn't work *well* enough yet, and Rossetti and I will take care of her till she does, if she lives.'[20] Arguing that 'a commission will be charity', Ruskin located Elizabeth Siddall's art and Ellen Heaton's acquisition of an art-work by a woman in the realm of private benefaction.[21] This tactic was enhanced by the highly controlled contexts in which Elizabeth Siddall's art was viewed, occasionally shown to friends or more rarely released to an invited audience as at the Pre-Raphaelite exhibition held at Russell Place in London in 1857 to which the artist contributed seven works.

Works by women artists were occasionally acquired by the new municipal galleries. Sophie Anderson's *Elaine*, bought in 1871, was the first picture to be paid for out of the Liverpool rates and the first to enter a civic gallery. But as Jane Sellars has documented, Liverpool's rapidly expanding art collection, housed in a purpose-built gallery, did not accumulate works by women. By 1896 only ten of the eighty-six works purchased for the collection from the Liverpool Autumn Exhibitions were by women, a disproportionately low proportion given the numbers of women exhibitors; by 1900 only thirteen works by women had entered the collection by purchase, donation or public subscription.[22] Although women artists were producing the grand historical paintings favoured by the new galleries, theirs were rarely among the founding works. Helen Allingham, Sophie Anderson, Alice Havers and Emily Mary Osborn were among those who saw their work enter municipal collections in their own lifetimes.[23] Maud Sulter has indicated that works by women artists in the national collection of British art, housed at the Tate Gallery in London, 'are few in number and even more randomly representative of their oeuvres than those of male artists'.[24] Only Anna Lea Merritt's *Love Locked Out* (RA 1890) and Lucy Kemp Welch's *Colt Hunting in the New Forest* (RA 1897) were acquired for the nation, and the Tate Gallery, through the Chantrey Bequest.

University colleges in Oxford and Cambridge occasionally purchased work by women. In 1841 St Catherine's College, Cambridge, purchased Mary Ann Criddle's *St Catherine*, a three-quarter length, life-size robed female figure tied to a wheel, from the Royal Academy exhibition for 50 guineas (£52.10s).[25] Mary Ann Criddle contributed to the competitions held at Westminster Hall in the 1840s, but neither she nor indeed any woman artist gained the prestigious commissions for the decoration of the new Houses of Parliament.[26] Commissions for municipal buildings were rarely forthcoming. Jessie Toler Kingsley, and perhaps other women artists in Manchester, assisted Ford Madox Brown with his murals for the Town Hall in the 1880s.[27] From 1898 Henrietta Rae was at work on *The Charities of Sir Richard Whittington*, measuring 18 by 12 feet, for the Royal Exchange in London.[28] With the revivals of mural painting and Anglo-Catholicism in the closing decades of the century, women artists secured orders for church decoration. Emily Ford produced religious paintings for

All Saints' Leeds and St Anne's Lambeth, and Anna Lea Merritt painted frescoes for St Martin's Church, Chilworth (1893–4).

Women artists participated in the growing reprographic markets, augmenting their income from sales of oil paintings or watercolours and their reputations as artists by designing illustrations for magazine and book publishers. A few, such as Helen Allingham, Mary Ellen Edwards, and Florence Claxton, were salaried members of staff or regular contributors to illustrated papers. Unlike their male contemporaries who contributed scenes of urban poverty, making them the basis for large-scale paintings, or sketches of contemporary political or military events, women were commissioned for vignettes of middle-class social and domestic life.[29] In addition papers such as *The Graphic* or the *Illustrated London News* purchased individual exhibited paintings for reproduction as featured illustrations as well as commissioning series, such as Clara Montalba's Venetian watercolours.[30] In the 1890s W. H. Lever purchased Dorothy Tennant's *Street Arabs at Play* and Louise Jopling's *Home Bright, Hearth Bright*, intending that the depiction of grubby working-class boys and the image of graceful middle-class women washing china should advertise the benefits of Sunlight soap.[31]

Regular work as commercial artists, direct orders from clients and a relationship with a dealer helped women artists to counteract the fluctuations of the art market which were aggravated by the recession from the later 1870s to the 1890s. Louise Jopling's account books indicate pronounced variations in her sales. From earnings of nearly £1,500 in 1878, her income slumped to £605, then £370 and was at its lowest in 1881 at £331. By 1882 it had recovered to £961, rising to £1,103 in 1883 but dipping again to £494 in 1884. While these modulations can in part be attributed to illness, domestic worries and familial cares, factors which chequered many women's careers, they can also be located in the instabilities of the national economy. In 1900 Anna Lea Merritt expressed the view that 'there is no income so fluctuating as that of the artist'. She considered that £200 was required to establish a young artist and pay for a year's expenses of studio, models and materials.[32] A successful career required so much more: technical expertise, an eye for the market, the careful cultivation of dealers, critics and clients, and the skilful manipulation of the masquerade of femininity to secure representation in a world divided and defined by sexual difference. Not until late in the century and even then only in a few highly controlled environments did women artists have the facilities or possibility of meeting or entertaining their male clients in those urban spaces of a London club, a public restaurant or a hotel in which men conducted business: for the most part such social encounters would have connoted impropriety or even sexual deviancy on the part of the woman. Nor could women artists participate in the homosocial bonding networks which tended to advantage selected male artists in prestigious commis-

sions, remunerative sales, lucrative contracts, professional distinctions and critical acclaim. But running counter to this system of patronage, which preferred masculine values and concerns, was the culture of *matronage* in which women supported art by women.

THE CULTURE OF MATRONAGE

Throughout the nineteenth century women artists often sold their paintings to women friends, relatives, and clients. This support system can usefully be defined as matronage.[33]

Across the period 1770 to 1830 the word matron had several meanings, Its primary and most common meaning of a married woman coexisted with connotations of support between women in the social rituals of femininity.[34] To matronise was to chaperone and to act as guardian, guide and assistant, as in Susan Ferrier's novel *Marriage* of 1831, in which an aunt recommends to a young woman the company of an older woman.

> [Lady Maclaughlan] will Matronize you to the play, and any other public places you may wish to go; as both my Sisters and I are of the opinion that you are rather young to Matronize yourself yet, and you could not get a more Respectable Matron than Lady Maclaughlan.[35]

The noun matronage, in use from the 1770s to the 1880s, is re-used here in *Painting Women* to signify the richness and diversity of women's cultural relationships; it is not intended to suggest any coherent or unitary women's culture. As a concept, matronage necessarily connects women of varying perspectives and conditions and it is important to recognise that where support for women artists was assisted through friendship and kinship, these were historically structured relationships between particular groups of women which were primarily organised on the axis of class. Matronage can be distinguished from patronage, thus restoring to the latter practice its fundamental orientation.[36] The concept of matronage brings to the surface of historical visibility the ways in which cultural production by women and cultural consumption by women were socially and economically interrelated.

Queen Victoria, herself an amateur artist, was undoubtedly a leading, if not lavish, supporter of women artists. She purchased Emily Mary Osborn's *My Cottage Door* (RA 1855), which depicted a young woman with a basket of apples standing at a doorway, and *The Governess* (RA 1860).[37] Emma Richards's four religious pictures – *Religion, Faith, Hope* and *Charity* – were acquired for her by Prince Albert and a self-portrait was painted on command in 1853.[38] (plate 11) Royal commissions inscribed sexual difference, for while the Queen turned to Mary Severn and Henrietta Ward for portraits of the royal children,[39] orders for large historical works on political themes were assigned to male artists. When

her husband was commanded for two such paintings, Henrietta Ward worked as his assistant, making useful studies of details.[40] The Queen acquired two pictures from the Royal Academy exhibition of 1874, Alice Havers' *Ought and Carry One* and Elizabeth Thompson's *Calling the Roll*.[41] She followed her purchase with a commission to the latter for *The Defence of Rorke's Drift* in 1879. The artist disliked the subject of an attack by Zulus on a white military hospital camp, considering that 'it was against my principles to paint a conflict'.[42] For over twenty years from 1862, when the Female School of Art was granted royal protection, Queen Victoria took a 'continued personal interest in the welfare of the school', making a 'frequent selection and purchase of works'.[43] Her interest in women artists was also indicated by her appointment in 1879 of Helen Angell as Flower Painter in Ordinary.[44]

Matronage extended the economic and social power of middle- and upper-class women which, as Dorothy Thompson has indicated, was exercised as customers and employers as well as through their donations to and good works for philanthropic societies.[45] For Angela Burdett-Coutts, an extremely wealthy woman, her activities as a philanthropist and as an art collector were united in her concept of 'woman's mission to woman' when she purchased works by women. She bought Mary Ann Criddle's *Lavinia and Her Mother* from the Society of Painters in Water-colour in 1849 and her series of *The Four Seasons* in 1854.[46] This same year she had hoped to purchase Anna Mary Howitt's *Margaret Returning from the Fountain*, which depicted the moment in Goethe's *Faust* when the heroine recognises that she is pregnant. The painting's appeal to its potential buyer lay not only in its subject matter – Angela Burdett-Coutts was already involved in the rescue work of prostitutes – but also in its morality for, briefly to anticipate the arguments of part II, in the 1850s high culture and philanthropy shaped a field of vision and power for middle-class women.[47] Angela Burdett-Coutts also supported Rebecca Solomon by purchasing *Behind the Curtain* (RA 1858) which portrayed a group of travelling players, and commissioning *Roman Wedding Party* (c. 1866–70).[48] In 1879 she founded the Art Students' Home for Women in Brunswick Square in London and acted as its President.[49] She made key-note speeches at the Female School of Art and funded the scholarships and prizes named after her.[50]

From the 1840s to the 1860s a few women purchasers are recorded, such as Lady Chetwynd who bought *Nameless and Friendless* (plate 10) in 1857. The novelist Eliza Lynn Linton, best known for her articles in the 1860s on 'the Girl of the Period', bought several works by Rebecca Coleman.[51] By the later decades numerous women supported women's art: Mrs Warren de la Rue who commissioned Anna Lea Merritt's *Romeo and Juliet* (1883); Mrs George Garrett and Mary Smyth, Mrs Charles Hunter (sister of the composer Ethel Smyth), both of whom owned works by Annie

Swynnerton; the many purchasers of Helen Allingham's watercolours.[52] Women clients often selected women portraitists, perhaps because of the proprieties of the situation. Margaret Gillies in the 1840s, Louise Jopling, Anna Lea Merritt, Lillie Stacpoole Haycraft and Louisa Starr in the 1870s and 1880s all produced portraits of female sitters.

In the later nineteenth century women's institutions, organisations and commercial concerns all favoured women's art; girls' schools, for example, would house portraits of founders and teachers.[53] In the 1890s the Studio Afternoon Tearooms in London, 'entirely managed by ladies', sold the pictures by women artists which were exhibited on its walls.[54] Margaret Macdonald Mackintosh co-designed and produced decorative schemes for Kate Cranston's tearooms in Glasgow, creating an overall scheme which included menus and cards designed by herself, Frances Macdonald and Jessie M. King.[55]

From their inception women's colleges at Oxford and Cambridge garnered collections of paintings, sculptures, photographs, books, pamphlets and catalogues. When Philippa Fawcett graduated from Newnham College in 1890, having been awarded the highest place in the Mathematical Tripos examinations, her mother Millicent Fawcett presented this Cambridge women's college with *Towards the Dawn* by Emily Ford, 'in remembrance of her daughter's success'. This large painting, depicting an allegorical figure with light rising behind it, was hung in the common room.[56] Several years earlier a portrait of Barbara Bodichon was painted by Emily Mary Osborn for presentation to Girton College. The portrayal of this feminist campaigner, suffragist, founder of Girton and woman artist, and its context in an institutional repository of women's culture, draws together the strands of production and representation, meaning and signification which structured women's art practice in the nineteenth century.

EMILY MARY OSBORN'S PORTRAIT OF BARBARA BODICHON

Emily Mary Osborn exhibited a large portrait of Barbara Bodichon at the Grosvenor Gallery in London in 1884 before it was presented to Girton College, Cambridge the following year.[57] Nothing is known of the circumstances of the commission which probably rested on personal friendship and shared interests in feminism. This portrait is now untraced, and a smaller, perhaps later, portrait has been donated to Girton College (plate 13).[58]

Established in 1869 and moving in 1873 to purpose-built premises in the village from which it took its name, Girton College was the first women's college to provide higher education at university level. Barbara Bodichon was a founder and major donor. In the planning stages she gave £1,000 to encourage other gifts, in 1884 she put £5,000 into the building funds and at

her death she bequeathed £10,000.[59] Before her severe illness of 1877 Barbara Bodichon took an active interest in the college, serving on the executive committee and often arbitrating between students and staff. With Emily Davies, co-founder and first Mistress of Girton, she organised furnishings, fittings, furniture and decorations, providing her own pictures for the walls. The first shipment of her art-work was dispatched in 1870.[60] In 1875 she offered to pay for the decoration of two rooms in the new premises. With Gertrude Jekyll she devised a scheme for painting and papering the whole college, then rather spartan, and she consulted her friend on the planting and design of the college gardens.[61] In 1891 before she died Barbara Bodichon confirmed the gift of her paintings to the college:

> she definitely makes over all her paintings now on the walls of (or in) Girton College to the College She is certain that she cannot leave the paintings in a better position – or in better hands – always with the hope that they may be a source of pleasure to some of those who will come year after year to reside and work at Girton. Her hope indeed is always to impart to others through her paintings some of the strength and happiness that her intense study of nature has brought into her own life.[62]

Although Barbara Bodichon was independently wealthy, she worked for thirty years as a landscape artist and contributed regularly to exhibitions in London and the provinces, inspired by her belief in paid work for women.[63] Bessie Rayner Parkes wrote of her:

> she was well endowed with fortune, and her paintings early commanded considerable prices; and of the money at her disposal she was a most liberal and conscientious guardian.[64]

Barbara Bodichon poured her money into women's campaigns and organisations, funding the Society of Female Artists, the *English Woman's Journal*, Girton College and leaving a legacy to Bedford College to improve the facilities in the studio named after her.[65]

Feminism informed Barbara Bodichon's pursuit of a career, her businesslike conduct, her exhibition and sales record. For egalitarian feminists women artists represented successful professionals whose achievement justified and supported middle-class women's active role in the social field and economic arena. From the 1880s women artists constituted a prominent group of signatories to the petitions for women's suffrage. Paintings were included in the exhibitions which demonstrated the range and skills of women's work such as the Loan Exhibition of Women's Industries organised in Bristol in 1885 by Helen Blackburn.[66] The importance of women artists to these campaigns was demonstrated in the cover design of the

exhibition catalogue in which one of the four vignettes showed a woman artist at work.[67]

The status of women artists in the women's movement undoubtedly contributed to Emily Mary Osborn's decision to portray the founder of Girton seated at an easel at work on an oil painting, although her sitter had retired from exhibiting and public life several years before. Moreover, as a landscape painter Barbara Bodichon usually produced and exhibited watercolours.[68] Even though the status of watercolours had risen by the 1880s, oil painting was still privileged in the academic hierarchy. Emily Mary Osborn thus represented Barbara Bodichon engaged in a professional activity which could not be mistaken for an amateur accomplishment in watercolour sketching. This image of serious endeavour was produced for a collegiate context in which the portrait, hanging in the dining-room,[69] was seen by women whose aspirations were not artistic but academic and professional.

During the nineteenth century newer educational institutions followed Oxbridge precedents in adorning their rooms and corridors with monumental portraits of founders and Chancellors, weighted down with their chains and robes of office. Women of Barbara Bodichon's generation had no such regalia although they had fought for and achieved an equivalent status. There were moreover well-known examples in the history of art of the rendition of the male artist as an intellectual, most notably Sir Joshua Reynolds's self-portrait in doctoral robes (c. 1780) and the more recent self-portrait of Sir Frederic Leighton, the current President of the Royal Academy (RA 1881), in which he portrayed himself, wearing doctoral robes and his medallion of office, against a section of the Parthenon frieze. But since women had been rigorously excluded from the institutions of higher education, no pictorial conventions had been developed for their portrayal in these contexts. In the presentation portrait Barbara Bodichon wears an aesthetic dress with a draped scarf suggesting an academic hood, and in the version now at Girton (plate 13) the fur borders of her dark green gown have been arranged so as to invoke and feminise the official robes in which men who held university or civic office were painted. The subversive resonances of this portrait can be inferred from the horror expressed in Walter Besant's *The Revolt of Man* (1882) that women in becoming the dominant sex and working as judges, doctors, lawyers and artists, would be represented in portraiture 'with all the emblems of authority – tables, thrones, papers, deeds and pens'.[70] Emily Mary Osborn's two portraits of Barbara Bodichon thus took up a pictorial challenge, employing differing strategies in the visual representation of a public figure who was a prominent feminist campaigner, a founder of the college and a woman artist.

Like the donations to the college library, the presentation portrait of Barbara Bodichon gave substance to women's traditions of culture and

learning. Gifts and bequests to Girton College library, named after a major donor, Lady Henrietta Maria Stanley of Alderney, created an important educational resource which not only contained materials for academic study but also housed important archives of women's history and a collection of women's portrait photographs, given by women who were keenly aware of the need to preserve the history they were making.[71]

In nearly twenty years of suffrage campaigning, Helen Blackburn (1842–1903) had amassed an extensive collection which she bequeathed to Girton College. Helen Blackburn was secretary to the London Central Committee of the National Society for Women's Suffrage from 1874 to 1895 and to the Bristol and West of England Society from 1880 to 1895. She edited the *Englishwoman's Review* from 1881 to 1890 and published the Women's Suffrage Calendar from 1886 to 1899. She assembled books, pamphlets, catalogues, photographs, periodicals and newspaper cuttings in memory of two suffragists, Lydia Becker and Caroline Ashurst Biggs, arranging these materials in a mahogany bookcase of her own design into which were set two watercolour portraits by Elizabeth Guinness of the women who had inspired her. Each book contained a bookplate to their memory.[72] Women who worked with Helen Blackburn considered this collection an invaluable resource. Lilias Ashworth Hallett who completed the binding of the pamphlets testified, 'There will always be a few women who will look back through the years with interest and gratitude to the struggles of the early workers.'[73]

In the later nineteenth century portraiture became increasingly important to the women's movement in representing its members and their political objectives. That Helen Blackburn considered visual imagery a central component in women's history was evidenced by the memorial portraits on the bookcase, the inclusion of fifty-six photographs in her collection (the majority of which were of women suffragists), and the numerous images, including Emily Mary Osborn's original portrait of Barbara Bodichon, illustrating her account of women's suffrage.[74] In 1892 she was active in the unsuccessful campaign to present Susan Isabel Dacre's portrait of Lydia Becker to the National Portrait Gallery.[75] The following year she donated her 'Portrait Gallery of Eminent Women' to University College, Bristol, for the Women Students' Room.[76] Approximately 190 photographs and engravings of women mounted in olive green cloth in oak frames portrayed the history of women from the Norman Conquest to the later nineteenth century. According to Millicent Fawcett:

> She [Helen Blackburn] collected and arranged an interesting series of portraits of abbesses, peeresses, and other notable women who in days long gone by had represented the spindle side of the nation.[77]

Frequently exhibited, this collection was included in the Bristol exhibition

of 1885, displayed at the offices of the London Central Committee in 1893, and later the same year formed part of the British section of the Woman's Building at the World's Columbian Exposition in Chicago.[78]

Articulating a novel kind of portraiture and invested with new feminist meanings for women's portraits, Emily Mary Osborn's presentation portrait of Barbara Bodichon took its place in the first university college for women. This context is important for constituting its possible meanings for contemporary viewers. To locate the portrait's significance and signification to the community of women for whom it was made, it is necesary to return once again to Elizabeth Cowie's theorisation of woman as sign which was outlined in the introduction. Elizabeth Cowie argued that woman as sign represents neither a pre-existing individual nor the community of women. On the contrary the sign woman acquires meaning from its production and exchange in a specific system of signs. She concluded:

> It is therefore possible to see 'woman' not as a given, biologically or psychologically, but as a category produced in signifying practices To talk of 'woman as sign' in exchange systems is no longer to talk of woman as the signified, but of a different signified, that of: establishment/re-establishment of kinship structures or culture. The form of the sign – the signifier in linguistic terms – may empirically be woman, but the signified is not 'woman'.[79]

With its careful attention to identifiable systems of signification and their bases in social practices and institutions, this path-breaking theory can be put to work to assist an understanding of the ways in which women resignified the sign woman in the later nineteenth century. As the sign woman is meaningful only in the systems of signification in which it occurs, it can be argued that when this sign is produced and exchanged in patriarchal kinship, 'woman' signifies not a woman nor women. Rather in these instances woman as sign functions as a signifier of difference and its meanings secure the foundation of patriarchal culture. However the sign woman was not stable; its significations were not prescribed. Woman as sign was struggled over by groups competing for power in late Victorian Britain, groups which produced colliding systems of signification. In the women's networks, movements, organisations and institutions which proliferated from the 1870s onwards women produced, exchanged and resignified the sign woman, so challenging the foundations of difference and of culture.

The formation of women's colleges and college collections as at Girton, and the creation of women students' rooms such as that at University College, Bristol, were central to these developments. In these institutional spaces women were surrounded by, and could construct meanings for, images of the women who in the past and the present had been active in the struggles for women's education, employment and civil rights. Matronage

in women's colleges such as Girton assisted in preferring women to scholar-ships and academic appointments. Matronage operated in the London and Glasgow societies of women artists, placing women in their positions of honour and on their boards of management. Middle-class women worked together in educational institutions and settlement houses; they cam-paigned together in numerous societies, voicing in the suffrage movement their common cause as women.[80] They enjoyed each other's company in a wide range of social spaces such as women's restaurants and tea-rooms which catered exclusively or made special provision, as did Kate Cranston in Glasgow, for women. They lived together in lodgings, colleges, houses, and in purpose-built apartments.[81] They socialised in the many women-only clubs; by 1899 there were twenty in London and nine elsewhere, including the Glasgow Society of Lady Artists' Club.[82]

These newly defined social and institutional spaces of femininity gener-ated situations and occasions, rituals and relationships, discourses and practices in which women produced and exchanged the sign woman as an explicitly visual sign – in looking at each other or in the making, viewing and owning of women's images of women. This is the location of Emily Mary Osborn's portrait of Barbara Bodichon: the exchange of woman as a visual sign within a relational continuum created by women between production, representation, spectating and ownership. These relays be-tween making and viewing, representation and signification enacted by women broke woman as sign from its significations of the establishment of patriarchal kinship or patriarchal culture. Emily Mary Osborn's portraits of Barbara Bodichon do not represent woman as the cipher of masculine desire and such meanings would not be preferred within the context for which they were made and in which they were seen. At one level woman as sign here denotes the founder of a woman's college, a new status for a woman in the discourses and institutions of power/knowledge, but at a deeper level of signification woman as sign was produced and exchanged in this collegiate context to signify the foundation of cultural, intellectual and social communities of women and their exchanges of meaning. Across the rituals of women's friendship, the networks of women kin, the relations of matronage, the daily practices of viewing women's images of women – from paintings to personal style – across women's movements and organi-sations, historically specific systems of signification were constituted in the later nineteenth century in which woman as sign was produced and exchanged between women to signify the foundation of communities, cultures and meanings of women.

Plate 14 Henrietta Ward, *'God Save the Queen'*, Royal Academy, 1857.

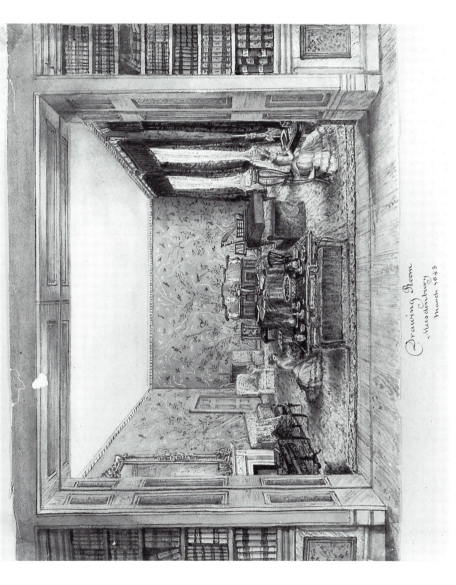

Plate 15 Charlotte Bosanquet, *Drawing Room at Meesdenbury, March 1843.*

Plate 16 Lucette Elizabeth Barker, *Laura Taylor and her son Wycliffe*, 1859.

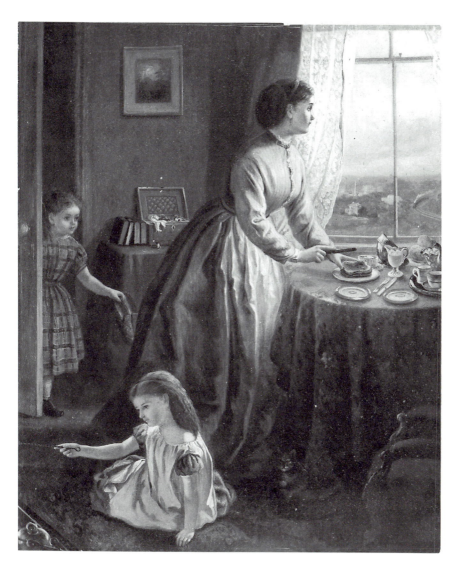

Plate 17 Jane Bowkett, *Preparing Tea*, 1860s.

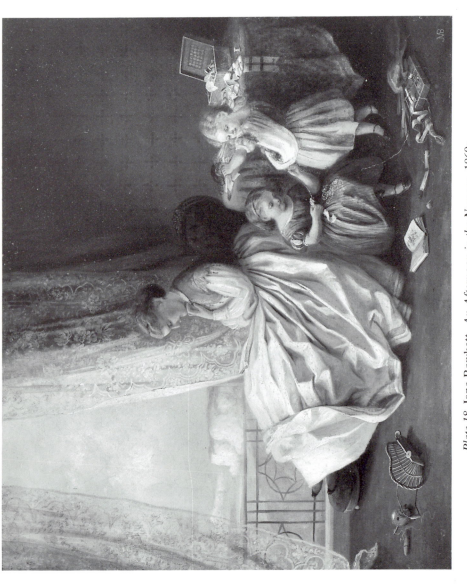

Plate 18 Jane Bowkett, *An Afternoon in the Nursery*, 1860s.

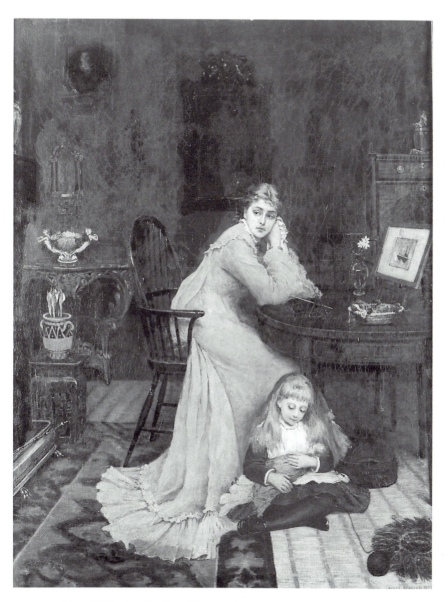

Plate 19 Louise Jopling, *Weary Waiting*, Royal Academy, 1877.

Plate 20 Maud Hall Neale, *Two Women in an Aesthetic Interior*, 1880s.

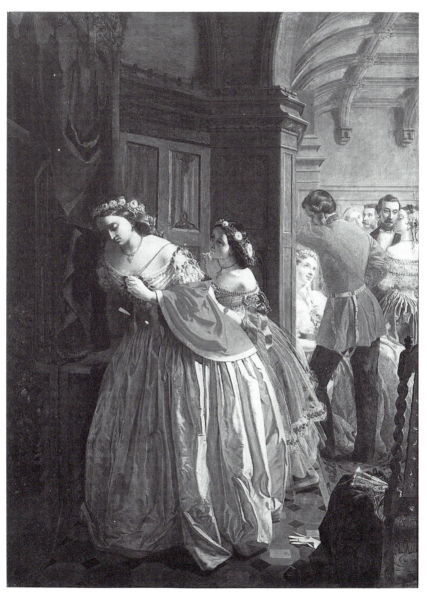

Plate 21 Alice Walker, *Wounded Feelings*, 1861, British Institution, London, 1862.

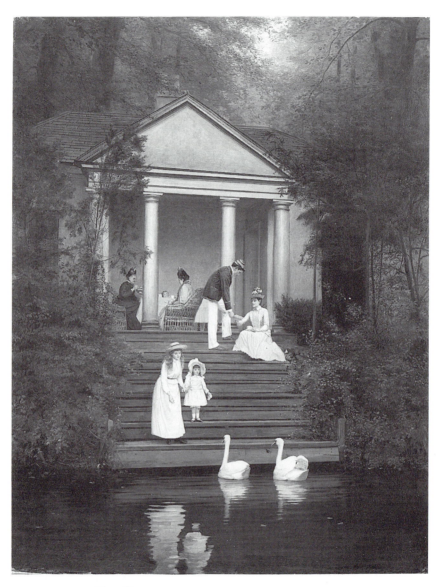

Plate 22 Edith Hayllar, *Feeding the Swans*, 1889.

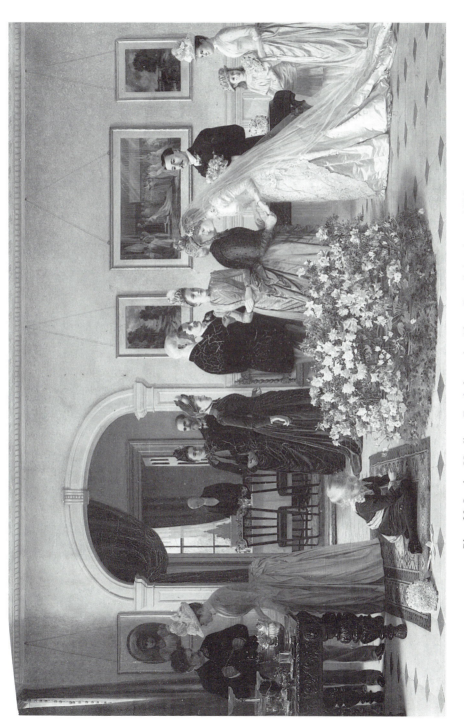

Plate 23 Jessica Hayllar, *Fresh from the Altar*, Royal Academy, 1890.

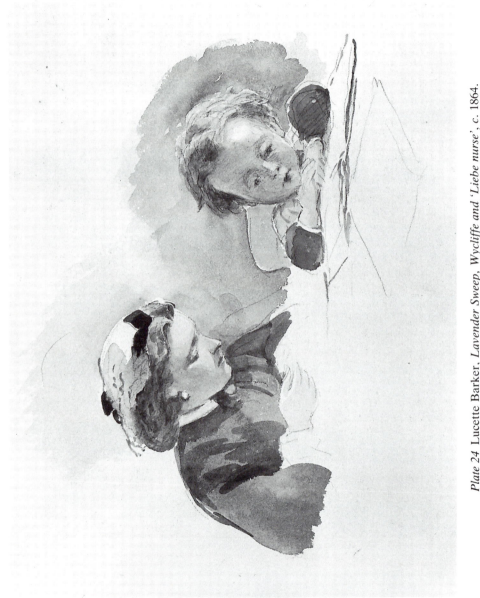

Plate 24 Lucette Barker, *Lavender Sweep, Wycliffe and 'Liebe nurse'*, c. 1864.

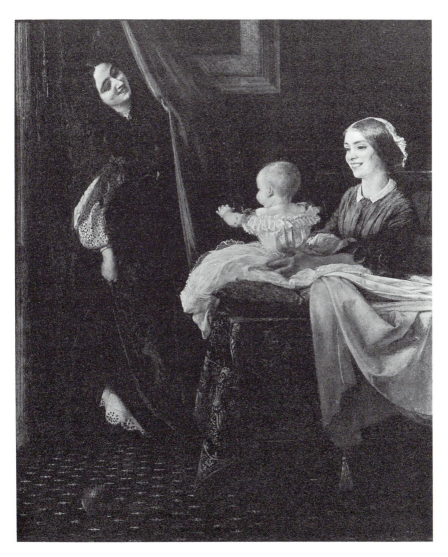

Plate 25 Joanna Wells, *Peep-bo*, Royal Academy, 1861.

Part II

WOMEN PAINTING WOMEN

DIFFERENCING THE GAZE

In Charlotte Brontë's novel *Villette* of 1853 Lucy Snowe visits the picture gallery in Brussels.[1] The dramatic encounters which take place in this pivotal scene are central to the novel's address to the position and representation of women in mid-Victorian society. Lucy Snowe asserts her right to look at a painting of a semi-draped Black woman reclining on a couch entitled *Cleopatra*. Her declaration is countered by Paul Emanuel who considers the *Cleopatra* to be unsuitable for the gaze of an unchaperoned single woman; he unsuccessfully attempts to divert her attention to four scenes depicting the life of a woman as a young girl, a wife, a mother and a widow. Lucy Snowe's dismissal of both the *Cleopatra* and *La vie d'une femme* are set in play against the different viewing positions of masculinity, and the field of vision is structured not only in sexual difference but also in intersecting hierarchies of race and class. For Lucy Snowe *Cleopatra* represents a woman who 'had no business to lounge away the noon on a sofa' since she appeared 'strong enough to do the work of two plain cooks'. For the masculine spectators the *Cleopatra* is either the epitome of sensuality, or 'une femme superbe – une taille d'impératrice, des formes de Junon' (a superb woman – the stature of an empress, the figure of Juno), or a personage of no interest. All however concur with the view expressed by Paul Emanuel that she is 'une personne dont je ne voudrais ni pour femme, ni pour fille, ni pour soeur' (a person I should not wish for wife, daughter or sister). Charlotte Brontë locates the activities of spectatorship and the practices of visual representation securely within the social production of difference. At the heart of her discourse is the feminine spectator, the middle-class woman whose pleasures included looking at art and appraising images of women.

Villette is one of several texts by women in nineteenth-century Britain to address the representation of women and to portray a middle-class woman actively looking and taking pleasure in her gaze. The novel can be located in the considerable debates around *woman's look*.[2] Representations of women in visual culture and reflections on women's appearance – what women looked like – participated in the management of sexuality.

Visual images became increasingly important in defining feminine sexuality and in regulating difference. Discussions of the proper targets and suitable situations for a woman's gaze carried over into debates about the kinds of art and the appropriate categories of representation for women painters; the claim that domestic painting (or still life) was appropriate for women was but one strategy for the organisation of sexual difference in the field of vision.

Analysis of the sexual politics of looking has been central to feminist theory. Laura Mulvey's article 'Visual Pleasure and Narrative Cinema', first published in *Screen* in 1975, proposed a fissuring of the field of vision based on and productive of sexual difference:

> In a world ordered by sexual imbalance, pleasure in looking has been split between active/male and passive/female. The determining male gaze projects its fantasy on to the female figure, which is styled accordingly. In their traditional exhibitionist role women are simultaneously looked at and displayed, with their appearance coded for strong visual and erotic impact so that they can be said to connote *to-be-looked-at-ness*.[3]

Laura Mulvey's essay has become a catalyst in what has been recognised as a more urgent interrogation of the feminine spectator and the search for an account of feminine pleasures in looking which has been engaged across high and popular culture. The issues of how and to whom now accompany the investigations of the meanings of images of women, as the 'object' of the masculine scopophiliac gaze has been transformed into the 'subject', she who sees. In her essay 'Modernity and the spaces of femininity' Griselda Pollock set an agenda for the relocation of the female spectator in a historical formation, that of nineteenth-century France. She identified the formation of a split field of vision as part of a social ordering of sexual difference in which bourgeois masculinity was positioned as *flâneur*, the man about town with roving eyes who took pleasure in modern urban spectacle and cross-class sexual encounters. In diametric opposition, bourgeois women were located in the domestic interior, the balcony, the garden and the leisure spaces of the theatre or park. These 'spaces of femininity' offered bourgeois women a different order of visual gratification in which the gaze was 'that of equal and like'; their look was not the 'mastering gaze' of the voyeur or *flâneur* but an exchange between women of reciprocal glances within spaces characterised by proximity.[4] Mulvey's analysis draws on psychoanalytic film theory, particularly the work of Mary Ann Doane who has recently extended her discussions of spectatorship in *The Desire to Desire: The Woman's Film of the 1940s*. Indicating that the female gaze can be traced in the interplays between the representations of women actively looking and the filmic solicitations of the female spectator, Doane suggests

that 'it is the constitution of vision as a process both within the filmic text (the representation of the woman seeing) and between text and spectator which most warrants attention'. As the ascription of the gaze to the woman has 'potentially disruptive effects', the positioning of women as spectators as well as the ways in which women look is highly regulated.[5] She notes that in common with other feminist film theorists she has encountered profound difficulties in conceptualising the female gaze, concluding that these derive from and indicate not the shortcomings or disagreements of feminism but the contradictions central to the social and psychic construction of female spectatorship.[6]

Another, contradictory direction in the study of spectatorship has been to break with psychoanalytic theory, with its binary fissuring of the field of vision and tendency to homologise femininity, for a mapping of a multiplicity of positions and the inscription of a multitude of spectators. Directly challenging psychoanalytic film theory propounded in the influential magazine *Screen*, Suzanne Moore contended in her contribution to the collection *The Female Gaze: Women as Viewers of Popular Culture* that 'if a female gaze exists it does not simply replicate a monolithic and masculinised stare, but instead involves a whole variety of looks and glances – an interplay of possibilities'.[7] Laura Marcus has perceptively commented that *The Female Gaze* represents 'the shift in feminist theory from psychoanalytically informed theorisations of "sexual difference" to concepts of "difference" as real differences of class, race and gender', concluding rightly that while 'the feminist recognition of these differences is long over due', it need not be accompanied by an abandonment of the insights of psychoanalytic theory or a return to untheorised accounts of images.[8]

These different approaches can assist a discussion of feminine spectatorship in the second half of the nineteenth century. Psychoanalytic film theory has insisted on the *production* of sexual difference and subjectivity while drawing attention to the processes in which subjects accept, reject, subvert or challenge the positions offered by visual texts. At the same time, to address feminine spectatorship is to reinstate a multiplicity of viewers and viewing. Vision is indeed about 'a whole variety of looks and glances – an interplay of possibilities' which were historically and culturally constructed in a social order in which sexual difference was simultaneously produced with differences of class and of race. Vision for women was formed in the interplays between the representations of women looking, the discursively produced modes of perception and positionalities of spectatorship and the positions taken up by women as spectators in and from which visual texts became intelligible. Central to such an inquiry is the question as to whether visual texts by women addressed specific communities of women who, within the positionality of the feminine, could read against the grain, could look otherwise.

Feminist analysis of high culture has tended to prioritise issues of

production and representation. An inquiry into spectatorship enables an investigation into the ways in which women's paintings became significant to and for women, their particular investments, gratifications and expectations; it leads to an interrogation of the possibilities of specifically feminine/feminist pleasures. Feminine spectators have remained beneath the surface of historical discourse. Relocating and re-placing them depends on an analysis of the historical organisations and contradictory formations of difference. The relocation of feminine spectators is not to advance a claim that all women – or indeed all middle-class women – saw from the same place, or made sense of what they saw in the same way. Nor is it to claim that anatomy could guarantee a *female* way of looking or *female* spectator but to address the positionings in femininity, understood as a category which is socially and psychically constituted. Women were located in and took up viewing positions in a social formation in which femininity was not monolithic but multiply shaped and fractured by colliding determinants such as age, dis/ability, religion, politics, sexuality and location, as much as race or class. The field of vision was dynamically traversed by the glances of African and Asian women; the relays of the gaze were held in tension by the looks of working-class women, unregarded in nineteenth-century discourses identifying cultural consumption with the bourgeoisie. The term 'female gaze' suggests a way of seeing common to all women. On the contrary, vision was a social and cultural activity framed by and taking place within the broader field of power relations which were not polarised but a tense and unstable web of interrelated and productive forces.

The diversities of feminine spectatorship are not easily equated with the nineteenth-century discourses on high culture for much, particularly in the histories of women, has disappeared beneath their eddying surfaces. Moreover, as feminist film theorists have emphasised, feminine spectatorial positionalities constructed in and by discourses and institutions are not synonymous with the social subjects who viewed visual culture.[9] Nineteenth-century art criticism did not represent or claim to include all the possible readings for contemporary art or all the positions from which pictures were viewed. Working to unify the disparities in the viewing publics, critical writings preferred certain meanings and prioritised specific positions. Many viewpoints were either not registered or only fleetingly referenced. Middle-class women were occasionally recognised as a constituent group and target audience. They were assigned and indeed took up positions as representatives of feminine purity.[10] However, the critical contention that women delighted in pictures of mothers and children is not historical evidence that feminine spectatorial pleasures were so constituted: discursive productivities are not after all to be equated with social effectivities. Women spectators did not simply inhabit pre-existent viewing positions, nor did they necessarily see from the perspectives which were

deemed appropriate to their class and their sexualities. Vision was a process of negotiation, a strategy for redefinition, which was situated in the interplays between representation, spectatorship and signification.

Woman's look can be traced across several fields of vision which were historically specific to the nineteenth century. Several modes of perception were designated appropriate for, and taken up in diverse, heterogeneous and contradictory ways by women. From the 1850s onwards, the philanthropic gaze empowered middle-class women's encounters with and representations of working-class women, framing them within strict hierarchies. Philanthropy assigned middle-class women an elevated status in rescue work: their purity qualified them for their mission of salvation and distanced them from their objects of concern. As Mary Ann Doane has indicated in relation to filmic texts of the 1940s, pathos contains the potential disruption of ascribing the gaze to women.[11] The philanthropic gaze facilitated white bourgeois women's depictions of the sufferings of the poor, the conversions of the heathen, the boundaries of feminine respectability and the destitution of the outcast while inciting sympathy for those on whom it focused.

At the mid-century the philanthropic gaze extended women artists' representations beyond the domestic field of vision which was considered most suitable for them and the greatest source of pleasure for feminine spectators. As modern-life paintings, an artistic category which emerged in the mid-nineteenth century, domestic pictures and the critical discourses which circulated (with) them may be classified as realist texts. As the dominant mode of representation and signification in bourgeois societies, realism depends on a closed system of meaning in and by which realist texts are read/viewed as depictions of a pre-existent reality. Its means of visual representation – highly detailed paintings full of narrative clues – and its mode of signification were widely installed and dispersed through nineteenth-century institutions and discourses as diverse as fiction and medicine, high art and the social sciences. To be intelligible and legible, realist texts require and assign a fixed positionality for the reader/viewer in and from which they appear simply to describe the physical and moral order of bourgeois society.[12] Visual pleasure is constituted in recognition and identification. Edward Said has observed that 'the novel's realistic bodying forth of a world is to provide representational or representative norms selected from among many possibilities. Thus the novel acts to include, state, affirm, normalise and naturalise some things, values and ideals, but not others.'[13] Citing Said and drawing on feminist studies, Anita Levy has commented that realist novels were understood as 'a body of knowledge that helped to train individuals, especially women, to take up their respective positions in the productive and reproductive spheres'. She argues that they provided readers 'with the materials for representing their desires to themselves and in so doing they place limitations on how and

what to desire'.[14] Realist texts – and this includes fiction and non-fiction, visual and written texts – were also *productive*, generating positionalities and identifications which were decisively differenced. Critical discourses which encouraged visitors to the Royal Academy exhibitions to view domestic scenes as pictorial equivalents of their daily lives had a particular resonance of address to those middle-class women whose identities and activities were organised around family and household. With the historical separation of home and work, middle-class men's diurnal experiences increasingly lay outside the domestic sphere and their professional and commercial activities were, to a large extent, beyond pictorial represen-tation. Perhaps it was middle-class women's location in a sexually differ-enced field of vision, along with their disparate positionalities in the social order, which generated their contradictory visions of domesticity. For if women represented the maternal gaze, a look which, as Carol Duncan has demonstrated, was culturally instituted for women from the later eigh-teenth century,[15] women also posited a looking elsewhere. In Jane Bowkett's *An Afternoon in the Nursery* the children's mayhem is unre-garded and unseen by a woman (coded indeterminately as neither a mother nor a governess) who focuses her gaze and her entire attention on a book (plate 18).

The visual representation of women looking produced definitions of the appropriate targets of a feminine gaze. Women's pictures depict middle-class women looking at women and occasionally at men of their own family circle. A downcast gaze was considered a sign of feminine modesty, as in *Nameless and Friendless* (plate 10), while a direct glance at a male stranger would be construed as an indicator of sexual deviancy. It seems significant that two representations of women at the moment of their look, *Pippa Passes* and *The Lady of Shalott* (plates 29 and 37), were produced by Elizabeth Siddall, a woman whose cultural referents were located at the margins of bourgeois culture. Women's look was regulated as much in relation to space as to the gendered body. From the mid-century, there were profound debates over landscape as a site and sight for women. Discussions focused on the propriety of women painting out of doors, the appropriateness of the artistic category and the suitability of rural scenes for women's visual representation. The development of a metropolitan mode of perception facilitated women as beholders *and* representers of the countryside.

Whereas the philanthropic, domestic and metropolitan gaze facilitated women's active looking, in the aesthetic field of vision, formed from the 1860s onwards, visual pleasure was redefined to target the visual spectacle of woman. Later nineteenth-century painting is characterised by an excess of unseeing female faces, female bodies swathed in or divested of drapery, female figures doing very little other than *looking* beautiful. As Griselda Pollock has argued in her analysis of the most iconic of these forms, they

were produced for and productive of viewing positions for masculinity.[16] The institution of a regime of representation and signification, in which woman is reduced to an explicitly visual sign to represent difference and signify masculinity, would seem to disposses women of vision and pleasure. But this was not the case. In the management of sexuality, femininity was constituted as the locus of the network of *women's* gazes: pleasuring looks and appraising glances were directed to women's visual representations of femininity, whether these were constituted in their dress, appearance and 'personal style' and/or their high cultural images of women. As Lisa Tickner has powerfully shown in relation to the imagery of the women's suffrage movement in the early twentieth century, representations of women were highly debated between women and put to widely divergent uses.[17] In the nineteenth century different categorizations and colliding versions of womanhood were put in play by different constituencies of women. This is not to propose a coherent, homologous women's culture free from discord or disagreement which delighted women equally. Instead, it is to identify specific communities of women drawn together by the proximities of class, culture and friendship, networks of women linked by family, religion, politics or feminism. These circles of elected affinities generated shared meanings which reciprocally connected the participants. In high culture as in the modest practices of civil society women produced and exchanged the visual sign woman, and in so doing they re-signified this sign to generate meanings about women's cultural exchanges and feminine/ feminist pleasures.

The second part of *Painting Women* is concerned with women's high cultural images of women and their contradictory and heterogeneous representations of femininity. The four chapters place women's domestic paintings, portrayals of women workers, rural scenes and historical subjects in their historical contexts, investigating how, what and to whom these pictures of women had meaning. The discussions draw on Elizabeth Cowie's founding analysis of 'woman as sign', feminist theories of sexuality and representation and Michel Foucault's theories of discourse and power, surveillance and visibility, to address the formations of feminine and feminist desires, the production and management of visual pleasures.

7

DIFFERENCE
AND DOMESTICITY

Women artists produced and publicly exhibited numerous depictions of
middle-class women teaching or caring for children, reading, sewing or
sitting thinking at home. Increasingly numerous from the mid-1840s and
quickly classified by critics as a distinct artistic category,[1] these domestic
subjects represented femininity in terms of the social and economic roles of
dependent daughter, wife, mother.[2] Promoting domesticity as the pre-
ferred mode of womanhood, they constituted it as the difference of
femininity. Domestic paintings assisted in the formation of a cohesive and
distinctive middle-class culture in which heterogeneous and contending
groups otherwise distanced by politics, religion, income or geography
commonly subscribed to an ideal of femininity. In addition, domestic
scenes were viewed as catering to specifically middle-class tastes and
markets. Art critics discussed them in terms of morality, one of the key
terms in shaping middle-class identity and in regulating sexual and class
differences.

Domestic femininity was constituted across a range of diverse sites,
variously and contradictorily enunciated from the level of the state which
in 1851 introduced the new category of 'wife' into the census classifications,
to the proliferating literatures specifically addressed to middle-class women
which defined the appropriate and acceptable modes of behaviour, lan-
guage and appearance for a 'lady' – those 'little books' so despised by
egalitarian feminist Bessie Rayner Parkes, 'treating of her special functions
in the social economy, mapping out beforehand her lines of action, and
bringing to bear upon the outlaw the whole weight of public opinion'.[3]
Profound shifts in the definitions of gentility were registered in the declass-
ing of the term 'woman' and the currency of the word 'lady', shorn from its
eighteenth-century aristocratic associations and increasingly used from the
1840s to identify a middle-class femininity ordered around conduct and
appearance rather than given by birth or rank.[4] This redefinition instituted
a particular regime of surveillance and self-scrutiny in which the feminine
body, a discursively constituted category, was now marked as the visible
sign of femininity. Critical writings on art as much as the texts specifically

120

addressed to middle-class women contributed to this management of sex-
uality which was put in play from medicine to education, from social
investigation to high culture. At the same time, domesticity attained its
hegemonic status against other definitions of womanhood; it collided with
and was reworked in relation to middle-class women's bids for vocational
training and professional work. By no means evenly or monolithically
formed, femininity was constantly redefined, articulated with and against
simultaneous definitions of class, race and nation.

From the 1830s onwards, definitions of sexual difference were often
managed through a polarity set up between public and private. While
femininity was assigned to home and family, masculinity by contrast was
apportioned the public world of city streets and urban institutions, admin-
istration, finance and paid productive labour. For the bourgeoisie the
distinction between public and private was perceived in moral terms, home
being imagined as a haven of morality from the rapacity and ruthless
competition of entrepreneurial capitalism, a sanctuary – and the language
was specifically Christian – safeguarded by feminine purity. However, even
in the 1830s and 1840s the social locations of bourgeois women extended
beyond domestic interiors to places of religion, philanthropy and urban
leisure and from the 1860s these were widened to vocational training and
paid employment, charitable and social work, travel and urban consumer-
ism. As definitions of masculinity and femininity changed, sexual differ-
ence was continually put into play and visually codified a wide range of
social practices from the modest activities of daily life to the new traditions
of civil society, the life sciences and in high culture. Domestic paintings
became key sites for the regulation of bourgeois femininity as domesticity
and for the definition of its social spaces, rituals and relations. They
brought marriage and motherhood into public visibility and scrutinised the
class-specific proximities of the bourgeois household.

Victorian modern-life paintings have usually been perceived as docu-
ments of the age, unproblematically recording, absorbing or transcribing a
pre-existent social reality. The most frequently used image of a mirror
neutrally reflecting the past misrepresents the contradictions in the social
formation in which these paintings were made, and the processes through
which meanings were produced for them. Oil painting was a practice of
social representation governed by historically specific codes and produced
and viewed in institutions located in broader fields of power relations. The
visual representation of domesticity and the critical discourses on realism
which emerged at the mid-century were structural to the formation of the
ideological positions in which these pictures were painted and understood
by artists and their clients.

From the early 1850s to the later 1860s the *Art Journal*, which promoted
itself as the authoritative cultural magazine, put forward modern-life paint-
ing as particularly English, claiming domesticity was a national character-

istic. In the 1850s domestic paintings were caught in debates about a national school of painting and their popularity shifted the ground away from history painting which was pre-eminent in the academic hierarchy and celebrated in the 1840s as the locus of a national school. Many of these debates and issues were condensed in the *Art Journal*'s introduction to 'Scenes Domestic – Grave and Gay' in its review of the Royal Academy of 1863:

> England, happy in her homes, and joyous in her hearty cheer, and peaceful in her snug firesides, is equally fortunate in a school of Art sacred to the hallowed relations of domestic life. From the prince to the peasant, from the palace to the cottage, the range in rank is wide; yet the same sentiments – love to God, charity to neighbours, duties of parents and children, sympathy ready to mourn with those who mourn, or to rejoice with those who are glad in heart – these principles and emotions, the outpourings of our universal humanity have found earnest and literal expression through domestic pictures, which, both by their number and mastery, may almost claim to be national. The public at large naturally bring such compositions to the test of their own experience, and they are right in so doing. The most skilled critic, indeed, can scarcely do more; for works of this class are successful just as they awaken a dormant sympathy, just in the measure of response they find within the breast of each one of us, beating to the same pulse of life. The life, indeed, which moves around us and within us is the same life which should live again within these pictorial transcripts.[5]

Art criticism was not simply responsive to individual pictures, but a domain productive of social meanings and definitions, an arena in which different viewpoints struggled for predominance. Critical writings negotiated the heterogeneous positions of the viewing publics for art; they offered, among all the possible readings, preferred readings for works on display. In this passage from the *Art Journal* a specific viewing position for domestic pictures is articulated. The reader is incited to test the 'pictorial transcripts' against personal experience and to respond with sympathy. National unity is invoked through the evocation of a 'universal humanity' which, in transcending social differences, unites prince and pauper. Indeed, an appeal to an unspecified and universal citizen was necessary if modern-life painting was to be a valid contender for the 'national school'. Citizens are therefore addressed around common ideals of home and domesticity, elaborated here with a specifically Christian language in contrast to the predominantly secular nature of official discourse. The audience for high cultural images of domesticity was however patterned in diversity: social, religious and political distinctions were mapped onto and intersected with constructions of sexual difference. Given the substantial

presence of middle-class women as exhibitors and viewers at public exhibitions, how then can the historically specific relations between them and the representation of femininity as domesticity be investigated? Did women spectators see domestic pictures differently? Did women artists represent these scenes in sexually specific ways? Were particular modalities of perception constituted for women viewers in relation to pictures of women and children at home?

In a recent essay Griselda Pollock has proposed an important analysis of the modern-life paintings of Mary Cassatt and Berthe Morisot. Setting aside interpretations of their works as expressions of femininity, reflections of daily life or authentic depictions of women's experience, Griselda Pollock has located the artists and their work within the historical development of Paris as a modern city. She has mapped the spaces of femininity (a term which encompasses psychic as much as social and economic formations) available to and painted by women artists from domestic occasions such as afternoon tea to urban recreation, discussing the ways in which women painters and their representations of bourgeois womanhood were formative of and shaped by the social ordering of sexual difference. This discussion, joined to a reflection on these artists' predilections for pictorial spaces which offered proximity, is linked to a consideration of 'the social spaces from which the representation is made and its reciprocal positionalities'. Griselda Pollock concludes:

> The producer is herself shaped within a spatially orchestrated social structure which is lived at both psychic and social levels The spaces of femininity operated not only at the level of what is represented, the drawing-room or sewing-room. The spaces of femininity are those from which femininity is lived as a positionality in discourse and social practice.[6]

This analysis can be productively put to work in a consideration of the relations between women and modern-life painting in nineteenth-century Britain, where the construction of bourgeois femininity around an ideal of domesticity yielded the perception that domestic subjects were the appropriate forms of art and most gratifying visual artefacts for women. A differencing of the gaze in relation to these subjects was made, for example, in the claim that Henrietta Ward's painting 'God Save the Queen' (plate 14) would 'delight all mothers'.[7] Although critical discourses on modern-life painting proposed an unspecified citizen, these same discourses had a particular resonance of address to middle-class women in their appeal to compare art and life, to set 'pictorial transcripts' beside personal experience. Domestic life and household scenes were specifically designated the province of middle-class women: it was these spectators, located in the feminine, who could bring high cultural representations of domesticity 'to the test of their own experience', that is an experience and

knowledge of domestic spaces which were socially constructed and histori-
cally formed for bourgeois women. Texts such as the *Art Journal* review of
1863 therefore contributed to the manufacture of a viewing position, a
mode of perception for domestic pictures which encouraged, for and in
relation to middle-class women, a reciprocity between the spaces rep-
resented and the spaces from which these representations were made and
viewed. This is not to say that women spectators accepted such an address,
engaged in these comparisons, or agreed to this positionality of viewing
and meaning for the diverse depictions of domesticity offered by women
artists in publicly exhibited pictures. But it is to indicate the historical
production of certain cultural elisions around femininity and to propose the
formation of a specific modality of perception which could assist the
interpellation of women subjects into consensual forms of womanhood and
so sustain domesticity as the difference of femininity.

Middle-class women brought to the viewing of domestic scenes a
jumble of colliding representations drawn from disparate sources; they
lived out and experienced domestic ideology in contradictory, uneven
ways, inflected by age, religion, marital status/spinsterhood, occupation,
geographical location, economic and class status, dis/ability and race. This
heterogeneity was brought to bear in the complex processes of making and
viewing visual texts whose meanings were by no means stable but in
process, and subject to contradictory readings. Meanings were generated
in the relays between production, representation and spectatorship and it
was on this ground that battles to fix the meanings of femininity and
contests over the significations of the sign woman were fought out.

WOMEN ARTISTS AND DOMESTIC FEMININITY

In the intense debates of the 1850s and 1860s over the national school of
painting, cultural production was managed in terms of sexual difference.
Domestic pictures and still life were considered particularly suitable for
women artists:

> It may be that in the more heroic and epic works of art the hand of
> man is best fitted to excel; nevertheless there remain gentle scenes of
> home interest, and domestic care, delineations of refined feeling and
> subtle touches of tender emotion, with which the woman artist is
> eminently entitled to deal.[8]

In the 1850s the growing popularity and separate classification of domestic
paintings coincided with the increasing numbers of professional women
artists contributing to public exhibitions. Pressures were subtly exerted on
women to produce domestic pictures, and critical censorship of certain
subjects as unsuitable, indecorous or over-ambitious 'for a lady' could
influence a woman artist's decision about an exhibited picture circulated

with her name. Unlike women writers, women artists rarely used pseudonyms and reviewers all too readily linked a woman's subject matter with her conduct and appearance, or measured her personal morality by her choice of theme. While such pressures worked at one level to regulate women artists' ambitions, several. painters, such as Henrietta Ward, Rebecca Solomon and Emily Mary Osborn made a successful transition from domestic subjects to historical works. Moreover, domestic subjects by women were drawn into the debates as to whether modern-life paintings were worthy representatives of a national school of art; the languages in which they were discussed drew on and contributed to perceptions of class, race and nation as much as on the formations of sexual difference.

Throughout the period women artists established their careers with paintings portraying middle-class women and children at home; complex social forces made it appropriate and possible for them to produce pictures which contributed substantially to the processes by which marriage and motherhood became the preferred definitions of womanhood. The status of domesticity was not attained by the imposition downwards of a dominant ideology; rather its hegemonic position was secured through and challenged by a range of cultural and social practices including the interventions and representations by women. Women artists engaged with the changing definitions of domesticity in varying and heterogeneous ways, producing pictures which reinforced, negotiated or countered consensual views of bourgeois femininity. From the spaces of femininity they reshaped that social and psychic terrain central to their own identity.

Women artists held contradictory relationships to domesticity. While producing images which presented middle-class women as wives and mothers, women artists themselves did not spend all their time in household management or child-care. Similar disjunctions were inhabited by women writers of etiquette manuals and deportment books who likewise made their livings advocating an ideal of domesticity which ran counter to the organisation of their own working and social lives.[9] Post-structural theories of subjectivity and authorship assist the investigation of the divergences between different registers of femininity, each with their own specificities. According to post-structuralist theory, subjectivity is not a single, fixed, or unitary entity, but discontinuous and fragmentary, historically produced in and by specific discourses. Subjects can take up quite contradictory modes of subjectivity at different times or even at the same moment.[10] Women artists could thus accommodate professional practice, often working from home, while promoting femininity as exclusively dependent and domestic.

Moreover there was no necessary correlation between the artist and the cultural products circulating with her author-name, itself a product of discourse.[11] In the mid-nineteenth century domestic pictures were usually perceived as extensions or personal expressions of the woman artist's

femininity. More recently the figure of the artist has been invoked to posit a coincidence of interests and meanings between the maker and the work. The scholarly and curatorial procedures of art history have been organised around the category of the author, yielding the texts of the monograph, biography and catalogue, seeking to explain the work by the life and the life by the work. But to propose a biographical subject or gendered authorship as the founding cause of the work of art is to erase the complexities of cultural production and the historical polyvalences of visual representation. Publicly exhibited pictures of domestic subjects were produced by spinsters, married women with children, married women without children, women whose lived definitions of domesticity varied widely. There was no causal relation between the woman artist's domestic situation and the kind of pictures she made, no formative link between her home life and her scenes of home. On the contrary, relations between these two different historical registers were manufactured in and by nineteenth-century cultural discourses. Women artists and their diverse picturings of domestic life were shaped by and participated in the historical formations of femininity.

In the 1850s Henrietta Ward became a successful painter of domestic paintings. In later life she recollected that as a young woman she had been counselled in her role of wife/mother by an older acquaintance,

> [Mrs Collins] told me I was very wrong not to make all my child's clothes and give all my time to domestic matters, and that if I did my duty to my husband and home there would be no time to paint.[12]

She noted that although she had been 'foolish enough to take [it] to heart for a time', she quickly repudiated this advice and resumed her professional career. In her reminiscences she attributed her initial focus on mothers and children to her own circumstances, remarking that this 'was surely natural, as all my leisure moments were of necessity spent in looking after and amusing my children'.[13] But what Henrietta Ward portrayed as natural was formed within the codes of decorum surrounding women's art practice and within historically constructed elisions between the woman artist and her art. Female friends, relatives, children and servants were readily available as models. Henrietta Ward's children often modelled for her. Joanna Boyce included her baby daughter Alice in her domestic painting, *Peep-Bo* (plate 25). Jane Bowkett's first Royal Academy exhibit, *Preparing for Dinner* (RA 1861), was painted in her father's house with her sister and the cook as models.[14] Mary Hayllar and her children sat to her sisters, Edith and Jessica Hayllar.[15] Catherine Madox Brown's watercolours of her family included *Thinking* of 1870 portraying her mother Emma sewing.[16] Whereas paid working-class models were often perceived as impure, immoral and unrespectable, a middle-class sitter, especially a friend or family member, was considered to guarantee the purity and

respectability of the image and to provide a suitable target for a respectable woman's gaze – as an artist and as a visitor to a public exhibition.[17] It was therefore especially important in the production of domestic paintings, key arenas for the definition of bourgeois identity, to select models from within the artist's family and household and thus to create a sexually specific coincidence between that sphere of femininity in which the picture was made and the social rituals and relationships which were represented.

Men's paintings of domestic subjects often depicted female members of their own family and household whose presence was indicated by the titles of exhibited pictures such as *Portrait of Florence Cope at Dinner Time* (RA 1852). W.P. Frith tipped reviewers that his wife and child were portrayed in *'When we Devote our Youth to God . . .'* (RA 1852).[18] The power relations in which men's scenes of the bourgeois home were produced and viewed were not equivalent to those surrounding domestic paintings by women. A man's domestic subjects depicted female models whose domesticity was secured by his own professional activity, and he pictured women, children and servants who could be publicly identified as his dependants.

Men's and women's different experiences of the domestic world had effects in relation to their domestic paintings. Although these pictures were interpreted as personal expressions or extensions of a woman artist's femininity, there was a disarticulation between the mode of femininity lived by a woman artist and that version which she represented in her domestic paintings. There was a dislocation between the social spaces of bourgeois femininity represented as the drawing-room, morning room, conservatory or garden temple, the rituals of afternoon tea, card-calling, child-care or the white wedding, and the lived femininity of a woman artist, managing a career, sales and clients as much as a partner, family or household. Women artists made strategic choices to construct their professional careers around the art perceived as particularly appropriate for them. Far from reflecting their own lives, or indeed the lives of the majority of middle-class women, these works actively defined femininity as domesticity and mapped its social terrain as the bourgeois home. They engaged with the profound changes in this version of bourgeois womanhood across five decades and negotiated its contradictions with oppositional images.

'GOD SAVE THE QUEEN' BY HENRIETTA WARD

Motherhood – unmentioned in the histories of conquest and serfdom, wars and treatises, exploration and imperialism – has a history, it has an ideology.

Adrienne Rich, 1977.[19]

'God Save the Queen' (plate 14) depicts a woman seated at an upright

piano teaching two girls and a boy to sing the national anthem.[20] The boy has his trumpet, sword and helmet, the youngest girl holds a doll and the eldest girl rests her hands on her sister's shoulders. The children are portrayed as obedient, affectionate and sexually differentiated. The woman is represented as wife (her wedding band is clearly visible), mother and moral guardian of her children.

'God Save the Queen' was one of numerous written and visual texts which organised women's identity and pleasures around home and family, marriage and motherhood. The titles of Sarah Stickney Ellis's widely circulated and often reprinted books, *The Mothers of England* (1843), *The Daughters of England* (1845) and *The Wives of England* (1846), signalled the key roles for middle-class women. Infant and child-care handbooks written by pious mothers, clergymen and doctors emphasised the special responsibility of middle-class women for the moral education and spiritual welfare of their children, and promoted the home as the most effective locus for the transference of bourgeois morality and culture: the inheritance of property and values was to be guaranteed by the piety and purity of the middle-class woman and the home over which she presided.[21] As Carol Duncan has demonstrated, a new visual representation of motherhood as intimate and loving, even blissful, emerged in the transitions to bourgeois social formations.[22] High culture became a key site for the management of historical shifts around motherhood which came with the rearrangements of sexual difference. The social institution of the family and the visual representation of domesticity became central to the identity of the bourgeoisie, their sense of class difference, their politics of population and their bid for cultural hegemony.

'God Save the Queen' was produced across the intense debates initiated from 1854 about the economic position, social roles and morality of middle-class women which attended the passage of the Matrimonial Causes Act (which permitted divorce by women only in exceptional circumstances) and the unsuccessful campaigns to reform the laws which gave the husband absolute control over his wife's property. Both the legislative event and the legislative failure upheld domesticity and dependency as the preferred forms of womanhood. But the crisis in the patriarchal ordering of feminine sexuality was not resolved, for the speaking-out by women against marriage and the double standard of sexual conduct, along with the emergence of the first organised feminist campaigns, presented unsettling challenges to that order.[23] 'God Save the Queen' was inserted in these debates, inscribing woman's position in the family with that particularity of sexual difference which was only available to a woman artist. In 1857 the *Art Journal* advised its readers that 'God Save the Queen' 'is we presume a composition of family portraiture'.[24] Several years later it apprised its readers that it could

so far reveal the secrets of the artist's home as to announce that the lady presiding at the instrument is Mrs Ward herself, and the youthful choristers are her children, whom she is teaching, like a loyal woman, our grand national anthem.[25]

The painting then could be read as a self-portrait, a picturing by a woman artist of herself as patriotic mother. Circulating with a woman artist's author-name, the painting thus lent considerable weight to the ideology of domestic femininity. But there were contradictory indications. Read as a 'pictorial transcript', as a scene in the life of the woman who was artist, mother and wife, the picture could also be interpreted as part of the bid by women artists to feminise professional identity.

Although Henrietta Ward did not contribute to the imagery of the domestic impact of the Crimean War which filled the exhibitions from 1855 to 1857, 'God Save the Queen' can be positioned in a rising tide of nationalism organised around the person of the monarch.[26] Changes in print technology and the wider distribution of news about public figures and events, together with the elaboration of royal ritual, combined with nineteenth-century discourses on individualism to produce Queen Victoria as the visible sign of the nation and a figure with which her female subjects could identify. After her accession in 1837 the public image of Queen Victoria was reworked from a young queen to a responsible wife partnered by her Consort, the mother of nine children and a royal dynasty. Her appearance – dark-haired, petite, neatly dressed – was offered as a model of femininity on fashion plates and music covers like the one depicted in 'God Save the Queen' and in high culture (plate 23). 'God Save the Queen' therefore condensed a range of meanings around domesticity and nation-hood in its picturing of patriotic mother and loyal children, representing motherhood not only as woman's highest pleasure, but as her national duty, a patriotic act in which she fulfilled her responsibilities to her family, her class, her nation and her Queen.

The favourable reception of pictures such as 'God Save the Queen' was by no means assured. For their supporters these homely scenes were repositories of national character and sentiment; their stylistic detail carried their moral message. For their detractors, however, domestic scenes with their garish colours and high finish were vulgar, 'painful to all well-regulated minds' and unworthy representatives of English art.[27] Most critics commended 'God Save the Queen' when it was shown at the Royal Academy exhibition of 1857. The artist's supporters at the Art Journal contended that 'there are not many better works in the collection'.[28] The Athenaeum considered:

The thing is nothing – only a bit of beauty; a lovely English interior of our own time, with all its accidents of dress, decoration and emotion; a bit of English domestic history.[29]

As we have seen, the *Illustrated London News* posited a viewing position by suggesting that it was 'a picture which will delight all mothers'.[30] The *Spectator*, however, while praising the figures as 'life-like', considered that the whole was 'vulgarised by over-dressing in the lady's figure'.[31] At this date vulgarity had particular resonances in both the literatures of art and about women. According to women's magazines, deportment manuals and art criticism, dress, appearance and conduct indexed degrees of respectability, purity and refinement; vulgarity connoted all those modes of dress and behaviour which were considered inappropriate or indecorous for a 'lady'.[32] For the critic of the *Spectator* the elaborate attire of the female figure in *'God Save the Queen'* was at odds with the neat and modest dress expected of and properly chosen by a respectable woman. This disquiet with the signifiers of respectability and purity registered that profound trouble with the sign woman symptomatic of the mid-century crisis. As the *Spectator* indicated there was no fixed consensus in the bourgeoisie as to what constituted a 'lady'; it was a category in formation, constantly reshaped around distinctions of class, discourses of nation, the challenges of feminism. The very uncertainty of the sign woman and the weight which it carried in cultural politics necessitated its constant production and exchange.

Henrietta Ward's renown depended on the image of woman artist as mother which she consciously created and which was promoted by the *Art Journal* and the *Athenaeum*. Depicting herself, her children and her servants, she exhibited the first of her highly successful domestic scenes, *The Morning Lesson*, portraying a middle-class mother instructing her child, at the Royal Academy of 1855. She followed this with *The Intruders*, in which a child and a kitten invade an elegantly furnished drawing-room, and with *'God Save the Queen'*.[33] Throughout these years she and her husband lived near Windsor, in part to secure royal attention, and in part to assist the preparation of Edward Matthew Ward's two royal commissions. When Queen Victoria visited the Ward's residence she was presented with the delightful spectacle of the woman artist as mother. And having seen and admired and chanced upon some small sketches of the Ward's children, the Queen commanded a study of Princess Beatrice.

By 1857 Henrietta Ward had begun to shift her career in the direction of history painting.[34] In the 1860s scenes of the lives of queens and eminent women were shown at the Royal Academy (plate 38). The elisions between the artist's home life and her scenes of home were no longer in play: critical discourses shifted from the perception of her works as manifestations of her person to the view of them as expositions of her womanly and particularly her maternal sentiments. Art literature continued to argue for a coincidence between the femininity of the artist and her works, and Henrietta Ward's fame as a history painter was secured on these grounds.

PICTURING THE PRIVATE SPHERE

Bringing marriage and motherhood to visibility in the highly public domain of the exhibition room, domestic pictures represented what was often referred to as 'the private sphere'. Scenes of women and children at home also filled middle-class women's albums of watercolours and drawings, along with landscape views sketched in their locality or on holiday.

The amateur practice of art was a sign of bourgeois and aristocratic femininity. It was attended by special social conventions and expectations and produced in conditions which favoured watercolours rather than oils. Mounted into albums or presented in folios, works were displayed at home to an audience of family and friends and occasionally contributed to exhibitions: the presence of titled amateurs such as Louisa, Marchioness of Waterford lent social cachet to the Grosvenor Gallery shows.[35] While amateurs' watercolours and drawings are seemingly direct, they were not transcriptions of life or expressive documents of experience. They were made within current codes of high-cultural representation and shaped by a reciprocity between lived domesticity and its visual representation. Constituted as subjects within the specific terrain of domestic femininity, women amateurs mapped its spaces, rituals and relations as a differentiated positionality in the social order of sexual difference.

From the 1830s women amateurs made drawings of the interiors of the houses in which they lived. The watercolours by Mary Ellen Best, for example, detail the furnishing of the rooms and the activities of their occupants, including the artist herself at work.[36] Charlotte Bosanquet, a spinster who spent her later years staying with her numerous relatives, made studies of the public rooms, usually the library, hall or drawing-room, of their residences (plate 15). One of her sketchbooks was entitled 'The Bosanqueti – a selection of several Mansion Houses, Villas, Parks, Lodges, etc, the principal residences of a distinguished Family with descriptive notes.'[37] These drawings can be located in a recently established tradition of watercolours by professional male artists of the interiors of the residences of titled families and royalty.[38] But in taking up this practice women shifted its class locations and reworked its pictorial conventions. While concerns for matters of interior decoration remained as indicators of the family's wealth, taste and status, there was a particular and novel focus on the inhabitants. At least one in three of Charlotte Bosanquet's interiors show women conversing, sketching, reading, drawing, casting accounts, writing, talking to children, playing music, or depict children playing. This pictorial mapping of femininity and its social terrain as the domestic interior coincided with the recodification of domestic femininity in the 1830s and 1840s as part of the emerging social order of the bourgeoisie. Charlotte Bosanquet's watercolours constitute bourgeois womanhood in relation to an interior world, its kinship and class relations, its pleasures

131

and occasions. Domestic rituals were (and are) historically specific, and as afternoon tea became a social event in the second half of the century it entered visual representation (plates 17 and 22).

There was a reciprocity between these visual representations of bourgeois femininity and the social spaces in which they were made and viewed, a conjunction between the cultural practice of amateur watercolours as a sign of femininity and the imaging of this newly defined version of bourgeois womanhood. Most significantly, these amateur watercolours delineated the social and psychic terrain of domestic femininity before it attained visibility in public exhibitions and galleries from the later 1840s onwards.

In the nineteenth century amateur artists were usually differentiated from professionals on economic grounds; amateurs did not make art for money and their sales were usually for charitable purposes. But more than this, women's amateur practice was characterised by the particular overlaying between visual representations of femininity and the domestic life of women themselves, socially constructed within their positionality in femininity.

Lucette Barker and her sisters were taught to draw by their father Thomas Barker, vicar of Thirkleby in Yorkshire, who also paid for lessons and encouraged visits to private collections and London exhibitions. But he was determined that his daughters should not work for their living. Meeting the family in 1846 the writer Margaret Gatty reported:

> The father paints all day long. He married on £60 per annum. They have only £200 now How they have become so wonderful is a perfect mystery, and the old Pater is very odd and won't allow them to turn their talents to any account Pigheaded and egotistical are the Parents, and pigheaded, though not a bit conceited, are the daughters.[39]

Numerous sketchbooks and albums by the sisters have survived. Leila and Octavia made still-life and botanical studies. Lucette was probably the most prolific, contributing to public exhibitions in the 1850s in her own name.[40] Notations indicate that sketches were redrawn, coloured and worked up into finished watercolours which were then mounted into presentation albums, a process which suggests care, selection and deliberation.

One large album, its cover embossed with Lucette Barker's initials, contains studies of her sisters and women friends made in the 1850s and 1860s, including several of her sister Laura with her son Wycliffe (plate 16).[41] While it seems a direct study taken from life, this watercolour is enmeshed in new ideas about child-rearing: from the 1840s breast-feeding was promoted as the healthy option for the responsible mother. Medical science and high culture brought motherhood into public debate and, as

Lynda Nead has shown, the young mother breast-feeding her baby became a popular subject at the Royal Academy as a secular version of the Madonna.[42] Lucette Barker's watercolour follows the pictorial protocols for this kind of subject: silhouetted against the background, the woman and child are positioned in an intimate and contained closeness. Such similarities between an amateur watercolour and publicly exhibited paintings can be attributed in part to priority, in part to the tuition of amateurs whose copying of 'Old Masters' trained them in high-cultural conventions. The watercolour is accompanied by two pencil studies, one of the baby being bottle-fed. The sheet of paper is textured by a multiplicity of representations and practices which exceeds any unitary image of motherhood or of infant care as breast-feeding. Furthermore this page is included among a variety of drawings of children asleep, accompanied by a nurse, playing with a toy, sketches of women conversing or reading, portraits of friends and kin. Although the drawings are not signed, which makes attribution occasionally difficult, they are often inscribed with the name of a person depicted, a date, an event, a place; that is, they are drawn into a particular frame of viewing and reading. Looking at an album in the drawing-room was a particular social activity, different from viewing works in a public gallery. The drawings and annotations offered subject positions to the various members of the circle of family and friends whose proximity gave them access. Seen in an order not necessarily fixed by the page sequence, these works would have been subject to varying, even contradictory, narratives and interpretations by viewers who positioned themselves in the structures of kinship and friendship in which the drawings were made. As Jane Beckett and Jo Lambert have observed in relation to family photograph albums, the cultural activities of production and viewing were formative in making identities.[43] The social and psychic order of sexual difference was not fixed, but constantly shifting. Social and conversational exchanges around watercolours and drawings depicting scenes familiar to their makers and viewers were among the cultural practices in and by which domestic femininity was formed.

LOCATING THE CITY IN A DOMESTIC FRAME

From the 1830s onwards cities and towns in Britain underwent massive rebuilding and expansion, being transformed into complex social and economic organisations defined and divided by differences of class, gender and race. The shifting patterns of urbanisation demanded a reordering of the relations of power/knowledge: the city was constituted as a discursive category in the new knowledges of those groups within the bourgeoisie who struggled for control over the urban environment and its inhabitants. Metropolitan agencies, professional experts, improving employers and investigative journalists constituted the city as a field for surveillance,

intervention and regulation. Across a range of texts the territories of the city were brought to visibility, their populations specified, their inhabitants differentiated and categorised. Registers of knowledge were compiled and cross-referenced and a moral topography was produced through the overlaying of all these various delineations of public health, public order, income levels, occupations and morality. Working-class areas were located at the intersections of the mappings of crime, infection, high mortality, poverty, prostitution, and political unrest which frequently coincided with the older, undeveloped and unimproved areas of the inner city.[44] In diametric contrast, the suburbs – those constellations of purpose-built bourgeois dwellings and gardens – were characterised as the locus of health, morality, order, lawfulness and prosperity. The prevailing image of the bourgeois home as 'the place of Peace; the shelter, not only from all injury, but from all terror, doubt, and division . . . a sacred place, a vestal temple',[45] was fabricated in the bricks and mortar of surburban developments separated, materially and ideologically, from working-class areas.[46] The moral topography of the city was constantly repatterned by class struggles and shaped by the social ordering of sexual difference. Masculine and feminine identities were mapped in relation to different areas of the city: while the city streets were defined as the terrain of masculinity, they were also traversed by working-class women. In diametric opposition, bourgeois femininity was assigned to the family home. But as Lynne Walker has demonstrated, the 1860s witnessed a major redrawing of urban territories as middle-class women increasingly visited theatres, concert halls, parks, galleries and museums, studied at art schools, frequented restaurants, shops, hotels, tea-shops and public libraries, attended meetings of civic committees and women's organisations and walked across the city.[47]

Visual representation was an important arena for the codification of urban space. City plans, schematised transport routes, maps of the social investigators, along with high cultural images of buildings, streets, markets and parks, managed careful distinctions of urban terrains for their publics, specifying those areas in and against which the bourgeoisie positioned themselves. In some images two contrasting zones were brought into direct conjunction. Jane Bowkett's *Preparing Tea* (plate 17) was produced at the intersection of the discourses on domestic femininity and the moral topography of the city. Seen through the window of an interior in which a woman and children are making tea, the city is placed in a domestic frame.

Preparing Tea portrays a woman standing at a tea-table by a window; one child toasts bread by the fire, another brings a pair of men's slippers. A tabby cat sits on a foot-stool by an empty chair. China and silver gleam on the table. The room is ordered, its inhabitants neatly and modestly dressed. The visual signs of the painting constitute the woman as responsible wife and mother and the children as dutiful daughters. Their activity

is centred round the tea-table and the fireside, two of the most prevalent signs of domestic felicity in the 1860s. Not only did art criticism proclaim the Englishness of 'snug firesides', but for many hearth was synonymous with home and home was 'a temple of the hearth'.[48]

The contrast between the room with its landscape painting and the view out of the window to a distant city and approaching train, works with the slippers, empty chair and depiction of the preparations for tea to suggest a narrative reading around the imminent arrival of a father/husband. The composition organises clearly demarcated spaces and identities for masculinity and femininity: femininity is pictorialised as domesticity, dependence and familial service whereas masculinity is outside the home and at the same time the pivot for its social activities and kinship relations.

This articulation of sexual difference through the visual contrast of interior and exterior is managed in several paintings by Jane Bowkett in the 1860s. In *Looking out for Father* a woman and two children sit beside a tea-table looking out over a cityscape of spires, rooftops and buildings.[49] The woman's dress and the sparsely furnished interior in which a shelf balances precariously and a cat sits by an empty plate do not connote solid bourgeois comfort, prosperity or order. Domestic paintings represented and addressed heterogeneous groups in the middle classes, renegotiating respectability across boundaries of class. Women's picturings of the spaces and rituals of the home do not exhibit any uniformity of subject matter or perspective. Rather, across a diversity of imagery, a wide range of domestic pleasures, situations and occasions are offered from mothering and child-care to teaching, taking tea or reading, from solitude to company, from a household headed by an absent husband to a home shared by two women or the residence of a spinster.

CONTRADICTIONS

Domesticity was not a unitary category but rather a mode of femininity which was constantly changing as contending versions were put in play. Domestic subjects by a woman artist did not necessarily show any consistency in approach. Jane Bowkett's varied from *Valuable Assistance* depicting a woman teaching a child to sew, to *A Young Lady in a Conservatory* showing a fashionably dressed woman idling away her time tending flowers.[50]

An Afternoon in the Nursery, in which a woman is reading by a window open to a view of the south coast[51] while two children make mayhem behind her, is an intriguing painting (plate 18). As it is not possible to see whether the woman has a wedding band, it is not clear whether she is the children's mother or perhaps a female relation; the absence of black mourning dress, one of the visual signs of the governess, prevents an identification as the children's neglectful teacher.[52] The portrayal of the

woman does not draw on the pictorial conventions for the novel reader, a popular subject in the 1850s in which a single figure reclined on a sofa or coyly regarded the spectator. What is striking here is the woman's complete lack of interest in the children's antics. In its delineation of a woman's absorption and pleasure in reading, *An Afternoon in the Nursery* countered contemporary recommendations voiced by Ruskin that a woman should be 'wise, not for self-development but for self-renunciation'.[53] It contests definitions of domesticity in which a neat roon and well-behaved children connoted well-regulated femininity. *An Afternoon in the Nursery* seems therefore to counter hegemonic forms of femininity, to be produced, as it were, against the grain of that litany of advice in manuals, novels, women's magazines, sermons, a textual web which was densely patterned in contradictions. While consensus could cohere around the figure of the dutiful wife/mother, this version of femininity only achieved hegemonic status against a number of competing definitions.

In 1858 Margaret Tekusch exhibited *The Wife* 'in which a dainty young matron, habited in the costume of the last century, sits copying law papers for her husband, while with the left hand she amuses her baby in its cradle'.[54] Significantly this painting was shown at the second exhibition of the Society of Female Artists, the first occasion on which artists were invited to produce work for this venue. *The Wife* contributed to current feminist debates on women, work and motherhood. As early as 1851 Harriet Taylor had publicly attacked the patriarchal construction of motherhood as an exclusive, all-absorbing activity debarring women from paid work.[55] These ideas were reworked in the writings of Bessie Rayner Parkes and Barbara Bodichon, in the campaigns for the reform of the Married Women's Property Acts from 1854 to 1857 and in the pages of the *English Woman's Journal* from 1858. Positive action was taken in 1859 with the setting up of the Society for the Promotion of the Employment of Women and an office for the copying of law documents.[56] *The Wife* was therefore strategically inserted into contemporary feminist campaigns, creating an historical precedent with its image of a working wife and mother. Margaret Tekusch was certainly connected to feminist circles; a friend of Eliza Fox, she was a signatory of the 1859 Royal Academy petition.[57]

Nearly twenty years later Louise Jopling contributed *Weary Waiting* to the Royal Academy exhibition of 1877 (plate 19). From the small watercolour on the table of a ship immured in the ice, contemporaries interpreted *Weary Waiting* as portraying 'the mother and child of an Arctic explorer'.[58] Unlike her painting *Good Night* of 1886,[59] *Weary Waiting* does not represent the maternal relationship as a source of delight; nor is wifely dependence depicted as gratifying. As in Annie Swynnerton's portrait of Susan Dacre of 1880 (plate 8) this break with hegemonic forms of femininity is matched with a break with the visual codes for its representation: the

feminine body is not fashioned into a stylish hourglass or decorated with elaborate trimmings. This analysis is not to fix a single meaning to *Weary Waiting* or *An Afternoon in the Nursery* but to argue for the instability and deferral of meanings and the strategies of resistance and contradiction in the social ordering of power which were played out in visual representation. Visual culture participated in the struggles to fix the definitions of femininity, in the collisions over the signification of woman.

Domestic femininity was, and has been, consensually defined around marriage, motherhood and the family; but domestic life also was organised in the partnerships, kinship relations and friendships between women and by single women living alone. There are numerous works by women artists depicting women together in a domestic context from the sketches in watercolour albums to publicly exhibited pictures such as Margaret Carpenter's *The Sisters* of 1839, a portrait of her two daughters, or Emily Mary Osborn's *For the Last Time* of 1864, portraying two women in deep mourning pausing in a hallway.[60] In Maud Hall Neale's *Two Women in an Aesthetic Interior* (plate 20) one woman plays the piano while the other listens in a room that is furnished with pictures of women, 'Liberty' prints, pot plants, a lily and a sunflower.[61] Such depictions marked out the spaces and rituals of women's friendships, differing profoundly from that repertory of simpering beauties which graced the keepsake albums and public exhibitions with titles such as *The Sisters*.[62] In their oppositional works, women artists wrenched woman's image away from the circuits of masculine desire and recast the sign woman in the exchanges and meanings of women's networks, rituals and pleasures. Alice Walker's *Wounded Feelings*, exhibited in 1862, addressed women's friendships (plate 21). In a distant room where couples have congregated, a seated woman glances up over her fan at an officer, a more respectable form of masculinity after the Crimean War. Clearly differentiated by dress, pose and gesture, masculinity and femininity are bound together in the circuits of desire and sexuality. By contrast two women meet in a dark hallway. One has thrown down her glove and fan, discarding those indices of flirtation and competition whose use in captivating or discouraging a suitor was discussed in numerous etiquette manuals.[63] She is comforted by a woman friend whose cross connotes Christian sympathy. The picture thus foregrounds the strength and support of women's friendships, marking them off from the cycle of courtship and marriage. In the painting and in the practices of viewing it, woman as sign was visibly produced and exchanged between women.

The challenge of these oppositional images lies partly in their portrayal of the spinster, a figure who was represented in subject paintings such as Florence Claxton's *Scenes in the Life of an Old Maid* shown at the Society of Female Artists in 1859, and in portraits such as that of Lydia Becker (plate 47). While the spinster gained increasing status in the women's

movement and feminist writing from the 1880s onwards, this mode of independent femininity (inhabited by many women artists) did not dislodge the high cultural predominance of marriage and motherhood in the closing decades of the century.

DOMESTIC RITUAL AND THE 'NEW IMPERIALISM'

Edith Hayllar and Jessica Hayllar were among the many women artists who specialised in domestic pictures in the 1880s and 1890s. Their paintings generally portrayed women and/or children taking tea, conversing, playing music, studying, arranging flowers in a spacious interior, garden temple, or boathouse. Edith Hayllar's *A Summer Shower* (RA 1883) and Mary Hayllar's *The Lawn Tennis Season* of 1881 depict mixed tennis parties while a few pictures by Edith Hayllar show men at lunch or a shooting party.[64] It has been claimed that these 'canvasses document the family home [Castle Priory, Wallingford] as well as its daily life',[65] a view which obscures the ways in which these paintings contributed to the organisation and regulation of sexual difference in the later nineteenth century.

Edith Hayllar and Jessica Hayllar were highly prolific artists, producing far more than the one or two works accepted for Royal Academy exhibitions. In their small, highly finished pictures motifs, poses, figures, details, accessories and settings were persistently repeated. It was in this process of continual reiteration and variation that a regime of representation was constructed to define the social spaces and rituals of femininity within the sexually differentiated terrain of the bourgeois residence. Their works contributed to the processes in and by which domestic femininity was maintained as a predominant form against the pressures of economic and social transformation and the challenges of feminism. The occasional paintings portraying one of the sisters at work do not fracture this regime of representation but rather contain women's art practice within the domestic interior (plate 7).

Edith Hayllar's *Feeding the Swans* of 1889 sets out the formation of femininity in the middle-class family in which women were positioned as wife, mother, daughter, sister, grandmother, female cousin or aunt, kinship positions which differentiated women and girls from men and boys (plate 22). On the setting of the riverside steps of a garden pavilion, graduated stages in femininity are marked out from youth to old age, each one signalled by dress and activity. The composition arranges a rising progression from girlhood to courtship, motherhood and widowhood.

In the later 1880s Jessica Hayllar produced four paintings which addressed the transitions of femininity. *A Coming Event* (RA 1886) intimates a forthcoming marriage; *Fresh from the Font* (RA 1887) portrays three women admiring a baby; in *The Return from Confirmation* (RA 1888) a young girl is greeted by an older woman.[66] Christian ritual, bourgeois

social customs and nationalism were intricately woven together in the last painting of the series, *Fresh from the Altar* (RA 1890) (plate 23). Here the bride is met by an older woman beneath an engraving of the coronation of Queen Victoria.[67]

In the later nineteenth century bourgeois social rituals around femininity were highly elaborate with specific codes of dress and deportment. The formal ceremony of afternoon tea, pictured in many paintings by Edith Hayllar and Jessica Hayllar, now merited its own section in revised editions of Mrs Beeton's *Household Management*.[68] New traditions such as the white wedding were referenced in two of Jessica Hayllar's series. By the later decades of the century, brides frequently wore white or cream which, along with matching accessories of lace veiling, pale-coloured shoes and sprays of orange blossom, signified the purity and virginity of the woman at the threshold of marriage. Customs of dressing the bridesmaids in white, showering the bride with rice, playing Mendelssohn's 'Wedding March', cutting the cake, and the wedding breakfast turned the wedding into an elaborate and expensive spectacle. As much a part of the renewed imperialism of the period as the invented traditions of monarchy,[69] this lavish celebration of marriage coincided with and depended on global relations of colonial production and consumption, and the meanings of feminine purity invested in these rituals were part of the rearticulations of race and racial purity in imperialist discourses.

Paintings by Edith Hayllar and Jessica Hayllar represented a closed and contained world, in which kinship, family and domestic ritual signify social order. Drawing on the analysis of Rosemary Hennessy and Rajeswari Mohan, the paintings can be located within the strategies for containing a crisis in the regulation of feminine sexuality in a period of heightened imperialism. In 'The construction of woman in three popular texts of empire',[70] the authors characterise the ways in which discourses of alterity were rearticulated to contain a crisis in the patriarchal arrangements of femininity, sexuality and the family. Legislation enacted in Britain and India between 1882 and 1885 managed the contradictions between women as property and women as property owners precipitated by the increasing numbers of women in work. Across multiple points of discourse and social practice, feminine sexuality was organised on a global axis of racial difference, polarising the white woman as 'mother of the race' against the colonised Black woman. As Rosemary Hennessy and Rajeswari Mohan argue:

> Reading changes in the construction of the feminine subject in terms of the global relations of Empire, as they functioned in Britain and India in the 1880s and 1890s, explains the sexualisation of women in Britain and the colonies as mutually dependent.[71]

Later nineteenth-century reorganisations of global relations provoked an

increased categorisation of sexuality and intensification in the policing of sexualities, especially those which were classified as deviant, abnormal, inverted or perverse, against those which were legitimated as normative. As the social formation was shattered and imperial hegemony threatened by a series of structural contradictions, discourses of alterity were rearticulated to secure a new social order. High culture was a powerful site for these redefinitions. In representing woman as wife/mother, *Fresh from the Altar* and *Feeding the Swans* participated in the containment of the perceived crisis in the social organisation of alterity brought about by women's paid employment, feminist 'speaking out' against masculine sexuality and marriage, nationalist struggles in the colonies and the rise of socialism.[72] In their delineation of femininity within the sexually differentiated structures of the family and the social spaces and rituals of the bourgeois household, paintings by Edith Hayllar and Jessica Hayllar represented femininity as domesticity and constituted domesticity as *the* difference of femininity.

8

WORKING WOMEN

VISIBILITY AND THE POWER OVER LIFE

Wearied as some of us are with the incessant repetition of the dreary story of spirit-broken governesses and starving needlewomen, we rarely obtain a glimpse of the full breadth of the area of female labour in Great Britain.[1]

Writing in 1859, Harriet Martineau noted the particular limitations on the representation of women's work in public discourse. Similar constraints regulated the domain of high culture. From the 1840s to the 1890s women artists exhibited numerous paintings of needlewomen, teachers, servants or flower-sellers, and more rarely artists' models, theatrical performers, prostitutes or factory workers. Analysis of these images engages a rereading of the writings of Michel Foucault to interrogate the matrix of power/knowledge/pleasure which framed the visual representation of working women. Far from being pictorial transcripts of women's working lives and experiences, these high-cultural productions were made and viewed within historically specific intersections of race, class and sexual difference.

In *Surveiller et punir* and *La volonté de savoir* Foucault analysed the formation of new modalities of power over life which shaped the social formations of the nineteenth century.[2] Directed to individuals and to the population as a whole, this power was dispersed in the life sciences, medicine, education, the organisation of workplaces and the social institution of the family. It was, Foucault argued, not repressive but productive, 'bent on generating forces, making them grow, and ordering them, rather than one dedicated to impeding them, making them submit, or destroying them'.[3] Discourses on sexuality became the matrix for this calculated management of life, the meeting-point for discourses on the individual body and the social body:

the mechanisms of power are addressed to the body, to life, to what causes it to proliferate, to what reinforces the species, its stamina, its

141

ability to dominate, or its capacity for being used. Through the themes of health, progeny, race, the future of the species, the vitality of the social body, power spoke *of* sexuality and *to* sexuality.[4]

The microtechniques of this power over life were the surveillance and examination of individuals and their classification within the population. Setting aside humanism's claim for essential individuality, Foucault demonstrated the ways in which the individual was constituted in and by discourses and institutional practices. Knowledge about the individual was, he contended, central to the workings of power.

> For a long time ordinary individuality – the everyday individuality of everybody – remained beneath the threshold of description The chronicle of a man, the account of his life, his historiography, written as he lived out his life formed part of the rituals of his power. The disciplinary methods reversed this relation, lowered the threshold of describable individuality and made this description a means of control and a method of domination. It is no longer a monument for future memory, but a document for possible use.[5]

In crossing the threshold of visibility, in becoming observed and classifiable, individuals were subjected to, and became subjects of, disciplinary power. 'In discipline, it is the subjects who have to be seen. Their visibility assures the hold of the power that is exercised over them.'[6] It is this address to visibility in the strategic field of power relations which has made Foucault's work of such profound interest to historians of visual culture.

Analysis of Foucault's writings necessarily goes beyond Foucault, for whom discourses on sexual and racial difference did not traverse the workings of power/knowledge or generate formations of resistance. Feminist historians have prioritised sexual difference. Lucy Bland has set out the historical construction of feminine sexuality around an opposition between pure and fallen, often managed on class lines.[7] While not prioritising class, Foucualt argued that the power over life was integral to the workings of capitalism, optimising (that is, putting to the most productive, profitable use) the capacities of the workforce, producing 'docile bodies' whose utility was to be maximised in partitioned spaces and 'profitable durations' of time. This power over life was therefore 'without question, an indispensable element in the development of capitalism', inserting and distributing bodies into the machinery of production.[8] But Foucault did not take account of the varying ways in which these processes were structured by and resisted on the axes of sexual difference and racial difference. The placement of the feminine body – itself a discursively constituted category[9] – into capitalist production was highly contested from the 1840s onwards. One debate focused on hours of work: reformists, manufacturers and women workers by no means agreed on 'profitable durations'. But the

main struggle was over women's work itself; fought out over the feminine body, it was as much concerned with race as with sexuality. Discourses on domesticity and motherhood which intensified in the 1840s and the 1880s positioned women outside paid labour and in the home, a social terrain defined against the workplace. To their opponents, loose alliances of reformists, working women signified social disorder: 'filth, destitution and disease', improvidence, intemperance, crime and delinquency were all claimed as the characteristics of the families, homes and husbands of working women.[10] The reformists represented the woman worker as chronically ill and mentally exhausted, an unfit mother, a polluter of the race, a prostitute. In the early 1840s parliamentary reports on children's employment obsessively detailed bodily and especially gynaecological disorders while lamenting 'the fatal influence on morals and domestic habits'.[11] And, as Angela John has shown, forty years later the pitbrow women were vilified as unfit mothers who endangered the future of the race.[12] Dysfunctions of the feminine body were thus perceived as indices of a widespread social chaos.

It was not just that, as Foucault contended, the hysterisation of women's bodies was a strategy in the deployment of sexuality. Rather the whole 'politics of population' was founded on the discursive constructions of the feminine body and the specifications of its usefulness as its reproductive capacity. With the assignment of the feminine body to motherhood and wifehood, feminine sexuality was regulated to legitimate reproduction in marriage. It was on these grounds that women were disqualified and excluded from paid labour. For the reformists, women's work and prostitution (which they viewed as causally linked) represented an unrestrained feminine sexuality in an unregulated body, subject neither to the power over life or to patriarchal kinship.

Definitions of femininity and women's work were traversed by discourses on race. Throughout the period 1840 to 1900 motherhood was articulated in relation to race and imperialism, but from the 1880s onwards white women of all social classes were increasingly targeted as the mothers of the race and globally polarised against colonised Black women. In the later nineteenth century when imperialist discourses were concerned to optimise the reproductive capacities of the white feminine body within marriage, white women workers and Black women were posited as twin threats to imperial hegemony.[13] Black women's access to paid labour and their placement in global capitalism were structured by uneven tensions between race, sex and class. Ziggi Alexander has drawn attention to the racism encountered by the doctress Mary Seacole, debarred from army nursing in the 1850s by white bourgeois women whose stake in this new profession was secured by their exclusion of several experienced and highly skilled Black women.[14] According to the historian Rozina Visram, Asian women in Britain worked chiefly as nursemaids and the massive surveil-

lance networks which bypassed domestic servants rarely targeted the ayahs.[15]

The centrality of the optimised feminine body in the politics of population helps to explain some of the concerns of the texts on working women. Definitions of bourgeois women as mothers collided with middle-class women's claims for space in the labour market and in the new professions. Paintings of the governess coincided with a high point in these debates in the 1840s and 1850s. But while the teacher remained a recurring image of the middle-class working woman, pictured in the later decades in Elizabeth Forbes's *School is Out* of 1889 (plate 36), the newer identities of factory inspector, trades union organiser, social worker or clerical worker seem to have been disregarded in visual culture.[16] Two works sent from Britain to the Woman's Building at the World's Columbian Exposition in Chicago in 1893 indicate the tensions between high cultural representation and changing definitions of womanhood. Annie Swynnerton's major contribution of a depiction of Florence Nightingale at Scutari Hospital was flanked by pictures of a mother with her child and a young woman caring for an older woman. The whole comprised a 'threefold presentation of woman's great duty and prerogative, the care of the weak and the helpless'.[17] Anna Lea Merritt's image of women graduates accompanied her much larger *Needlework* which showed graceful ladies at embroidery frames.[18] Here as elsewhere in the Woman's Building women's work was interpreted as an extension of the refinement and charitable activities ascribed to bourgeois femininity.

High-cultural images of working-class women formed an integral part of the systematic acquisition of knowledge on individuals and social groups by investigative journalism, social work, state commissions and colonial administration. Women artists were among the new constituency of professional experts who collected information on working-class women, who brought them to visibility and to categorisation: the sketchbook page, the framed canvas, the illustration in a publication on social investigation extracted the solitary figure from the multitude and offered it up to perusal and examination. In fine art, as in the social sciences, the processes of individuation fragmented the urban crowd, dispersed the multitudes of the labouring poor and dispelled the mass of the residuum. Discursive categories transformed the population into easily recognisable individuals, classified according to their work and productivity: the seamstress, the prostitute, the servant, the factory girl, the flower-seller. Neither myths nor stereotypes, these categories were constituted in and by discourses.

Paintings of working women became intelligible to their publics within the inter-textualities of the discursive category, through specific modalities of perception and through narrative readings. Critical writings which wove stories around the painted figures had much in common with the characterisations of narrative fiction, and they shared the linearity of the case

histories introduced in medicine, investigative journalism, official inquiries, philanthropic reports and social work. And like these disciplines, high culture, along with travel writing and tourist literatures, offered vicarious excursions to urban territories and rural terrains beyond the social spaces of their consumers, journeys which could be made without leaving the suburban villa, the terraced house, the club smoking-room, the exhibition gallery. Seeing and knowing informed 'the pleasure that comes of exercising a power that questions, monitors, watches, spies, searches out, palpates, brings to light'.[19] And with the pleasures of high culture, premised on decoding the details, extrapolating the life-stories, came subject positions. Subjectivities were formed in recognising the differences between viewer/reader and delineated individual. Distinct repertories of visual signs demarked the named individual of the bourgeoisie (the sitter in a portrait, the artist) from the solitary figure of the discursive category who was individuated but not individualised. Cultural consumption was thus not passive reception but an active process of viewing, of making sense and ascribing meanings.

Massive debates attended the high-cultural representation of working women. There was little consensus on whether they provided suitable subjects for art. At the mid-century the picturing of working-class figures was facilitated by critical writings on art's power to convey morality and elicit compassion in the spirit of philanthropy.[20] Morality, a key term in cohering the disparate groups of the bourgeoisie, drew modern-life painting into mid-century reformism. Morality was also a central term in the self-definition of bourgeois women who invoked feminine purity in support of their philanthropic activities, in particular 'woman's mission' to the poor and the fallen. In the 1850s, peak years of their charitable work[21] and the decade in which discourses on morality in art were predominant, the philanthropic gaze shaped a field of vision and power for middle-class women.

But while the growth of institutional charity and the art profession augmented middle-class women's activities, they also extended their social disciplining and class surveillance. Power/knowledge was invested in their paintings of working women and their pictures of philanthropy. In Anna Blunden's *An Episode from Uncle Tom's Cabin* (1853) and her *A Sister of Mercy* (RA 1856), in Rebecca Solomon's *A Friend in Need* (RA 1856) and *A Young Teacher* (plate 26), the purity of a white female figure is constituted in a hierarchically ordered difference to a Black child, a poor dying woman, an outcast mother and an Asian nursemaid.[22]

This philanthrophic vision was one of the factors shaping the presences and absences of working-class women in high culture. The subject matter of women artists was informed by the social and psychic terrains of femininity and extended by charity work in the 1850s. But more than this, philanthropy offered a structured perception of social relations while

providing a model of bourgeois femininity as active in the social field. Thus the sufferings of the poor became an acceptable and appropriate subject for a publicly exhibited picture by a respectable middle-class woman.

Women artists' repertory was not greatly extended by the changes in women's work in the later decades of the century. Seamstresses, lace-makers and flower-sellers appeared from the 1850s to the 1890s.[23] This limited range was varied by infrequent portrayals of the surface workers in the Cornish tin mines as in Emily Mary Osborn's *The Bal Maidens* or theatrical artistes as in Mary Ellen Edwards's *Sweet Success* (RA 1873).[24] Women factory workers were occasionally depicted as in Eliza Fox's *Study of a Factory Child* (RA 1850) or Annie Swynnerton's *The Factory Girl's Tryst* (RA 1881). The massive increase in images of rural women from the 1880s, discussed in chapter 9, occurred across a period of profound trans-formations in British agriculture and major changes in the perceptions of the relations between town and country.

DOMESTIC SERVANTS

Working-class women carried out the labour-intensive work of bourgeois households – bedmaking, laying fires, cooking, cleaning, washing, slopping out, carrying coal and water, washing up. Visual images of the middle-class home as a place of order and comfort registered their often invisible work and long hours. Throughout the period domestic service was the largest occupation for women who worked as general servants, housemaids, hou-sekeepers, cooks, nursemaids, lady's maids.

The labour of these women was indispensable to women artists. While they produced pictures, servants maintained the interiors of the household and serviced its occupants. In the 1850s Henrietta Ward, a prolific pro-fessional painter, employed a governess and two nurses for her children, as well as several servants.[25] The numbers of servants employed, as well as the gradations between them, indexed an employer's social status and depended upon her earning capacity. When Jane Bowkett lived in Gravesend her extensive family, which included three children, her hus-band, his parents and his sister, was serviced by two women servants: Ellen Wright, 19 years old, and Emma Dibbings, 49. Ten years later, with a move to fashionable Kensington, renowned for its large residences and extensive retinues of servants, a smaller family comprising the artist, her husband and their two sons engaged three women: Emma Dollins, aged 50, and Charlotte and Fanny Allen, aged 22 and 20.[26]

By the 1880s most London servants were not born in the capital but, like Charlotte and Fanny Allen, migrated to their place of work, leaving behind kin, family and friends. Surviving testimony indicates the pain of these separations.[27] In service in the bourgeois household they were lifted out of their own class and culture and 'made over' into servants. Servants were

expected to speak nicely or remain silent, answer to a servant's name, dress neatly or wear a uniform, attend family prayers, church or chapel and behave deferentially. The relations between women servants and employers were structured in the broader hierarchies of class and race; proximities of daily contact were shaped by complex tensions. Class relations were uneven; servants' resistances and refusals disrupted domestic rituals and fractured class disciplining. Margaret Forster's recent novel *Lady's Maid* has skilfully fictionalised the conflicts of desire for Elizabeth Wilson who worked as 'Wilson' for Elizabeth Barrett Browning and was known as Lily by her family and friends.[28] Naming was but one practice of representation. At the level of visual culture female servants were invaluable models for women artists.[29] Many of their publicly exhibited pictures of cooks, nursemaids or housemaids were studied from women working in their own households. In the 1850s Henrietta Ward's thriving practice was founded on domestic genre paintings which often included nursemaids. *'God Save the Queen'* depicts a nursemaid on the stairs attending to a younger child (plate 14). *The Bath* (SFA 1858) depicted a nursemaid with two boys, while *Sunny Hours* (SFA 1860) showed 'a small group of children with their nursè'. In *The First Step in Life* (RA 1860) a nurse helps a child to walk, watched by its parents.[30] Joanna Boyce's *Peep-Bo* (RA 186l) (plate 25) portrays a woman servant holding a baby while its mother plays at hiding behind a curtain. Paintings such as these negotiated a central contradiction in bourgeois notions of working-class women. Imaged as healthy and strong, often powerful in physique, they were also regarded as morally polluting. In all these images the physical well-being of the child is assigned to the nursemaid who bathes the children and bodily supports them, while moral welfare is apportioned to the middle-class mother. This distinction was maintained by the numerous manuals advising middle-class women of the importance of a mother's moral influence and by the numerous high art images depicting mothers instructing their children, from Henrietta Ward's *The Morning Lesson* of 1855 to Jessica Hayllar's *Morning Lessons* of 1893.[31] In watercolour albums, as in a drawing of a nursemaid and child by Lucette Barker, carefully mounted into a presentation album, this division was not so strictly encoded (plate 24). But an inscription beneath this drawing anchors the power relations in which this woman servant was positioned in the household and in which her image was perceived by those who glanced at this album as part of the amusements of the drawing-room and the rituals of polite society. The inscription reads 'Lavender Sweep, Wycliffe and "Liebe Nurse" '.[32] In the written and visual text the woman is represented simply as a servant: unnamed, she is known only by what was probably the child's designation.

Augusta Wells filled several sketchbooks with drawings of women servants in which a pencil outline carefully describes the woman, her activity and its processes. In one a woman, her head bent down, stretches forward

to clean a large plate; a clutter of small dishes lies on the table, a row of clean platters fills the shelf on the wall beside her. She is neatly dressed, with cap and capacious apron and rolled-up sleeves. As in Joanna Boyce's oil sketch of a woman servant descending the stairs carrying a large platter,[33] women's labour is made visible and rendered with seriousness and dignity. But these sketches and drawings are not social documents which reveal hidden aspects of private lives. All the visual signs of pose, dress, gesture, setting and activity codify these woman as servants. They are presented as neat, clean and industrious, as having precisely those qualities advocated in household manuals and servants' instruction books. Everything about these women from their dress to the places they work – the scullery or back stairs – specifies their difference from the middle-class women who pictured them.

Class differences were written on to the feminine body. Servants were depicted with cap and apron, rolled-up sleeves, a sturdy physique and broad hands. While housework and frequent immersion in water and caustic chemicals undoubtedly roughened women's hands, the visual signs of the servant were produced and perceived in contrast to those denoting a lady – tapering hands, tailored gloves, white, unmarked skin, petite figure. In manuals such as Isabella Beeton's *Household Management* a servant's appearance is discussed in relation to her duties and status in the household. The housekeeper, 'clean in her person and her hands', was differentiated from the kitchen maid whose hands were all too often 'coarse and chapped' and the general servant whose 'hands are not always in a condition to handle delicate ornaments', and whose clothes are marked by 'the blacks and dirt on servants' dresses (which at all times is impossible to help)'.[34] Vignettes show neatly dressed servants busy at work. A well-ordered household with efficient, tidily dressed servants signified well-regulated middle-class femininity, and this sign was produced and exchanged between bourgeois women in household manuals, domestic rituals and in high culture. Moreover it was across these sites that the social disciplining of the large working population of domestic servants, not subject to journalistic or official inquiries, was largely conducted.

Feminist historians researching Hannah Cullwick have addressed the complex terrain of the representation of working-class women. While Leonore Davidoff has argued that visual images of the female servant with large hands, bare arms, rolled-up sleeves, a cap and apron and even household brushes could trigger a highly sexualised masculine desire which was sustained by cross-class heterosexual relations, Heather Dawkins has discussed the ways in which Hannah Cullwick – in her diaries and in the photographs which she commissioned of herself – fashioned an image which functioned not only as a sign of masculine desire but which, in deploying the same repertory of visual signs, signified her physical strength, her skills in housework and her endurance.[35] Hannah Cullwick acquired a precise

awareness of the codes and signs of the servant, knowing when and where and to whom bare arms and dirty hands were unacceptable.[36] What is evident therefore is the polyvalency of the visual signs of the servant. Bare arms, cap and apron, rolled-up sleeves could be invested by different spectators with conflicting and sexually differenced meanings and desires.

The representation of servants in art was highly contested. In some instances, as in *'God Save the Queen'* (plate 14), the visual presence of the nursemaid was simply not registered in reviews which constituted the middle-class mother and children as the subject of the painting. Elsewhere women artists were censured for depicting servants, and Joanna Boyce's *Our Housemaid* (RA 1857) was derided as 'a trifle for a *lady* like Miss Boyce'.[37] Class antagonism traversed the *Athenaeum*'s criticism of *Peep-Bo* (RA 1861) (plate 25):

> No doubt the servant-girl's face is excellent as a portrait, and so interesting to her acquaintances and friends; but without desiring invariable beauty in pictures, we do feel objection to sheer ugliness as not desirable in Art. Her hands are large beyond natural require-ments or the habit of labour.[38]

Here the bourgeoisie are constituted as the exclusive subjects and viewers of high culture and they are invoked as the measure of aesthetic beauty against the 'sheer ugliness' of the servant. The *Athenaeum* charged the artist with having broken the circuits of pleasurable viewing and disturbing the functions of painted portraiture which was, according to most mid-century critics, reserved for employers, not employees. These claims were enunciated at a historical moment when photography became a cultural terrain for contending social classes to claim a presence in represen-tation.[39] Photographic portraits of working-class women in walking dress or working attire, often as in the case of Hannah Cullwick commissioned by themselves, challenged the class exclusivities of portraiture and the disciplinary uses of photography.

Perhaps the most interesting aspects of *Peep-Bo* remained unspoken in its reviews. The painting registers a bourgeois woman's re-ordering of the interplay of this cluster of signs to map the classed positions of women in the spaces of femininity. For its women viewers *Peep-Bo* could rely on and invoke sexually specific formations of pleasure and desire while charting that sexually differenced terrain of femininity.

In the paintings by Edith Hayllar and Jessica Hayllar of the 1880s women servants dressed in severe uniforms are signs of efficient household man-agement. Jessica Hayllar's *And Flowers of Every Hue Shall Grace the Festal Day* (RA 1883) shows a parlourmaid carrying a tray from the back stairs into the hall where a gardener arranges a display of plants. As in her sister's works the women servants are positioned at the boundaries be-tween distinct spaces in the house. In Edith Hayllar's *Kind Enquiries*, a

parlourmaid opens the front door to two middle-class women, one with her card in her hand. With its view from inside to outside, the painting defines the boundaries of domestic space and registers the complex interplay of class and gender in domestic ritual in which servants acted as gate-keepers. Edith Hayllar's *Seniores Priores* (RA 1885) portrays a parlourmaid stand-ing at a doorway to the men's dining-room, so marking the threshold of the masculine territories of the house, not entered by bourgeois women but attended by women servants. These spacious apartments were visually differentiated from the servants' quarters. Edith Hayllar's *Blackberry Tart* (1885) depicts a low-ceilinged kitchen with shelves of sparkling pots and a sturdy table on which a cook is rolling out pastry.[40]

The sisters' paintings depict women servants as neat, clean and orderly, attired in dark dresses with cap and apron. The increasing hierarchisation of servants in the later nineteenth century was indicated by uniforms which replaced the plain and print dresses of the mid-century. This erosion of any vestige of personal taste in servants' dress, which heightened the visible differences between family and household, coincided with the develop-ment of an elaborate 'personal style' by fashionable women.

The high-cultural imagery of women servants produced by women artists participated in the categorisation and surveillance of working-class women. As employers and as painters they assisted in the transformations of working-class women into servants. Their paintings and drawings brought women servants to visibility and into a regime of representation which classified them within a distinct and different register of femininity. In none of these images are women servants sexualised. But neither do these figures disturb or disrupt domestic ritual. Rather, women servants are produced and exchanged as signs of household order by bourgeois women positioned as household managers and interior designers, employers and cultural consumers. In daily life, however, this field of vision was traversed by looks both ways; servants observed their employers. As Mary Braddon commented in her novel *Aurora Floyd* of 1863, 'nothing that is done in the parlour is lost upon these quiet, well behaved watchers from the kitchen . . .'.[41] The most interesting perspectives in feminine spectatorship were located outside the high-cultural frame, the viewpoints of Black and white working-class women who saw paintings of themselves or pictures of servants on the walls of the houses in which they worked.

AYAHS

From the beginning of the eighteenth century, and probably earlier, south Asian women were employed by British families as ayahs or nursemaids. Their histories and experiences have been recovered by Rozina Visram in her pioneering book *Ayahs, Lascars and Princes. Indians in Britain 1700–1947*.[42] Indian women were integral to the households of white British

families in India, and indispensable on the long sea crossings from the subcontinent during which they took charge of the white women and children and the baggage. After 1858, when India came under direct British rule and the colonial presence became more ritualised, increasing numbers of ayahs were employed, and as travel became easier and quicker more ayahs journeyed to and from Britain. In Britain ayahs might be retained but they were often discharged, left to find a return passage with another family. One source estimated that by 1870 as many as 100–200 ayahs travelled to London each year, and numbers were so high that by 1900 an Ayahs' Home was established for women from south and south-east Asia who were employed by families within the rapidly expanding British empire.

Rosina Visram noted that, although numerous, ayahs rarely entered historical representation. Official interest was rarely taken in their welfare since they were perceived as 'never much trouble'. Written records including the ayahs' own accounts are few, as are visual images. By the mid-eighteenth century the ayahs' presence was visibly registered in the family portraits of white men who made their careers and fortunes in India. In the nineteenth century, photographic portraits and images of ayahs coexisted with watercolour studies.[43] One of the rare exhibited pictures of an ayah in the nineteenth century is Rebecca Solomon's A Young Teacher, exhibited in London in 1861.[44] But all too often Asian women entered representation within colonial modalities of perception.

The ayah in Rebecca Solomon's A Young Teacher (plate 26) wears an enveloping striped shawl over a western dress; her head is partially covered. The ayah has her arm protectively around the youngest child and as in paintings of white servants she provides physical care. Moral education is apportioned to an older white girl reading from a book.

Reviewers interpreted the visual distinctions between the ayah and her charges within contemporary beliefs about the hierarchies of racial difference. They perceived the Black woman as an Indian, and as inferior to the white girl:

> A Young Teacher is a vigorous and remarkable picture in its way, full of effective, but not exaggerated contrasts. A young English girl, with a luxuriant fall of blonde hair, is giving a reading lesson to the seated Hindoo nurse on whose knee a little prattler is seated, looking at the picture book before them. In the painting of the wondering ayah, with her semi-intelligent, semi-physical type of countenance, there is genuine and unaffected earnestness.[45]

Although the model was not necessarily a south Asian woman, this interpretation of the figure located the painting within the reorganisation of the historical relations between Britain and India after the events of 1857 to 1858.

After the Indian National Rising of 1857 and the imposition of direct rule the following year, the missions of civilisation and Christianity, in which white middle-class women were given special status, were intensified. As education became a major area of colonial policy, so it was also deployed as a key component in the discourses of racial superiority. *A Young Teacher* drew on and participated in a long-standing visual tradition, established alongside the bids to secure colonial control over the subcontinent, in which India and Britain were imaged as female figures.[46] A *Punch* cartoon of 1858 commemorating the passing of the India Act depicted India as lavishly adorned with jewellery and wearing an anglicised dress kneeling at the feet of Queen Victoria, offering her self, her wealth, her service.[47] In *A Young Teacher* race relations are distilled into an image of gentle guidance.

ARTISTS' MODELS

Figure paintings such as *A Young Teacher* (plate 26) were usually based on drawings made from models employed by the artist in her work-room. While servants did double duty as unpaid models, and family and friends posed, women made independent livings as paid models, often working on a regular basis for a particular artist, art school or artists' group, and posing without clothes or in character roles and costume. Louise Jopling's exhibited picture *A Modern Cinderella* (RA 1875) depicts a model, wearing only chemise and petticoat, hanging up her studio costume. In the model's undress it is an entirely class-specific representation. Paid modelling was undertaken by Black and white women of the working-classes; viewed as low status and unskilled, it has been marginalised in art history.

There is at present little documentation on artists' models, paid or unpaid. Visual images and titles of pictures testify to the presence of Asian women in artists' studios.[48] Women of African descent posed for Joanna Boyce for an oil sketch (1860) and for an unfinished oil *Sybil* (1861), and to Eliza Fox for St Felicitas in her painting *St Perpetua and St Felicitas* of 1861.[49] A young Black girl is depicted in Anna Blunden's *An Episode from Uncle Tom's Cabin* of 1853.[50]

But paintings only mark a presence, and one which was was systematically transformed for high culture. In *Uncle Tom's Cabin* racial difference is hierarchised through the appearance and disposition of the two figures and the lighting effects. Topsy's hair is short, for the novel recounts how her plaits were shorn as a sign of her submission to a white family, and the painting does not necessarily describe the actual appearance of a Black child or give any indication of contemporary African hairstyling. Relations of power between she who was depicted and she who depicted were enmeshed in the broader dynamics of race and in this instance shaped within the philanthropic field of vision in which women artists inscribed

their practice at the mid-century. Michelle Cliff has written of the disjunctures between Black women's histories and their visual representations and addressed the in/visibilities structuring their appearance in high culture:

> In my room there is a postcard of a sculpture by the Venetian artist Danese Cattaneo, done in the mid-sixteenth century – *Black Venus*. The full-length nude figure is bronze. In one hand she holds a hand-mirror in which she is looking at herself. On her head is a turban around the edges of which curls are visible. In her other hand she carries a cloth – or at least what appears to be a cloth. Who was she? A slave? Perhaps in the artist's own household, or maybe that of his patron – one of the many Black women dragged from Africa to enter the service of white Europeans. I have no idea who she actually was. She was an object – then as now.[51]

SURVEYING SEAMSTRESSES

Anna Blunden's painting of a shirtmaker, exhibited in London in 1854 with a quatrain from Thomas Hood's poem 'The Song of the Shirt', depicts a woman in a dark green dress sitting in an attic room by an open window (plate 27).[52] A shirt, workbox, scissors and thread lie on the table before her. She clasps her hands as if in prayer. Her head is silhouetted against a cityscape: the dawn sky is flared with red and yellow. Anna Blunden's image circulated in several sites of middle-class pleasure, instruction and philanthropy. Shown in a London exhibition, it was reproduced in a leading general-interest magazine in connection with a fund-raising campaign.[53] Several readings were thus possible for its viewing publics, set in place by its contexts and produced through the decoding of the visual signs of pose, dress, habitat, accessories.

Recent commentators have located the picture among those 'portraying contemporary social, economic and political problems'.[54] The painting, however, does not pictorialise a pre-existent reality which can be unproblematically excavated by modern historians. Rather the painting draws on and contributes to the formation of the discursive category of the seamstress which negotiated and temporarily resolved the crisis in representation and signification provoked by working women.

A particular categorisation of women workers in the clothing trades emerged in the 1840s. Across all the diversities of production – from outwork to workroom, the making of whole garments to piecework, adult to children's wear, clothes to accessories – the discursive category of the seamstress was formed and incessantly repeated. In novels, short stories, poems, parliamentary commissions, investigative journalism, newspaper articles, magistrates' and police reports as much as cartoons, magazine illustrations and oil paintings, the seamstress was persistently imaged as

young, pale, haggard and gaunt. She worked long hours with few breaks for rest or meals in a crowded workroom or miserable attic. She was physically ill and mentally exhausted. No one text originated or was the source for this discourse which circulated across a wide range of social institutions from the state to medicine, the police and philanthropy, from high culture to popular culture.[55] While claiming veracity and objectivity, written and visual texts repeated and echoed each other, producing a closed regime of 'truth' on the seamstress. These texts rarely addressed the specificities of production and consumption in the clothing trades. Occasionally they discussed familial, kinship and friendship networks. An interest in the income and outgoings of working women was accompanied by a fascination with their sexual activities. The processes of cutting, stitching, pleating and finishing generally remained beneath the surface of discourse, visible now only in the surviving garments. Texts on the seamstress were intelligible within the discourses on the labouring population and the management of public order, public health and morality in the 1840s and 1850s. Written and visual images were shaped by contemporary concerns with the classification of individuals into categories and the regulation of feminine sexuality. Anna Blunden's representation of the shirtmaker was produced in and contributed to the discursive construction of the seamstress as a pallid, gaunt and tired young woman.[56] Dawn breaks, indicating that she has worked all night. Partitioned in the frame the figure is available for scrutiny and inspection; her environment and her hours of work are detailed.[57] In this 'management of the population' space is allotted and time calculated. However, unlike most texts on the seamstress, prominence is given to the full dress shirt which with its stitched collar and cuffs and its pleated front was one of the most skilled and laborious pieces of needlework.[58]

In most reports on the seamstress pale and haggard features connoted bodily disorder. The consequences were individual and social: premature death, prostitution, unfit mothers 'of unhealthy and miserable offspring'.[59] For the reformers and social investigators of the 1840s and 1850s – a loose alliance of medical practitioners, philanthropists, journalists, public health experts and politicians – working women contradicted domestic femininity and disrupted social order.[60] Disorder was written on to and read off the feminine body, represented as persistently and chronically ill. The best-known high-cultural image of the seamstress, Richard Redgrave's painting of 1844, included a medicine bottle as an index of the woman's ill health. The Children's Employment Commission, cited in so many texts on women workers, placed the seamstress in medical discourse, privileging and empowering male doctors, a new professional group. Their evidence presented a wide range of complaints and disorders, most of which specified dysfunction in terms of unregulated sexuality and gynaecological failure. The disordered feminine body was perceived as a sign of social disorder

manifested in widespread prostitution or race degeneration.[61] The haggard appearance of Anna Blunden's shirtmaker conforms to this discursive categorisation but her painting contains no direct clues to sickness.

With her hands clasped and her eyes raised, the figure of her shirtmaker refers to depictions of Mary Magdalene, a popular guise for the prostitute. But the processes by which this image could be read in terms of a widely held belief that needlework led to prostitution depended not only on decoding the pictorial allusions but also on structures of narrativity in which visual and written texts on the seamstress were perceived. Art criticism invited viewers to elaborate a story around the depicted figures in order to extrapolate the moral of the painting from its pictorial detail.

By the 1850s the narrative of the rescue challenged the story of the prostitute's seduction and suicide.[62] In November 1849 the *Morning Chronicle* provided life-histories of needlewomen who had become prostitutes, some of whom had been 'saved' by Christian intervention. Biographical narratives were accompanied by delineations of their outer appearance along with graphic descriptions of 'the mental and bodily agony of the poor Magdalene' at the moment of her confession.[63] With reporters hidden behind screens, the newspaper staged a visual spectacle of shame in which needlewomen confessed to prostitution. It relayed the visual, aural and moral pleasures of this event to its readers: 'Never in all history was such a sight seen, or such tales heard.'[64] Investigative journalists such as Henry Mayhew insisted that the *Morning Chronicle* articles provided eye-witness accounts and literal transcriptions: 'the poor creatures shall speak for themselves'.[65] But as Michel Foucault has indicated, these new life sciences such as investigative journalism actively constituted their objects of knowledge and particular strategies of discourse yielded specific visibilities. The interview, favoured by journalists and parliamentary inquirers, was among the principal techniques of investigation and surveillance, and in the reports of seeing and telling, narrativity united the disparate and dialect elements of working-class women's speech into a seamless 'confession' and bound written text to visual display. By the time Anna Blunden exhibited her picture the discursive visibilities of the seamstress were well formed and narratives of needlewomen turning to prostitution and their salvation were familiar to the viewing publics for high culture. A specifically Christian reading of salvation is implied by the pose of Anna Blunden's seamstress and by the dawn sky, a common metaphor for the light of Christ.

Quotations in exhibition catalogues facilitated the practices of reading paintings and composing meanings in terms of biography and morality. The last four lines from this verse of 'The Song of the Shirt' which accompanied Anna Blunden's picture accessed another well-known story of the seamstress.

Oh! but to breathe the breath
Of the cowslip and primrose sweet –
With the sky above my head,
And the grass beneath my feet,
For only one short hour
To feel as I used to feel,
Before I knew the woes of want
And the walk that costs a meal!

The young country girl who travelled to needlework in the city was a familiar figure in official documents, magazines, fiction and paintings and she is referenced here by the view of the city rooftops. Distinctions between country and city were mapped on to the major organising polarity of pure/fallen around which feminine sexuality was constructed; briefly to anticipate the discussion of the representation of the prostitute, the city was defined as the locus of the 'fall' and the habitat of the fallen. In addition the juxtaposition of the poem and the picture provided a framework for the subject outside the frame to read the subject in the frame as an individual with pleasures and desires, a past and a present, a life-story shaped by a journey which, given the connotations of the city, would be construed as one from health to sickness, bodily dysfunction and even death.[66]

Various contradictory readings of Anna Blunden's image could thus be made by contemporary viewers. The figure could be seen as a country-woman longing for home or a reformed prostitute saved by Christianity; it could be perceived in terms of that pious respectability which framed so many high-cultural representations of the working classes. But whichever reading was preferred, the visual appearance of the shirtmaker and her environment located her within the deserving poor. In many texts the seamstress was pictured in a dirty and decaying attic room.[67] Thomas Hood's poem provided the most familiar description of a shirtmaker attired in 'unwomanly rags' and working in a room with only 'a bed of straw,/ A crust of bread – and rags/ That shattered roof – and this naked floor – / A table – a broken chair.' Although Anna Blunden quoted this poem in the catalogue, her picture does not offer degradation, dirt or disrepair. The shirtmaker's neatness and personal tidiness marked her as one of the respectable working class.

The discursive categories of the deserving poor and the respectable working class assisted in social disciplining by separating a group of individuated subjects whose neatness, sobriety, religion and industry marked them as worthy of bourgeois attention and benevolence and differentiated them from the unreformed and unreformable 'mass of the residuum'.[68] So classified, they did not disturb but rather contributed to the social order. This image of piety and hard work was articulated and perceived in the

philanthropic field of vision and power taken up and inhabited by middle-class women whose activities in the social field were organised around philanthropic and rescue work. Produced within the middle-class imperatives to improve and reform, Anna Blunden's picture of a seamstress was part of that 'calculated management over life'.

GOVERNESSES

Anna Blunden was educated as a governess. The daughter of a bookbinder in Exeter, she was expected to earn her own living. But after working in two households in Devon, she left for London where she trained at Leigh's classes and launched her career in 1854 with her picture of a seamstress.[69] As the skills of governesses often included drawing and watercolours, several became painters. Susan Isabel Dacre was sent to Paris to train and work as a governess but on her return to Manchester she enrolled at Manchester Art School in 1871.[70] By this date governessing was one of several options, but in the 1840s and early 1850s it was, like fine art, one of the few paid occupations for middle-class women.

Governesses were employed to care for small children, teach girls accomplishments and chaperone young women. As middle-class women working for money in a bourgeois home, a domain defined outside economic transactions, governesses occupied a contradictory position. They were hired for their gentility and refinement, those very qualities which marked a 'lady' whose femininity determined that she did not work.[71] To manage these contradictions a specific discursive categorisation of the governess was formed and circulated. From the 1840s to the 1860s the governess was the subject of numerous novels and periodical articles and a focus for philanthropic concern, the Governesses Benevolent Institution being formed in 1843. A narrative soon became familiar: born and bred a lady, the governess worked because she had no male relative to support her. But while economic fluctuations left many middle-class women without financial resources, others were expected to earn independent livings as teachers. The discursive category of the governess was thus forged across a conflict between economic conditions and the ideology of domestic femininity central to middle-class identities. The struggle to anchor the governess's class position was thus part of the broader mapping of the social terrains and class boundaries of the bourgeoisie at a specific moment of its formation.

Elizabeth Eastlake's ferocious attack in 1848 on Charlotte Brontë's novel *Jane Eyre* negotiated the fractured elements of this discourse:

> the real distinction of a governess in the English sense is a being who is our equal in birth, manners and education, but our inferior in worldly wealth. Take a lady, in every meaning of the word, born and

bred, and let her father pass through the gazette, and she wants
nothing more to suit our highest *beau ideal* of a guide and instructress
to our children. . . . There is no other class which so cruelly requires
its members to be, in birth, mind and manners, above their station, in
order to fit them for their station.

For Elizabeth Eastlake, the trouble with Jane Eyre was her independence,
her lack of gentility and refinement. And, being no lady, Jane Eyre could
not elicit that compassion for the governess 'who is entitled to our gratitude
and respect by her position' and 'by the circumstances which reduced her
to it'.[72]

But whereas Jane Eyre, heroine, and *Jane Eyre*, novel, could not be
contained within the philanthropic vision, it was this modality of percep-
tion which was deployed by women painters depicting this figure. In
Rebecca Solomon's *The Governess* of 1854 (plate 28) the visual signs of
pale skin, tapering hands and slender figure signal the governess as middle-
class; her black dress indicates mourning and financial destitution. She is
Elizabeth Eastlake's 'needy lady', presented as an object of charitable
concern. A compassionate reading was engaged by the catalogue quotation
from Martin Tupper's *Proverbial Philosophy*:

Ye too the friendless, yet dependent, that find no home or lover,
Sad imprisoned hearts, captive to the net of circumstance.

For the *Art Journal*, sympathy for the governess was elicited by the
contrast between the two female figures: 'A young lady and a youth are
engaged in a flirtation at a piano, while a governess is plodding in weary
sadness through a lesson with a very inattentive pupil.'[73] Against the
woman at the piano, identified as a flirt, a term of moral opprobrium
connoting vulgarity and impropriety, the governess's modesty and
decorum signal that she is a lady.

Emily Mary Osborn's *The Governess* of 1860 constructed a comparison
between a governess and her employer.[74] The governess is depicted stand-
ing before a mother seated in a chair and surrounded by ill-behaved
children. The catalogue quotation, carefully chosen from Longfellow's
'Evangeline', directed the viewers' sympathies to the governess:

Fair was she and young, but alas! before her extended
Dreary and vast, and silent, the desert of life, with its pathway,
Marked by the graves of those who have sorrowed and suffered
 before her.
Sorrow and silence are strong, and patient endurance is god-like.

The governess was varyingly described by critics as 'a tall handsome girl in
black', 'dignified, intellectual and handsome', 'a young, slight, interesting,
unprotected female, standing in unabashed simplicity, sensitive and re-
fined'. The seated figure was said to be 'very vulgar, corpulent and "loud"',

'a fat, coarse mother', 'stout, ill-tempered and richly dressed [whose] children are ugly, malevolent-looking demons'.[75] As we have seen, refinement and vulgarity were defined as polarised modes of bourgeois femininity, and they were perceived as qualities which could be assessed through the visual signs written on to the feminine body and marked in deportment and dress. Refinement was also a matter of sensibility. Pity was elicited for the governess's sufferings, her distressing circumstances, her class marginality. The catalogue quotation was chosen to prompt sympathy for the tall grave figure so visibly contrasted to the mother and her children. The differences in class between the two women was taken up by the *Art Journal* which applauded the painting as 'a bitter satire on an all too prevalent vice . . . the practice of treating educated women as if they were menial servants'.[76] This leading cultural magazine praised the artist within the mid-century discourses of morality for having 'made Art to exercise its highest privilege, that of a teacher'.[77]

These two paintings by Rebecca Solomon and Emily Mary Osborn did not fundamentally shift the discursive category of the governess. In eliciting sympathy, particularly through a contrast to an uncongenial employer, the governess was inserted into a philanthropic field of vision. But between 1854 and 1860 egalitarian feminism broke the representation of the middle-class working woman as an object of pity. One problem for women artists across these years was how to negotiate new identities and modalities for their perception of working women in high culture. By depicting the governess as a lady, these two works refuted prevailing ideas that middle-class women who worked lost status. Unlike Emily Mary Osborn's powerful depiction of the independent and dignified school teacher in *Home Thoughts* (RA 1856), these pictures of the governess did not rework the discursive category in which they were constituted. After 1860 the figure of the governess largely disappeared out of visual culture and out of discussions about women's work, as campaigns broadened beyond the limited horizons of private teaching.[78]

PURITY, PLEASURE AND THE VISUAL REPRESENTATION OF THE PROSTITUTE

Any discussion of the imagery of the prostitute necessarily begins with *Myths of Sexuality* in which Lynda Nead discusses the ways in which visual culture participated in the regulation of feminine sexuality. She argues that 'the particular conditions of artistic production and consumption and the special values attached to high culture . . . turned the fallen woman into an extremely difficult subject for art.'[79] As she points out, the categorisation in high culture and the rescue work of the prostitute as a social outcast circulated against other discourses in which the prostitute signified social disorder.

159

Visual representations of the prostitute by women artists were clustered in the 1850s, a decade of active philanthropy by middle-class women. Their paintings intervened in the cultural management of feminine sexuality and in the production of visible differences between the pure and the fallen. Anna Mary Howitt's *The Castaway* was shown at the Royal Academy in 1855; neither the painting nor the compositional study (completed by August 1854) have been traced. Its title referenced the prostitute as social outcast, and according to one contemporary it was 'a rather strong-minded subject, involving a dejected female, mud with lilies lying in it, a dust-heap and other details'.[80] The lilies in the rubbish heap alluded to the popular mythology of the prostitute's progress from country virtue to city vice, the city streets being the scene for the prostitute's seduction, destitution, reclamation or suicide. In Rebecca Solomon's *A Friend in Need* (RA 1856) a middle-class woman intervenes to assist an outcast woman cradling her child on the steps of a church, its metropolitan location being identified by the wall-poster for the London Missionary Society, an agency which encouraged women's rescue work.[81] Contrasted with an officious beadle, the middle-class woman represents morality as private charity. In philanthropy and high culture middle-class women claimed, and were ascribed, an elevated and sexually defined status in rescue work. As embodiments of feminine purity they were positioned in a special relationship of sisterhood and salvation to the fallen women whom they reclaimed. This role is visually defined in *A Friend in Need*, assumed by the woman artist and offered to the bourgeois women of her audience.

Anna Mary Howitt had interrogated the categorisation of feminine sexuality in an earlier work, *Margaret Returning from the Fountain*, shown at the National Institution in London in 1854. The painting depicted the moment in Goethe's poetic drama *Faust* in which Margaret (also called Gretchen) realises that, as Faust who has seduced her will betray her, she has lost her purity. Critics admired the figure of Margaret, interpreting the pose as a sign of her 'deep grief and penitence'. Outer appearance was read as a manifestation of inner state: 'The sweet face of Margaret is full of silent, uncontending anguish; her heart has sunk within her and she presses her hand on her cold forehead.'[82] Inter-textual relations enabled narrative individuation and positioned the moral reading of the image. Sympathy was elicited by the identification of Margaret as a social outcast. Individuated and pitied, her life-story was cast from past to future and the workings of her mind and heart were scrutinised. This solitary, remorseful figure countered fears of prostitution as a widespead social disorder. Whereas in rescue work the admission of 'sin' was seen as a turning point towards rehabilitation (this was the function of the *Morning Chronicle*'s staging of the spectacle of shame of the London needlewomen in 1849), in high art the moment of recognition could not halt the prostitute's inevitable progress to death. But readers of *Faust*, part 1, would know that

160

although Gretchen dies in prison, there is an intimation that she is saved. Situated at the intersections of high art and philanthropy, *Margaret Returning from the Fountain* was well received and even claimed as 'the finest picture of the year'.[83]

Visual categorisations of the prostitute intensified between 1854 and 1856. *Margaret Returning from the Fountain* was exhibited in the same year as Holman Hunt's portrayal of a prostitute's moment of recognition, *The Awakening Conscience*. By August 1854 Anna Mary Howitt had begun painting *The Castaway*. The compositional design for this subject was included in a portfolio which circulated between artists where it was seen by D.G. Rossetti then at work on *Found*, which like *The Castaway* utilised details of a cityscape (including a rose discarded in the gutter to signify the prostitute's impurity) and set in play a contrast of city vice and country health.[84] By November 1854 Elizabeth Siddall had completed *Pippa Passes*, depicting an encounter in Robert Browning's poem of the same title (1841) between a respectable working woman and three prostitutes who have been discussing their clients (plate 29).[85]

While links can be traced between these artists, their perspectives on prostitution differed sharply and their class and sexual identities positioned them heterogeneously in relation to visual categorisations of the pure and the fallen. Anna Mary Howitt's interests in the rescue and reformation of prostitutes placed her within that philanthropic field which was perceived by many middle-class women as extending 'woman's mission' into the public sphere.[86] But what was the viewing position of a woman born into an artisan family who was defined by Ruskin as a 'princess' and by Barbara Bodichon as 'not a lady' but construed by both of them as an object of philanthropic concern?[87]

Elizabeth Siddall's art is usually seen as imitative and intensely personal. But the themes of her drawings and watercolours were those which preoccupied high culture in the 1850s: the categorisation of feminine sexuality and the interrogation of the margins of class. In *Pippa Passes* Pippa's purity is signified by her neat appearance, her contained pose, her downcast gaze – here, as in *Nameless and Friendless* (plate 10), a sign of modesty. Depicting not a solitary figure but a group, the artist deploys the direct gaze and ostentatious finery widely ascribed (particularly in popular culture) to the prostitute. Here the pure and fallen are not differentiated across class, but within class; purity and respectability are the attributes of the silk-winder journeying round the city on her annual holiday. This representation was inflected by the divergent class appropriations of respectability at the mid-century. Patterns of respectability became a focal point in the identity of the upper strata of the working class to which Elizabeth Siddall belonged,[88] at the same time as bourgeois versions of respectability saturated high-cultural images of the working classes.

The sexual and class dynamics of looking at high-cultural images of prostitutes were underwritten by the practices of art collecting: possession was invested in the relays of the gaze. The philanthropic field sustained Angela Burdett-Coutts's desire to purchase Anna Mary Howitt's *Margaret Returning from the Fountain* in 1854 when the collector and philanthropist was already involved in rescue work which accorded with her developing ideas of 'woman's mission'.[89] But *Margaret* was snapped up by a Mr Herbert, a collector of modern painting,[90] an act which typified the moves to secure masculinity as the privileged viewing position for these pictures. *The Castaway* was bought by Thomas Fairbairn, a Manchester engineer who acquired William Holman Hunt's *The Awakening Conscience*. Thomas Plint, a Leeds stockbroker who firmly believed in the efficacy of high art to articulate bourgeois morality, purchased Joanna Boyce's *The Outcast*.[91] For these two northern capitalists, stark polarities of feminine sexuality were to be regulated by high culture. And for both, feminine purity guaranteed an ordered, optimised male workforce, resistant to strikes and to drink.[92]

Joanna Boyce's *The Outcast*, exhibited in 1859 with the quotation 'No joy the blowing season brings', depicted a woman and her child outside in a storm. For her unfinished painting of *Gretchen* she turned to Goethe's *Faust* (plate 30).[93] With long blonde hair, a serene and distant gaze, arms akimbo, and pose which was distinctly unladylike, *Gretchen* was produced at an intersection between new critical discourses on art and redefinitions of feminine sexuality. In the 1850s high-cultural images of the prostitute were caught between a moral imperative for the depiction of degradation and an aesthetic investment in the spectacle of woman's beauty.[94] These contradictions were resolved by transforming the fallen woman into an object of explicitly visual pleasure. Neither a sorrowing victim, tattered outcast, nor tragic corpse, this image of woman invoked neither compassion nor sympathy but masculine sexual desire. Coinciding with a perceived collapse of visible distinctions between the pure and the fallen and new critical discourses which rejected narrative moralism, visual pleasure was invested in and articulated as the spectacle of woman.

This artist's *La Veneziana* of 1860 (RA 1861) was an early and innovative example of this new pictorial mode developed at the turn of the decade. A half-length of a woman wearing an opulent dress with richly slashed sleeves and bejewelled decoration is profiled against a rich green ground. This depiction of a redhead with thick, loose hair, strongly defined features and a prominent nose and jaw articulates a new style of femininity which departed from the royal model of oval face, petite features and dark, glossy hair.[95] The title references Venetian art, a source for the picture and an advanced taste for this date, without precisely fixing the woman as pure or fallen.

In the *Athenaeum* the picture was described as 'a profile of a lady with

small reptile-like eyes and tawny-coloured hair, rank and harsh; a cruel, square jaw and heavy, pitiless face'.[96] In his reviews this proselytiser of D.G. Rossetti frequently conjured a cruel, destructive *dominatrice*, matching this image to his friend's paintings.[97] His writings were part of the cultural practices of a homosocial circle of male artists, writers and purchasers who promoted masculine fantasies of power and desire as the privileged viewing position for this artistic category. But this was only one point of view, one which has however been perpetrated in the patriarchal discourses of contemporary art history. There were considerable challenges for women artists in the profound shifts away from moral topography and out of the philanthropic field of vision. If visual pleasure was not to be exclusively annexed for masculinity but secured for the enjoyment of women, the terrain of femininity had to be redefined by women, for women. Articulations of women's pleasure in women, sustained in those communities and contexts where woman as sign was produced and exchanged between women, contested the appropriation of woman as a sign of masculine desire. It is these cultural collisions between sexually differenced significations of woman which are explored in the last chapter.

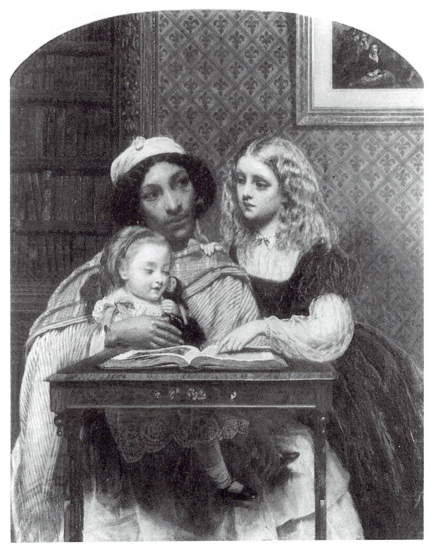

Plate 26 Rebecca Solomon, *A Young Teacher*, Winter Exhibition, London, 1861.

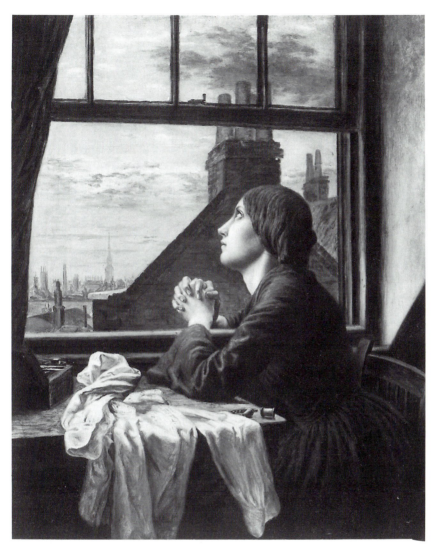

Plate 27 Anna Blunden, *'For Only One Short Hour'*, Society of British Artists, London, 1854.

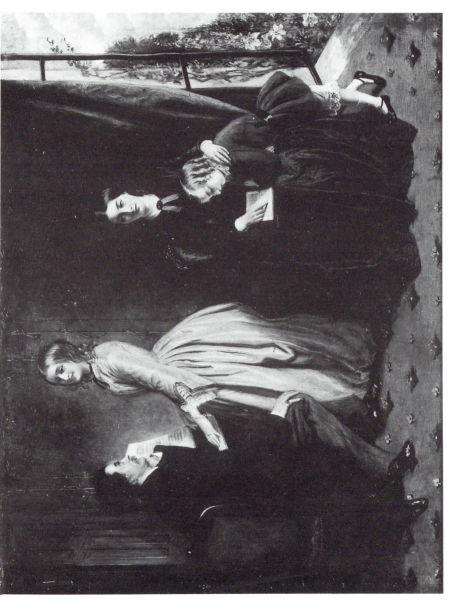

Plate 28 Rebecca Solomon, *The Governess*, Royal Academy, 1854.

Plate 29 Elizabeth Siddall, *Pippa Passes*, 1854.

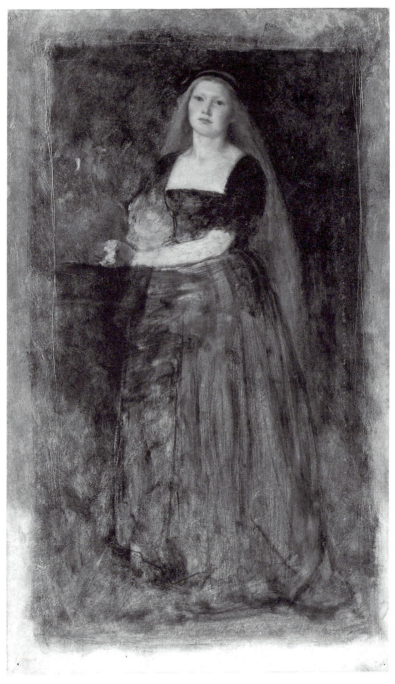

Plate 30 Joanna Mary Boyce Wells, *Gretchen*, 1861.

Plate 31 Rosa Brett, *Study of a Turnip Field, Barns and Houses*, after 1863.

Plate 32 Ellen Gosse, *Torcross, Devon*, *c.* 1875–9.

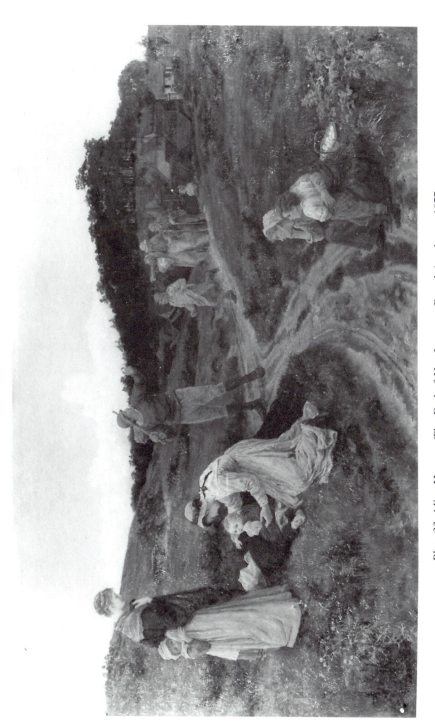

Plate 33 Alice Havers, *The End of Her Journey*, Royal Academy, 1877.

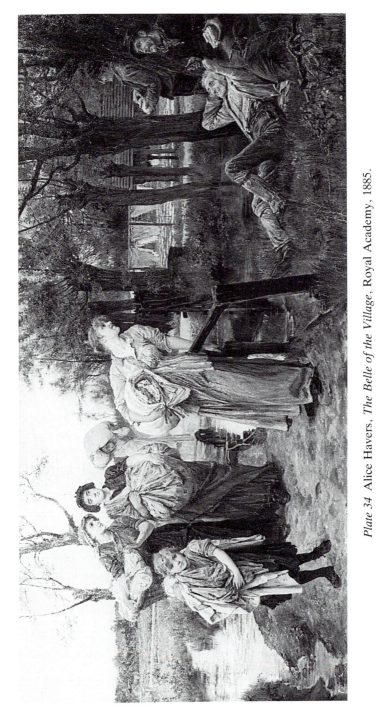

Plate 34 Alice Havers, *The Belle of the Village*, Royal Academy, 1885.

Plate 35 Helen Allingham, *Near Witley, Surrey*. This cottage was also noted by Gertrude Jekyll in *Old West Surrey*, 1904.

Plate 36 Elizabeth Armstrong Forbes, *School is Out*, Royal Academy, 1889.

FROM TOWNS TO COUNTRYSIDE AND SEASIDE

PICTURING THE SCENERY, ENJOYING THE VIEW

The train stops, and our destination is at length reached – we have passed from the quiet of the country with its thousand pictures of rural beauty and repose, into the full life, the fever, the bustle, and the fret, of the hard-working manufacturing town. But the pictures which have passed before the eye during our long railway ride still recur to us there, and the quiet beauty of that long panorama of glorious English landscape will dwell in our happy memory for many years to come.[1]

This narrative of a journey recounts many of the pleasures which were inherent in looking at landscape for nineteenth-century spectators. Here are all the delights of glimpsing scenes out of train windows, perceiving the countryside as a series of aesthetically pleasing views, enjoying the refreshing contrast to the town and fulfilling a sense of belonging not just to a country but to a nation. The text speaks of women's pleasures in travelling and beholding and, contextualised in a feminist magazine, *Eliza Cook's Journal* of 1851, it addresses and constitutes a feminine subject position for enjoying and experiencing landscape as pictures, and pictures of landscape.

This positionality was taken up and lived by women landscape painters in the second half of the nineteenth century. Most professional women artists lived in towns, working for a largely but not exclusively urban clientele. Not for them that place in the country squirearchy enjoyed by establishment landscapists who ploughed their profits into estates, becoming local magnates and powerful agents in the rural economy.[2] Women artists made studies and sketches on holidays and excursions to the countryside, working them up in their studios into exhibition pieces. These finished works were then shown in the exhibitions and dealer galleries

in London and the larger cities or at the art societies of country towns.

Landscape painting flourished in the capitalist economy of the nineteenth century. It was a luxury commodity, and for artists promoted by dealers landscape art was highly profitable. In a highly urbanised society, the countryside was remote – glimpsed through train windows, enjoyed on holidays, pictured in illustrated magazines or on gallery walls. Landscape painting, tourism and travel literature created the countryside as a knowable, recognisable, and distinct domain, fundamentally different to, and often contrasted with, urban life, society and work. And all these cultural practices transformed the rural working classes into picturesque spectacles. Indeed the term picturesque, reiterated in the writings on art, travel and the countryside, assisted in forming a metropolitan modality of perception in which land and country dwellers formed pictorial compositions.

Landscape paintings were not only seen in urban contexts. They were discussed in general interest magazines, which by subscription circulated across the country; they were reproduced in agricultural manuals written for and presumably read by farmers whose wealth was rurally based.[3] Middle-class professionals who lived in the country – doctors, lawyers, clergy, merchants, farmers as well as the industrialists who retired to country estates – purchased landscape views in oil or watercolour. For them as much as for their urban counterparts, buying and enjoying landscapes contributed to their sense of class identity and these cultural activities bound together the diverse groups in the bourgeoisie.

Landscape paintings were produced across the reorganisations of rural society, profound shifts in attitudes to the countryside, and major changes in British agriculture which took place in a global context. From a predominantly agricultural economy in 1850 with more than one-fifth of the occupied population in agriculture, Britain was transformed by 1914 to a predominantly urban society and industrial economy with fewer than one in ten working on the land. And whereas agriculture had generated approximately one-fifth of the national income at the mid-century, by 1914, as one of many major industries rather than the dominant one, it yielded one-fifteenth.[4] Economic changes were accompanied by shifts in land ownership with the purchasing of country estates by wealthy industrialists and landscape painters and the creation of peers without land, such as Baron Leighton or Baron Tennyson, from among the men of the professional classes.

In the 1850s and 1860s farming was dominated by profitability. High capital investment – in machinery, buildings, field drainage, stock, fertilisers and feeds – reaped high prices and high profits. This large-scale capitalist arable farming, with priority given to cereals, was largely established in south and east England, from Dorset and Wiltshire to East Anglia. But by the later 1870s many farmers were complaining of an

agricultural depression which they variously attributed to farm wages, natural causes, low prices and imports. Certainly poor harvests, bad weather, animal diseases, the collapse of grain prices, and imports of food and grain combined to bring changes in agricultural practices, social relations and capital investment in the last quarter of the nineteenth century. Particularly in the southern and eastern counties, arable farming and wheat growing declined against grazing, dairying, livestock and market gardening, with increasing areas of land put to pasture or left to weeds. Moreover, during this period of general economic slump, less capital still had to generate profit. During the 1880s new patterns of farming were established with increasing mechanisation, regimes of dairying, calf-rearing, poultry and pigs, chemical rather than organic fertilisers, and the deskilling of a declining workforce. Reconceptualised by the mid-century as a domain less subject to nature than malleable to the skills of science, farming in the 1880s and 1890s worked in partnership with large-scale engineering, industrialised milling, agro-chemicals, and manufactured animal feeds.[5]

Furthermore, by this date British farming was caught in the financial policies of British imperialism and the fluctuations of world markets. If food production in Britain suffered because of the extensive free-market importing of North American wheat and South American meat, British industries were increasingly based on processing oils, rubber and petrol, often imported from British-owned estates, and depended on high capital investment overseas. The manufacturing of soap, cleaning products and animal feeds by Lever Brothers, for example, relied on long-standing trade links between Merseyside and Africa, the import of oils, and the ownership of oil plantations in the Solomon Islands and central Africa (now Zaire). William Lever's wealth was founded on the considerable industrial enterprise which became Unilever *and* on his large agricultural estate in the Wirral. His huge art collection contained many British landscapes.[6] These works took meaning in relation to Lever's views on his workforce, as well as against the despoliation of north-west Britain by heavy chemical industries and the devastation of central Africa where Lever Bros 'opened up plantations in virgin forest'.[7]

By the later nineteenth century scenes of rural homelessness and unemployment competed with sunny views of the Thames, South Downs and Kent in private collections and exhibition rooms. They jostled for place with misty vistas of Scotland, scenes of North Africa and re-creations of a classical past. As it was confirmed as the locus of English heritage and hailed as a repository of national traditions and values, landscape art and its critical discourses became the ground for global battles for power over land.

Paintings of the rural working classes formed part of the regimes of surveillance which Michel Foucault analysed as characteristic of bourgeois social formations. Social investigators and high culture offered vignettes of

country figures, cottages and customs, as well as seamstresses in city attics. This surveillance was conducted not only through the formal mechanisms of state regulation such as the Census or Royal Commissions (such as that on Employment of Children, Young Persons and Women in Agriculture in 1867) but also through investigations of individuals. Claiming 'impartiality, authenticity and comprehensiveness', the *Morning Chronicle* investigated rural districts in the later 1840s, and as in its inquiries in London, it focused on overcrowded, unventilated dwellings, dirt and disease, irregular wages, intemperance, immorality and 'fearful depravity', all exacerbated by women working out of the home.[8] By the later decades social scientists had descended on the countryside: Maud Davies's *Life in an English Village* of 1909, with its photographs of a cottage and 'an old inhabitant', was produced out of her research at the London School of Economics. While they characterised the countryside and its inhabitants as backward and traditional, these social knowledges were new, the products of those self-consciously urban groups who based their bids for professional identity on this expertise.

Metropolitan landscape painters, like journalists and social inquirers, set off into the countryside to map an unknown terrain. In the mid-1880s Ellen Clacy went on painting trips in search of subjects. As she recollected in 1913, a chance encounter prompted her Royal Academy exhibit of 1885, *Will Myers, Ratcatcher and Poacher*:

> I was up North painting a Carpenter's Shop for 'background' for my (then) next Royal Academy subject I had my easel in a dark corner – and the old carpenter was mending a cradle: very quietly a tired man slipped furtively in & sat or leaned as you see him . . . after a short 'sitting' I let him go – with an appointment for the next day.[9]

The language is that of the metropolitan tourist. Based in London, the artist ventured into what she perceived, and probably experienced, as an unknown and distant region, 'up North', entirely unspecified except in its contrast to the south and London centres of cultural production and consumption.

Analytical work on metropolitanism and the cultural production and consumption of the countryside has been considerably advanced by Nicholas Green's analysis in *The Spectacle of Nature*. In his discussion of the cultural formation of a metropolitan modality of perception of the countryside, Nicholas Green argued that it was 'the material and cultural fabric of the metropolis which set the terms for the social production of the countryside'. He linked the production of landscape imagery with the rituals of its consumption in the modest practices of civil society. Drawing links between landscape art, tourism, city spectacle, the new technologies of shopping, and the urban professionalism of landscape artists and dealers, he mapped a regime of pleasure in which 'being in the country and

viewing images of nature in paint and print were equally set up as a *pictorial* treat, to be pleasurably consumed with the eyes'. The countryside was framed in pictorial terms for metropolitan entertainment.[10]

While *The Spectacle of Nature* specifically addressed a historical moment in France from the 1820s to the 1850s the broader parameters of its analysis can be put to work in the British context where class perceptions of land were shifted away from the eighteenth-century 'prospect' which bound an elite pictorialising of landscape to the preponderantly aristocratic owner-ship of land.[11] From the 1840s onwards the rapid expansion of the travel industries fostered more broadly based metropolitan patterns of enjoying the countryside, from half-day excursions to country holidays (complete with rented cottage) and artists' colonies. Viewing landscape became a leisure activity in which seeing, enjoying and picturing country scenery were separated from seeing land as property. And as landscape came to be enjoyed as a picture – in a gallery or print shop, on an excursion or a holiday, out of a train window, or in an illustrated magazine – the metropo-litan mode of perception broke the older links between viewing and owning. Tourism enabled a range of people from city dwellers to inhabi-tants of provincial towns to travel to and from the country and to enjoy its pictorial representation in a range of different cultural sites, from land-scape paintings to illustrated books and novels about rural life. The circuits of this pleasuring, consuming gaze directed to the countryside positioned bourgeois women as spectators, writers and picture-makers of landscape. At the same time this pictorialising vision focused on working-class women, and their visual representation became a prerequisite in the formation of a late nineteenth-century picturesque.

From the mid-nineteenth century increasing emphasis was given to painting out of doors, artists and art critics advocating 'truth to nature'. Like the social inquirers, landscapists staked their bids for professionalism on their claims to first-hand experience, empiricism and scientific method. Sexual difference was written into these cultural practices. Privileged by the social organisation of bourgeois masculinity, male artists – colleagues, fathers and sons – accompanied each other on excursions to the country-side: 'From one modest inn to another they travelled, mostly on foot, setting up their easels in a solitary spot, painting each subject which struck them on the way.'[12] The baggage of these rising urban professionals often included a wife and children for domestic support and recreation. Outdoor sketching was considered a suitable pastime for middle-class women whose landscape watercolours, shown to family and friends, were accompanied by inscriptions which anchored their meanings to people and places known and enjoyed. Louisa Paris, for instance, annotated her sketches with lengthy comments: 'Sketch on the Undercliffe towards Beachy Head, Mama joined us while sketching, and accompanied us afterwards to the beach under Beachy Head!! tremendous walk for her! 25th Sepr. 1852.

L.C.P.'[13] For a woman, professional practice as a landscape artist not only required specialist training, but also facilities for travel and outdoor work and, at the mid-century, some familial encouragement. Some families, however, such as the Stannards of Norwich, contended that outdoor work was inappropriate for women, and Eloise Stannard was channelled into still life.

At the same historical moment egalitarian feminists were forging a feminist politics in relation to landscape, bringing together an independent practice of the arts with new ideals of womanhood. Wearing reformed dress and sturdy boots, Barbara Bodichon, Anna Mary Howitt and Bessie Rayner Parkes went on country excursions, immersed themselves in the scenery, compared the views to works by well-known artists, and composed paintings and poems. Mobilising current metropolitan assumptions about the healthfulness of the countryside, these women redefined femininity as active, strong, working and self-determined. Loose clothing and strenuous physical activity ran counter to hegemonic definitions of femininity as interior and domestic and of the feminine body as delicate. These politics informed the depiction of *Ye newe generation* (plate 4), a sketch of Bessie Rayner Parkes astride a mountain gorge clasping her book of poems, and three drawings of Barbara Bodichon outdoors: 'absorbed', 'in ye breeze', and 'in the pursuit of Art'.[14]

Barbara Bodichon founded her work as a landscapist on assiduous sketching and painting out of doors. In the 1850s this activity was perceived as unconventional for women, and she was somewhat salaciously described by a male artist as 'a young lady . . . who thinks nothing of climbing up a mountain in breeches or wading through a stream in none, in the sacred name of pigment'.[15] Certainly women who determined to work outdoors in the following decade found themselves the target of those gazes from which bourgeois women were generally shielded:

> Painting under the Cliff last Tuesday, I was disturbed by a shower of pebbles and mud upon my white umbrella. Looking up I beheld a crowd of young ruffians chucking missiles at me with the energy of even sleepy Dorset youths. I remonstrated, I threatened; I addressed them in violent language as vagabonds, rascals, brutes and any other expletives which came in handy. But it was no use, and I ignominiously packed up my tools and retired.[16]

Tourism deposited a range of people into the countryside who were indecipherable to its inhabitants; contrasts between town and country and class conflicts fuelled this onslaught on a woman painter. In 1872 Louise Jopling became the focus of holiday-makers' curiosity.

> I am, I believe, one of the sights of the village – with an easel in the garden of Bellevue, a large white umbrella (which a gallant captain

holds over me), a youth and a maiden standing to me as models. People come and stare in at the gate, opera glasses are levelled at us in the distance, and strangers come and beg for a peep, and altogether it is very amusing.[17]

As her letter indicates, working out of doors could still be on the margins of respectability. Ten years later women who identified themselves as professional and self-consciously modern were painting 'en plein air' in the artist colonies of northern France. By the later decades, the refiguring of femininity and access to art-school training (where painting excursions were on the women's curriculum) fostered outdoor work and, with increased mobility, women such as Ellen Clacy travelled independently as part of a professional career. Some, like Ellen Gosse, painted landscapes when on holiday and many depicted their locality (plates 31 & 32). Others were chaperoned by their husbands or eschewed full 'plein air' painting, finding the required public visibility on an exposed site at odds with their codes of propriety.[18]

As travel from the city to the countryside became a central part of the professional identity of women landscapists, rural working-class women were located *in* the countryside – walking to market, to work in the fields, to the river and the drying grounds, between villages and small towns, from the woods with bundles of faggots. Particularly affected by the agricultural changes, rural working-class women were displaced from field work into casual and part-time work and domestic occupations like charring and washing. Helen Allingham's watercolours of women carrying washing, sticks or baskets of vegetables, as much as her images of cottage mothers, registered these profound shifts in women's employment and rural population. In the later nineteenth century women artists again and again worked over the theme of arduous travelling in the countryside. In Alice Havers's painting, death is *The End of Her Journey* (RA 1877) (plate 33). Ellen Clacy's *The Vagrant*, shown in Liverpool in 1876 with the lines, 'But of the wanderer none took thought/ And where it pleased her best she sought/ Her shelter and her bread', and *Whither* (Liverpool Autumn Exhibition, 1890), are among the many untraced works by women on this theme. Catherine Sparkes's *Nearing the Frontier* (RA 1881) depicts a woman, children and two men on a cart hurtling along against a stormy evening sky, while Jane Bowkett's *Four Miles More* at the same exhibition portrayed a man, woman and child 'trudging wearily along the high road to find work to do. The poor woman is nigh worn out'[19]

Landscape paintings were drawn into the vigorous contestations of meaning around land, the countryside and rural life. By the 1880s rural life was both valued and vilified for its resistance to change. The idea of the countryside as a rural retreat and bastion of ancient traditions was sternly countered by portrayals of rural society as outmoded and antiquated, in

the grip of an unreforming and unreformed aristocracy. It was equally rejected by the agriculturalists' vision of the countryside blighted by depression. Some, however, struck a note of optimism. While socialists hailed rural life as the birthright of the proletariat, for others it was to be the moral reformatory of 'darkest England'.

All these meanings for the countryside were sustained against changing representations of the city; from 1870 London was perceived as an escalating urban crisis. Travel writers, artists, journalists and social scientists intensified their surveillance of and interventions into urban working-class districts. Their publications were embellished with graphic descriptions and decorated with engravings, photographs, maps and tables. Artists of both sexes rarely portrayed the industrial workers of the city. In high culture poverty, crime, intemperance, vagrancy and the darkness of night were constituted as the condition of the urban proletariat, a vision sustained in diametric contrast to sunny scenes of the countryside and bright vistas of middle-class urban pleasure such as Elise Paget's *Trafalgar Square on a Summer's Day* of 1889.[20] Although Louisa Swift's *The Casual Ward* (Society of Lady Artists, 1872) anticipated Luke Fildes's *Applicants for Admission to a Casual Ward* (RA 1874) by two years, women artists' images of urban poverty seem to have been numerically fewer and were certainly less publicly fêted that those by their male contemporaries. Artists such as Fildes would base their exhibited pictures on studies for their illustrations for the *Graphic*, made when prowling round poor districts of London. Female contributors to the the *Graphic*, a general-interest magazine issued from 1869, were commissioned for scenes of middle-class life. Helen Allingham, a staff illustrator and reporter from 1870 to 1874, wrote a monthly fashion column and was sent to cover flower shows, ladies' social events and theatrical performances.[21] Middle-class women were not generally at liberty to wander round city streets or stray into working-class areas. Their excursions tended to be informed by social work or prompted by socialism. In the 1880s, as in the 1850s, philanthropy framed women artists' representations of the urban working classes. Louise Jopling's *Saturday Night: Searching for the Bread-winner*, shown at the RA in 1883 with the quotation, 'Pay-night, drink-night, crime-night', depicts a woman with two children pausing at the entrance to a public house. It was produced within the stance of morality on which women artists grounded their art practice and under the banner of temperance, a campaign which included a strong element of class disciplining.

THE AESTHETICS OF RURAL POVERTY

Images of harvesters and gleaners were widely exhibited during the years of 'high farming' when high yields and high profits were the predominant discursive representations of agriculture. Throughout the period of agricul-

tural 'depression', and persistently in the wet and cold seasons of 1875 to 1882, painters continued to provide sunny scenes of harvest, seemingly oblivious of the bad weather, poor crop yields and declining acreage under cultivation. Alice Havers's *'The Moon is up but yet it is not Night'* (RA 1878) shows two women walking through a field of uncut corn. It is an idyllic pastoral scene poeticised by a line plucked out of context from Byron's poem, *Childe Harold*.[22] From the later 1870s such scenes vied for attention with landscapes depicting homelessness and unemployment in desolate settings. The multiple significations of landscape – as tourist sites, picturesque views or agricultural productivity – were seriously challenged by the representations of rural poverty, inclement weather, barren land and agricultural depression generated across high culture, agricultural writing and official publications.

The work of Alice Havers indicates some of the contradictions of landscape practice in the 1870s and 1880s. During her working life she produced a wide range of work. *They Homeward Wend Their Weary Way* (RA 1876), in which a girl carrying washing and a woman weighed down with a bundle of wood trudge through a flat landscape criss-crossed by streams and punctuated by a windmill and a few trees, was one of her many paintings of rural working-class women. This category also included *The End of Her Journey* (RA 1877, plate 33); *The Moon is up . . .* (RA 1878); *Stonepickers* (RA 1879); *Rushcutters* (RA 1880); *Trouble* (RA 1882), described as 'a cottage family in time of sickness and want';[23] and *The Belle of the Village* (RA 1885, plate 34). It is not at present known where or if Alice Havers travelled in Britain for her landscapes or whether she was accompanied by her husband, Frederick Morgan, also a landscapist. *Blanchisseuses* (RA 1880) and *Peasant Girls, Varengeville* (RA 1879) were probably based on studies made in northern France near Dieppe, where there was a well-established English community. These large-scale pictures of working women were interspersed with allegorical figures of the months such as *June* and *September* (RA 1878); images of women sometimes dressed in 'Waterloo costume' lingering beside river-banks; scenes of cross-class dalliance, and pictures of middle-class family outings.[24] The one urban scene to have survived, *''Tis a Very Good World'*, contrasts two poor children, a crossing sweeper and a flower seller, to a fashionable woman and her daughter.[25]

Agricultural plenty, rural poverty, death, middle-class fun, the physical labour of working women: all are present in this varied corpus of work. *The End of Her Journey* (RA 1877) (plate 33) is a remarkable painting – in its size, and its vision. By the 1870s women who wanted academic success and professional status exhibited large-scale oils on contemporary themes or historical subjects, intervening in and so shaping the current debates about high culture. *The End of Her Journey* depicts a death. Taking place at a roadside rather than in an interior with its connotations of home and

family, this death is bleak in comparison to its more usual displacement to images of funerals, mourners and churchyards.[26] But the starkness of the event is mitigated by the painting's visual and narrative strategies.

The End of Her Journey deploys two distinct forms of visual represen-tation for suffering working-class women. The hollow-cheeked haggard image had been forged in the 1840s when art criticism invested it with the power of eliciting compassion. Three decades later, critical strictures that 'there is little in a theme of such grovelling misery [as Fildes's *Applicants* of 1874] to recommend it to a painter whose purpose is beauty'[27] combined with the intensification of discourses which founded aesthetic pleasures on the visual spectacle of woman to bring about major changes to this ima-gery. In *The End of Her Journey* full-cheeked prettiness counters emaci-ation, and both categories draw on classical precedents.

Having trained at South Kensington, Alice Havers was well-versed in the procedures for selecting poses from Greek or Roman sculpture for academic figure painting. The seated woman on the verge in *The End of Her Journey* is based on the classical relief of *Weeping Dacia*, an image of lamentation which was greatly admired in the early nineteenth century for its 'inimitable beauty'.[28] The woman standing on the left of the compo-sition echoes mourning figures on funerary monuments and her facial features are cast in a classical mould. As still as the stones on which they are based, these two female figures anchor passivity and a restrained emotionality to femininity. They frame the composition and enfold mourn-ing within it. In the distance, men and boys are hurrying along the path from the village nestled in the trees. Death is contained. The community will provide.

In *The Belle of the Village* (plate 34) the female figures have that monumentality of form, derived from Roman sculpture, which character-ises high art of the 1880s (plate 45). Whereas in the 1840s and 1850s the muscularity of working-class women was pitted against a model of petite delicacy to signify class distinctions, here sturdy anatomy is combined with dress and attributes to specify contrasted kinds of working-class feminine sexuality. This neo-classical refashioning of rural women assigns them within a class-specific system of visualisation which marks their difference. The signs of femininity, class and rurality were written on to and read from the body and facial features. The representation and recognition of these body-maps, like reading the narratives of the paintings and identifying the art precedents, contributed to the cultural identities of the artist and her audiences.

The representation of feminine sexuality around the opposition pure/impure in *The Belle of the Village* is structured by this perception. A contrast is set up between the modestly dressed washerwomen whose sobriety of dress and demeanour signifies their respectability and the bare-headed, golden-haired woman, whose open-necked bodice and dishevelled

dress display a sculpted form. At the centre of the painting, she is the target for the disapproving glances of the other washerwomen and the desiring gazes of the men sprawled beneath the trees. She looks back with that direct stare given to city prostitutes. This exchange of desire disturbs the order of sexual difference and displaces any attention to work. Produced within the debates generated by the enfranchisement of male agricultural workers in 1884, *The Belle of the Village* depicts rural men as indolent and idle by choice rather than circumstance.

Alice Havers found buyers for her paintings among prosperous industrialists. William Menelaus, the manager of Dowlais Ironworks, South Wales, purchased *They Homeward Wend Their Weary Way* in 1876 from Agnews.[29] Joseph Armitage of Manchester bought *September*; and Robert Taylor Heape of Rochdale, a textile magnate, magistrate, banker, investor and art collector, owned *The End of Her Journey*. *The Belle of the Village* was acquired by the Atkinson Art Gallery in Southport in 1889.[30] As these large exhibition pieces rarely generated sufficient income, Alice Havers, like many others, diversified her practice. She exhibited widely, sending works to the provinces if they had not sold in London. She made drawings for the *Magazine of Art* and the *Graphic*, book-illustrations, and designs for book-covers.[31] In 1888 she moved to Paris to study French painting and exhibited *And Mary Kept All These Things and Pondered Them in her Heart* in the Salon, having shown it the previous year at the Royal Academy.[32] Alice Havers's early death in 1890 precludes analysis of how decisive a shift to large-scale history painting or to French techniques she would have taken, but these were career moves on which women ambitious for professional recognition staked their claims from the mid-1880s.

COUNTRY LIVING

Unlike Alice Havers, Helen Allingham elected to work in watercolour. This medium was increasing in status in the second half of the century and attracting a range of collectors from specialists to those who appreciated its generally smaller scale and lower prices. Helen Allingham became one of its most successful practitioners, establishing a reputation for her depictions of country cottages. She was a highly productive artist who by her own estimate had exhibited over 1,000 watercolours by 1903.[33] Regular solo shows were held by the Fine Art Society in London. Her work was widely reproduced, reviewed and discussed. Her subjects and style were so well known that they were imitated, the *Art Journal* commenting in 1881 on 'one or two flagrant instances of the members [of the watercolour societies] changing their style of painting in imitation of a lady's work which just now happens to be deservedly popular'.[34] Professional recognition came with election to associate of the Old [Royal] Watercolour Society in 1875 and membership in 1890. During her own lifetime her

cottage subjects were promoted as embodying the English tradition of watercolours and hailed as representing 'the productive life which brings wealth and prosperity and happiness to a nation and lays the foundation of all that is its honour and pride'.[35] What were the historical conditions in which a woman artist achieved such pre-eminence and in which her small watercolours were invested with such profound cultural meanings?

As a young woman Helen Allingham was employed as a graphic artist on several London magazines. Her commissions included illustrations for the *Cornhill*'s serialisation in 1872 of Thomas Hardy's *Far From the Madding Crowd*, a novel whose title alone promises an armchair excursion to a region remote – in time and place – from the modern metropolis. On her marriage in 1874 Helen Allingham relinquished her graphic work for watercolours, producing portraits as well as scenes of middle-class domesticity and rural life, many of which were based on earlier illustrations. In 1881 she and her family moved to Sandhills near Witley in Surrey, already the haunt of artists and writers, and she began to produce the cottage subjects for which she became famous. Returning to London in 1888 and settling in Hampstead, she made frequent sketching excursions by rail.[36]

Helen Allingham's career as an artist was patterned by her journeys from London to the southern counties. Her art and her travels were shaped by the massive transformations in agriculture in southern England in the later nineteenth century. She found her subjects in those southern counties where land was being taken out of arable cultivation and put to pasture and grass, dairying and market gardening. Whereas in the 1870s her rural scenes featured agricultural labour as well as domestic work,[37] from the mid-1880s her watercolours most frequently depicted women and children at cottage doors, in gardens full of flowers, all bathed in sunshine.[38] Helen Allingham portrayed the countryside most affected by agricultural change, transforming overgrown hedges and ditches, uncut bracken, unrepaired fences, unimproved housing and tumbledown cottages into a rural idyll centred on cottage domesticity (plate 35).

Helen Allingham made sketches on site in spring and summer, working up her studies into finished watercolours in the studio. The figures were based on models posed in her garden or taken from studies in her note-books.[39] She commented in a letter of 1890: 'like many other artists, I paint on the spot as much as possible, working up those drawings later'.[40] Her working life was shaped by the social order of sexual difference. Whereas the ideological and material spaces of masculinity gave male agricultural writers considerable freedom of movement and access to many forms of transport, as a married woman and the mother of small children Helen Allingham was bounded by a socially determined 'inability to roam about whither she chose', and according to her biographer, 'she never sketched in public on a Sunday'.[41] In Surrey she found subjects in her locality and was often accompanied by her husband on sketching expeditions.[42] The in-

creasing mobility and independence of middle-class women which facilitated the career of her friend, Gertrude Jekyll – who from 1885 scurried around Surrey in her dog-cart, taking photographs of and notes on vernacular buildings and craft-workers – also had an impact on Helen Allingham's activities. As a widow and based in London from 1889, she travelled more widely in search of subjects.

In the late 1880s Helen Allingham worked with Kate Greenaway, going on visits and sketching the same cottages. She recalled:

> I think it was in the spring of 1888 that we went out painting together in the copses near Witley and became really *friends* One day in the autumn of 1889 [when they were neighbours in Hampstead] we went to Pinner together on an exploring expedition for subjects and were delighted with some of the old cottages we saw there. I had been pressing her ever since our spring time together at Witley to share with me some of the joys of painting out of doors. Another day we went farther afield – to Chesham and Amersham In the spring of 1890 I took my children to Freshwater, Isle of Wight and found rooms for us near Kate. She and I went out painting together daily, either to some of the pretty old thatched cottages around Farringford or to the old dairy in the grounds During the summer of that year (1890) we continued our outdoor work together, generally taking an early train from Finchley Road to Pinner, for the day. She was always scrupulously thoughtful for the convenience and feelings of the owners of the farm or cottage we wished to paint, with the consequence that *we* were made welcome to sit in the garden or orchard where *others* were refused admittance.
>
> Though we often sat side by side, painting the same object (generally silently – for she was a very earnest, hard worker – and perhaps I was, too), it seemed to me that there was little likeness between our drawings – especially after the completion in the studio. But she was one of the most sensitive of creatures and I think she felt it might be wiser for both of us to discontinue the practice of working from the same subjects[43]

Friendship patterns and codes of respectability encouraged women to work together and thus provide for themselves the sisterly equivalent of men's sketching clubs and father/son excursions, but their working relationships were constrained by critical comparisons between their works.

Helen Allingham's recollection indicates the ways in which country cottages were framed as artistic subjects. Artists, like journalists and parliamentary commissioners, started their investigations with predominant social groups, in this case 'the owners of the farm or cottage'. Helen Allingham's acquaintance with Alfred, Lord Tennyson, provided opportu-

nities for drawing cottages on his estate, and the consent of landowners facilitated other sketching occasions.

When Helen Allingham moved to Witley in 1881 she joined a well-established artists' colony. Surrey had long been popular with landscapists: Joanna Boyce Wells painted Surrey scenes, such as *Heather Gatherer, Hindhead*, in the later 1850s when she divided her time between London and the country.[44] By 1871 the Census of Surrey attributed the increased population at Witley 'to the attractions of the scenery, many artists having taken up residence in the district'.[45] Neighbours included Gertrude Jekyll, Tennyson and the artist who had popularised Surrey scenes, Miles Birket Foster. In the 1880s middle-class professionals who had settled in Surrey – artists, craft-workers, gardeners, writers and printers – socialised together, sharing the pleasures of country walks, picturesque sites, vernacular architecture, cottage gardens and wild flowers and visiting the local gentry.

Surrey was highly recommended in the tourist literature: 'The tourist in search of the picturesque will find Surrey a most attractive county, full of variety and interest'; some parts were judged 'so wild and romantic as to render it difficult for the tourist to believe that he is at so short a distance from the great metropolis'. Recommending 'picturesque lanes, old-timbered farms, trees of great age and beauty, and low wooded hills', the guide books conjured up panoramas and views in terms of pictorial compositions:

> Witley is very picturesque, especially at one point on Hambledon common, where a hill covered with pines rises right; the foreground is dotted with single trees . . .; left are cottages and an old saw-pit; and over a wooded middle distance the blue crests of Hindhead lift themselves.[46]

Tourism and artistic practices overlapped in several ways. Articles with titles like 'Rambles in Surrey' or 'Out of Doors in Surrey' recommended excursions to the art lover, archaeologist, tourist and city clerk, and extolled the countryside in pictorial terms – 'Hill and dale, wood and water, combine to form perfect landscapes.' They appeared in general-interest and art magazines adjacent to reviews of the Surrey watercolourists.[47] It is not that the one influenced the other, but rather that both created a system of visualisation in which metropolitan pleasures were generated through seeing the countryside *and* landscape art as pictorial compositions. Enjoying tourist literatures interlocked with going on excursions, country holidays and visits, frequenting art galleries and purchasing landscapes. As one reviewer commented of Helen Allingham's collection of *Surrey Cottages* in 1886, 'we cannot help thinking that this exhibition will make the neighbourhood she depicts more attractive to those who are content to seek for country beauties within easy access'.[48] These elisions

were sustained by the artist's practice of outdoor sketching in spring and summer, her watercolours most often portraying the seasons favoured by tourists.[49] Moreover the sunny blue skies and sparkling white fabrics contrasted strongly with the increasing pollution of industrial areas and the capital, so reinforcing notions of the countryside as an excellent holiday venue and the repository of health.

For cultural workers and middle-class commuters, Surrey was in easy reach of the capital and at a pleasurable distance from it. With its ancient buildings, traditional crafts and cottage gardens, the county seemed to offer an older, pre-industrial and feudal way of life, in need of preservation from its erosion by modern civilisation. Helen Allingham belonged to a circle of friends interested in rural crafts and vernacular buildings. Gertrude Jekyll often pointed out cottages, photographing them herself. Occasionally an acquaintance would organise an afternoon's jaunt, 'to an old ruinous cottage, Dickhurst, he had so often told us of, and thought Helen might like to paint'.[50] These enthusiasms were part of a country life-style. The Allinghams leased a recently built house, the design of which echoed local features.[51] This kind of architecture was popular with Surrey residents: Gertrude Jekyll was one of many clients for vernacular houses designed by Lutyens, Voysey and Shaw from the 1870s to the 1890s.[52] She commissioned a house and the 'hut' at Munstead Wood where she created a famous garden from the inspiration of Surrey's well-known cottage gardens (recommended in the guide books). As she admitted in *Wood and Garden* of 1899, 'I have learnt much from the little cottage gardens that help to make our English waysides the prettiest in the temperate world', and she collected 'hardy garden plants, mostly from cottage gardens'.[53] In *Old West Surrey* of 1904, a decidedly preservationist text illustrated with over 300 of her own photographs, Gertrude Jekyll expressed a view shared by many of this circle, 'that older life was better and happier and more fruitful and even, I venture to assume, much fuller of sane and wholesome daily interests'. She noted with regret that Surrey's 'now being thickly populated and much built-over, has necessarily robbed it of its older charms of peace and retirement'.[54] Indeed, by this date, suburbanisation and middle-class housing had done much to change the county, and tourism (days-out, coach and rail excursions, cycling tours, weekend cottages, summer holidays) had become a major industry, alongside market-gardening, calico-bleaching, printing, and the making of paper, oil, brick, candles, glass, gunpowder and cement for London markets.

To many intellectuals, socialists and manufacturers, the country cottage represented health, purity and happiness in contrast to what was perceived as the misery, dirt and disease of the industrial cities. The Allinghams were closely associated with a broadly based alliance of preservationists who worked to protect rural crafts, traditions and buildings. Although Helen was not a member of the Society for the Protection of Ancient Buildings,

her cottage scenes were certainly part of this movement. Moreover, her husband prefaced the catalogue to her 1886 exhibition with the contention that 'in the short time, to be counted in months, since these drawings were made, no few of the Surrey cottages which they represent have been thoroughly "done up" and some of them swept away'.[55] Reviews of the exhibition also drew the artist's work into a preservationist discourse, claiming that 'everyone who visits this most attractive exhibition may do something for preserving the external beauty of the cottage homes of our peasantry'.[56] Helen Allingham enhanced the 'external beauty' of her cottages by the addition of archaising details; she had a set of diamond lattice windows – and doubtless other items of architectural salvage – in her studio, which she painted in where appropriate.[57] She would add thatch or omit outbuildings as she considered necessary. With their thatched and half-timbered buildings, cottage gardens, massed trees and foliage, Helen Allingham's cottage subjects contributed to a preservationist perception of the countryside as a rural idyll lost to the present. She drew on a pictorial tradition founded in the later eighteenth century, the picturesque value of her watercolours residing in the depiction of ancient exteriors in contemporary garden settings. While her imagery was in line with prevailing views that gardening was a moral improver of the rural working classes, encouraging temperance, industry and health, more importantly perhaps, her watercolours participated in the formation of new styles of gardening led by Gertrude Jekyll, in whose publications and designs glimpses of vernacular buildings through luxuriant plantings were considered artistic and pictorial.[58] Again it is not that one cultural form or activity influenced the other, but rather that across the increasingly diverse commodifications of rurality in the later nineteenth century particular sets of visual codes and formats were recirculated to constitute the pictorial pleasures of landscape.

Against the preservationists, other reformers considered that cottages encapsulated all that was insanitary and immoral. The Royal Commission on Housing of the Working Classes in 1885 stated that in rural areas 'evils were found everywhere'.[59] In Mary Ward's novel *Robert Elsmere* of 1889 a Surrey estate is run by an agent 'who combined the shrewdness of an attorney with the callousness of a drunkard'. The estate cottages exemplified the landowner's lack of concern:

> . . . a miserable group of houses, huddled together as though their bulging walls and rotten roofs could only maintain themselves at all by the help and support which each wretched hovel gave to its neighbour. The mud walls were stained with yellow patches of lichen, the palings round the little gardens were broken and ruinous. Close beside them all was a sort of open drain or water course, stagnant and noisome Behind them rose a high gravel bank edged by firs, and a line of oak trees against the sky. The houses stood in the

shadow of the bank looking north, and . . . the dreariness, the
gloom, the squalor of the place, were indescribable

The passage is consciously visual in its account, calling up and lightly
travestying the cottage scenes of Helen Allingham, by then the most well-
known of the Surrey watercolourists. The novelist's description, given two
pages later, of the interior of one of these cottages firmly refuted the
picturesque views of the preservationists:

> Inside the hovel was miserable indeed. It belonged to that old and
> evil type which the efforts of the last twenty years have done so much
> all over England to sweep away: four mud walls . . . with no upper
> storey, a thatched roof, now entirely out of repair, and letting in the
> rain in several places, and a paved floor little better than the earth
> itself.[60]

Against those who wanted to save ancient buildings, another equally vocal
middle-class contingent of doctors, sanitarians, and writers campaigned for
new buildings and improvements, presenting themselves as a modern
morality against an outdated feudal aristocracy. In this medico-moral
discourse, characterised in Mary Ward's novel by Robert Elsmere, clergy-
man, educator and amateur doctor, the cottage was a site for conflict *in*
class as much as between classes. These debates were condensed in an
exchange which took place over Helen Allingham's watercolour *On Ide
Hill, Kent* of 1900 which pictured a group of women and children beside a
cottage situated in front of a view of countryside recently preserved
through the efforts of Octavia Hill. Far from finding the scene picturesque,
the local doctor berated the artist for painting 'a house that had more fever
in it than any other in the parish'.[61]

By the turn of the century there was some doubt as to whether country
cottages were suitable subjects for art, one writer contending: 'The agricul-
tural labourers' home nowadays does no longer suggest itself to the fancy
of the poet or the brush of the painter for ideal treatment.'[62] Yet at the
same time Helen Allingham's watercolours of cottages and half-timbered
houses were widely reproduced in those books such as *The Cottage Homes
of England* of 1909 and *Old English Country Cottages* of 1906, which
considered that ancient cottages which harmonised with their surroundings
were suitable for inclusion in art whereas modern dwellings 'entirely
opposed to all ideas of the beautiful' were not.[63] Convinced that the
English countryside was changing, its old buildings decaying and its tradi-
tions vanishing, these publications promoted Helen Allingham's waterco-
lours as works of art and as records of a disappearing rural past.

At the heart of this rural idyll was the working-class woman as mother.[64]
Whereas in the artist's early watercolours the figures conspicuously occupy
the foreground, in the cottage subjects they are usually smaller in scale and

placed in the middle ground (plate 35). Accompanied by children, animals and birds, women and girls stand in front of cottage doors, beside garden gates and within luxuriantly planted plots, the setting evoking the long pictorial and literary traditions of the *hortus conclusus* as the representation and locus of feminine sexuality. Women and girls are shown holding children, sewing, pausing in their sweeping, hanging out spotless washing, or gossiping at the gate. They are usually attired in out-of-date dresses and sun-bonnets provided by the artist herself. While all these references summoned up a past seemingly diametrically opposed to the present, Helen Allingham's cottage subjects drew on and contributed to contemporary debates about feminine sexuality. In these images working-class femininity is codified as respectable, and ordered around cleanliness, domesticity, responsible motherhood, small-size families, and correct distribution into dwellings (that is, without overcrowding which would signify an unregulated sexuality). This representation of feminine sexuality can be related to the changes in the workforce brought about by transformations of capital and technology in the later nineteenth century. The large workforce of the 1830s and 1840s was no longer required. Health and fitness, rather than sheer numbers, were now considered important by employers. For the industrialist William Lever, who owned two Surrey scenes by Helen Allingham, the cottage signified domestic femininity:

> The picture of a cottage crowned with a thatched roof and with clinging ivy and climbing roses and a small garden foreground suggesting old-fashioned perfume of flowers and a home in which dwell content and happiness, appeals straight to the heart of each of us, and there are few who can resist its quiet, peaceful influence for good.[65]

It was just such an 'influence for good' which Lever wished to cultivate with a building programme initiated in 1888 for the workers at his soap factory. The cottages, half-timbered houses and village organisation of Port Sunlight re-created rural patterns of settlement destroyed by the industrialisation which had made Lever's fortune.

In Helen Allingham's images of country cottages women do not engage in paid labour. At the historical moment when women's employment was shifting dramatically these images extract the feminine body from productive labour, specifying it instead for its reproductive utility. It was a visual move which coincided with concerns for responsible motherhood, healthy children and the fitness of the population.[66] Its address to working-class feminine sexuality parallels the representation of middle-class domesticity in works by Edith and Jessica Hayllar (plates 22 and 23). Helen Allingham's cottage scenes successfully amalgamated domestic painting and landscape, two strands of art practice which were promoted in the nineteenth century as representing English heritage and national traditions. It was this powelful combination of the rural idyll and domestic

femininity that enabled the working-class woman at the cottage gate to signify social order.

SEA-CHANGES AT NEWLYN

In 1885 Elizabeth Armstrong (later Forbes), accompanied by her mother, settled in Newlyn. The arrival of artists in this Cornish town from the early 1880s coincided with a period of expansion and prosperity. The harbour was extended by the building of the south pier from 1884 to 1886 and the opening of the north pier in 1894; and large warehouses replaced the old cottages along the Cliff. The fishing industries for mackerel, pilchard and herring were rivalled only by tourism; the railway disgorged shoals of holiday-makers every summer. The painters assisted in Newlyn's transformation, taking an interventionist role in the town's economy; they rented rooms, commissioned houses and purchased the studios erected by speculative builders. When some of the settlers drifted away, Elizabeth and her husband Stanhope Forbes opened an art school to attract others. While these middle-class citizens employed the Newlyners as artists' models and household servants, they socialised with each other, organising a whole spectrum of social rituals from studio showings to dinners and theatricals to preserve their separate and distinct social identity. As careerists they bought into the system of annual production of large oils for London exhibitions, going for the academic prestige of the Royal Academy rather than the more self-consciously modern venues like the New English Art Club. And the Great Western Railway which brought the visitors and the artists carried back paintings to London.[67] It was in these overlaps between social and professional spaces, in the meshing together of high art and holiday-making, in the visual coincidences between Royal Academy paintings and tourist photography that a specifically metropolitan perception of Newlyn was formed, for, as Nicholas Green has argued, 'the artistic invasion was paradigmatic of metropolitan colonisation more generally'.[68]

The artistic colony was structured by profound contradictions. The artists identified themselves as modern against their perceptions of Newlyn's archaism and its 'naturally picturesque' subjects.[69] But the commercial enterprise of the artists, as much as the modernisation of the fishing industries, so changed Newlyn's economy and its appearance that by the later 1890s the artists became nostalgic for the Newlyn which they had created in their paintings. A limited repertory of visual motifs – work-clothes, fishbaskets, boots, sou'-westers, aprons, fish nets – and settings connoted a pre-industrialised way of life governed not by finance capital or global trade but by nature, the sea and the seasons.

This representation was underwritten by a rigorous ordering of sexual difference in the paintings and the arrangements of the artistic colony. In their exhibited pictures male artists heroised masculinity as seafaring

fishermen or shore-based craftsmen, while depicting women in cottages or at the quayside anxiously waiting or hopelessly sorrowing. Women's active work in the fishing community – selling, gutting and packing fish, netmending, knitting guernseys, sewing oilskins and flannels, curing and preserving – as well as their skills in household management and child-care, were only obliquely referenced.

The perception of Newlyn painters as 'a brotherhood of the palette'[70] coincided with the emergence of new artistic identities which welded masculinity and modernity. These identities were supported by a range of artistic practices, the organisation of art groups and the emergent critical discourses on the modern, all of which privileged masculinity by excluding or marginalising women artists, while positioning women as the wives of respectable professionals or the mistresses and models of self-proclaimed 'bohemians'. Caroline Gotch[71] and Elizabeth Forbes encountered tensions between their social roles as women and their activities as artists. As painters they negotiated the contradictions between the protocols of respectable femininity and the colony's definitions of modernity as outdoor painting on the beach, quayside and streets.

Before she married Stanhope Forbes in 1889, Elizabeth Armstrong often worked in London or rented a studio in St Ives, where the artistic colony included Marianne Stokes.[72] With her etchings, shown in London, Elizabeth secured membership of the Society of Painter Etchers in 1885. As a printmaker her contacts were with Whistler and Sickert whose claims to modernity were at odds with those of the Newlyn school. Perhaps because of printing difficulties in Cornwall, perhaps because of Stanhope Forbes's disapproval, she ceased etching and relinquished her membership of the Painter Etchers on her marriage.

Work at Pont Aven in Brittany in 1882 and in the Netherlands in 1884 skilled Elizabeth Forbes in 'plein air' painting and familiarised her with the pictorial vocabulary of the modern painter: old buildings, cobbled streets, peasant costumes, traditional customs.[73] But at Newlyn where 'the possibility of painting out of doors is what principally has made this part of Cornwall famous, and originated the "Newlyn Brotherhood"',[74] the artist discovered that European artistic practices did not translate easily across the Channel. Certain codes of feminine decorum conflicted with the public visibility entailed in setting up an easel on the beach or quayside, surrounded by a crowd of spectators, and with the casual transactions and associations with strangers necessary for hiring the men and women of the fishing community as models to give the required authentic flavour. At first she worked in a net-loft cum marine stores.[75] Later as a respectable married women she elected to paint in a 'hut for outdoor work', in her own garden, *At the Edge of the Wood* (RA 1894) being 'painted a stone's throw from her studio, within the boundary of her domicile'.[76] Although these huts were also used by male artists who moved them about the countryside

for controlled views and lighting effects, modern painting as defined at Newlyn required working on the canvas 'en plein air'. In the privacy of her workroom or in the seclusion of her garden Elizabeth Forbes could pose her models away from public scrutiny and without turning herself into a public spectacle. On trips abroad she sketched and painted out in the countryside, chaperoned by her artist-husband.[77] By these means she avoided the experiences of those independent women who courageously set up their easels and worked alone, only to find themselves the target of curious gazes or even hostility.

Elizabeth Forbes distanced herself from the fishing subjects with which Newlyners were generally identified. Like several others she painted cottage interiors and street scenes set in Newlyn, and landscapes with figures. She stated that she made a conscious decision in Britanny to take up subjects of children:

> I soon realised that I lacked the power to give expression to what moved me so greatly in its larger aspects, and I turned to the quaint child-life of the place which delighted me.[78]

Paintings of children were deemed appropriate for women artists. With an exhibition entitled *Children and Child Lore* at the Fine Art Society in 1900 they proved marketable and successful. The artist often worked with hegemonic definitions of sexual difference. In *Critics* (*c.* 1883–5) a girl holding a baby watches a boy drawing on the wall, the very embodiment of the mythology of innate masculine genius.[79] But in *School Is Out* (plate 36), a large Royal Academy exhibition piece of 1889, she represents a less prescribed set of gendered roles for the children while demonstrating her considerable skills as a modern painter. Socially positioned in the feminine, and therefore excluded from the Newlyn practice of outdoor painting on the seafront, Elizabeth Forbes made a bid with *School Is Out* to redefine modernity as it was being constituted in England in the 1880s. She intervened in the current debates, shaping definitions and challenging them. The depiction of light falling into the room, the tonal juxtapositions, the assured brushwork are all hallmarks of recent developments in French painting techniques and their skilful deployment stakes her claim as a modern artist. The subject of the painting, however, collides with the definitions of the modern emerging in the masculine avant garde. Portraying the newly professionalised woman teacher assisted by a female pupil teacher and surrounded by children at the end of a school-day, *School Is Out* is an image of a modern middle-class woman at work.[80] The painting therefore takes issue with, and indeed contradicts, masculine versions of modern art. As feminist art historians Carol Duncan and Griselda Pollock have powerfully argued, masculine definitions of modern art and masculine identities of the modern artist have been founded on the commodification of the body of woman.[81] The pleasures invoked by *School*

Is Out were not those incited by depictions of working-class women as sexually available, but those residing in the portrayal of a modern professional woman and her class disciplining. The significant challenges by women artists to definitions of the modern on the terrain of femininity have been written out of those modernist histories which celebrate masculinity and its signs. And it is these sexually differenced collisions in the definitions of modernity and femininity which were central to the art practice of women in the later decades of the century.

10

CULTURAL COLLISIONS

JOHN RUSKIN vs ANNA MARY HOWITT

In 1856 two women friends, ambitious for professional recognition and critical notice, completed their first large-scale historical paintings. Anna Mary Howitt put the finishing touches to *Boadicea Brooding over Her Wrongs* for which Barbara Bodichon modelled for the warrior queen,[1] while Joanna Boyce completed *Rowena Offering the Wassail Cup to Vortigern*. Both pictures were sent to the Royal Academy and both were rejected.[2] Undaunted, Anna Mary Howitt despatched *Boadicea* to the Crystal Palace exhibition where it met a mixed reception from critics. While reviewers considered it promising, 'daring and genuine in aim', they were critical of the forest setting, dismissing it as 'Botany not Art'.[3] The painting attracted the notice of John Ruskin who, in a letter rather than in his published criticism, advised Anna Mary Howitt to desist from such elevated themes and paint still life instead. 'What do *you* know about Boadicea? Leave such subjects alone and paint me a pheasant's wing.'[4] According to the artist's mother, Ruskin's disapproval was devastating:

> Our daughter had, both by her pen and pencil, taken her place amongst the successful artists and writers of the day, when, in the spring of 1856, a severe private censure of one of her oil paintings so crushed her sensitive nature as to make her . . . withdraw from the ordinary arena of the fine arts.[5]

While Mary Howitt blamed Ruskin for terminating her daughter's successful career, what was at stake in this collision between the eminent critic and the young woman painter were the larger issues of women's identities and activities as artists.

In the 1850s when the numbers of women history painters increased and some, like Emma Richards, were attracting royal favour, history painting became the most contentious arena of women's cultural intervention, in which women challenged the sexual differencing of the artistic hierarchy which ascribed the most prestigious category of history painting to men and

187

allocated the less valued forms of still life to women. It was as history painters that women encountered the greatest opposition to their training. Even when women were admitted to the Royal Academy schools after 1860, they were excluded from the life class, considered essential for the history painter. It was the Royal Academy schools, therefore, which became the target of a concerted campaign for women's art education, launched in the later 1840s when women artists like Anna Mary Howitt made their presence known by attending the Academy's public lectures.[6] To counter their exclusion Anna Mary Howitt and Joanna Boyce had studied in Europe, so preparing themselves for the season of 1856.

Boadicea and *Rowena* portrayed women of ancient British history. Joanna Boyce pictured the single figure of Rowena by marriage with whom the Saxon Hengist, who had defended the Britons from the Scots and Picts, gained the territory of Kent. These depictions of women countered prevailing ideas of historical agency as the biography of great men, and consensual ideas of women's passivity and dependency. The challenge made by Anna Mary Howitt and Joanna Boyce was therefore not simply about women's rights to work in an elevated category of art, but an interrogation of the hegemonic definitions of femininity represented in high culture.

Anna Mary Howitt and Joanna Boyce made calculated interventions as women history painters. The rejection of their works by the Royal Academy, the attack on Anna Mary Howitt's *Boadicea* by Ruskin, the failure to award any commissions for the decoration of the new Houses of Parliament to women, were all part of a collision over the definitions of culture and cultural production polarised by sexual difference. Viewed from the perspectives of women's art history, the debate between Ruskin and Anna Mary Howitt, although it took place in private correspondence, marked as significant a dispute over art practice as that which was staged some twenty years later in the trial between Ruskin and Whistler, a highly public encounter which has been perceived as a turning point in the development of English art.[7] Anna Mary Howitt's bid for cultural status ran counter to Ruskin's contention, expressed in a letter to the artist Anna Blunden, that 'no woman has ever been a great painter yet', an opinion which was founded on his belief that women should occupy a secondary, dependent position in culture and society.[8] For Anna Mary Howitt the events of 1856 were decisive – she abandoned her career as an artist.[9] *Boadicea*, however, was a landmark in women's art. In taking as her model Barbara Bodichon, an egalitarian feminist already well known for her public campaigning for the reform of the married women's property laws, Anna Mary Howitt visibly elided the contemporary activist with the warrior queen who defied and outwitted Roman imperialism. At one level, therefore, *Boadicea* was produced and could be read within women's struggles for equal rights – in law, property, education, work, culture

and history. And for the community of women who recognised the model, *Boadicea* articulated a feminist politics of representation.

ELIZABETH SIDDALL:
WOMAN IN THE RELAY OF THE GAZE

Elizabeth Eleanor Siddall left her employment in the millinery trade to become an artist's model. Encouraged by the Pre-Raphaelite cult of expressive genius unfettered by academic training and given intermittent tuition and advice, she worked as an artist, continuing to sit occasionally as a model. On a visit to Sussex in the spring of 1854 Elizabeth Siddall posed for Barbara Bodichon, Anna Mary Howitt and D.G. Rossetti who wrote of the occasion: 'She is looking lovelier than ever Everyone adores and reveres Lizzy. Barbara Smith, Miss Howitt, and I made sketches of her dear head with an iris stuck in her dear hair.'[10] In the drawings by Barbara Bodichon and Anna Mary Howitt Elizabeth Siddall is portrayed with a massive forehead, columnar neck, large heavy lids and averted gaze. As in Rossetti's drawings, her appearance is reworked into a blank and passive mask of beauty.[11] This visual transformation of Elizabeth Siddall by both women and men of the bourgeoisie was facilitated by the relations of class power which shaped the exchange of looks between artist and model. Barbara Bodichon firmly distanced herself from this working-class woman, writing, 'Miss S. is a genius and very beautiful and although she is not a lady her mind is poetic.' She warned Bessie Rayner Parkes that 'She is of course under ban having been a model (tho only to 2 PRBs) ergo do not mention it to any one.'[12] For these middle-class women, friendship networks were based on familial alliances and their egalitarian feminism was class-specific. Rather than promoting Elizabeth Siddall's career as an artist – by buying her work or securing commissions for her – they treated her an an object of philanthropic concern who needed hospitalisation as an invalid.[13]

Elizabeth Siddall resisted her transformation by the aesthetic and the philanthropic gaze. In her work as an artist, begun in 1852, and in her poetry[14] she persistently addressed the look of women. *The Lady of Shalott*, one of her first recorded works, takes its subject from Tennyson's poem, first published in 1842 (plate 37). The Lady of Shalott is held by a mysterious curse to weave 'a magic web of colours gay' depicting scenes reflected in the mirror. When Sir Launcelot 'flash'd into the crystal mirror' the Lady turns from her task to look down on Camelot:

> Out flew the web and floated wide;
> The Mirror crack'd from side to side;
> 'The curse is come upon me,' cried
> The Lady of Shalott.

Elizabeth Siddall's drawing resists the narrative trajectory of the poem in which the Lady, dying, floats by boat down the river to Camelot. In Rossetti's illustration for Moxon's edition of Tennyson's *Poems* of 1857 Launcelot gazes at the dead woman, scrutinising her face: woman is constituted as cursed, helpless, dying. Rich textures of fabric and drawing delineate the sensuous curves of the feminine body, and the fairness of the iconic face is presented for the pleasure of the masculine gaze.[15] By contrast, Elizabeth Siddall pictures a cool, airy and spacious workroom with evidence of past labour. This setting is similar to that in her drawings of *St Cecilia*, based on Tennyson's poem 'The Palace of Art', in which a woman artist is located in a plain interior, reminiscent of a nun's cell; in one version of *St Cecilia* there is a crucifix and quatrefoil icon of the Virgin.[16] This contrast between interior and exterior, glimpsed through the apertures, not only carried an ideological separation of the spaces of masculinity and femininity but also constituted art as an activity distanced from the external world, a theory being elaborated in Pre-Raphaelite circles of the 1850s against the predominant critical discourses of realism.

The Lady of Shalott's long robe, her uncovered head and loose hair connote her purity; her piety is indicated by the crucifix, a detail added by the artist, along with the furniture and bird perched on top of the tapestry frame. The purity of the Lady was perceived and understood against the impure woman figured in many guises from the adulterous Guinevere (never depicted by Elizabeth Siddall) to the prostitutes in her drawing *Pippa Passes* (plate 29). The Lady is constructed as chaste and calm, set apart, physically and sexually, from the chivalric practices of the Arthurian court presided over by Guinevere. The Lady is not offered as a spectacle for the masculine gaze. Seeing, not only seen, she is represented at the moment of her look.

Women's looking was imaged in several works by Elizabeth Siddall: the exchange of glances in *Pippa Passes*, Margaret's vision of her dead lover in *Clerk Saunders*, the search for a sight of ships at sea in *The Ladies Lament for Sir Patrick Spens*. *Lady Clare*, also based on a poem by Tennyson, depicts a moment of recognition and refusal in which Alice, a servant, tells Lady Clare that she is not nobly born but Alice's own child. As Alice reaches up to look into her daughter's face, Lady Clare presses her hand against her mother's face, rejecting her vision and her speech.[17]

Nineteenth-century beliefs about love, sexuality and class structured the representations of the medieval past. In *Lady Clare*, dynastic marriages to secure feudal power based on land are reworked into notions of romantic love, affective election and companionate marriage which were all specific to the nineteenth-century bourgeoisie, masking the class and gender determinants of capital and kinship. Medieval ideals of courtly love and chivalry provided models for relations of sexual difference with polarised distinctions between the spheres of masculinity and femininity.

190

Medieval subjects were developed from reading *Morte d'Arthur* and Froissart's chronicles of the wars of the fourteenth century, along with more recent publications such as Scott's *Minstrelsy of the Scottish Border*[18] and Tennyson's *Poems*. Specific visual strategies and devices were developed from a careful study of medieval manuscripts.[19] A deliberate awkwardness of figure drawing and unsettling shifts of perspective opposed Renaissance notions of anatomy and perspective enshrined in academic traditions. This pictorial language was combined with fourteenth-century dress and archaised furniture to image a medieval past diametrically opposed to the modern present. Subjects of the tournament such as Elizabeth Siddall's *The Woeful Victory*, or of chivalric quest such as her studies of *Sir Galahad*, were developed in Pre-Raphaelite art from about 1856 to 1864. In Elizabeth Siddall's *Lady Affixing a Pennant to a Knight's Spear* the scene takes place away from the departure for battle or crusade. The disposition of the two figures encodes femininity as submissive and attentive against masculinity as action. But there are no characters, no stories, no visual clues to facilitate a narrative reading or to point to events outside the frame, no descriptive details which carry a moral message. This watercolour articulates a different order of visual statement to academic history painting or modern-life subjects. In terms of an art history concerned with priority the work is innovative. But it is also path-breaking in another way. As in Siddall's watercolours, highly textured studies or simple line drawings, the woman in *Lady Affixing a Pennant to a Knight's Spear* wears a plain, unadorned dress. Described with bold, flat slabs of colour, this robe shrouds rather than displays the figural form, displacing it from a desiring gaze. There are no decorative patterns to elaborate the surface or captivate the eye.

Elizabeth Siddall's art has been viewed as expressive biography, as illustrations to the story of her life and love. This closed circuit can be broken by situating the artist's work as interventions into and against an art practice in which woman was produced as an explicitly visual sign of masculine pleasure. Rossetti's drawings, in particular, reiterated a set of visual codes and devices, extrapolated from but not representative of Elizabeth Siddall's own features, to signify femininity as visibly different. The object of the gaze of others, Elizabeth Siddall was admired by men and women of the bourgeoisie for her beauty and codified in their drawings for her *to-be-looked-at-ness*. Her images addressed the desires of women and for women, women looking and the look of women.[20] Elizabeth Siddall's art was inscribed at the very centre of an emergent regime of representation and spectatorship which was concerned with the cultural management of sexual difference.

THE SEARCH FOR HEROINES

Now there are occasions, in which an abstract quality of thought is far more impressibly and intelligently conveyed by *impersonation* than by *personification*. I mean Aristides might express the idea of justice; Penelope, that of conjugal faith; . . . Iphigenia, the voluntary sacrifice for a good cause; . . . Jephthah's daughter, heroic resignation and self-denial, . . . Eve not as Milton but as maternity, . . . Hagar as the poor cast-away driven forth with her boy into the wilderness; Rebekah as the exultant bride; and Rachel as the mild, pensive wife. They would represent in a very complete manner, contrasted phases of the destiny of Woman.[21]

Anna Jameson, an art historian whose writings were concerned with the imagery of women in high art, set out a theory of representation familiar to viewers and producers of those paintings which took their subjects from literature, the bible and history. Many middle-class women who attended art galleries would be unfamiliar with the texts on which such pictures were based, since their education would not necessarily have included any serious study of Greek, Latin or history. In the exhibition room, however, the repetition of certain figures assisted their recognition, while a selected quotation printed in the catalogue pointed to an interpretation. But as Anna Jameson indicated, texts were frequently reinterpreted and the meanings attached to particular characters often changed. Differing meanings could be sustained in communities of writers and readers, artists and spectators.

From the 1840s onwards women artists and writers were researching and chronicling the women who made history. Their focus was almost exclusively regal and aristocratic, for these socially elevated heroines provided examples for contemporary forms of bourgeois femininity and concepts of ladyhood. The prolific historian Agnes Strickland outlined her moral imperative in the preface to *The Lives of the Queens of Scotland* of 1850:

The biographies of Royal Females who have played distinguished parts in the history of a country – especially those who have been involved in the storms caused by revolution in public opinion – afford not only instances of lofty and heroic characteristics elicited by striking reversals of fortune, but the most touching examples of all that is lovely, holy and endearing in Womanhood.[22]

History became a site for struggles over definitions of femininity. Conflicting versions of the past in pen and paint, each backed with substantial historical research, argued for differing interpretations of the past and offered contending precedents for the present. In the 1860s several women who had already established reputations as painters of modern-life subjects

shifted to the production of history painting. Rejecting the prevalent images of women as passive, dependent, mourning or sorrowing over the vicissitudes of romantic love, they depicted those 'lofty and heroic characteristics' of courage, fortitude and assertive action.

The history of Mary Queen of Scots was considerably debated in the nineteenth century. Accounts of her purity and innocence collided with allegations of her complicity, criminality and sexual impropriety. For Agnes Strickland, a positionality in the feminine made all the difference:

> If the favourable opinions of her own sex could be allowed to decide the point, then may we say that a verdict of not guilty has been pronounced by an overpowering majority of female readers of all nations, irrespective of creed or party
>
> . . . to the honour of her womanhood be it repeated, that not one person of her own sex, from the wives of the Regents Moray and Mar down to the humblest serving-maid in any of her Palaces, could be induced to corroborate the slanders of her successful foes, by deposing a word to her disadvantage.[23]

Carefully sifting her documents and setting Mary's purity, goodness and virtue against the perfidy, personal ambition and treachery of those who had plotted against the Scottish Queen, Agnes Strickland took issue with previous historians, concluding that 'the innocence of the royal victim is manifested by the variety and number of the monstrous fictions . . . devised against her'.[24]

Henrietta Ward turned to the writings of Agnes Strickland for her Royal Academy contribution of 1863 which depicted Mary Queen of Scots on the morning of 23 April 1567 conferring to the Earl of Mar the care and education of her son, the future James VI of Scotland and I of England (plate 38). For Henrietta Ward, as for Agnes Strickland, history was made as much by women as by men, as much in the nursery as on the battlefield. The scene takes place at Stirling Castle, the traditional nursery for the royal children of Scotland. According to Agnes Strickland, Mary's conduct was inspired by 'purest feelings of maternal love and solicitude for the safety, health and weal of the babe'.[25] Mary stands tall and erect in her widow's weeds at the centre of the composition, poised between the world of the women – her ladies-in-waiting and the Countess of Mar bending over the crib – and the world beyond, where her horse is waiting. This dignified representation of the Scottish queen departs from the portrayals by male artists who invariably depicted Mary Queen of Scots bursting into tears, fainting and incapable of ruling, or as a wicked and devious conspirator.[26]

For their spectators one of the pleasures offered by history paintings was unravelling the story. Readers of Agnes Strickland's account would have been familiar with the consequences of the event: Mary will never see her child again, Mar will betray her, Boswell will abduct her and force mar-

riage. Other pleasures were constituted in assessing the artist's historical accuracy. Painters studied costume books, portraits, antiquarian sources and historical documents, extracting information and blending details. Journalists pointed out that the cot was painted from the original and they praised 'the accessories, which have been chosen with an eye to historic fidelity'.[27] There were also the pleasures of witnessing the disputes between historians. One review of Edward Matthew Ward's *The Night of Rizzio's Murder* (RA 1865) considered that:

> In choosing Froude for his authority the painter seems to indicate that he accepts the more criminating view of Mary Stuart's character, which recent revelations have done so much to confirm, and in doing so he, of course, sets aside the feminine pleadings of Miss Strickland, which as becomes her sex, Mrs Ward has illustrated[28]

According to the critics the choice of historian was sexually determined.

For viewers in 1863 the depiction of Mary Queen of Scots had political and religious resonances. *Queen Mary quitted Stirling Castle* . . . (plate 38) was produced across the varying histories of politics, religion and monarchy in the sixteenth century and the power relations between England and Scotland. The painting negotiated the practices of delegated child-care in aristocratic families in Scotland to emphasise the significance of Mary's resolution as queen and mother to have her son educated in the Protestant religion. This decision enabled the joint rule of the two kingdoms from 1603 and the Act of Union which formally united Scotland and England and ensured the Protestant succession in 1707. Paintings depicting the trials and tribulations of deposed monarchs were generally perceived within the predominant Whig view of the British past as a progression towards 'liberty', safeguarded by the Protestant succession.[29] Whereas for Agnes Strickland Mary Queen of Scots contributed to this development, for Froude, as for many other historians, the Catholic Queen represented the treacherous foe of liberty and of Protestantism.[30] The choice of historian was therefore determined by an artist's political perspectives and formative of his or her visual image of Mary Stuart. Furthermore, the cultural interest in Scotland, manifested by the numerous paintings of its past and its landscape in the 1850s and 1860s, was shaped by a broader concern which, in promoting an interest in things 'Scottish', legitimated a variety of English interests – industrial, commercial, touristic and monarchic – north of the border.[31]

Henrietta Ward's *Queen Mary quitted Stirling Castle* . . . was fêted by critics who asserted that it was 'thoroughly a woman's subject, which a woman's heart and hand may best understand and paint', a picture which 'afforded full scope for the artist's womanly and domestic feeling'.[32] Critical debate was reduced to a sexual categorisation in which bourgeois

femininity was construed as expressed on and embedded in the canvas. But in securing this single and unitary meaning for the painting, reviewers evaded discussion of an event central to the history of the British monarchy and unionist politics.

The political weighting of Henrietta Ward's *Queen Mary quitting Stirling Castle . . .* contrasted sharply with the historical paintings by Fanny McIan and Emily Mary Osborn whose *The Escape of Lord Nithsdale from the Tower in 1716* (RA 1861) depicted the Countess of Nithsdale effecting the flight of her husband, imprisoned for his support of the Stuart cause.[33] Fanny McIan's sympathies with the Jacobites prompted subjects such as her centennial *Highland Refugees from the '45 on the Coast of France* exhibited in 1845. *The Highlands, 1852*, first shown in 1852, was a vast canvas of over seventy figures, portraying those dispossessed by the clearances:

> The first of sixteen families is leaving the shore to the piper's wailing notes. The head of the family silently pulls his bonnet over his brow, while his young wife and child look out with withheld tears, the former gazing for the last time at what was once her home, and the old broken-hearted father cowers down in the boat with his face buried in his hands. On the shore are collected other houseless families, bidding or looking a last adieu to the emigrants, and themselves engaged in the harrowing preparations for departure. The only unmoved spectator in the scene is the sailor who has charge of the boat.[34]

Now lost, this large and important painting is only known through contemporary reviews.

Rebecca Solomon, like Henrietta Ward and Emily Mary Osborn, shifted her artistic practice from modern-life painting to historical subjects in the later 1850s. This career move was probably motivated by desires for greater critical recognition and ambitions for success in that category of art which had greatest academic status. Religion and politics framed the subject of her contribution to the Royal Academy exhibition of 1862, *Fugitive Royalists*, also known as *The Claim for Shelter* (plate 39). The picture departed from most depictions of the English Civil War which were either partisan – glorifying combat and military leaders – or portrayed star-crossed lovers. Although various narratives were fabricated by reviewers, according to the *Art Journal* the painting depicts a Royalist and her son being offered refuge by a Puritan woman whose sick child lies asleep, a bible open on her knee.[35] Contrasts in the posture and dress of the two women indicate their political allegiances. But an alliance is formed between them. The accompanying quotation, a line from *Troilus and Cressida*, 'One touch of nature makes the whole world kin', sets its terms as motherhood. Maternal sentiment was one of the most popular critical

195

interpretations of women's paintings, avidly searched for in the woman artist or in her depictions of women. The critic of the *Illustrated London News* was delighted with the painting, claiming that, 'It is difficult to imagine a subject more felicitously conceived, or more likely to be rendered by a lady.'[36] Motherhood was constituted as the apex of femininity and generally regarded as the main source of women's pleasure and well-being. Across a range of texts from medical studies to women's deportment books, from paintings to art criticism, woman as mother was constituted a sign of social order and stability. But if *Fugitive Royalists* participated in the social regulation of femininity as motherhood, it also contributed to the contemporary representation of women's friendship in high culture (plate 21). In imaging these mothers of the past, women artists were exploring different interpretations of this role. They represented motherhood not simply as an exclusive bond between the mother and her child, but as constituted in broader social and political frameworks. Whereas Henrietta Ward's modern-life paintings such as *'God Save the Queen'* (plate 14) pictured femininity as domestic and maternal, her historical works of the 1860s such as *Queen Mary quitted Stirling Castle* . . . explored the relationships between womanhood, the Crown and the State at a period when Queen Victoria became increasingly remote from her subjects.

Motherhood was also redefined in the portrayals of the Early Christian martyrs, Vivia Perpetua and Felicitas, who were imprisoned and killed in AD 203. Both chose death for their faith above life as mothers. These two figures were of particular interest to Owenite and Unitarian women who supported the anti-slavery campaigns in the northern states of America and egalitarian feminism. Margaret Gillies's *Vivia Perpetua in Prison* of 1858, based on the dramatic poem by her friend Sarah Flower Adams, showed Vivia Perpetua at prayer.[37] Eliza Fox, who as a young woman had been befriended by Sarah Flower Adams and Margaret Gillies, painted *St Perpetua and St Felicitas* in 1861 and like her mentor she sent her picture to the Society of Female Artists. Eliza Fox depicted St Felicitas as a Black woman of African descent.[38] The representation of a Black woman raises important questions. Who modelled for the artist, and what did she think about her image? In this charged dynamic, what were the relations of power between the two women and how was this negotiated in the painting? As the picture has not been traced, the way in which the Black woman was visually represented cannot be assessed. Although she recollected that her subject had been inspired by Anna Jameson's account of the two women, 'both young, both mothers, with nothing to sustain them but faith, and that courage from on high',[39] Eliza Fox would undoubtedly have drawn on the dramatic poem in which it is Felicitas who converts Vivia Perpetua to Christianity. Sarah Flower Adams stated that although Felicitas had been enslaved on earth, she had no master in the sight of God. It is probable that this painting by a woman artist who was undoubtedly an egalitarian and a

feminist and probably an abolitionist represented Felicitas in a dignified manner.

RE-SIGNING WOMAN

In the later 1860s and early 1870s the photographer Julia Margaret Cameron and the artist Marie Spartali produced a cluster of images which engaged with a newly defined visual field in which aesthetic pleasure was invested in the visual spectacle of woman. Their cross-generational project (the photographer was over twenty years older than the painter) utilised the two women's reading, their extensive knowledge of pictorial conventions, and Marie Spartali's Greek heritage (her father was Greek Consul in London). Drawing on painterly and photographic protocols of dress, pose and attributes as well as popular middle-class entertainments of charades, theatricals and *tableaux vivants*, the photographs, drawings and paintings depicted invented characters or re-created figures from literature and history. For Julia Margaret Cameron's photograph of *Mnemosyne*, the mother of the muses, Marie Spartali is pictured in a loose robe; her hair, braided on the crown, falls over one shoulder, and she holds a strand of ivy (plate 40).[40] There was an exchange, a reciprocity between Julia Margaret Cameron's photographs of Marie Spartali and the artist's early works, her self-portraits and the half-lengths of women (plate 41) with which she launched her career. Playing with the masquerade of femininity and the making of appearance, this collaboration worked with and against the emergent artistic strategies and critical discourses of Aestheticism. From the 1860s onwards narrativity and moral messages gave way to aesthetic pleasures projected on to the visual spectacle of woman. Images which focused the gaze on to highly stylised facial features, a body swathed or sculpted in rich drapery and adorned with sumptuous accessories, evoked a positionality for masculinity – spectating, coveting, possessing – which was supported by the homosocial relations between artists, critics and buyers.[41]

How did women artists deal with this reduction of woman to visual icon? When the philanthropic gaze faltered, when distinctions between pure and fallen collapsed, when this field of vision and power for middle-class women was destabilised, how did women artists engage in visual representation? How did they negotiate signifying systems in which woman as sign, to rework Elizabeth Cowie's proposition, signified not woman but masculinity,[42] to produce and exchange woman as a sign of women's pleasures, women's cultures? From which viewing positions and spaces of femininity could different meanings be sustained? These questions cannot be answered by a nineteenth-century recourse to biologism and essential femininity. An interrogation of the meanings of this constellation of images by Julia Margaret Cameron and Marie Spartali, or of comparable works by Rebecca Solomon, Emma Sandys or Constance Phillott,[43] necessitates an

investigation of the distinct modes of representation and spectating in which woman as sign was re-signed by women.

In a self-portrait drawing of 1871 Marie Spartali depicted herself in sixteenth-century dress, with her arms resting on a parapet and one hand holding a fan. The gaze, serious, steady, direct, engages the spectator.[44] While the artist draws on the codes of Venetian art already re-used by male artists such as D.G. Rossetti, her self-image has none of the tousled hair, opulent costume, lavish jewellery, or stylisation of lips and eyes. Facial features and fabrics are not spread out flat to create that highly decorative surface considered stimulating to masculine sexual and aesthetic pleasures. Marie Spartali manages the slippage between pure and fallen to negotiate that respectability essential for a woman artist's self-portrait, and although this self-image, like Julia Margaret Cameron's photographs, may be a depiction 'in character', the reference is not to Venetian courtesans but women's achievement in the arts, the subject of the artist's early works.

The Lady Prays Desire (plate 41) depicts the allegorical figure who 'by well doing sought honour to aspire' in Spenser's *The Faerie Queene*. Two lines from book two, canto nine, were quoted in the catalogue of the Dudley Gallery exhibition in 1867 where the artist made her debut.

> Pensive I am and sad of mien,
> Tho' great desire of glory and of fame.

Marie Spartali completely reworked the iconographic allusions, replacing the Lady's poplar branch (sacred to Hercules) with olive leaves which, together with the owl, book and inscription, signify the presence of Athena, goddess of war and of wisdom.[45] The theme of ambition for public success was reiterated in its companion, *Korinna, the Theban Poetess* which, according to one contemporary, was a self-portrait.[46] *Procne in Search of Philomela* of 1869 portrayed the woman who was transformed into a nightingale and became famous for her song. All these works represented women of skill, wisdom, aspiration and attainment. Moreover, Athena's gift to Athens of the olive branch (referenced in *The Lady Prays Desire*) was more highly valued than Poseidon's gift of water, and Korinna five times defeated her pupil and rival Pindar, acclaimed as the greatest lyric poet in Greece.

Marie Spartali launched her career at exhibitions favourable to young artists, the Dudley Gallery and the Society of Female Artists. In public galleries and in the feminised spaces of the bourgeois home middle-class women appraised images of women as pictures on the walls and viewed the images which women created and inhabited through dress, hairstyling, deportment, all the components in and by which femininity was constituted as visibly different. The production and exchange by women of woman as a visual sign was sustained across the daily practices of civil society, cultural consumption and the reciprocities of women's friendships as well as the

cultural collaborations between women artists. And it was in these contexts that woman was circulated as a sign of women's cultural activity.

Marie Spartali developed a personal style which drew on and generated high-cultural imagery of women. Although she was often likened in appearance to pictures by D.G. Rossetti or E. Burne-Jones (a viewing practice enhanced by her modelling for them), her personal style was related to her own paintings of women. *Fiammetta Singing* (plate 42) was exhibited in 1879 at the Grosvenor Gallery in London where the artist appeared at private views in 'aesthetic' dresses, probably of her own design, thus resembling the attire of the female figures in her exhibited works. *Fiammetta Singing* was accompanied with a quotation:

> Love steered my course, while yet the sun rode high,
> On Scylla's waters, to a myrtle grove . . .
> And there my lady, 'mid the shadowings
> Of myrtle trees, 'mid flowers and grassy space
> Singing I saw, with others who sat round.[47]

The watercolour articulates an ideal of cultivated womanhood which was derived, as were the costumes, pictorial format with garden setting and the poem, from Renaissance Italy. Writings on the feminine courtier which advocated education, writing poetry, painting, singing, playing and composing music provided historical precedents for women's practice of the arts.[48] In common with Marie Spartali's earlier works, *Fiammetta Singing* asserts women's artistic skills while representing an audience and community shaped within the social order of sexual difference. *Fiammetta Singing* demarcates a particular space of and for femininity, representing women's pleasure in women's culture and articulating a continuum between production and consumption. In giving prominence to Fiammetta's singing for a group of women, the watercolour decentres the masculine subject of the poem while offering masculinity its favourite and familiar position as voyeur. The pleasures of looking at these works did not terminate in the frozen stasis of the uninhabited face and unseeing gaze, nor were they confined to the trivial pursuits of seeing the forbidden.[49] In these works by Marie Spartali and photographs by Julia Margaret Cameron, woman as sign is re-signed from visual icon to woman of culture. No longer limited to a signifier of masculine desire, woman as sign was re-signed around the pleasures invoked by and invested in cultural exchanges between women.

BODYMAPS

In the 1880s and 1890s many women artists were staking their careers and critical reputations on large-scale history paintings in oil. Sophie Anderson, Alice Havers, Marianne Stokes, Elizabeth Forbes, Jessie Macgregor and Anna Lea Merritt were among those sending to the Royal

Academy, while Evelyn de Morgan preferred the Grosvenor Gallery (plate 43).

Psyche Before the Throne of Venus, an enormous canvas measuring six feet four inches by ten feet, was begun by Henrietta Rae in 1892 and completed for the Academy exhibition of 1894 (plate 44).[50] It was one of the most ambitious paintings by a women artist. Henrietta Rae selected an incident from William Morris's poem *The Earthly Paradise* (1868–70) which retold stories from classical texts for middle-class readers, including most women, who were unfamiliar with Greek or Latin. In this massive work containing fourteen figures the painter departed from the classical convention, often retained in the nineteenth century, of imaging the lovers Cupid and Psyche. Instead she portrayed a decisive event in the narrative when Psyche, in search of Cupid, lies prostrate at the throne of Venus. Jealous of Psyche's beauty, Venus set Psyche a series of tasks which she carried out with the secret help of Cupid, finally being united with him.

Henrietta Rae launched her career as a painter of large-scale neo-classical subjects with *Ariadne Deserted by Theseus*, shown at the Royal Academy in 1885. She drew in the classical galleries at the British Museum and enrolled at the Royal Academy schools, augmenting her study by attending life-classes at Heatherley's in the evenings. In 1890 she visited Paris where she attended Julien's Academy and took note of French academic paintings of the female nude.[51] By 1894 Henrietta Rae was well regarded: *Ophelia* had been purchased for the Walker Art Gallery from the Liverpool Autumn Exhibition of 1890 and three years later the artist was the first woman to serve on this exhibition's selection committee.[52] The critical reception of *Psyche*, however, was tempestuous. A favourable review in *The Times* which complimented the 'very ambitious performance' and 'good drawing and pleasant colour' nevertheless complained that the 'whole picture errs on the side of over-prettiness; there is little emotion even in the prostrate figure of Psyche, and none anywhere else'.[53] The *Magazine of Art* deployed familiar sexual stereotypes in its censure of painter and painting:

> we instinctively feel that the painter has never quite grasped the greatness of this scene of classical mythology – the figures with all their charms are not the inhabitants of Olympus, but denizens of an ungodly earth.[54]

The *Athenaeum* found fault with the technique as well as the image:

> A sort of confectionary piece is Mrs H. Rae's 'Psyche Before the Throne of Venus'. Most thinly painted and meretricious, from the point of view of art, are the nymphs and goddess of this large and pretty picture Superfine as it is, we fail not to be surprised at

finding that here nymphs and goddess resemble ballet girls, while Venus' court is like an opera scene.[55]

The main attack was focused on the representation of the female nude. Male critics complained that Henrietta Rae had provided the wrong target for their gaze, reminding them of contemporary working-class women bought and used for casual sex. This interpretation of *Psyche* was encouraged by the distinctive stylisation of the female body derived from French academic art which was at this date ascribed highly charged sexual connotations. An appropriate masculine viewing experience and the correct representation of the female nude were to be found, according to these writers, in Leighton's *Summer Slumber* and Poynter's *Horae Serenae*, shown alongside *Psyche* at the Royal Academy of 1894. The *Athenaeum* reviewer was in ecstasies about the President's picture in which the draperies 'veil, without concealing the fine lines of her body and virginal contours. Her limbs and face are charmingly drawn, and modelled with delicate research.' In Poynter's painting he considered 'their fluttering draperies veil without disguising their limbs'.[56] Henrietta Rae's painting disturbed a masculine field of vision, and the critical attack was strident and potentially damaging. Accusations or even intimations of impropriety undercut the ground of morality and purity on which middle-class women founded their art practice and their activity in high culture and public life.

With the revival of history painting in the later nineteenth century, the female nude was constituted as the sign of artistic achievement and academic endeavour. Neo-classical painting which privileged the depiction of the female nude was both a site for women's intervention and an arena of struggle in which their rights for professional recognition were strongly contested. It was as painters of the female nude that women artists were most challenged. Anna Lea Merritt's image of an unclothed boy, *Love Locked Out* (RA 1890), was the first picture by a woman artist to be purchased by the Chantrey Fund, so entering the national collection of British art.[57] But this artist's rendition of the female nude in *Eve*, although hung to advantage in the Royal Academy exhibition of 1885, was unfavourably reviewed as 'a dull and incompetent study from the nude, apparently made in a painting school . . . [which] has not the smallest technical claim to a place on the line'.[58] As feminist art historians have demonstrated, the female nude condensed a cluster of power relations, signifying women's subordination in the hierarchical relations of patriarchal power.[59] In representing the female nude, women artists staked their claims to that sign of academic status which was simultaneously the principal signifier of women's subordination. The cultural collisions around Henrietta Rae's *Psyche* or Anna Lea Merritt's *Eve* engaged the broader terrain of representations of feminine sexuality and the struggles over its definitions.

The purity campaigns of the later nineteenth century provided middle-

class women with a language and public space for debating sexuality.[60] Visual imagery was not infrequently invoked in these campaigns. The National Vigilance Association, formed in 1885 to press for the raising of the age of consent, launched prosecutions against pornography and visual spectacles in music halls; in the later 1890s it pressurised Scotland Yard to establish a special department for pictures and books.[61] The purity campaigns thus structured a moral modality of perception for women spectators of high culture, and in 1885 its languages informed a fierce debate over the female nudes in London exhibitions. Referring to 'a noble crusade of purity' one woman correspondent to *The Times* considered that 'the indecent pictures that disgrace our exhibitions' could not be seen by 'a modest woman . . . without a burning sense of shame'. She considered that 'women artists as yet seem content to shame their sex by representations of female nudity'. Other women correspondents refuted this view.[62] This debate registered the heterogeneous perspectives of middle-class women and the links they established between different areas of visual representation.

Particular social, cultural and political values were invested in the classical past.[63] Ancient Greece and Rome were considered as high points of civilisation initiating western European history, notions which obliterated the much older civilisations of Asia and Africa as well as their contributions to European culture. Admiration for classical societies founded on slavery and militarism provided powerful examples for the practices and beliefs of British imperialism in the later nineteenth century. Neo-classical paintings not only coincided with a period of vigorous imperial expansion, but they also contributed to and participated in a broader movement in which the classics were established as a discipline in the reformed public schools and universities as the principal component of a masculinity carefully groomed for the administration of Britain and Empire. Anna Lea Merritt's *War* (RA 1883) (plate 45) references the British occupation of Egypt in 1882 and the 'Cape to Cairo plan' which met with strong resistance, notably by the Mahdi, from 1882 to 1885. Described by the artist as 'Five women, one boy, watching army return – ancient dress',[64] *War* depicts a group of women wearing a mixture of classical and Italian Renaissance dress who are watching the triumphal parade of soldiers passing below their balcony. As in numerous paintings of the period, the classical past was mobilised in the formation of sexual difference.

The academic conventions, derived from the study of 'the antique', which recast the feminine body and face in a classical mould were based on assumptions that perfect form had been attained in classical art. These visual codes assisted in the production of an extensive repertory of white-skinned female nudes paraded in neo-classical and 'orientalist' paintings whose cultural significance was to be found in the global relations of late nineteenth-century imperialism.[65] As sexual difference was increasingly

specified in relation to race and racial difference increasingly hierarchised, woman's body became the locus of a global politics of population shaped by the interests of empire. Neo-classical paintings were part of the regulation of femininity across an axis of racial difference and the promotion of white women as the mothers of the race. The struggle in high culture over the female nude was a struggle over woman as sign of imperial power. With their classical references from costumes and settings to statuary and storylines, neo-classical paintings provided an important site for the necessary reorganisation of history, representation of race and regulation of feminine sexuality which accompanied, and contributed to, the consolidation of British imperial power.

These large paintings did not crudely or passively reflect pre-existent values; their production and critical reception condensed a crisis in imperialism provoked by transitions to monopoly capitalism, uneven international competition between western European nations and nationalist uprisings and resistances in colonial territories. By 1900 the academic tradition could no longer support such contradictions and it was as much for these reasons as for the anti-academic discourses of modernity that the academic tradition lost its credibility and declined.

MODERNITY: WOMEN'S STAKE

In Glasgow in the 1890s a group of independent women trained at the Art School, establishing careers in the city and becoming a distinctive presence in its art world. By the later nineteenth century Glasgow was a major port and a thriving commercial and industrial complex where substantial capital investment funded shipbuilding, engineering, financial services, a stylish urban environment and a brisk trade in luxury goods. Prosperous business men and women supported architects, artists and designers whose work depended equally on Glasgow's metal and furniture trades and its textile manufacture. Glasgow became the centre of a modern movement in art and design in which women took key roles and achieved international recognition. Feminist research has firmly documented women artists and designers working in the city, assessing their contributions to a style and a movement all too often assigned to male protagonists.[66] In reclaiming women's stake in shaping and strategising the modern, feminist historians have questioned existing definitions, drawing attention to the ways in which patriarchal discourses on sexual difference have underwritten masculine claims to the modern. Women's stake, their centrality in the modern in Glasgow in the 1890s and 1900s, was located at the intersections between competing definitions of the modern in the discourses of art, new formations of femininity, the reorganisation of urban space and the emergence of what was called the 'new philosophy'.

Margaret Macdonald and Frances Macdonald were among the many

sister–artist partnerships in Glasgow. Both women attended the Glasgow School of Art from 1890 to 1894. From 1896 to 1899 they set up a studio together, producing embroidered panels, metalwork, illuminated manuscripts, cartoons for stained glass and designs for posters, that for *Drooko* being commissioned by a umbrella manufacturer.[67] They collaborated on separate pieces under a single title, jointly conceived and executed some items and produced independent works (plate 46). Designs were modulated across different media – watercolour, stained glass and metalwork – and recast for a range of decorative schemes. The sisters were apparently pleased by the joint attribution of their work.[68]

From 1894 they contributed to shows in Glasgow and the following year their works were included in the exhibition *L' Oeuvre Artistique* in Liège. It was in Europe that their work met with its greatest success. *Dekorative Kunst*, a leading art periodical, illustrated their designs in its early issues and featured them prominently in two articles in which it hailed Glasgow artists as the exponents of the modern. Distancing them from current painting trends in London and differentiating them from the 'Glasgow Boys', who now represented an 'obsolete painting tradition' derived from Whistler, *Dekorative Kunst* commended Margaret Macdonald, Frances Macdonald, Charles Rennie Mackintosh, James Herbert Macnair (who became known as 'the Four') and Talwin Morris for their 'striking originality', 'lyrical symbolism', 'striving for pure lines', and links to the 'spiritual movement', all key terms in European symbolist aesthetics in the 1890s.[69] Commissions and critical acclaim followed as work by 'the Four' was celebrated in European art journals, competitions and exhibitions, notably at the Vienna Secession exhibition of 1900 and the International Exhibition of Modern Decorative Art in Turin two years later.[70]

In Britain Margaret and Frances Macdonald, along with others of the Glasgow School, found moderate support from the *Studio*, the only major art magazine of the 1890s to keep abreast of new developments in European art. Following a visit to the city, the editor Gleeson White attempted to create a critical context for the Glasgow artists. Claiming that their 'very audacity and novelty deserve to be encouraged', he commended the 'distinct effort to decorate objects with certain harmonious lines and strive for certain "jewelled" effects of colour'. He was at pains to defend them from assertions that they were 'eccentric, extravagant and chaotic, and merely mad', arguing that while their work 'may controvert established precedent . . . it does so in an accomplished manner, and with a sincere effort to obtain new and pleasing combinations of mass and line'.[71] By this date Margaret and Frances Macdonald had earned the nickname of 'the spook school' and their work often met with hostility, misunderstanding and ridicule, many reviewers finding it inaccessible and incomprehensible. One reviewer of the Arts and Crafts Exhibition of 1896 contended that their 'faces of weird import' and 'ghostly long-drawn figures' were

inspired by magic and ritual and concluded that 'it would be hazardous for the average person to suggest their interpretation'.[72] Two years earlier their contributions to the Glasgow School of Art Club exhibition had been assessed in similar terms, one critic writing of their 'weird designs . . . impossible forms, lurid colour and symbolism', and another commenting, 'As to the ghoul-like designs of the Misses Macdonald, they were simply hideous.'[73]

As the critic of *Dekorative Kunst* recognised, Frances and Margaret Macdonald's work conformed neither to establishment principles nor to that art which claimed to be modern in the 1890s. Their work was not in sympathy with the revivalism of the Arts and Crafts movement, had little in common with the 'Glasgow Boys' or the New English Art Club, and took an approach to symbolism markedly different from that demonstrated by English artists such as Burne-Jones or Evelyn de Morgan (plate 43). Frances and Margaret Macdonald shared the concerns of the European symbolist artists and writers with representation less as a depiction of external appearances and more as the encoding and revelation of spiritual realities. The sisters' art can thus be related to a central preoccupation in European art and aesthetic theory from the later 1880s which broke with the pictorial conventions of academicism, realism and impressionism in order to convey a spiritual world beyond, but intersecting with, the physical plane, and which rejected a definition of the modern as the painting of modern life. Artists and writers were invested with new roles as seers, interpreters and unveilers of spiritual planes which could be accessed through sleep, heightened perception, occult science, western and eastern religions, and through the contemplation of symbolist art and literature. Margaret and Frances Macdonald's work was produced within a newly defined discursive formation which brought together new theories of knowledge, the individual, society and sexuality. Recent studies of eastern arts and religions, along with the 'new philosophy', in which a positivist account of material existence was rejected in favour of the proposition that mind and matter, the physical and the spiritual, were not separate but interlinked planes of the same reality, informed the conceptions of modern art with which Frances and Margaret Macdonald worked and in which their art was situated.[74]

The discursive and representational break was achieved by the early 1890s. From 1893–4 to 1896–7 Frances and Margaret Macdonald's works were characterised by attenuated forms, a departure from academic composition and drapery painting, an absence of narrativity or archaeological or contemporary *mise-en-scène*, an investment of natural forms with symbolic meaning, and the presence of the 'seeing eye' which perceived spiritual reality.[75] Frances Macdonald's *Ill Omen* of 1893 (plate 46) could not be more unlike Henrietta Rae's *Psyche at the Throne of Venus*, shown at the Royal Academy of 1894 (plate 43). It was this distance from

academic figure painting which was seized upon by reviewers who wrote of the sisters' 'rather weird adaptation of the human form to decorative purposes'.[76] Underpinning this comment is the main objection to Frances and Margaret Macdonald's work: their disinclination to conform to prevailing aesthetic principles which invested aesthetic pleasure in the visual spectacle of woman represented according to hegemonic notions of feminine beauty. Critics were certainly troubled by the representation of femininity in the sisters' works of the 1890s. In 1894, in response to the Glasgow School of Art Club exhibition, the *Glasgow Evening News* printed a satirical poem, referring to one of the most contested shifts in femininity in the later nineteenth century:

> Would you witness a conception
> Of the woman really New
> Without the least deception
> From the artist's point of view . . .
> As painted by her sister
> Who affects the realm of Art
> The Woman New's a twister
> To give nervous man a start . . .
> Sadly scant of fleshly padding
> And ground-spavined at the knees.[77]

When *Ill Omen* was exhibited at the Liverpool Autumn Exhibition in 1896 it was derided as 'Yellow Book madness' and the artist was labelled 'decadent'.[78] Categorisation of the deviant, abnormal or obscene was at a high point in the 1890s, newly organised around visual imagery as photography was used in pseudo-scientific studies of criminality and sexuality to provide evidence of the visible manifestation of deviancy.[79] Frances Macdonald's image became a point for the definition and regulation of feminine sexuality, a site where the boundaries of normativity could be drawn.

The elongated figures of women in Margaret and Frances Macdonald's works of the early to mid-1890s certainly break with the academic moulding and fashionable styling of the feminine body. But did this self-consciously innovative imagery shift the definitions of femininity? To what extent did the production of self-consciously modern art by women engage with modern identities for women? Frances Macdonald's watercolour *Ill Omen* also entitled *Girl in the East Wind with Ravens Passing the Moon* is a spare, composed image, formed by geometrical oppositions, close tonal harmonies from green to blue, yellow to cream and a flatness partly derived from Japanese prints which were widely distributed in Europe at this period and perceived as a hallmark of the 'modern'. *Ill Omen* rejects that cast of virgins and sirens which peopled academic art, Art Nouveau and the *Yellow Book* and through which polarities of feminine sexuality

were managed. *Ill Omen* intimates a psychic or spiritual state, one of premonition. The raven, harbinger of doom in Romantic poetry, appeared in Margaret Macdonald's watercolour of 1894, *The Path of Life*, in which a central female nude is flanked by two winged representatives of light and darkness, beyond whom are two female figures, one accompanied by a rose and swallows, the other by a thistle and ravens. The path of life is the passage of the soul to spiritual enlightenment or unknowingness.[80] In *The Path of Life* where nudity is deployed to signal the exposed soul, and in *Ill Omen* in which the female figure is veiled in a simple tunic, the feminine body is not the sight or site of masculine spectatorial desire. As Janice Helland has recently written of *Ill Omen*, 'this strong independent woman is unavailable to the voyeuristic viewer'.[81] The representation of woman by Margaret and Frances Macdonald can be compared to the 1890s' images of single women whose autonomy disrupted the hierarchical arrangement of sexual difference and whose depiction could disturb masculine aesthetic pleasure. Woman's stake therefore in the emergent discourses and practices of the modern was thus not only her presence but her self-determined representation.

WOMEN ARTISTS, WOMEN'S RIGHTS

In 1872 Louise Jopling exhibited *Queen Vashti Refusing to Show Herself to the People* at the Royal Academy. Years later she claimed that this queen who was divorced for disobeying her husband's command represented 'the originator and victim of "women's rights"'.[82] Large-scale history painting was rarely the arena in which women artists challenged hegemonic definitions of femininity, preferring to portray women as victims of romantic love or as mothers.[83] Henrietta Ward, an active suffragist, occasionally depicted Elizabeth Fry whose example was, however, more likely to inspire female philanthropy than feminist campaigning.[84] Neither Barbara Bodichon, who painted landscapes, nor Helen Allingham, both of whom publicly supported women's suffrage, exhibited images which directly engaged with the issues of women's rights. Women artists gave their support to the women's movement as successful professionals and public figures. It was not in the struggles for academic success or in the achievement of professional recognition that women artists developed a politics of visual representation but in their production of portraiture. Commissioned by women's organisations, suffrage societies and campaigners, portraits articulated public identities for the radical and pioneering women of their own social class. Working-class women first made and carried the suffrage banners which so radically changed the visual spectacle of women's campaigns for the vote.

Women artists painted numerous portraits of feminist campaigners and activists from the 1830s to the 1890s,[85] often producing them within the

social and economic structures of matronage. In the 1830s and 1840s Margaret Gillies painted feminist writers such as Harriet Martineau (RA 1832), Mary Howitt, on her own (RA 1847), and with her husband (RA 1846), Mary Leman Grimstone (RA 1835) and Sarah Flower Adams.[86] Shown in exhibitions, sold as individual prints and reproduced in *The People's Journal* edited by Mary and William Howitt, these portraits gave visible identity to women who were voicing demands for women's education and employment before feminism was organised as a movement. These portraits were also located in the artist's project to provide visual records of the circle of progressive middle-class intellectuals to which she belonged and in which feminist politics were inflected through radical and class politics. In a letter writter in 1839 to one of her clients, Margaret Gillies set out her position:

> Artists in general seize every opportunity of painting the nobility of wealth and rank it would be far more grateful to me to be able to paint what I conceive to be *true* nobility that of genius long faithfully earnestly and not without suffering labouring to call out what is most beautiful and refined in our nature and to establish this as a guide and standard of human action.[87]

Margaret Gillies outlined a strategy in cultural politics to secure the visual representation of the bourgeoisie whose economic and social power had been demonstrated by the enfranchisement of property-owning men seven years previously. Her aim was to wrench portraiture away from the aristocracy, whose predominance in the social formation and as purchasers of art was now challenged by her own social class. Portraiture was to be put to work in picturing artists and writers whose status was not given by birth or rank but by intellectual power and that truly middle-class ability, triumph over adversity. Moreover, portraiture was not just to be a description of external appearance but it was to represent the moral vision of the bourgeoisie.

In the second half of the century, portraiture became increasingly important to the women's movement. A shared feminist politics often informed the choice of painter or sitter. Eliza Fox painted a portrait of Harriet Martineau and one of Barbara Bodichon.[88] Laura Herford, a leading figure in feminist campaigns for art education and the first woman student at the Royal Academy, painted Elizabeth Garrett Anderson while Rhoda Garrett was portrayed by Annie Swynnerton.[89] Images of feminist activists were also circulated in photography and collections complemented albums of family and friends. In addition, photographs formed the basis of memorial portraits. In 1897, when Helen Blackburn arranged her collection of suffrage materials in a bookcase of her own design and commissioned Elizabeth Guinness to provide watercolours of the two women who had inspired her, the artist's portrayals of Lydia Becker and Caroline

Ashurst Biggs were modelled on photographs in Helen Blackburn's collection, taken several years before when the sitters were alive.[90] By the later decades of the century portraits of suffragists were commissioned by women's institutions. Emily Mary Osborn's portrait of Barbara Bodichon was painted for Girton College, Cambridge (plate 13). Elizabeth Guinness's crayon drawing of Helen Blackburn commemorated her retirement from secretaryship of the Bristol and West of England Suffrage Society in 1895.[91]

Susan Isabel Dacre's portrait of Lydia Becker, editor of the *Women's Suffrage Journal*, was produced within the intersecting circles of friendship and suffrage politics in Manchester (plate 47). Originally a life-size three-quarter length, the portrait depicts the sitter in a neat black dress, with closely bound hair, and wire-rimmed spectacles. The sobriety of her appearance is relieved only by the lace and a crimson rose. Exhibited in 1886 at the Manchester Academy of Fine Arts alongside portraits of the city's worthies, the painting shaped a public identity for a woman leader without any of the trappings of state robes or civic ritual with which men might be depicted. Ruffles, lace and flowers were common accessories in portraits of women at this period: here they are the only visual signs of bourgeois femininity. The portrait negotiated Lydia Becker's distinctive public image. In cartoons she was satirised as an unfashionable and plain spinster.[92] As photographs of her show, she cultivated a severe expression and unadorned style of dress,[93] probably considering like many suffragists that dark dresses, particularly in black and not necessarily high fashion, were the hallmark of respectability. There was, however, no consensus on public visibility among members of the women's suffrage movement. Some, like Florence Fenwick Miller, columnist of the *Illustrated London News*, considered that fashionable costume best assisted the cause. While she agreed to differ with Lydia Becker on suffrage objectives, Florence Fenwick Miller deplored her appearance, observing that she was 'uncommonly plain and hard-looking, and she did not cover her natural disadvantages by that gracious benignity of manner which makes some ugly elderly women so perfectly charming'.[94]

Susan Isabel Dacre's portrait was thus produced within the suffrage debates on the spectacle of woman. The representation of Lydia Becker's body rejects the current codes of fashionable styling, supine pose, hourglass figure, lavishly trimmed costume. Lydia Becker's facial features are not moulded into a blank mask of beauty: the gaze is direct. The severity of manner – of sitter and portrait – connote a refusal and reworking of hegemonic definitions of womanhood. Declining the visual protocols which transformed women into a visual icon of masculine desire, the portrait represented Lydia Becker as a respectable public figure. For those communities of women who saw it in Manchester, in Helen Blackburn's rooms in London and at the headquarters of the National Society of Women's

Suffrage,[95] the portrait produced woman as a sign of feminist resistance, inciting women's desires for representation and equality, not only in politics but also in the domain of culture. After Lydia Becker's death in 1890 the National Society of Women's Suffrage launched a campaign 'to purchase the portrait . . . and place it in a building of a public and national character' as a memorial to Lydia Becker.[96] The National Portrait Gallery publicly declined this portrait, as it was to reject one of Emily Mary Osborn's portraits of Barbara Bodichon a few years later on the grounds that the ten-year rule required a decade to elapse after the death of the sitter. But privately the portrait of Lydia Becker was dismissed as without artistic merit and condemned as 'a *very* indifferent work of art. The hair, costume and hands are painted in a meaningless manner.'[97] The portrait is now in the Manchester City Art Galleries, presented in 1920 by the Manchester branch of the National Union of Women's Suffrage Societies. The conditions of its acceptance were that the artist, then in her seventies, cut down the original three-quarter length to its present size.[98]

In their history of the radical suffragists Jill Liddington and Jill Norris rightly indicated that histories of the women's movements in the later nineteenth century have been dominated by accounts of middle-class women like Lydia Becker.[99] In the 1880s the dynamic participation of working-class women took the women's suffrage campaign out of the social spaces of bourgeois femininity into public meeting-halls and on to the streets, transforming its politics and its spectacle.

In May 1880 members of the Westminster Tailoresses Union marched in a procession of working-class women from Pimlico and Whitechapel to St James Hall in central London carrying a yellow silk banner which they had made. The banner bore an invitation to attend the National Demonstration of Women and an inscription:

> We're far too low to vote the tax
> But not too low to pay.[100]

The banner wove together the politics of class and feminist resistance, registering the active presence of working-class women as trade unionists and suffragists. Numerous banners were on show on the platforms of the public meetings convened in 1883 to call for women's suffrage to be included in the Reform Bill of 1884. At one meeting in July 1883 at St James Hall:

> The platform was gaily decorated with banners on which the names of Belfast, Birmingham, Glasgow, Dublin and other towns which were there represented were written. Shortly before 8 o'clock a procession of women, trades unions, entered the hall with another banner, and mounted the platform.[101]

Scrolls with quotations 'in favour of women's suffrage' were hung from the

gallery.[102] A year later at a meeting in Edinburgh 'banners with appropriate mottoes' decorated the hall, and in Newcastle one of the banners proclaimed 'Women claim equal justice with men'.[103] It seems likely that the banners were textual with woven, painted, stencilled or appliquéd mottoes. Prominent at women's suffrage meetings and formative of the campaign's visual display, working-class women probably initiated or at least set precedents for the suffrage marches and banners which became so central to suffrage spectacle in the years 1907 to 1914.[104]

EPILOGUE
In the foreground

Painting Women is one of several books to be written on Victorian women artists since Elizabeth Ellet and Ellen Clayton paved the way in the nineteenth century. Even though the literature on women artists is slowly increasing, even though – or perhaps because – this past is so recent, there is still much to be recovered and rewritten. As broadly based interest and scholarly research develop, so the picture will change. Perspectives will shift, the constituency of women artists will be re-figured and women's representations re-viewed. It is, after all, these movements of women which have prompted the will to know and given priority to the study of women as much as they have created the women's movements. In these processes of change, the historical priorities of the past may well not be those of the future. In charting a critical path for the future the contemporary artist and art historian Lubaina Himid has written:

> There has to be a strategy for the nineties. Black women artists must push themselves and more especially their work much further: beyond the boundaries set in the last one hundred years. From the cusp of modernism to the present day There can be no survey, no overview, no clear picture of art in the twentieth century without the work, the theory and the philosophy of the Black Woman artist It is obvious that there can be no real future unless the past is consolidated, recognised as present and used as a guide for the future We have a key role to play in the cultural arena. We always have had. We always will.[1]

These reflections are a salient reminder that as significant interventions are made by women, so art history as a cluster of knowledges about the art of the past and the present is subject to change. Transforming and *differencing* the canonical traditions of art history engages a range of strategies. Feminist studies enable the recovery of women artists and the study of their works. Perhaps more importantly, they put in play other readings and meanings which counter prevailing assumptions in the west that individu-

212

ality as well as artistic creativity are masculine. Writing women artists into the history of art has necessitated a reformulation of the discipline since the old paradigms work to silence or to marginalise women artists. Feminist studies have also enabled a reconsideration of the meanings invested in visual images of women. These two projects are in many ways interdependent, for high culture is a key domain for the production of social meanings about the significance and signification of woman – as cultural producer and as visual sign. Teresa de Lauretis has commented that feminist studies take place in and indeed presuppose an *elsewhere* in discourse.[2] It is in and from this space of difference that feminist studies produce meanings which run counter to and contradict those which currently prevail in western societies. Feminist studies are by no means limited to the academy. They take place in the wider contexts of communities linked by conversations, campaigning, reading, writing; they are to be found in the enjoyment of art, in its broadest definitions, by women.

Painting Women has discussed some of the many women artists working in Victorian Britain. It has considered the diversity of their work and the varying ways in which they participated in the production of social meanings. *Painting Women* is one of several versions which could be told. It has been woven together from visual and written texts whose meanings are in process, always deferred, and open to be remade by readers and spectators. *Painting Women* is full of local stories, snatches of conversations, glimpses out of windows and into rooms, glances beyond the frame. There are many other lives which could be recounted, issues which could be considered, all of which beg the question as to why this fragment of the past should exert such fascination, but that's another story.

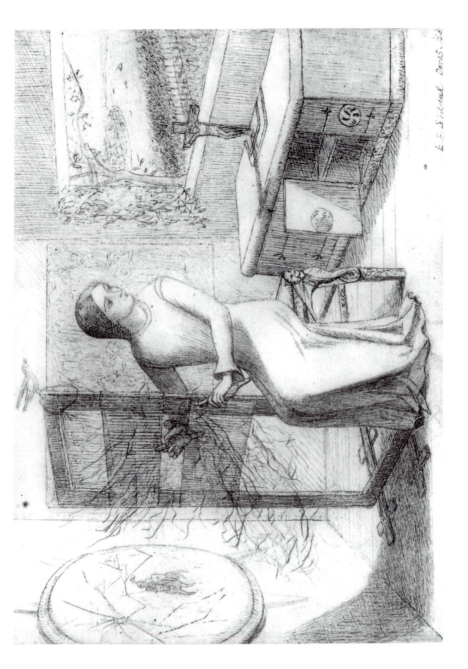

Plate 37 Elizabeth Siddall, *The Lady of Shalott*, 1853.

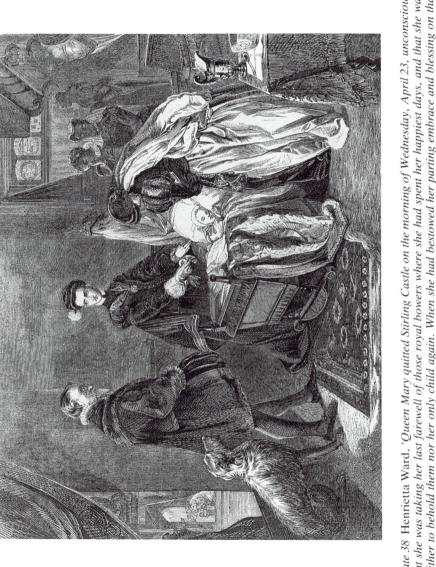

Plate 38 Henrietta Ward, 'Queen Mary quitted Stirling Castle on the morning of Wednesday, April 23, unconscious that she was taking her last farewell of those royal bowers where she had spent her happiest days, and that she was neither to behold them nor her only child again. When she had bestowed her parting embrace and blessing on that beloved object of her maternal solicitude, she delivered him into the hands of the Earl of Mar herself, and exacted at the same time from that nobleman a solemn pledge that he would guard his precious charge from every peril, and never give him up, under any pretext, without her consent.' Miss Strickland, Royal Academy, 1864.

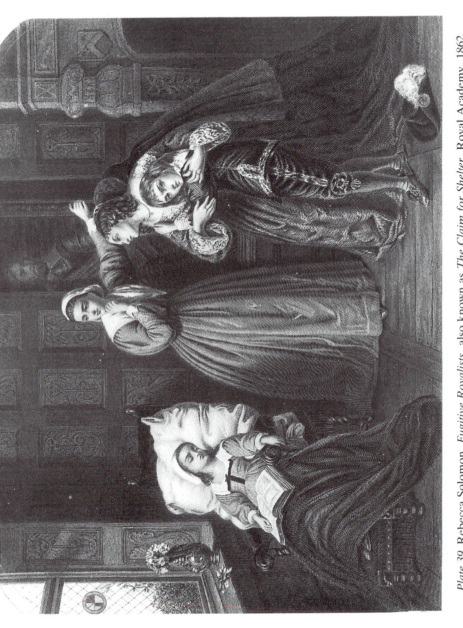

Plate 39 Rebecca Solomon, *Fugitive Royalists*, also known as *The Claim for Shelter*, Royal Academy, 1862.

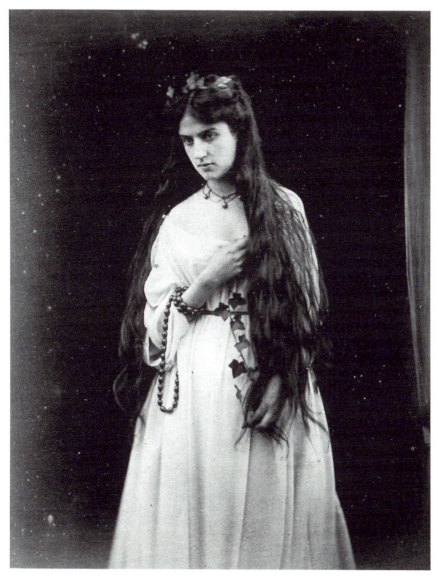

Plate 40 Julia Margaret Cameron, *Mnemosyne*, 1868. The model for this photograph is Marie Spartali Stillman.

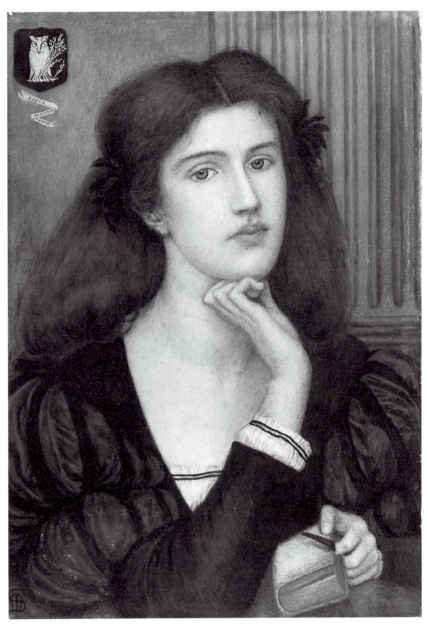

Plate 41 Marie Spartali, *The Lady Prays Desire*, Dudley Gallery, London, 1867.

Plate 42 Marie Spartali, *Fiammetta Singing*, Grosvenor Gallery, London, 1879.

Plate 43 Evelyn de Morgan, *Aurora Triumphans*, Aurora's bonds fall away as Night flees and three figures herald the triumph of dawn, Grosvenor Gallery, 1886.

Plate 44 Henrietta Rae, *Psyche at the Throne of Venus*, Royal Academy, 1894.

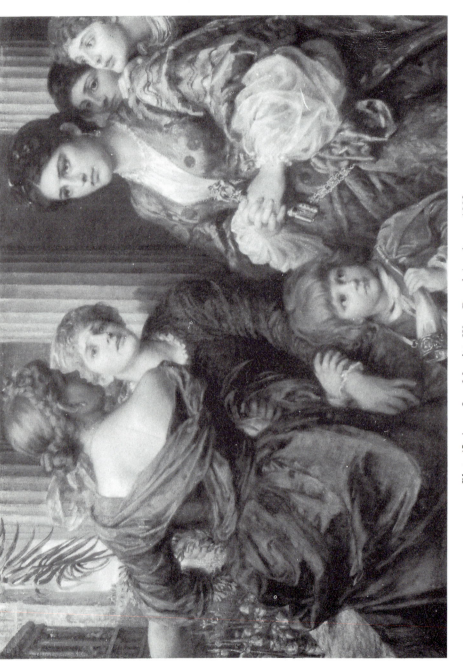

Plate 45 Anna Lea Merritt, *War*, Royal Academy, 1883.

Plate 46 Frances Macdonald, *Ill Omen*, 1893.

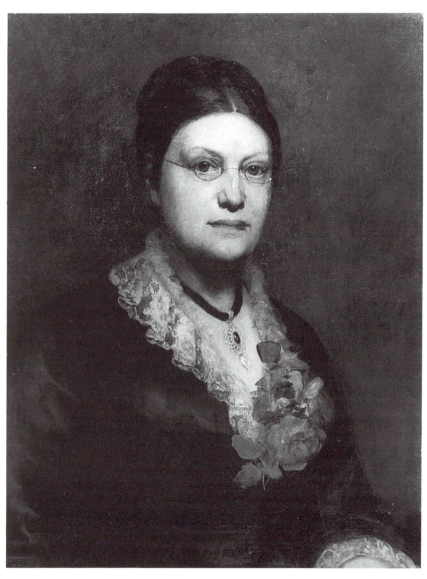

Plate 47 Susan Isabel Dacre, *Lydia Becker*, 1886. Presented to Manchester City Art Gallery in 1920 by the National Union of Women's Suffrage Societies, Manchester branch.

CHECKLIST OF ARTISTS

ABBREVIATIONS

fl.	flourished, that is the years in which activity is recorded
ARA	Associate of the Royal Academy of Arts (twentieth century)
GSLA	member of Glasgow Society of Lady Artists
MSWP	member of Manchester Society of Women Painters
NAC	member of Norwich Art Circle
RA	Royal Academician (twentieth century)
RBA	member of Royal Society of British Artists (twentieth century)
RE	member of the Royal Society of Painter-Etchers
RI	member or associate of the New Watercolour Society, later Royal Institute of Painters in Watercolour
RP	member of the Royal Society of Portrait Painters
RSW	member of the Royal Scottish Watercolour Society
RWS	member or associate of the Old, later Royal Watercolour Society
SWA	member of Society of Female Artists, later Lady Artists, Women Artists
WIAC	member of Women's International Art Club

Artists are indexed under their most frequently circulated name.

Helen Paterson Allingham, RWS, 1848–1926, watercolourist
Laura Epps, Lady Alma-Tadema, 1852–1909, figure painter
Sophie Gengembre Anderson, 1823–1903, figure painter
Helen Cordelia Coleman Angell, RWS, 1847–84, flower subjects in watercolour
Charlotte Elizabeth Babb, 1830–1907, figure painter
Margaret Holden Backhouse, SWA, b.1818, fl.1846–82, figure and portrait painter

Mary Backhouse (Miller), SWA, fl.1866–80, figure and portrait painter

Dhumbai F. Banajee, fl.1892–5

Leila Florentina Catherine Barker, 1825–1903, flower studies in watercolour

Lucette Elizabeth Barker, 1816–1905, figure, animal and landscape subjects in oil and watercolour

Octavia Constance Barker (Kingsley), 1826–1917, flower studies in watercolour

Anne Charlotte Fayermann Bartholomew, SWA, 1800–62, painter of portrait miniatures, figure and still life subjects

Fanny Jane Bayfield, NAC, 1850/1–1928, flower subjects in watercolour

Ellen Brooker Beale (Lloyd), 1831–1900, landscape painter

Sarah Sophia Beale, fl.1860–89, figure painter and art writer

Vanessa Stephen Bell, 1879–1961

Jane Benham (Hay), fl.1848–67, figure painter

Mary Ellen Best, 1809–91, interiors and figure subjects in watercolour

Anna Elizabeth Blunden (Martino), 1829–1915, figure and landscape painter

Barbara Leigh Smith Bodichon, SWA, 1827–91, landscapes in watercolour and oil

Charlotte Bosanquet, 1790–1852, interiors and figure subjects in watercolour

Agnes Rose Bouvier (Nicholl), b.1842, fl.1866–92, watercolourist

Eliza Martha Bowkett, b.1839, fl.1862–7, landscape painter

Jane Maria Bowkett (Stuart), 1837–91, figure painter

Jessie Undine Bowkett, b.1857, fl. 1880–81, figure painter

Leila Matilda Bowkett, b.1852, fl.1876–81, landscape painter

Joanna Mary Boyce (Wells), 1831–61, figure and landscape painter

Rosa Brett (also called Rosarius), 1829–82, landscape painter

Alberta Brown (Frank), fl.1870–77, figure painter

Eleanor Fairlam Brown, fl.1853–76, landscape painter

Catherine Madox Brown (Hueffer), 1850–1927, figure subjects in watercolour

Lucy Madox Brown (Rossetti), 1843–94, figure subjects in watercolour

Helen Paxton Brown, GSLA, 1876–1956, embroiderer and watercolourist

Ethel Buckingham (Havers), NAC, fl.1887–1901, d.1918, portraits, flowers and landscapes in oil and watercolour

Kate Elizabeth Bunce, 1856–1927, figure painter

Myra Louisa Bunce, 1854–1919, landscape painter and metalworker

Georgiana Macdonald, Lady Burne-Jones, 1840–1920

Katherine Cameron (Kay), RSW, RE, GSLA, 1874–1965, flower subjects in watercolour

Julia Margaret Cameron, 1815–79, photographer

Margaret Sarah Geddes Carpenter, 1793–1872, portrait painter

Anna Maria Kenwell Charretie, 1819–75, painter of portraits, figure and flower subjects

Millie Childers, fl.1888–1921, portrait painter

Ellen Clacy, fl.1870–1916, figure painter

Florence Claxton, fl.1859–79, figure painter and illustrator

Rebecca Coleman, SWA, fl.1867–79, figure painter

Marian Huxley Collier, fl.1880–84, figure and portrait painter

Emma Wren Cooper, SWA, b.1837, fl.1872–93, still-life and figure subjects in watercolour

Fanny Corbaux, Marie Françoise Catherine Doetter, RI, 1812–83, miniaturist

Louisa Corbaux, RI, b.1808, fl.1828–81, figure subjects in oil and watercolour

Ann Cotman, 1812–62, landscape subjects and copyist

Edith Courtauld (Arendrup), b.1846, fl.1864–78, figure and landscape painter

Mary Ann Alabaster Criddle, RWS, 1805–80, figure subjects in oil and watercolour

Emily Crome, 1801–40, still-life painter

Grace Cruickshank, fl.1860–92, miniature painter

Susan Isabel Dacre, MSWP, 1844–1933, figure, landscape and portrait painter

Margaret Dicksee, 1858–1903, figure painter

Emily Francis Strong Pattison, Lady Emilia Dilke, 1840–1904, figure painter and art historian

Annie Dixon, fl.1844–93, miniature and portrait painter

Mary Elizabeth Rosenberg Duffield, RI, 1819/20–1914, flower subjects in watercolour

Maud Earl, 1848–1943, animal painter

Mary Ellen Edwards (Freer, Staples), b.1839, fl.1862–1908, figure painter and illustrator

Anna Maria Fitzjames, SWA, fl.1852–76, still-life painter

Elizabeth Adela Armstrong Forbes (also called Elizabeth Stanhope Forbes), RWS, RE, 1859–1912, figure subjects in oil and watercolour

Emily Susan Ford, WIAC, 1851–1930, figure painter

Eliza Florence Fox (Bridell, Bridell-Fox), ?1824–1903, figure painter

Susan Elizabeth Gay, fl.1874–6, landscape painter

Kate Gilbert (Hughes), b.1843, fl.1885–8, landscape painter

Margaret Gillies, RWS, 1803–87, portrait and figure painter

Margaret Gilmour, GSLA, 1860–1942, painter and designer

Mary Gilmour, GSLA, 1872–1938, painter and designer

Eliza Goodall (Wild), fl.1846–55, figure painter

Ellen Epps Gosse, 1850–1929, landscape painter

Sylvia Gosse, 1881–1968

Caroline Burland Yates Gotch, fl.1880–1902, figure painter

Mary L. Gow (Hall), RI, 1851–1929, figure subjects in oil and
watercolour

Kate Greenaway, RI, 1846–1901, watercolourist and illustrator

Elizabeth Sarah Guinness, fl.1873–1900, figure and portrait painter

Harriet Harrison, SWA, fl.1857–77, flower subjects in watercolour

Maria Harrison, RWS, fl.1845–93, flower subjects in watercolour

Mary Rossiter Harrison, RI, 1788–1875, fruit and flower subjects in
watercolour

Alice Mary Havers (Morgan), SWA, 1850–90, figure painter

Lillie Stac(k)poole Haycraft, fl.1886–96, portrait painter

Edith Hayllar (Mackay), 1860–1948, figure painter

Jessica Hayllar, 1858–1940, figure painter

Kate Hayllar, fl.1883–1900, still-life painter

Mary Hayllar (Wells), fl.1880–5, painter of figure, landscape and still-life
subjects

A. Laura Herford, 1831–70, figure painter

Anna Mary Howitt (Watts), 1824–84, figure painter

Maud Hurst, WIAC, fl.1896–1927, printmaker

Gertrude Jekyll, 1843–1932, painter, photographer, designer and
gardener

Louise (Goode) (Romer) Jopling (Jopling-Rowe), RBA, RP, SWA,
WIAC, 1843–1933, figure, portrait and landscape painter

Lucy Elizabeth Kemp-Welch, RI, RBA, WIAC, 1869–1958, horse and
landscape painter

Jessie Marion King (Taylor), GSLA, 1875–1949, designer and illustrator

Jessie Toler Kingsley, MSWP, fl.1882–9, still-life subjects

Laura Knight, RA, 1877–1970, figure painter

Caroline Blanche Elizabeth Fitzroy Lindsay, RI, SWA, 1844–1912, figure
painter

Marie Elizabeth Cornelissen Seymour Lucas, 1855–1921, figure painter

Ann Macbeth, GSLA, 1875–1948, embroiderer

Jessie Macgregor, SWA, fl.1872–1904, d.1919, figure painter

Fanny (Frances) Mathilda Whitaker McIan, 1814–97, figure painter

Margaret Macdonald Macintosh, 1864–1933, designer

Frances Macdonald MacNair, 1873–1921, watercolourist and designer

Agnes Eliza MacWhirter, b.1837, fl.1867–79, landscape and still-life
painter

Anna Lea Merritt, RBA, SWA, RE, 1844–1930, figure painter

Clara Montalba, RWS, 1842–1929, landscape subjects in oil and
watercolour

Ellen Montalba, fl.1868–1902, figure, landscape and portrait painter

Evelyn Pickering de Morgan, 1855–1919, figure painter

Annie Feray Mutrie, 1826–93, flower and fruit painter

218

Martha Darley Mutrie, 1824–85, flower painter
Isabel Oakley Naftel, SWA, 1832–1912, watercolourist
Maud(e) Naftel, RWS, SWA, 1856–90, landscape and flower subjects in watercolour
Anne Gibson Nasmyth, 1798–1874, landscape painter
Barbara Nasmyth, 1790–1870, landscape painter
Charlotte Nasmyth, 1804–84, landscape painter
Elizabeth Wemyss Nasmyth, 1793–1863, landscape painter
Jane Nasmyth, 1788–1867, landscape painter
Margaret Nasmyth, 1791–1869, landscape painter
Maud Rutherford Hall Neale, fl.1889–1938, figure and portrait painter
Jessie Rowat Newbery, GSLA, 1864–1948, embroiderer and designer
Gertrude Elizabeth Offord, NAC, 1860/1–1903, flower subjects in watercolour
Emma Eburne Oliver (Sedgwick), RI, 1819–85, watercolourist
Emily Mary Osborn, SWA, b.1834, fl.1851–after 1909, figure and landscape painter
Elise Paget, fl.1879–89, townscapes
Louisa Catherine Paris, 1813/14–75, watercolour views
Caroline Paterson (Sharpe), 1856–1911, watercolourist
Kate Dickens Perugini, SWA, 1839–1929, figure painter
Constance Phillott, RWS, 1842–1931, figure and portrait painter
Henrietta Rae (Normand), 1859–1928, figure and portrait painter
Agnes Middleton Raeburn, RSW, GSLA, 1872–1955, watercolourist
Frances Rayner (Coppinger), fl.1860s, architectural subjects in watercolour
Louise Rayner, 1829–94, architectural subjects in watercolour
Margaret Rayner, SWA, fl.1866–90, architectural subjects in watercolour
Nancy Rayner, RWS, fl.1848–55, d.1855, figure and architectural subjects in watercolour
Rose Rayner, fl.1854–66, figure subjects in watercolour
Evelyn Leslie Redgrave, fl.1872–88, landscape subjects in oil and watercolour
Frances M. Redgrave, fl.1864–82, figure and landscape painter
Flora Macdonald Reid, fl.1872–1910, figure painter
Emma Gaggiotti Richards, 1825–1912, figure and portrait painter
Emily Robinson, MSPW, fl.1880s, painter
Ellen Mary Rosenberg, 1831–after 1904, flower subjects in watercolour
Ethel Jenner Rosenberg, 1883–1909, miniature portraits
Frances Elizabeth Louisa Rosenberg (Harris), 1822–72, flower subjects in watercolour
Gertrude Mary Rosenberg, 1886–1913, landscapes in watercolour
Joanna Samworth, fl.1867–81, landscape and flower subjects in watercolour

Emma Sandys, 1843–77, figure painter
Mary Scott (Brookbank), RWS, fl.1823–59, watercolourist
Elizabeth Setchel(l), fl.1832–44, figure subjects
Sarah Setchel(l), RI, 1803–94, figure subjects in watercolour
Anna Mary Severn (Newton), 1832–66, portraitist
Elizabeth Eleanor Siddall (Rossetti), 1829–62, figure subjects in
 watercolour
Emma Sillett, 1801/2–1880, still-life painter
Dorothy Carleton Smyth, GSLA, 1880–1933, designer
Olive Carleton Smyth, GSLA, 1882–1949, figure painter
Rebecca Solomon, 1832–86, figure painter
Catherine Adeline Edwards Sparkes, b.1842, fl.1866–91, figure painter
 and illustrator
Marie Spartali (Stillman), 1843–1927, figure subjects in watercolour
Alice Squire, RI, SWA, 1840–1936, figure subjects and landscape in
 watercolour
Emma Squire, fl.1862–1901, figure and still-life subjects
Anna Maria Hodgson Stannard, fl.1852–69, still-life painter
Eloise Harriet Stannard, SWA, 1829–1915, still-life painter
Emily Coppin Stannard, 1803–85, still-life painter
Louisa Starr (Canziani), SWA, 1845–1909, figure subjects and portraits
Marianne Preindlsberger Stokes, SWA, 1855–1927, figure painter
Ellen Stone, fl.1870–78, figure painter
Amelia Stuart, b.1802, fl.1850s, figure painter
Miss G.E. Stuart, fl.1848–55, still-life painter
Theresa Fanny Stuart, 1829–1913, still-life painter
Louisa Swift, fl.1868–72, figure and portrait painter
Annie Louise Robinson Swynnerton, ARA, SWA, MSWP, 1844–1933,
 painter of figure subjects, landscapes and portraits
Margaret Tekusch, SWA, fl.1845–88, figure and portrait painter
Dorothy Tennant, Lady Stanley (Curtis), 1855–1926, figure painter and
 illustrator
Florence Elizabeth Thomas (Williams), fl.1852–68, still-life painter
Elizabeth Southerden Thompson, Lady Butler, 1846–1933, painter of
 military subjects
Helen Thornycroft, SWA, 1848–1912, figure painter
Theresa Georgina Thornycroft, b.1853, fl.1874–83, figure painter
Mary Simpson Tovey (Christian), fl.1872–6, figure and portrait painter
Eliza Turck, b.1832, fl.1851–86, figure and landscape subjects in oil and
 watercolour
Ellen Vernon, fl.1882–1910, watercolour landscapes
Florence Vernon, fl.1881–1904, landscapes
Mary Vernon, fl.1871–3, flower painter
Norah Vernon, fl.1891–9, watercolour landscapes

Alice Walker, fl.1859–62, figure painter

Cordelia Walker, fl.1859–68, figure painter

(Wilhelmina) Augusta Walker, fl.1870–76, figure painter

Mary Lemon Fowler Waller, SWA, fl.1877–1916, d.1931, portrait and figure painter

Emma Walter, SWA, fl.1855–91, still-life painter

Constance Walton (Ellis), RSW, GSLA, 1865–1960, flower painter

Hannah Walton, GSLA, 1863–1940, miniatures

Helen Walton, GSLA, 1850–1921, designer

Eva Ward, fl.1873–80, figure painter

Flora Ward, fl.1872–6, figure painter

Henrietta Mary Ada Ward, 1832–1924, figure painter

Mary Webb Ward, fl.1829–49, portrait miniatures

Louisa Stuart, Marchioness of Waterford, 1818–91, figure subjects in watercolour

Charlotte J. Week(e)s, fl.1876–90, figure painter and art critic

Augusta Wells, fl.1864–75, figure painter

Caroline Fanny Williams, 1836–1921, landscape painter

Emily Epps Williams, fl.1869–90, figure painter

APPENDIX 1
Artist families in Norwich

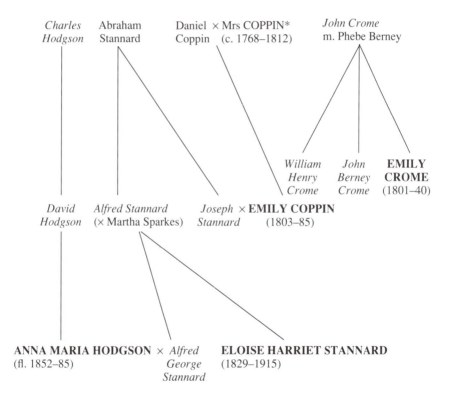

Charles Hodgson Abraham Stannard Daniel Coppin × Mrs COPPIN* (c. 1768–1812) *John Crome* m. Phebe Berney

William Henry Crome *John Berney Crome* **EMILY CROME** (1801–40)

David Hodgson *Alfred Stannard* (× Martha Sparkes) *Joseph Stannard* × **EMILY COPPIN** (1803–85)

ANNA MARIA HODGSON (fl. 1852–85) × *Alfred George Stannard* **ELOISE HARRIET STANNARD** (1829–1915)

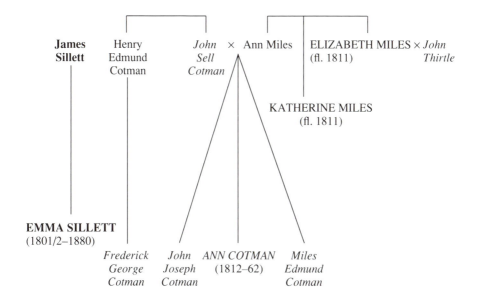

Key:
Artists in italic: landscape/architectural views
Artists in bold capital letters: still life
Artist asterisked: copyist
Artist in bold lower case letters: landscape and still life

APPENDIX 2

The women's petition to the Royal Academy of Arts, 1859

April, 1859

Sir, – – – – We appeal to you to use your influence, as an artist and a member of the Royal Academy, in favour of a proposal to open the Schools of that institution to women. We request your attentive consideration of the reasons which have originated this proposal. When the Academy was established in 1769, women artists were rare; no provision was therefore required for their Art-education. Since that time, however, the general advance of education and liberal opinions has produced a great change in this particular; no less than one hundred and twenty ladies have exhibited their works in the Royal Academy alone, during the last three years, and the profession must be considered as fairly open to women. It thus becomes of the greatest importance that they should have the best means of study placed within their reach; especially that they should be enabled to gain a thorough knowledge of *Drawing* in all its branches, for it is in this quality that their works are invariably found deficient. It is generally acknowledged that study from the Antique and from Nature, under the direction of qualified masters, forms the best education for the artist; this education is given in the Royal Academy to young men, and it is given gratuitously. The difficulty and expense of obtaining good instruction oblige many women artists to enter upon their profession without adequate preparatory study, and thus prevent their attaining the position for which their talents might qualify them. It is in order to remove this great disadvantage, that we ask the members of the Royal Academy to provide accommodation in their Schools for properly qualified Female Students, and we feel assured that the gentlemen composing that body will not grudge the expenditure required to afford to women artists the same opportunities as far as practicable by which they themselves have so greatly profited. We are, Sir, your obedient servants,

J.K. Barclay,

A.C. Bartholomew,

S. Ellen Blackwell,
Anna Blunden,
B.L.S. Bodichon,
Eliza F. Bredell (late Fox),
Naomi Burrell,
M. Burrowes,
Florence Claxton,
Ellen Clayton,
Louisa Gann,
Margaret Gillies,
F. Greata,
Charlotte Hardcastle,
Laura Herford,
Caroline Hullah,
Elizabeth Hunter,
Charlotte James,
Anna Jameson,
F. Jolly,
R. Le Breton,
R. Levison,
Eliza Dundas Murray,
M.D. Mutrie,
A.F. Mutrie,
Emma Novello,
Emma S. Oliver,
E. Osborn,
Margaret Robinson,
Emily Sarjent,
Eliza Sharpe,
Mary Anne Sharpe,
Sophia Sinnett,
Bella Leigh Smith,
R. Solomon,
M. Tekusch,
Mary Thornycroft,
Henrietta Ward.

A copy was sent to each of the forty Academicians and published in the *Athenaeum*, 30 April 1859, 581.

NOTES

INTRODUCTION

1 Deborah Cherry, *Painting Women: Victorian Women Artists*, Rochdale, Rochdale Art Gallery, 1987.

2 R. Parker and G. Pollock, *Old Mistresses: Women, Art and Ideology*, London, Routledge, 1981, 169–70.

3 Jane Sellars, *Women's Works*, Liverpool, National Museums on Merseyside, 1988. Maud Sulter, *Echo: Works by Women Artists, 1850–1940*, Liverpool, Tate Gallery, 1991.

4 Linda Nochlin and Ann Sutherland Harris, *Women Artists, 1550–1950*, Los Angeles, Los Angeles County Museum of Art, 1976. Neuen Gesellschaft für Bildende Kunst, *Das Verborgene Museum: Dokumentation der Kunst von Frauen in Berliner öffentlichen Sammlungen*, Berlin, Edition Hentrich, 1987. *The Women's Art Show, 1550–1970*, Nottingham, Castle Museum, 1982.

5 Sulter, 1991, 13, 26.

6 The title of an art-work by Barbara Kruger.

7 L. Tickner, 'Feminism, art history and sexual difference', *Genders*, 3, 1988, 92. G. Pollock, *Vision and Difference: Femininity, Feminism and the Histories of Art*, London, Routledge, 1988, 16–17.

8 An account of N. American and British approaches is given in T. Gouma-Peterson and Patricia Mathews, 'The feminist critique of art history', *Art Bulletin*, 69, 1987, 326–57.

9 W. Chadwick, *Women, Art and Society*, London, Thames & Hudson, 1990.

10 J. Marsh and P. G. Nunn, *Women Artists and the Pre-Raphaelite Movement*, London, Virago, 1989.

11 L. Nochlin, *Women, Art and Power*, London, Thames & Hudson, 1989, 145–78

12 L. Himid, 'Mapping: a decade of Black women artists, 1980–90', in M. Sulter, (ed.), *Passion: Discourses on Blackwomen's Creativity*, Hebden Bridge, Urban Fox Press, 1990, 68.

13 Z. Alexander, 'Preface', in M. Ferguson (ed.), *The History of Mary Prince, a West Indian Slave, Related by Herself*, London, Pandora, 1987, ix.

14 M. Foucault, *The Archaeology of Knowledge*, London, Tavistock, 1972.

15 M. Foucault, *Discipline and Punish*, Harmondsworth, Penguin, 1982. *The History of Sexuality. Volume I*, Harmondsworth, Penguin, 1981.

16 M. Foucault, 'What is an author?', *Screen*, 20 (1), 1979, 14.

17 G. Pollock, 'Artists' mythologies and media genius', *Screen*, 21 (3), 1980, 57–96.

18 V. Sanders, *The Private Lives of Victorian Women: Autobiography in*

Nineteenth-century England, New York, St Martins Press, 1989.

19 ibid., 5.

20 E. Clayton, *English Female Artists*, London, Tinsley, 1876, II, 186. Ellen Clayton's entries were based on questionnaires completed by the artists.

21 ibid., II, 289.

22 For example, the entry on Barbara Bodichon in ibid., II, 167.

23 Foucault, 1979. R. Barthes, 'The death of the author', *Image, Music Text*, translated S. Heath, London, Fontana, 1977.

24 The classic account is Catherine Hall, 'Gender division and class formation in the Birmingham middle-class, 1780–1850', in R. Samuel, (ed.), *People's History and Socialist Theory*, London, Routledge, 1981, 164–75. *Family Fortunes: Men and Women of the English Middle-Class, 1780–1850*, co-written with Leonore Davidoff (1987, London, Hutchinson), is more concerned with sexual difference.

25 For example, Parveen Adams, 'A note on the distinction between sexual division and sexual differences', *m/f*, 3, 1979, 51–7.

26 Pollock, 1988, 50–90.

27 Lynne Walker, 'Vistas of Pleasure: women consumers of urban space in the west end of London, 1850–1900', in *Cracks in the Pavement: Gender, Fashion, Architecture*, London, Sorella, 1993.

28 J. Beckett and D. Cherry, 'Women under the banner of Vorticism', *ICSAC Cahiers*, 1988, 8/9.

29 Clayton, 1876, II, 44, for example.

30 R. Hennessy and R. Mohan, 'The construction of woman in three popular texts of empire', *Textual Practice*, 3, 1989, 328–9.

31 A. Levy, *Other Women: The Writing of Class. Race and Gender, 1832–98*, Princeton, Princeton University Press, 1991.

32 L. Sargent (ed.), *Women and Revolution: A Discussion of the Unhappy Marriage of Marxism and Feminism*, Boston, South End Press, 1981.

33 Hazel V. Carby, 'White women listen', in Centre for Contemporary Cultural Studies, Birmingham, *The Empire Strikes Back*, London, Hutchinson, 1982, 212–34.

34 Chris Weedon, *Feminist Practice and Post-structuralist Theory*, Oxford, Blackwell, 1987.

35 L. Nead, *Myths of Sexuality: Representations of Women in Victorian Britain*, Oxford, Blackwell, 1988. L. Tickner, *The Spectacle of Women: Imagery of the Suffrage Campaign, 1907–1914*, London, Chatto, 1987. Pollock, 1988.

36 Foucault, 1981, 11. L. Bland, 'The domain of the sexual: a response', *Screen Education*, 39, 1981, 56–67.

37 Trinh T. Minh-ha, *Woman, Native, Other: Writing Postcoloniality and Feminism*, Bloomington, Indiana University Press, 1989, 96.

38 E. Cowie, 'Woman as sign', *m/f*, 1, 1978, 49–63.

39 D. Cherry and G. Pollock, 'Woman as sign in Pre-Raphaelite literature: a study of the representation of Elizabeth Siddall', *Art History*, 7 (2), 1984, 206–24. Here Siddall designates the historical individual, 'Siddal' the sign in art history, and 'Siddall' the sign in feminist discourse.

40 T. de Lauretis, *Technologies of Gender: Essays on Theory, Film and Fiction*, Bloomington, Indiana University Press, 1987, xi.

1 FAMILY BUSINESS

1 Elizabeth Ellet, *Women Artists in All Ages and Countries*, London, Bentley, 1859, 2.

2 Leonore Davidoff and Catherine Hall, *Family Fortunes: Men and Women of the English Middle Class, 1780–1850*, London, Hutchinson, 1987. As these historians have consistently indicated, concepts of family and household are not trans-cultural but determined by and changing with historical circumstances and pressures and formed in relation to class. Here family, household and marriage are investigated in the specific bourgeois forms which they took in the period 1840 to 1900.

3 'Chat with a famous Norwich artist, Miss Stannard', *Eastern Daily Press*, 14 October 1910. I am indebted to Norma Watt for all her help on the Stannard family.

4 F.M. Hueffer, *Ford Madox Brown*, London, Longmans, 1896, 252.

5 E. Clayton, *English Female Artists*, London, Tinsley, 1876, II, 236.

6 Clayton, 1876, II, 36. She continued her career as an artist after her marriage to an architect, S.J. Nicholl.

7 Clayton, 1876, II, 236.

8 ibid., II, 138.

9 ibid., II, 253.

10 ibid., II, 94, 136; W. Hardinge, 'A reminiscence of Mrs W. M. Rossetti', *Magazine of Art*, 1895, 341–6; F. M. Hueffer, 'The younger Madox Browns', *The Artist*, no. 19, 1897. His pupils included Marie Spartali, Theresa Thornycroft and Ellen Gosse.

11 C. Wood, 'The artistic family Hayllar', *The Connoisseur*, May 1974, 2–9.

12 Clayton, 1876, II, 21, 177.

13 *Art Journal*, 1876, 47; *Athenaeum*, 4 December 1875; J. L. Roget, *A History of the Old Water-colour Society*, London, Longmans, 1891, II, 297–301.

14 Hélène Postlethwaite, 'Some noted women painters', *Magazine of Art*, 1894, 20–21. *Queen*, 1 June 1889, 774.

15 Jan Reynolds, *The Williams Family of Painters*, 1973.

16 Clayton, 1876, II, 235.

17 I am indebted to Barbara Milner and Jill Knight of the Victoria Art Gallery, Bath, for documentation on these artists.

18 H. E. Day, *East Anglian Painters*, Eastbourne, Eastbourne Fine Art, 1969; A. Moore, *The Norwich School of Painters*, Norwich, Norfolk Museums Service, 1985; M. Rajnai, *The Norwich Society of Artists, 1805–33*, Norwich, Norfolk Museum Service, 1976; M. Allthorpe-Guyton, *A Happy Eye. A School of Art in Norwich, 1845–1982*, Norwich, Jarrolds, 1982; T. Fawcett, *The Rise of English Provincial Art*, Oxford, Clarendon, 1974, 201–3.

19 Norma Watt, *The Norfolk and Norwich Art Circle, 1885–1985*, Norwich, Norfolk Museums Service, 1985. Emma Sandys's brother, Frederic Sandys, was an artist, as were her father and several of her nieces.

20 Andrew Hemingway, 'Cultural philanthropy and the invention of the Norwich School', *Oxford Art Journal*, 11 (2), 1988, 17–39. Jane Beckett and Deborah Cherry (eds), *The Edwardian Era*, Oxford, Phaidon, 1987, 67–9. According to the key text, 'still life painting hardly comes within the scope of the present work, yet I cannot leave this talented family [the Stannards] without remarking that nearly all of its lady members exhibited talent as fruit and flower painters'. W. F. Dickes, *The Norwich School of Painting,* Norwich, Jarrolds, 1905, 540.

21 'Chat with a famous Norwich artist, Miss Stannard', *Eastern Daily Press*, 14 October 1910.

22 Clayton, 1876, II, 296; Roget, 1891, I, 553.

23 Ailsa Tanner, 'Painters of flowers', in Jude Burkhauser (ed.), *Glasgow Girls: Women in Art and Design 1880–1920*, Edinburgh, Canongate, 1990, 220.

24 Clayton, 1876, II, 300–1.

25 ibid., II, 286–7.

26 *Art Journal*, 1868, 46.

27 These arguments were extended in D. Cherry, *Painting Women*, Rochdale, Rochdale Art Gallery, 1987, 20–1.

28 Both women established independent artistic careers on leaving the familial environment, Mary Gow becoming a member of the Royal Institute of Painters in Watercolour. However, she resigned her membership in 1903 and married a painter, S. P. Hall.

29 Clayton, 1876, II, 68.

30 ibid., II, 143, 254.

31 C. Hall, 'The early formation of Victorian domestic ideology', in S. Burman (ed.), *Fit Work for Women*, London, Croom Helm, 1979, 15–32.

32 Anna Mary Howitt's articles were first published in *Household Words* and collected in her *An Art Student in Munich*, London, 1853.

33 Amice Lee, *Laurels and Rosemary: The Life of William and Mary Howitt*, London, Oxford University Press, 1955, 185.

34 Margaret Howitt (ed.), *Mary Howitt: An Autobiography*, London, Isbister, 1889, II, 89.

35 Howitt, 1889, II, 90.

36 C. E. Maurice, *Life of Octavia Hill*, London, Macmillan, 1913. Octavia Hill continued to draw for her own pleasure and she also made copies for Ruskin.

37 Eliza Florence Bridell-Fox, 'Memories', *Girl's Own Paper*, 19 July 1890, 657–61.

38 Clayton, 1876, II, 80–7.

39 I am indebted here to discussions with Susan Hamilton; see also F. E. Minneka, *The Dissidence of Dissent*, Chapel Hill, University of North Carolina, 1944; R. V. Holt, *The Unitarian Contribution to Social Progress in England*, London, Lindsey Press, 1952.

40 Richard Garnett, *The Life of W. J. Fox: Public Teacher and Social Reformer*, London, John Lane, 1910, 310.

41 ibid. Eliza Fox's portrait drawing of Eliza Flower, who died in 1846, is in Conway Hall, London. F. A. Hayek, *John Stuart Mill and Harriet Taylor Mill: Their Correspondence and Subsequent Marriage*, Chicago, University of Chicago Press, 1951, 111, 122.

42 Barbara Bodichon's notebooks, 1849, including abstracts of *Principles of Political Economy* by J. S. Mill and Harriet Taylor, are at Girton College, Cambridge; see Kate Perry, *Barbara Leigh Smith Bodichon 1827–1891*, Cambridge, Girton College, 1991. Margaret Tuke, *A History of Bedford College for Women, 1849–1937*, London, Oxford University Press, 1939, 313, 322.

43 S. S. Beale, *Recollections of a Spinster Aunt*, London, Heinemann, 1908, 149.

44 ibid., 134

45 A. M. W. Stirling, *William de Morgan and His Wife*, London, Thornton Butterworth, 1922, 176.

46 Beale, 1908, 141.

47 Sophia Beale exhibited figure paintings between 1860 and 1889, mostly at the Royal Academy. Her publications included guides to the Louvre, 1883, and to the churches of Paris, 1893. Ellen Beale exhibited in 1865, but seems to have ceased after her marriage to William Watkiss Lloyd.

48 Ina Taylor, *Helen Allingham's England*, Exeter, Webb & Bower, 1990. Clayton, 1876, II, 2–3.

49 I am most grateful to Maria Twist of Birmingham Libraries for the information that Helen Paterson was awarded prizes and medals in 1863 and 1865.

50 *Solomon: A Family of Painters*, London, Geffrye Museum, 1985, 6.

51 Monica Bohm-Duchen, 'The Jewish background', in *Solomon: A Family of Painters*, 8–9.

52 A. Baldwin, *The Macdonald Sisters*, London, Peter Davies, 1960, 97, 101, 103.

53 Her copy of John Philip's *Marriage of the Princess Royal* is in the Royal Collection.

54 For these years see Baldwin, 1960.

55 See chapter 5 for Lady Caroline Blanche Elizabeth Lindsay.

56 *The Lady*, 2 September 1886, 183; *Art Journal*, 1864, 241.

57 *Queen*, 5 October 1889, 465.

58 See J. Marsh and P. G. Nunn, *Women Artists and the Pre-Raphaelite Movement*, London, Virago, 1989.

59 For scanty references to Joanna Mary Boyce in her brother's journals, see 'The diaries of George Price Boyce', *Old Watercolour Society: Nineteenth Annual Volume*, 1941.

60 P. G. Nunn, *Victorian Women Artists*, London, Women's Press, 1987, 188–94.

61 Clayton, 1876, II, 261; *Art Journal*, 1884, 127. Rebecca Coleman, presumably another sister of William Coleman, is recorded in Clayton, 1876, II, 47–67, according to which she joined her brother in London, did household duties in the day and spent her evenings preparing his wood-blocks and making his tracings.

62 Clayton, 1876, II, 133.

63 ibid., II, 154.

64 Stirling, 1922, 174.

65 ibid., 181.

66 ibid., 177.

67 G. Burne-Jones, *Memorials of Edward Burne-Jones*, London, Macmillan, 1904, I, 218.

68 Eliza Goodall exhibited from 1846 to 1854, then only once as Mrs Wild in 1855. Clayton, II, 1876, 36.

69 ibid., II, 177.

70 Louisa Starr, 'The Spirit of Purity in Art', in Ishbel M. Gordon, Marchioness of Aberdeen (ed.), *Transactions (1899) of the International Council of Women*, London, 1900, 86. See also her daughter's recollections, Estella Starr Canziani, *Round About Three Palace Green*, London, Methuen, 1939.

71 L. Jopling, *Twenty Years of My Life, 1867–87*, London, John Lane, 1925, 57–8.

72 ibid., 64.

73 Roget, 1891, II, 247; Clayton, 1876, I, 398.

74 J. F. Fisher, 'Jane Maria Bowkett', *Women Artists' Slide Library Journal*, no. 20, 1988, 14–15; 'The World of Jane Maria Bowkett', *The Lady*, 18 December 1986, 1102–3. Her niece Eleanor (Nora) Bowkett exhibited 1896–1911. I am grateful to Dr Foley-Fisher for information on the Bowkett family.

75 *Queen*, 2 November 1889, 615.

76 I. McAllister (ed.), *Henrietta Ward: Memories of Ninety Years*, London, Hutchinson, 1924, 124. See also E. O'Donnell (ed.), *Mrs E. M. Ward's Reminiscences*, London, Pitman, 1911.

77 Leslie Ward, her son, was trained at the Royal Academy schools and became a well-known cartoonist on *Vanity Fair*.

78 McAllister, 1924, 124.

79 Marsh and Nunn, 1989, 50.

80 ibid., 51.

81 J. Troxell, *Three Rossettis*, Cambridge, Mass., Harvard University Press,

1937, 8.

82 Jopling, 1925, 175.

83 Stirling, 1922, 204.

84 *Queen*, 4 May 1889, 614.

85 *Magazine of Art*, 1894, 17; *Art Journal*, 1901, 307.

86 Information kindly provided by Gill Saunders.

87 S. Birkenhead, *Against Oblivion*, London, Cassell, 1943.

88 Birkenhead, 1943, 176.

89 as 87.

90 C. T. Newton's *Travels and Discoveries in the Levant* of 1865, the popular version of his reports on the excavations at Halicarnassus, reproduces several drawings by Mary Severn along with photographic views etched by her brothers.

91 This passage was recycled in *Gentleman's Magazine*, 1866, 435–6; *The Times*, 23 January 1866, 9; and *Art Journal*, 1866, 100.

92 B. Askwith, *Lady Dilke: A Biography*, London, Chatto, 1969. Kali A. K. Israel, 'Writing inside the kaleidoscope: re-representing Victorian women public figures', *Gender and History*, 2 (1), 1990, 40–8. A portrait of Emilia Dilke painting a decorative panel at Wallington by Pauline Trevelyan and Laura Capel Lofft is in the National Portrait Gallery.

93 As E. F. S. Pattison she published *The Renaissance of Art in France*, 1879 and *Claude Lorrain (1884)*; as Emilia Dilke, *Art in the Modern State*, 1888, and four volumes on French art of the eighteenth century, 1899–1902. See 'The art work of Lady Dilke', *Quarterly Review*, 205, 1906, 439–67, and Adele Holcomb and Claire R. Sherman (eds), *Women as Interpreters of the Visual Arts*, Westport, Conn., Greenwood, 1981.

94 W. Allingham to Emily, Lady Tennyson, 10 August 1874, Tennyson Research Centre, Lincoln. Lincolnshire County Council.

95 N. Annan, 'The intellectual aristocracy', in J. H. Plumb, *Studies in Social History. A Tribute to G. M. Trevelyan*, London, Longmans, 1955, 243–87.

96 L. Davidoff, *The Best Circles: Society, Etiquette and the Season*, London, Croom Helm, 1973, 77.

97 Label on the reverse of Emily Epps Williams's painting *Some of her Dolls*, private collection. John Brett's drawing of her sister, Laura, dated 1860, is in the Ashmolean.

98 Clayton, 1876, II, 6, 94. According to A. Thwaite, *Edmund Gosse. A Literary Landscape. 1849–1928*, London, Secker & Warburg, 1984, Ellen was a pupil and assistant of Lawrence Alma-Tadema.

99 E. Charteris, *The Life and Letters of Sir Edmund Gosse*, London, Heinemann, 1931, 68.

100 ibid., 71–2, my italics.

101 Thwaite, 1984, 214.

102 ibid.

103 ibid., 304.

104 ibid., 395.

105 Ellen Gosse exhibited several paintings before her marriage and 24 works between 1879 and 1893. Laura Alma-Tadema exhibited 34 works between 1873 and 1893. Like her husband she gave her works Opus numbers, 111 in all.

106 W. C. Monkhouse, 'Some English artists and their studios', *Century Magazine* (US edition), 24, 1882, 553–68.

107 W. Meynell, 'Artists' Homes', *Magazine of Art*, 1882, 184–8. Laura Alma-Tadema also modelled to her husband in the early years of their marriage.

108 ibid., 184–8.

109 Illustrated in Ellen Gosse, 'Lawrence Alma-Tadema', *Century Magazine* (US edition), 47, 1894, 482–97. See also Vern Swanson, *The Biography and Catalogue Raisonné of the Paintings of Sir Lawrence Alma Tadema*, Aldershot, Scolar, 1900.
110 Alice Meynell, 'Laura Alma-Tadema', *Art Journal*, 1883, 345–7.
111 Elizabeth Thompson, Lady Butler, *An Autobiography*, London, Constable, 1922.
112 *Art Journal*, 1876, 12; Clayton, 1876, II, 415–19.
113 Taylor, 1990, 96.
114 R. W. Maude, 'Mrs E. M. Ward: "Royalties as Artists"', *Strand Magazine*, 16, October 1898, 366–71. Henrietta Ward cultivated royal and aristocratic pupils.
115 A. L. Merritt, 'A letter to artists, especially women artists', *Lippincott's Monthly Magazine*, 65, 1900, 463–9.

2 SPINSTERS AND FRIENDS

1 F. P. Cobbe, 'Celibacy vs Marriage', *Fraser's Magazine*, 65, 1862, 233.
2 H. Martineau, *Autobiography*, London, Smith Elder, 1877, I, 133.
3 Sheila Jeffreys, *The Spinster and Her Enemies: Feminism and Sexuality, 1880–1930*, London, Pandora, 1985. Martha Vicinus, *Independent Women: Work and Community for Single Women, 1850–1920*, London, University of Chicago Press, 1985.
4 'The future of single women', *Westminster Review*, January 1884, quoted in Lucy Bland, 'The domain of the sexual: a response', *Screen Education*, 39, 1981, 61.
5 *Englishwoman's Review*, April 1885, 160.
6 E. Clayton, *English Female Artists*, London, Tinsley, 1876, II, 226, 258, 289.
7 A. Crawford (ed.), *By Hammer and Hand: The Arts and Crafts Movement in Birmingham*, Birmingham, City Art Gallery, 1984; J. Marsh and P. G. Nunn, *Women Artists and the Pre-Raphaelite Movement*, London, Virago, 1989. Kate Bunce's tempera painting, *The Keepsake*, of 1901 has a frame by Myra Bunce (Birmingham City Art Gallery).
8 Clayton, 1876, II, 87–94.
9 Letter from Margaret Gillies to Leigh Hunt (*c.* 1839), Leigh Hunt Collection, Ms L/G 48h, University of Iowa, quoted with kind permission.
10 J. Burkhauser (ed.), *Glasgow Girls: Women in Art and Design, 1880–1920*, Edinburgh, Canongate, 1990. 165–71.
11 C. Wood, 'The artistic family Hayllar', *Connoisseur*, May 1974, 2–9.
12 A. M. W. Stirling, *William de Morgan and his Wife*, London, Thornton Butterworth, 1922, 187.
13 ibid., 193.
14 Deborah Epstein Nord, 'Neither pairs nor odd, female community in late nineteenth-century London', *Signs*, 15, 1990, 733–54.
15 Clayton, 1876, II, 17.
16 *Art Journal*, 1864, 261.
17 Hélène Postlethwaite, 'Some noted women painters', *Magazine of Art*, 1895, 21.
18 Jeffreys, 1985, 86.
19 B. R. Parkes, *Poems*, London, Chapman, 1856.
20 A. M. Howitt, *An Art Student in Munich*, London, 1853, 89; Barbara Leigh Smith Bodichon to Bessie Rayner Parkes [1854], Girton College, Cambridge, Parkes Papers, V, 180.
21 Howitt, 1853, 91.
22 ibid., 91.

23 [A. M. Howitt], 'Sisters in Art', *Illustrated Exhibitor and Magazine of Art*, 2, 1852, 364.

24 [Howitt], 1852, 365.

25 Lisa Tickner, *The Spectacle of Women: Imagery of the Suffrage Campaign, 1907–1914*, London, Chatto, 1987, 19–20.

26 Cobbe, 1862, 233.

27 Barbara Bodichon visited Harriet Hosmer in Rome in 1854, and an article on this artist appeared in an early issue of the *English Woman's Journal*. See H. Burton, *Barbara Bodichon*, London, John Murray, 1949; F. P. Cobbe, *Italics*, London, Trubner, 1864. 374 ; Sarah F. Parrott, 'Networking in Italy', *Women's Studies*, 14 (4), 1988, 305–38.

28 Clayton, 1876, II, 159.

29 S. S. Beale, *Recollections of a Spinster Aunt*, London, Heinemann, 1908, 214–45.

30 D. M. Craik, 'A Paris Atelier', *Good Words*, 1886, 309.

31 ibid., 313.

32 ibid., 312.

33 C. Smith-Rosenberg, 'The female world of love and ritual, relations between women in nineteenth-century America', in *Disorderly Conduct: Visions of Gender in Victorian America*, New York, Knopf, 1985, 53.

34 Clayton, 1876, II, 156.

35 ibid., II, 155.

36 Burkhauser, 1990, 173; *The Lady*, 2 September 1886, 183.

37 For many independent women, including Harriet Martineau, owning and furnishing a home was an important component in an independent life, enabling redefinitions of domesticity outside heterosexuality. Frances Power Cobbe and Mary Lloyd lived in 'the dear little house in South Kensington [bought by Mary Lloyd] which became our home'. Mary Lloyd commissioned a sculpture studio in their back garden. *The Life of Frances Power Cobbe*, London, Swan Sonnenschein, 1904, 395.

38 M. Vicinus, '"One life to stand beside me": emotional conflicts in first-generation college women in England', *Feminist Studies*, 8 (3), 1982, 603–4.

39 For example, Ellen Cole, RA 1846; Fanny Corbaux, New Society of Painters in Water-colour, 1846, or Margaret Gillies, British Institution, 1846.

40 Susan Isabel Dacre, obituary, *Manchester Guardian*, 21 February 1933.

41 The portrait reworks the earlier conventions of inscribing the sitter's name on the canvas to represent the dynamic of friendship which produced it. The portrait was presented by Susan Isabel Dacre to Manchester City Art Gallery in 1932.

42 The definitive history is Lilian Faderman, *Surpassing the Love of Men: Romantic Friendships and Love between Women from the Renaissance to the Present*, New York, Morrow, 1981.

43 Christabel Maxwell, *Mrs Gatty and Mrs Ewing*, London. Constable, 1949, 107.

44 *The Brontës: Their Lives, Friendships and Correspondence in Four Volumes* (Shakespeare Head edition), Oxford, Blackwell, 1932, *passim*.

45 Private collection, repr. in *Miss Gertrude Jekyll, 1843–1932, Gardener*, London, Architectural Association, 1981, 3. Sally Festing, *Gertrude Jekyll*, London, Viking, 1991, plate 10.

46 Emma Stebbins, *Charlotte Cushman: Her Letters and Memories of her Life*, Boston, Houghton, Osgood, 1878, 77.

47 Nottingham Castle Museum.

48 This reworking of Elizabeth Cowie's analysis of 'Woman as sign' in *m/f*, 1, 1978, 49–63, is developed further in chapters 6 and 10.

3 AN EDUCATION IN DIFFERENCE OR
AN IN/DIFFERENT EDUCATION?

1 P. Nunn, *Victorian Women Artists*, London, Women's Press, 1987; J. Marsh and P. G. Nunn, *Women Artists and the Pre-Raphaelite Movement*, London, Virago, 1989; C. Yeldham, *Women Artists in Nineteenth-Century France and England*, New York, Garland, 1984.
2 I. Taylor, *Helen Allingham's England*, Exeter, Webb & Bower, 1990, 11–29.
3 Ellen Clayton, *English Female Artists*, London, Tinsley, 1876, 2, 14.
4 Elizabeth Cowie, 'Woman as Sign', *m/f*, 1, 1978, 49–63.
5 D. M. Craik, *A Woman's Thoughts about Women*, London, Hurst & Blackett, 1858, 50.
6 Clayton, 1876, II, 83.
7 ibid., II, 83–4.
8 I. McAllister (ed.), *Henrietta Ward: Memories of Ninety Years*, London, Hutchinson, 1924, 58; *Art Journal*, 1857, 215; *English Woman's Journal*, August 1857, 12.
9 Anna Mary Howitt to Barbara Bodichon, *c.* 1848–52, transcribed in Barbara Stephen's notebook, Cambridge University Library, Add. Ms 7621, with thanks to A. E. B. Owen for locating this document.
10 Louisa Garrett Anderson, *Elizabeth Garrett Anderson*, London, Faber, 1936.
11 *Annual Report*, Royal Academy of Arts, 1860, 35, Archives of the Royal Academy in London.
12 'A. R.', 'A letter from a lady', *Athenaeum*, 12 March 1859, 361–2.
13 *Athenaeum*, 30 April 1859; *English Woman's Journal*, 1859, 287; ibid., 1859, 144; *Athenaeum*, 8 September 1860, 330; *Art Journal*, 1860, 286.
14 Laura Herford asked Harriet Martineau to take up the issue in the *Daily News*; see V. Sanders (ed.), *Harriet Martineau: Selected Letters*, Oxford, Clarendon Press, 1990. I am indebted to Valerie Sanders for this information. See also Harriet Martineau, 'Female industry', *Edinburgh Review*, April 1859, 334. Anna Jameson, *Sisters of Charity and The Communion of Labour . . . A New Edition with a Prefatory Letter to the Rt Hon Lord John Russell*, London, Longmans, 1859, xliii–v.
15 Royal Academy Council Minutes, 14 May 1863, 137; Petition, 1864, Anderton catalogues, 26, 405, kindly supplied by Sidney Hutchison; *Art Journal*, 1864, 154; Royal Academy Council Minutes, 20 March 1867, 333.
16 Florence Martin's *The Life School* (RA 1884) depicts women students at the Royal Academy drawing from a model heavily swathed in drapery, repr. H. Blackburn, *English Art in 1884*, New York, Appleton, 1885, 118.
17 Jessie Macgregor, 21 November 1912, letter in the archives of Walker Art Gallery, Liverpool.
18 Royal Academy Council Minutes, 9 January 1872, 246; *Annual Report*, 1872, 7.
19 *Illustrated London News*, 21 December 1889, 795.
20 F. Leighton to E. Dilke [*c.* 1885], British Library, Add. Ms 43907; see L. and R. Ormond, *Lord Leighton*, London, Yale University Press, 1975, 73n. In 1889 the subject was discussed again when Briton Riviere proposed that female students should study the partially draped model; see letters in RA Archives.
21 S. C. Hutchison, *The History of the Royal Academy, 1768–1968*, London, Chapman and Hall, 1968.
22 Marsh and Nunn, 1989, 79.
23 Charlotte Weeks, 'Women at work: the Slade girls', *Magazine of Art*, 1883, 325.
24 A. Callan, *Angel in the Studio: Women in the Arts and Crafts Movement, 1870–1914*, London, Astragal, 1979, 27–43.

25 Second Report of the Department of Science and Art, 1854, 157; and Report of the Select Commission on the School of Design, 1849, 115–20.
26 Clayton, 1876, II, 148.
27 L. Knight, *Oil Paint and Grease Paint: Autobiography of Laura Knight*, London, Nicholson, 1936, 44ff.
28 A. Crawford (ed.), *By Hammer and Hand. The Arts and Crafts Movement in Birmingham*, Birmingham, City Museum and Art Gallery, 1984.
29 J. Burkhauser (ed.), *Glasgow Girls: Women in Art and Design 1880–1920*, Edinburgh, Canongate, 1990, 63–75.
30 The school, started by Henry Sass, seems to have offered life-drawing to women; see Clayton, 1876, II, 22, 164. Cary became the art teacher at Bedford College where a life-class, probably with draped model, was provided.
31 Information kindly provided by J. Street. This artist also attended a School of Design in 1854 and studied in Paris (see Nunn, 1987, 150–3); her drawing of women attending an anatomy lecture along with her notes 'from lectures on the Human Form by John Marshall', *c.* 1852, are in a sketchbook in a private collection, repr. D. Cherry, *Painting Women: Victorian Women Artists*, Rochdale, Rochdale Art Gallery, 1987, 5.
32 C. Neve, 'London art school in search of a home', *Country Life*, 17 August 1978, 448–50, 31 August 1978, 570–1. G. Massey, *Kings, Commoners and Me*, London, 1934, 134, claimed that because of its separate life-classes Heatherley's was 'the first school to admit lady students on equal terms with men'.
33 S. S. Beale, *Recollections of a Spinster Aunt*, London, Heinemann, 1908, 142. Leigh was by this date ill and had lost his voice.
34 Louise Jopling, *Twenty Years of My Life: 1867–87*, London, John Lane, 1925. Clayton, 1876, II, *passim*.
35 H. Herkomer, *My School and Gospel*, London, Constable, 1908.
36 The research of Maud Sulter and Lubaina Himid on Black women artists. Monica Bohm-Duchen, 'The Jewish background', in *Solomon: A Family of Painters*, London, Geffrye Museum, 1985.
37 R. Visram, *Ayahs, Lascars and Princes: Indians in Britain, 1700–1947*, London, Pluto, 1986, 177–87.
38 *Englishwoman's Review*, April 1895, 115.
39 G. Longman, *The Herkomer Art School, 1883–1900*, Bushey, privately published, 1976, 3, mistakenly places *Dhunbai* Banajee in the list of male students for 1892.
40 Visram, 1986, 182.
41 E. F. Bridell-Fox, 'Memories', *Girl's Own Paper*, 19 July 1890, 659.
42 Clayton, 1876, II, 156–7. Wilhelmina Augusta Walker's signature on the 1864 RA petition dates her attendance at South Kensington.
43 Knight, 1936, 44ff.
44 Hilary Taylor, 'If a young painter be not fierce and arrogant . . .', *Art History*, 9 (2), June 1986, 232–42.
45 Jessie Macgregor, 1912. Elizabeth Garrett Anderson experienced considerable hostility when she did well in her examinations at Middlesex Hospital; the male students petitioned for her dismissal; see L. G. Anderson, 1936, 80.
46 H. Taylor, 1986; Jane Sellars, *Women's Works*, Liverpool, National Museums and Galleries on Merseyside, 1988; Nunn, 1987, 52.
47 G. D. Leslie, *The Inner Life of the Royal Academy*, London, John Murray, 1914, 48.
48 A. L. Merritt, 'Recollections of Henry Merritt', in *Henry Merritt: Art Criticism and Romance*, London, Kegan Paul, 1879, 1, 7 (my italics).
49 E. Clayton, 1876, II, 136.

50 E. Clayton, 1876, II, 73, 126, 264, 274, 290.
51 Lady Blanche Lindsay, 'Recollections of Miss Margaret Gillies', *Temple Bar*, 1887, 265–73; thanks to Brenda Colloms for the reference.
52 E. Clayton, 1876, II, 290.
53 *Art Union* 1845, 295. I am indebted to Belinda Lady Morse for information on this artist.
54 Information kindly provided by Normă Watt.
55 J. Burkhauser (ed.), 1990, 63–75.
56 T. Mackenzie (ed.), *The Art Schools of London*, London, Chapman and Hall, 1895.
57 A. L. Baldry, 'Private schools of art: Mrs Jopling', *Studio*, 7, 1896, 40–6, according to which women had access to the life-model.
58 Maud Hurst advertised her lessons in watercolour sketching in Paris and England in *International Art Notes*, 1900, to which she also contributed 'The student in Paris', 1900, 42–5.
59 Lindsay, 1887, 271–2; Clayton, II, 290; H. Grote, *Ary Scheffer*, London, 1860. Joanna Boyce admired Scheffer's works in Paris in 1852; see Nunn, 1987, 150.
60 Clayton, 1876, II, 290.
61 Information kindly provided by J. Street; the artist's drawings from her sketchbooks from this period, in a private collection, are repr. in Cherry, 1987, 6.
62 *Work and Leisure*, 1892, 304; *English Woman's Year Book*, 1895.
63 Jo Ann Wein, 'Parisian art training of American women artists', *Women's Art Journal*, 2 (1), 1981, 42.
64 Craik, 1886, 309.
65 Margaret Howitt, *Mary Howitt: An Autobiography*, London, Isbister, 1889, II, 56–7.
66 C. Weeks, 'Lady art students in Munich', *Magazine of Art*, 1881, 343–7.
67 *Queen*, 18 October 1890, 576, kindly supplied by the staff at Platt Hall, Manchester.
68 Harriet Ford, 'The work of Mrs A. Stokes', *Studio*, 19, 1900, 150.

4 ART INSTITUTIONS AND THE DISCOURSES OF DIFFERENCE

1 The first woman associate of the Royal Academy was Annie Robinson Swynnerton, elected in 1922, and the first woman Academician was Laura Knight, elected in 1936.
2 Margaret Carpenter was frequently put forward by art critics in the 1840s; Annie Mutrie and Henrietta Ward were proposed, but not elected. Royal Academy Election Book, RA Archives, London.
3 Royal Academy Election Book, 19 June 1879, 119, indicates that the vote was 27/25 in favour of H. Herkomer; 23 April 1880, 125; 20 January 1881, 132; Royal Academy, *Annual Report*, 1879, 20. RA Archives, London.
4 *Examiner*, 3 March 1871, 229.
5 V. Swanson, *The Biography and Catalogue Raisonné of Sir Lawrence Alma-Tadema*, Aldershot, Scolar, 1990, 58ff.
6 H. Postlethwaite, 'Some noted women Painters', *Magazine of Art*, 1895, 18; J. Sellars, *Women's Works*, Liverpool, National Museum and Galleries on Merseyside, 1988, 5. Annie Swynnerton was the second and last woman artist to serve on the selection committee of the Liverpool Autumn Exhibition in 1895.
7 *Art Journal*, 1850, 192; *Athenaeum*, 11 May 1850, 510; J.L. Roget, *A History of the Old Water-colour Society*, London, Longman, 1891, I, 209–10; I, 145; II, 92. Women associates in 1879 were Helen Paterson Allingham, Helen Coleman

Angell, Mary Ann Criddle, Margaret Gillies, Maria Harrison and Clara Montalba.

8 The first three terms are fairly common in art criticism in the 1850s; the fourth is Ruskin's, who in a letter of 1858 exhorted the painter Sophia Sinnett, 'You must resolve to be quite a great paintress; the feminine termination does exist, there never having been such a being yet as a lady who could paint.' E. T. Cook and A. Wedderburn (eds), *The Collected Works of John Ruskin*, London, George Allen, 1904, XIV, 308. For the use of the term 'paintress' see also Cheryl Buckley, *Potters and Paintresses: Women Designers in the Pottery Industry, 1870–1955*, London, Women's Press, 1990, 8.

9 D. M. Craik, *A Woman's Thoughts About Women*. London, Hurst & Blackett, 1858, 50–7.

10 Extensive discussions of the history of the society and of the art press's response to its exhibitions have been given in P. G. Nunn, *Victorian Women Artists*, London, Women's Press, 1987 and C. Yeldham, *Women Artists in Nineteenth-Century France and England*, New York, Garland, 1984. Its nineteenth-century archives were destroyed in the 1939–45 war; more recent material is deposited at the Women Artists' Slide Library in London. Harriet Grote, a leading intellectual of the Philosophic Radicals in the 1820s and 1830s, a supporter of the reform of the married women's property acts in the 1850s, and suffrage campaigner in the 1860s is credited with having started and initially managed the society; E. Eastlake, *Mrs Grote, A Sketch*, London, Murray, 1880, 98.

11 According to Nunn, 1987, 86, between 1850 and 1879 nearly 300 women exhibiting in London only showed at the society. For the art classes in which Eliza Fox was involved, see *Art Journal*, 1864, 91; 1866, 383; 1868, 46.

12 [Bessie Rayner Parkes], 'The Society of Female Artists', *English Woman's Journal*, May 1858, 205–8.

13 *English Woman's Journal*, March 1859, 53.

14 *Illustrated London News*, 12 October 1889, 480.

15 S. Hall and B. Schwarz, 'State and society, 1880–1930', in M. Langan and B. Schwarz (eds), *Crises in the British State, 1880–1930*, London, Hutchinson, 1985, 7–32.

16 Jill Liddington and Jill Norris, *One Hand Tied Behind Us: The Rise of the Women's Suffrage Movement*, London, Virago, 1978; Philippa Levine, *Victorian Feminism, 1850–1900*, London, Hutchinson, 1987.

17 The concepts of feminists' languages and 'speaking-out' have been developed by Lucy Bland in her important series of articles, including 'Cleansing the portals of life: the venereal diseases campaign in the early twentieth century', in Langan and Schwarz (eds), 1985, 192–208, and 'The married woman, the New Woman, and the feminist', in Jane Rendall (ed.), *Equal or Different: Women's Politics, 1800–1914*, Oxford, Blackwell, 1987, 141–64.

18 Louise Jopling, *Twenty Years of My Life, 1867–87*, London, John Lane, 1925, 220.

19 Others members included Jane Atkinson, Emily Beresford, Jessie Toler Kingsley, Florence Monkhouse, Julia Pollitt, Fanny Sugars, E. Gertrude Thomson, Eleanor Wood and Margaret Wroe. Sandra Martin's exhibition, *Manchester Women Artists, 1880–1940*, Manchester, City Art Gallery, 1985, documented the society. See also *Englishwoman's Review*, October 1879, 469; February 1882, 88; *British Architect*, 30 November 1883, 252.

20 *Englishwoman's Review*, October 1879, 469.

21 *Englishwoman's Review*, January 1881, 29; February 1882, 88; *British Architect*, 3 October 1879, 135; 27 January 1882, 39; 30 November 1883, 252.

22 J. Seed, 'Commerce and the Liberal Arts, the political economy of art in

Manchester, 1775–1860', and J. Wolff, 'The culture of separate spheres', in J. Wolff and J. Seed (eds), *The Culture of Capital: Art, Power and the Nineteenth-century Middle Class*, Manchester, Manchester University Press, 1988, 45–82, 117–134. J.H.G. Archer, *Art and Architecture in Victorian Manchester*, Manchester, Manchester University Press, 1986.

23 *Manchester Academy of Fine Arts, A Short History*, Manchester, 1973, 8–9; S. Martin, 1985.

24 Ailsa Tanner, *The Glasgow Society of Lady Artists, 1872–1971*, Glasgow, Collins Gallery, 1982.

25 *Englishwoman's Yearbook*, 1899, 149.

26 J. Burkhauser (ed.), *Glasgow Girls: Women in Art and Design, 1880–1920*, Edinburgh, Canongate, 1990, 46.

27 E.B.S., 'The paintings and etchings of Elizabeth Stanhope Forbes', *Studio*, 4, 1894, 186–92.

28 For her publications see the bibliography by Claire Richter Sherman in A. Holcomb and C.R. Sherman (eds), *Women as Interpreters of the Visual Arts, 1820–1979*, Westport, Conn., Greenwood, 1981, 177–80; Kali A.K. Israel, 'Writing inside the kaleidoscope', *Gender and History*, 2 (1), 1990, 40–8.

29 See, however, *Academy*, 28 April 1877, 375; 20 May 1876, 493.

30 Sarah Tytler, *Modern Painters and their Paintings*, London, Isbister, 1882, for example, mentioned 6 British and 2 French women. Earlier in the century Anna Jameson had set a precedent for women art historians by concentrating on the representation of women, never completing her study of women artists.

31 A. Fish, *Henrietta Rae (Mrs Ernest Normand)*, London, Cassell, 1905; Mrs Lionel Birch, *Stanhope A. Forbes and Elizabeth Stanhope Forbes*, London, Cassell, 1906; Clara E. Clement, *Women in the Fine Arts*, Boston, Houghton Mifflin, 1904; W.S. Sparrow, *Women Painters of the World*, London, Hodder & Stoughton, 1905.

32 Ann Thwaite, *Edmund Gosse: A Literary Landscape, 1849–1928*, London, Secker & Warburg, 1984. For detailed studies of relations between men and analyses of the constructions of masculine sexuality which intensified the inscription of masculinity in cultural discourses see Eve Kosofsky Sedgwick, *Between Men: English Literature and Male Homosocial Desire*, New York, Columbia University Press, 1985 and Richard Dellamora, *Masculine Desire, The Sexual Politics of Victorian Aestheticism*, Chapel Hill and London, University of N. Carolina Press, 1990.

33 A. Barr, 'The development of abstract art', cover, *Cubism and Abstract Art*, New York, Museum of Modern Art, 1936.

34 G. Pollock, 'Modernity and the spaces of femininity', in *Vision and Difference*, London, Routledge, 1988, 50.

35 C. Harrison, *English Art and Modernism, 1900–1939*, London, Allen Lane, 1981.

36 Jane Beckett, 'Discoursing on Dutch Modernism', *Oxford Art Journal*, 6 (2), 1983, 66–78.

37 Jane Beckett has raised the issue as to whether English art, certainly that produced before 1900, can be constituted within a history of modernism. It is certainly the case that the 'modern' became a highly contested category in the art discourses of the 1880s and 1890s and I have therefore used this term to catch these debates.

38 G. Moore, 'Sex in art', *Modern Painting*, 1893, London, W. Scott [?1906], 228.

39 ibid., 226–7.

40 ibid., 235, my italics. Moore alleges that Mme Morisot 'never faltered in her allegiance to the genius of her great brother-in-law', thus once again inscribing

women in a position of dependency.

41 Lucy Bland, 'Marriage laid bare', in Jane Lewis, *Labour and Love: Women's Experience of Home and Family 1850–1940*, Oxford, Blackwell, 1986, 121–46.

42 E. Showalter, *A Literature of Their Own: British Women Novelists from Brontë to Lessing*, London, Virago, 1978, 184.

43 Lynne Walker, 'Vistas of pleasure: women consumers of urban space in the west end of London, 1850–1900', in *Cracks in the Pavement: Gender, Fashion, Architecture*, London, Sorella, 1993; Jane Beckett and Deborah Cherry, 'London', in *The Edwardian Era*, Oxford, Phaidon, 1987, 36–41.

44 This analysis relies on work undertaken with Jane Beckett and is based on Jane Beckett and Deborah Cherry, 'Women under the banner of Vorticism', *ICSAC Cahiers*, Brussels, 8/9, 1988, 129–43, and Jane Beckett and Deborah Cherry, 'Art, class and gender, 1900–1910', *Feminist Arts News*, 2 (5), 1987, 19–21.

45 *International Art Notes*, 1, March 1900, 1–2.

46 *International Art Notes*, n.s. 1, March 1901. The archives of the WIAC are now housed at the Women Artists Slide Library in London.

47 J. Quigley, 'Women's International Art Club', *Englishwoman's Review*, October 1908, 234–41.

48 *The Year's Art*, 1905, 120.

5 PROFESSIONAL AND PUBLIC IDENTITIES

1 The painting, 34 × 44″, is in a private collection; a drawing of the two central figures, with J. E. Millais's monogram, in the Ashmolean Museum, Oxford is attributed to, but may not be by, Emily Mary Osborn.

2 Lucy Bland, 'The domain of the sexual, a response', *Screen Education*, 39, 1981, 56–67. Lynda Nead, *Myths of Sexuality: Representations of Women in Victorian Britain*, Oxford, Blackwell, 1988.

3 Lynne Walker, 'Vistas of pleasure: women consumers of urban space in the west end of London, 1850–1900', in *Cracks in the Pavement: Gender, Fashion, Architecture*, London, Sorella, 1993. For discussion of the impact of the failure of the Married Women's Property Acts and the passing of the Matrimonial Causes Act in 1857 on representations of femininity, see Nead, 1988, 52ff. and Mary Poovey, *Uneven Developments: The Ideological Work of Gender in Mid-Victorian England*, London, Virago, 1988.

4 For fuller discussion of this discursive category see chapter 8.

5 *Art Journal*, 1857, 167. *The Spectator* complained that it was not clear whether the woman or the boy was the artist, 4 July 1857, 715. Critics and viewers puzzled over visual signs and in the processes of viewing ascribed them different readings. These cultural practices were part of the wider production of social meanings in which definitions were struggled over, meanings secured temporarily and constantly deferred. There was not, therefore, one reading of *Nameless and Friendless*, but several which vied for attention within the debates about bourgeois femininity.

6 This phrase is taken from Laura Mulvey, 'Visual pleasure and narrative cinema', *Screen*, 1975, in *Visual and Other Pleasures*, London, Macmillan, 1989, 14–26.

7 Deborah Cherry and Griselda Pollock, 'Woman as sign in Pre-Raphaelite literature: a study of the representation of Elizabeth Siddall', *Art History*, 7 (2), 1984, 206–27.

8 Nead, 1988, 178–9.

9 S. Stickney Ellis, *The Women of England*, London, Fisher, 1839, 331–3. One of the aims of this kind of literature was the moral improvement of middle-class

women and their moral differentiation as a class from the aristocracy who were perceived as idle and un-working.

10 Anne Brontë, *The Tenant of Wildfell Hall*, London, Newby, 1848.

11 Dinah Muloch Craik, *Olive*, London, Chapman, 1850. Olive takes up art not from personal choice but as a distressed gentlewoman desirous of repaying a debt.

12 'The vocations of women', *Eliza Cook's Journal*, 25 May 1850, 61.

13 ibid.

14 F. A. Hayek, *John Stuart Mill and Harriet Taylor: Their Correspondence and Subsequent Marriage*, Chicago, University of Chicago Press, 1951, 122–3; see also Harriet Taylor, 'The Enfranchisement of Women', *Westminster Review*, 1851, reprinted in Alice Rossi, *Essays on Sex Equality*, Chicago, University of Chicago Press, 1970, 91–121.

15 *Home Thoughts* is in a private collection. The artist was a signatory to the 1859 RA petition. By the mid-1850s a range of publications including women's magazines were discussing art as a career for middle-class women; see *Englishwoman's Review*, 18 April 1857, 1. For differing accounts of women and work see Leonore Davidoff and Catherine Hall, *Family Fortunes: Men and Women of the English Middle Class, 1780–1850*, London, Hutchinson, 1987; W.J. Reader, *Professional Men: the Rise of the Professional Classes in Nineteenth-century England*, London, Weidenfeld, 1966; Lee Holcombe, *Victorian Ladies at Work: Middle-class Working Women in England and Wales, 1850–1914*, Newton Abbott, David & Charles, 1973. It should also be noted that definitions of professional status were also produced in the formal mechanisms of state regulation. Along with other occupations without formal colleges or entrance examinations, artists were first classified as professionals in the Census of 1861 when 853 women painters were registered. The Census was also a key site for the regulation of sexual difference. Women working as artists were likely to be entered as 'wife', a category introduced in the Census of 1851.

16 See, for example, Samuel Baldwin, *Sketching from Nature*, 1857, private collection, repr. P.G. Nunn, *Victorian Women Artists*, London, Women's Press, 1987, 7.

17 This self-portrait, painted for Queen Victoria in 1853, is not to be identified with that which was exhibited at the Royal Academy in 1851. I am deeply grateful to Mr Charles Noble for this information.

18 R.Q. Gray, *The Labour Aristocracy in Victorian Edinburgh*, Oxford, Clarendon Press, 1976, 143.

19 *Rossetti's Portraits of Elizabeth Siddall*, Oxford, Ashmolean Museum, 1991. Deborah Cherry and Griselda Pollock, 'Woman as sign in Pre-Raphaelite literature: a study of the representation of Elizabeth Siddall', *Art History*, 7 (2), 1984, 206–27.

20 According to one reviewer who probably knew the artist, this painting portrayed the artist and her children, *Art Journal*, 1857, 167; 1864, 358. For further discussion of the painting, see chapter 7.

21 Nead, 1988, 81–6.

22 The work is untraced. *English Woman's Journal*, 1858, 208. *Athenaeum*, 3 April 1858, 439 remarked on 'the child drawing from the looking-glass, the studio with the strong-minded woman, and the rejected picture'. There is probably a reference in the painting of the Temple of Fame to Angelika Kauffmann's *Self-Portrait of the Artist Choosing Between Music and Painting*, c. 1794, in which the figure of Painting indicates the temple of fame (Lord St Oswald and the National Trust).

23 Both works untraced. Ellen Clayton, *English Female Artists*, London, Tinsley,

1876, II, 118.

24 *Portfolio*, 1877. Some considered that the sumptuous interior detracted from the pictures and it was modified.

25 Lady Caroline Blanche Elizabeth Lindsay was the daughter of Hannah Mayer who was the second daughter of Nathan Mayer Rothschild. She took lessons from Margaret Gillies and began exhibiting in 1875. With her husband Sir Coutts Lindsay she founded and managed the Grosvenor Gallery.

26 *Illustrated London News*, 6 April 1889, 448.

27 L. Davidoff, *The Best Circles: Society, Etiquette and the Season*, London, Croom Helm, 1973, 78.

28 Reader, 1966, 152.

29 Davidoff, 1973.

30 *Illustrated London News*, 2 April 1887, 379.

31 W.C. Monkhouse, 'Some English artists and their studios', *Century Magazine*, 24, August 1882, 553–68; F.G. Stephens, *Artists at Home*, with photographs by J.P. Mayall, London, Sampson Low, 1884.

32 *Illustrated London News*, 6 April 1889, 448.

33 *Illustrated London News*, 12 April 1890, 474.

34 Florence Fenwick-Miller's 'Ladies Column' ran from 1886. She stated at the outset, 6 March 1886, 232, that she would combine the staples of 'Dress, Domesticity, Charity and Society', with 'Culture, Thought and Public Welfare'. Descriptions of the costumes of fashionable women were thus combined with discussions of paid work for women, legal reform, women's suffrage and women artists.

35 *Illustrated London News*, 11 May 1889, 606.

36 Pre-Raphaelite Inc., repr. P. Bate, *The English Pre-Raphaelite Painters*, London, Bell, 1899, 112ff.

37 Stella Mary Newton, *Health, Art and Reason: Dress Reformers of the Nineteenth Century*, London, John Murray, 1974.

38 J. Burkhauser (ed.), *Glasgow Girls: Women in Art and Design, 1880–1920*, Edinburgh, Canongate, 1990, 49–55.

39 Lilias Ashworth Hall of 1872, in Helen Blackburn, *Women's Suffrage*, London, Williams & Norgate, 1902, 110–11.

40 Joyce S. Pedersen, 'School Mistresses and Headmistresses', *Journal of British Studies*, 15 (1), 1975, 135–62.

41 Newton, 1974. Viscountess Harberton of the Rational Dress Society was a prominent suffrage speaker.

42 *Illustrated London News*, 11 May 1889, 606; 2 August 1890, 154–5.

43 *Illustrated London News*, 9 February 1887, 407; 12 April 1890, 474.

44 Louise Jopling's portraits included Col Charles Lindsay, RA 1877; Lady Lindsay, 1880; Sir Robert Anstruther, RA 1880; his niece, Lady Mary Wood; Nathan Mayer, 1st Baron Rothschild, 1878; Ellen Terry, Grosvenor Gallery, 1883.

45 See L. Jopling, *Twenty Years of My Life*, London, John Lane, 1925, 265. The self-portrait, in pastels, is in a private collection, repr. cover (detail) P.G. Nunn (ed.), *Canvassing: Recollections by Six Victorian Women Artists*, London, Camden, 1986. Another smaller self-portrait is in Manchester City Art Gallery.

46 See Tamar Garb's excellent article on self-representations by Marie Bashkirtseff, 'Unpicking the seams of her disguise', *Block*, no. 13, 1987/8, 79–86.

47 Leeds City Art Gallery, 1889; repr. in D. Cherry, *Painting Women: Victorian Women Artists*, Rochdale, Rochdale Art Gallery, 1987, 1. There was a tendency in the later decades for women portrait painters to image themselves

holding palette and brushes.

48 H. Postlethwaite, 'Some noted women painters', *Magazine of Art*, 1895, 17–22.

49 Margaret Gillies was connected to Owenite socialism in the 1830s but her portraits were of a wide group of intellectuals, writers and artists.

50 Anthea Callan, *Angel in the Studio: Women in the Arts and Crafts Movement, 1870–1914*, London, Astragal, 1979, 212–21. *May Morris, 1862–1938*, London, William Morris Gallery, 1989.

51 J. Hannam, *Isabella Ford*, Oxford, Blackwell, 1989.

52 Leeds City Art Gallery, 1903; possibly based on a photograph by Elliott & Fry, Liverpool University Special Collections. Emily Ford wrote *Women and the Regulation System, Impressions of the Geneva Congress*, London, LNA, 1909.

53 Emily Ford's poster against the protective legislation of women's work, *They Have a Cheek. I've Never Been Asked*, was published by the Artists' Suffrage League in 1908. Labour Party Archives, London; repr. J. Beckett and D. Cherry (eds), *The Edwardian Era*, Oxford, Phaidon, 1987, 75.

54 Dora Meeson Coates, quoted in Lisa Tickner, *The Spectacle of Women: Imagery of the Suffrage Campaign*, London, Chatto, 1987, 19.

55 Quoted in Jane Quigley, 'A Yorkshire Artist', *Yorkshire Homes*, January 1928, 18–21, with thanks to Miss A. Heap for documentation on the artist.

56 Both de Morgan Foundation, London, repr. J. Marsh and P.G. Nunn, *Women Artists and the Pre-Raphaelite Movement*, London, Virago, 1989.

57 A.M.W. Stirling, *William de Morgan and his Wife*, London, Thornton Butterworth, 1922, 192.

58 The participation of women artists in the purity movements has not been investigated as yet, but will be included in my forthcoming study of feminism and visual culture. For an outline of the different movements see Philippa Levine, *Victorian Feminism, 1850–1900*, London, Hutchinson, 1987.

59 J. Matthews, 'Barbara Bodichon, integrity in diversity', in D. Spender (ed.), *Feminist Theorists: Three Centuries of Women's Intellectual Tradition*, London, Women's Press, 1983, 91.

60 Caroline Cornwallis, 'The property of married women', *Westminster Review*, October 1856, 331–60; petition and signatories, 336–8.

61 Ellen Clayton, *English Female Artists*, London, Tinsley, 1876, II, 188, 268.

62 *Englishwoman's Review*, 15 August 1887, 369–70.

63 *Opinions of Women on Women's Suffrage*, London, National Society for Women's Suffrage, 1879.

64 'Women's suffrage, a reply', *Fortnightly Review*, July 1889, 123–42; *Declaration in Favour of Women's Suffrage*, London, National Society for Women's Suffrage, 1889.

65 'An appeal against female suffrage', *Nineteenth Century*, June 1889, in P. Hollis, *Women in Public, 1850–1900*, London, Allen & Unwin, 1979, 322–8.

66 *Some Supporters of the Women's Suffrage Movement*, London, National Society for Women's Suffrage, 1897; copy kindly supplied by David Doughan of the Fawcett Library, London.

67 *Women's Suffrage Journal*, June 1884, 125.

68 *Women's Suffrage Journal*, 1889–90.

69 Charlotte Babb published several pamphlets on tax resistance including *A Word to Women Householders* and *A Practical Protest*. See also *Englishwoman's Review*, January 1874, 60.

70 Charlotte Babb was admitted to the Royal Academy Schools from Heatherleys in December 1861, Royal Academy archives, London. Although she did not sign the 1859 petition, her letter calling for women students was published in *Athenaeum*, March 1859.

71 *Englishwoman's Review*, January 1907, 56; October 1909, 283.
72 Tickner, 1987, 15–16.
73 Tickner, 1987, 123–4.
74 Elspeth King, *The Scottish Women's Suffrage Movement*, Glasgow, 1978, 17; Tickner, 1987, 243; Jane Beckett and Deborah Cherry, 'Spectacular Women', *Art History*, 12 (1), March 1989, 121–8.
75 Jane Quigley, 'Some leading women painters and craft workers', *Englishwoman's Review*, July 1909, 145–56.

6 MAKING A LIVING

1 *Critic*, 27 July 1861, 109. *The Child's Crusade* is reproduced in P. G. Nunn, *Victorian Women Artists*, London, Women's Press, 1987, pl. VI.
2 J. Oldcastle, 'Elizabeth Butler', *Magazine of Art*, 1879, 260. As paintings at the Royal Academy were hung from floor to ceiling, those at the top were referred to as 'skyed'.
3 Painting untraced. *Athenaeum*, 25 March 1854, 380; *Art Journal*, 1854, 105.
4 Jane Sellars, *Women's Works*, Liverpool, National Museums and Galleries on Merseyside, 1988. Norma Watt, *The Norfolk and Norwich Art Circle, 1885–1985*, Norwich, Norfolk Museums Service, 1985. Nunn, 1987, 68–112, covers the range of exhibitions in some detail.
5 Oldcastle, 1879, 260.
6 Bodichon Estate Documents, E/LS/1, Greater London Record Office.
7 L. Jopling, *Twenty Years of My Life, 1867–87*, London, John Lane, 1925, 27. Abie Sachs and Joan Hoff Wilson, *Sexism and the Law*, New York, Free Press, 1978.
8 The portrait is probably that in the collection of Robert Peerling Coale, Chicago, repr. Ann Sutherland Harris and Linda Nochlin, *Women Artists, 1550–1950*, Los Angeles, Los Angeles County Museum of Art, 1976, pl. 88. *Art Journal*, 1864, 261; *The Lady*, 2 September 1886, 183. For middle-class incomes see W.J. Reader, *Professional Men: The Rise of the Professional Classes in Nineteenth Century England*, London, Weidenfeld, 1966.
9 *Quatre Bras* is at the National Gallery of Victoria, Melbourne, Australia. For prices see Sellars, 1988, 1; Rosemary Treble, *Great Victorian Pictures: Their Paths to Fame*, London, Arts Council, 1978, 79; G. Reitlinger, *The Economics of Taste: The Rise and Fall of Picture Prices, 1760–1960*, London, Barrie, 1961, who designates the period 1860–1914 as 'the golden age of the living painter', recording that Millais received £4,930 for *North-West Passage*, Fildes 2,500 guineas for *Applicants* (RA 1874), and Long gaining 7,000 guineas for *The Babylonian Marriage Market*, 1875.
10 F. Leighton to F.G. Stephens, MS Don. e. 69. Oxford, Bodleian Library. For Gambart's transactions with artists such as Holman Hunt and Alma-Tadema, see J.S. Maas, *Gambart: Prince of the Victorian Art World*, London, Barrie & Jenkins, 1975.
11 Emilie Barrington, *The Life, Letters and Work of Frederic Leighton*, London, Allen, 1906, II, 114, 123.
12 *Fine Art Society: Centenary Exhibition, 1876–1976*, London, 1976, 5.
13 Helen Allingham's exhibitions at the FAS included *Drawings Illustrating Surrey Cottages*, 1886; *In the Country*, 1887; *On the Surrey Border*, 1889; *Surrey Cottages*, 1891.
14 *Pickles . . .* is untraced. *Art Journal*, 1864, 261.
15 These and works by Annie Mutrie and Margaret Backhouse owned by Prater were shown at the International Exhibition in London in 1862. *Peg Woffington*,

untraced, repr. in *Solomon: A Family of Painters*, London, Geffrye Museum, 1985, 20.

16 Rebecca Solomon wrote, *c.* 1863–4, to George Powell who purchased *The Wounded Dove* and doubtless other works, 'I can assure you I shall find the balance most useful to me, as I am like too many others alas! much in want of the needful.' I am indebted to Moira Vincintelli for informing me about the collection of Rebecca Solomon's letters in the George Powell collection, University College Wales, Aberystwyth.

17 A.M.W. Stirling, *William de Morgan and his Wife*, London, Thornton Butterworth, 1922, 190. Both works are in the De Morgan Foundation, London.

18 P.G. Nunn, *The Victorian Woman Artist, 1850–1879*, PhD thesis, University of London, 1982. Treble, 1978, 79. See chapters 8 and 9 for Fairbairn's, Plint's and Heape's purchases of women's works.

19 O. Doughty and J.R. Wahl, *The Letters of D.G. Rossetti*, Oxford, Clarendon, 1965, I, 250. Information on other sales such as that of *Clerk Saunders* to Charles Eliot Norton is similarly located in the Rossetti papers.

20 V. Surtees (ed.), *Sublime and Instructive: Letters from John Ruskin to Louisa Marchioness of Waterford, Anna Blunden and Ellen Heaton*, London, Michael Joseph, 1972, 158.

21 ibid., 157.

22 Sellars, 1988, 1, 15. Marie Spartali's *Madonna Pietra degli Scrovigni*, 1884, and Jessie Macgregor's *Jephthah*, 1889, were presented by public subscription. The Walker Art Gallery was founded in 1873 by the brewing magnate, city councillor, alderman, mayor and staunch conservative A.B. Walker. See Deborah Cherry, unpublished paper given at the Walker Art Gallery, 1988.

23 Sophie Anderson, *The Song*, Wolverhampton Art Gallery, 1881, repr. Nunn, 1987, 108; Emily Mary Osborn, *The Bal Maidens*, Cardiff Museum, now National Museum of Wales, 1881; Alice Havers, *They Homeward Wend Their Weary Way*, Cardiff Museum, 1882; Alice Havers, *The Belle of the Village*, Southport Art Gallery, 1889. Helen Allingham's *Valewood Farm* was bought for 55 guineas for Birmingham City Art Gallery in 1891.

24 Maud Sulter, *Echo. Works by Women Artists, 1850–1940*, Liverpool, Tate Gallery, 1991, 26, 38. The Chantrey Bequest was founded in 1878, the Tate Gallery, London opened 1897.

25 The work, 90 × 54″, is now untraced. An additional £10.18s. was paid to the artist for framing and carriage. Information kindly provided by Prof. J.H. Baker of the college.

26 The artist exhibited *Epithalamium* in the 1847 competition, but gave up oils thereafter for watercolours. Ellen Clayton, *English Female Artists*, London, Tinsley, 1876, II, 73–4; J.L. Roget, *A History of the Old Water-colour Society*, London, Longmans, 1891, 337–9.

27 Jessie Toler Kingsley exhibited at the Manchester Society of Women Painters in 1882; she lectured on 'Art in Relation to Modern Life' at the Manchester Academy in 1889. *Englishwoman's Review*, February 1882, 88; June 1889, 279. Florence Monkhouse recollected that she, Fanny Sugars, Susan Dacre and Jessie Kingsley assisted Ford Madox Brown; see *Manchester Guardian*, 3 February 1937; I am particularly grateful to Mary Bennett for this reference.

28 Reproduced in *Art Journal*, 1900, 379.

29 Compare the *Graphic*, 18 December 1869, 3 August 1872, 7 September 1872. Slightly later, newspaper illustration and work as front-line correspondents were important factors in the working lives of male military painters. See J.W.M. Hichberger, *Images of the Army. The Military in British Art, 1815–*

1915, Manchester, Manchester University Press, 1988.

30 The *Graphic* purchased Mary Waller's *Secret of the Sea* (RA 1886). The *Illustrated London News* bought Mary Waller's *Eve*, 1888, for colour reproduction, and Emily Mary Osborn's *The Christmas Tree*; see *Magazine of Art*, 1895, 20, and *Queen*, 5, October 1889, 465. For Clara Montalba see *Academy*, 4 August 1877, 125.

31 Sellars, 1988, 6–7.

32 A.L. Merritt, 'A letter to artists: especially women artists', *Lippincott's Monthly Magazine*, 55, 1900, 463–9.

33 The concept of matronage is also being developed in the USA. A symposium, *Matronage: Women as Patrons and Collectors of Art, 1300–1800* was convened by Cynthia Lawrence at Temple University in 1990.

34 The *Oxford English Dictionary* indicates that an earlier meaning for matron, of a married woman skilled in childbirth, noted in 1491, was displaced by the word midwife. The *OED* records matronize and matronage in use in the nineteenth century.

35 Susan Ferrier, *Marriage, A Novel*, Oxford University Press, 1971, 143.

36 The *OED* defines a patron as 'one who stands to another or others in relation analogous to that of a father', one who is 'a lord and master' and/or 'protector'.

37 *Art Journal*, 1864, 261; 1860, 170. *Lady*, 2 September 1883, 465; *Queen*, 5 October 1889, 465.

38 I am indebted to Sir Oliver Millar and Mr Charles Noble for information on works in the Royal Collection.

39 Henrietta Ward's portrait of HRH Princess Beatrice is at Osborne; Mary Severn Newton's drawings are in the Royal Library, Windsor.

40 Henrietta Ward's studies for E.M. Ward's two paintings, *The Emperor of the French Receiving the Order of the Garter at Windsor from Her Majesty the Queen* and *The Visit of Queen Victoria to the Tomb of Napoleon I at the Hôtel des Invalides*, are in the Royal Library, Windsor. I am most grateful to the Hon. Jane Roberts and Lady Delia Millar.

41 'Alice Havers, Mrs Frederick Morgan', *Dictionary of National Biography*, 13, 1917, 908–9. *Calling the Roll, Crimea* had been commissioned by Charles Galloway for 120 guineas (£126) but he ceded the work to the Queen; see Treble, 1978, 79.

42 Elizabeth Thompson, Lady Butler, *An Autobiography*, London, Constable, 1922, 187.

43 *Englishwoman's Review*, January 1884, 93.

44 Roget, 1891, II, 425.

45 Dorothy Thompson, 'Women, work and politics in Victorian England: the problem of authority', in Jane Rendall (ed.), *Equal or Different: Women's Politics 1800–1914*, Oxford, Blackwell, 1987, 57–81.

46 Clayton, 1876, II, 73–4.

47 Both works untraced. For further discussion of these issues see chapter 8. Having failed to purchase *Margaret*, Angela Burdett-Coutts reportedly commissioned a painting the following year, but this work has not been identified.

48 Clayton, 1876, II, 130; *Behind the Curtain* is reproduced in *Burlington Magazine*, 130, October 1988, 769.

49 *Englishwoman's Review*, May 1879, 234.

50 *Englishwoman's Review*, March 1880, 132.

51 Clayton, 1876, II, 66.

52 Anna Lea Merritt, Artist's Form, Tate Gallery archives, London; Mrs George Garrett lent six works (including a portrait of Agnes Garrett) and Mrs Charles Hunt lent nine works to the exhibition *Paintings by Mrs Swynnerton*,

Manchester City Art Gallery, 1923. Buyers are listed in H. Allingham and S. Dick, *The Cottage Homes of England*, London, Arnold, 1909, xiii–xvi.

53 Anna Lea Merritt's portraits include *Dorothea Beale* of Cheltenham Ladies College.

54 *Englishwoman's Review*, July 1893, 195.

55 Jude Burkhauser (ed.), *Glasgow Girls: Women in Art and Design, 1880–1920*, Edinburgh, Canongate, 1990, 35–42.

56 Untraced. *Newnham College: Record of Benefactors*, Cambridge, Cambridge University Press, 1921. I am indebted to the college archivist, Dr E.M.C. van Houts, and to Dr Hilary Diaper of Leeds University for their help in documenting the artist's work.

57 Kate Perry, curator at Girton College, has generously offered invaluable help and information on the portrait and Girton College. Her exhibition catalogue, *Barbara Leigh Smith Bodichon, 1827–1891*, Cambridge, Girton College, 1991, documents works by and material relating to Barbara Bodichon. Emily Mary Osborn and Barbara Bodichon both signed the 1859 RA petition.

58 The original portrait, measuring $40 \times 52''$, was removed from the college in 1929 by Barbara Bodichon's descendants. Now untraced, it is reproduced in Helen Blackburn, *Women's Suffrage*, London, Williams & Norgate, 1902, facing p. 47. An ink sketch of this version probably made by the artist for reproduction in Henry Blackburn, *English Art in 1884*, New York, Appleton, 1885, 159, and *Grosvenor Notes*, 1884, 197, is now at Girton College. A second oil portrait by Emily Mary Osborn, 118×96 cm, was donated by Hastings Art Gallery to Girton College in 1963. See Perry, 1991, 18–20. This vertical portrait can probably be identified as that offered to the National Portrait Gallery in the 1890s by Miss Leigh Smith which was 'submitted and declined' by the Trustees; see *Description of Portraits*, 11, no. 40, National Portrait Gallery Archives, London. It may be the *Portrait of Mme Bodichon* exhibited at the Society of Women Artists in 1899. Substantial differences exist between the two oils, not only in size and format but also in the rendition of the sitter who seems considerably older and more care-worn in the second. A list of subscribers is given in Girton College Executive Committee Minute Books, 9, 23 October 1885, 85.

59 Barbara Stephen, *Girton College, 1869–1932*, Cambridge, Cambridge University Press, 1933, 79–81. There was also a Barbara Leigh Smith Bodichon annual scholarship of £40 at the college in the 1890s.

60 Letters from Emily Davies to Barbara Bodichon, 31 January 1870, 25 February 1870, B 39 and 40. Information kindly provided by Kate Perry.

61 Stephen, 1933, 59, 146. The scheme was turned down by Emily Davies as too expensive. Postcard from Gertrude Jekyll to Barbara Bodichon, Girton College, see Perry, 1991, 23.

62 Letter from Alice Bonham-Carter to the Secretary of Girton College, 29 March 1891, entered in Girton College Executive Committee Minute Books, 12, on 4 April 1891, Girton College.

63 Barbara Bodichon, *Women and Work*, London, Bosworth & Harrison, 1857. My argument that Barbara Bodichon's feminism and art practice were informed by the same political principles departs from other studies which have tended to perceive them as separate strands.

64 *Englishwoman's Review*, July 1891, 148.

65 Jane Rendall, 'A moral engine: feminism, Liberalism and the *English Woman's Journal*', in Rendall (ed.), 1987, 112–38.

66 Contributing artists were Laura Alma-Tadema, Emily Ford, Louise Jopling, Clara and Hilda Montalba and Emily Mary Osborn.

67 *Englishwoman's Review*, April 1903, 72–80, attributes the cover design to Helen Blackburn and Mary Tothill; the second edition of the catalogue, in Girton Library, credits the latter. The vignette is accompanied by the motto 'The Artist's part is both to be and do.'

68 Two oils were included in Perry, 1991, no. 23, *Study of Sunflowers* which was lent by the artist in 1875 and bequeathed in 1891; and no. 32, *Shepherd and Sheep*, given by the artist to the suffragist Jane Cobden and presented by Jane Cobden Unwin to the College.

69 A photograph of the Dining Hall, Girton, 1887, shows Emily Mary Osborn's original portrait hanging to the right of the dresser; Perry, 1991, 23.

70 Reynolds's portrait, *c*. 1780, London, Royal Academy of Arts. For the Leighton portrait, see L. and R. Ormond, *Lord Leighton*, Yale University Press, 1975, pl. 147. I am indebted to Hannah Mapp for the comparison with Leighton. Walter Besant's comments are in *The Revolt of Man*, London, Chatto, 1882.

71 Stephen, 1933, 79, 138–9.

72 *Englishwoman's Review*, April 1903, 80. The bookcase and the two watercolour portraits are dated 1897. The condition of its bequest was that the collection remain intact in the bookcase, which now stands at the entrance to the library. The artist Elizabeth Guinness was active in the suffrage movement, holding meetings at her studio in London. She produced a portrait of Helen Blackburn in 1895.

73 L.A. Hallett to M. Pickton, 3 April 1903, Girton College.

74 Of Helen Blackburn's collection of fifty-six photographs, fifty-four are of women, mostly suffragists. Some are reproduced in H. Blackburn, 1902, which has twenty-seven illustrations.

75 *Englishwoman's Review*, January 1891, 55; when the portrait was offered to the National Portrait Gallery that year the owner was given as Helen Blackburn; see *Description of Portraits*, 5, no. 11, National Portrait Gallery Archives, London.

76 University College Bristol, *Report of the Council*, 1893–4, 13, states 'Miss Helen Blackburn, a former student presented to the College for the Women Students' Room a large and valuable collection of portraits of eminent British women.' Helen Blackburn was a student at UCB, 1886–8; see University College Bristol, *Calendar*, 1887 and 1888. I am indebted to Michael Liversidge of Bristol University who kindly provided information on Helen Blackburn and her donation.

77 *Englishwoman's Review*, January 1903, 2.

78 *Englishwoman's Review*, July 1893, 68, 152. According to several sources including Report of the Council, University College Bristol, 1893–4, 13, the collection was made for the Women's Building at Chicago. However, photographs were included in the 1885 Loan Exhibition of Women's Industries at Bristol organised by Helen Blackburn.

79 Elizabeth Cowie, 'Woman as Sign', *m/f*, 1, 1978, 49–63.

80 Martha Vicinus, *Independent Women: Work and Community for Single Women, 1850–1920*, London, Chicago University Press, 1985.

81 Lynne Walker, 'Vistas of pleasure: women consumers of urban space in the west end of London, 1850–1900', in *Cracks in the Pavement: Gender, Fashion, Architecture*, London, Sorella, 1993.

82 *Englishwoman's Yearbook*, 1899, 147–9; Eva Anstruther, 'Ladies Clubs', *Nineteenth Century*, 45, 1899, 598–611.

DIFFERENCING THE GAZE

1 Charlotte Brontë, *Villette* (1853), London, Dent, 1983, chapter 19, 'The Cleopatra', 190–202.

2 Mary Ann Doane discusses the double meanings of woman's look in *The Desire to Desire: The Woman's Film of the 1940s*, London, Macmillan, 1987, 177.

3 Laura Mulvey, 'Visual pleasure and narrative cinema', in *Visual and Other Pleasures*, London, Macmillan, 1989, 19.

4 Griselda Pollock, 'Modernity and the spaces of femininity', in *Vision and Difference: Femininity, Feminism and the Histories of Art*, London, Routledge, 1988, 87.

5 Doane, 1987, 178.

6 Doane, 1987, 7; she is referring to the work of Laura Mulvey, 1989, 29–38; E. Ann Kaplan, *Women and Film: Both Sides of the Camera*, New York, Methuen, 1983; Teresa de Lauretis, *Alice Doesn't: Feminism, Semiotics, Cinema*, Bloomington, Indiana, 1984.

7 Suzanne Moore, 'Here's looking at you kid', in Lorraine Gamman and Margaret Marshmont (eds), *The Female Gaze: Women as Viewers of Popular Culture*, London, Women's Press, 1988, 59.

8 Laura Marcus, 'Taking a good look', *New Formations*, 15, 1991, 101–9.

9 Doane, 1987, 34; Annette Kuhn, *Women's Pictures*, London, Routledge, 1982.

10 For a discussion of the mid-century representation of the cultural audience in terms of an ideal of feminine purity see L. Nead, *Myths of Sexuality: Representations of Women in Victorian Britain*, Oxford, Blackwell, 1988, 133.

11 Doane, 1987, 177–8.

12 J. Tagg, *The Burden of Representation: Essays on Photographies and Histories*, 1988, London, Macmillan.

13 E. Said, *The World, the Text and the Critic*, Cambridge, Mass., Harvard University Press, 1983, 176.

14 A. Levy, *Other Women: The Writing of Class, Race and Gender, 1832–98*, Princeton, Princeton University Press, 1991, 18.

15 Carol Duncan, 'Happy mothers and other new ideas in French art' (1973), in N. Broude and M. Garrard (eds), *Feminism and Art History: Questioning the Litany*, New York, Harper & Row, 1982, 200–19.

16 'Woman as sign: psychoanalytic readings', in Pollock, 1988, 120–54.

17 Lisa Tickner, *The Spectacle of Women*, London, Chatto, 1987.

7 DIFFERENCE AND DOMESTICITY

1. *Spectator*, 5 June 1852, 544.

2 Lynda Nead, *Myths of Sexuality: Representations of Women in Victorian England*, Oxford, Blackwell, 1988, provides an excellent discussion of modern-life painting and the ideal of respectable femininity.

3 Bessie Rayner Parkes, *Remarks on the Education of Girls*, London, Chapman, 1854, 3.

4 Sydney, Lady Morgan, 'Women versus Ladies', *Athenaeum*, October 1847, 1128. The author recommends the word woman, contending that 'lady' arose to discredit women intellectuals. In the 1850s the new category of 'lady' was used to marginalise women members of the watercolour societies.

5 *Art Journal*, 1863, 105–8.

6 Griselda Pollock, 'Modernity and the spaces of femininity', in *Vision and Difference: Femininity, Feminism, and the Histories of Art*, London, Routledge, 1988, 66.

7 *Illustrated London News*, 23 May 1857, 508.

8 *Englishwoman's Review*, 18 April 1857, 1.

9 Leonore Davidoff and Catherine Hall, *Family Fortunes: Men and Women of the English Middle Class, 1780–1850*, London, Hutchinson, 1987, 180–5.

10 Chris Weedon, *Feminist Practice and Post-structuralist Theory*, Oxford, Blackwell, 1987, 74–106.

11 M. Foucault, 'What is an author?', *Screen*, 20 (1), 1979, 13–29; G. Pollock, 'Artists' mythologies and media genius', *Screen*, 21 (3), 1980.

12 Isabel McAllister, *Henrietta Ward: Memories of Ninety Years*, London, Hutchinson, 1924, 52.

13 E. O'Donnell (ed.), *Mrs E.M. Ward's Reminiscences*, London, Pitman, 1911, 88.

14 Painting untraced. *Queen*, 2 November 1889, 615.

15 Christopher Wood, 'The artistic family Hayllar', *Connoisseur*, May 1974, 2–9.

16 1870, private collection.

17 This is the central issue in the use of female relatives as models by Pre-Raphaelite artists, enabling early Pre-Raphaelite ideals of 'truth to nature' and critical writings on realism at the mid-century to be equated with bourgeois persons and values. See Deborah Cherry and Griselda Pollock, 'Woman as sign in Pre-Raphaelite literature', *Art History*, 7 (2), 1984, 206–27.

18 *Spectator*, 5 June 1852, 544.

19 Adrienne Rich, *Of Woman Born: Motherhood as Experience and Institution* (1st edn 1977), New York, Norton, 1986, 34.

20 The purchaser, history and whereabouts of the picture are not known; engraved in *Art Journal*, 1864, 359.

21 I am indebted to Karen Clarke for discussions on infant care; see also Deborah Gorham, *The Victorian Girl and the Feminine Ideal*, London, Croom Helm, 1982.

22 Carol Duncan, 'Happy mothers and other new ideas in eighteenth-century French art', *Art Bulletin*, 55, 1973, 570–83, and reprinted in N. Broude and M.D. Garrard (eds), *Feminism and Art History: Questioning the Litany*, New York, Harper & Row, 1982, 200–19.

23 See Mary Poovey, *Uneven Developments: The Ideological Work of Gender in Mid-Victorian England*, London, Virago, 1988.

24 *Art Journal*, 1857, 167.

25 *Art Journal*, 1864, 358.

26 Dorothy Thompson, *Queen Victoria: Gender and Power*, London, Virago, 1990.

27 *The Times* 1863, cited in Nead, 1988, 15.

28 *Art Journal*, 1857, 167.

29 *Athenaeum*, 16 May 1857, 633.

30 *Illustrated London News*, 23 May 1857, 508.

31 *Spectator*, 9 May 1857, 502. This paper criticised Henrietta Ward's *The Bath* (Society of Female Artists, 1858); 'the colour here is very raw and glaring and the whole has something of a vulgar look', 3 April 1858, 380.

32 In *The Art of Dress*, 1839, 'the degree of neatness and good taste' in dress is indexed to 'delicacy of mind'; see Sarah Levitt, 'Fashion and Etiquette', *Feminist Arts News*, 1 (9), 1983, 9–11.

33 Both works are untraced but discussed in *Art Journal*, 1855, 167 and 1856, 168.

34 *Howard's Farewell* (RA 1858) was her first history painting, while *The First Step in Life* (RA 1860) was her last domestic subject shown at the Royal Academy.

35 For the conditions of her practice see A. Hare, *The Story of Two Noble Lives, being Memorials of Charlotte, Countess Canning and Louisa Marchioness of*

Waterford, London, Allen, 1893.

36 York City Art Gallery; see C. Davidson, *The Art of Mary Ellen Best*, London, Chatto, 1985.

37 Ashmolean Museum, Oxford; see J. Cornforth, 'Some early Victorians at home', *Country Life*, 4 December 1975, 1530–3.

38 As for example the illustrations in W.H. Pyne, *Royal Residences*, 1820.

39 C. Maxwell, *Mrs Gatty and Mrs Ewing*, Constable, London, 1949, 106–8. I am particularly indebted to Ann Thornton for information on the Barker sisters and for this reference.

40 RA 1853–60; SFA 1857–8. According to Margaret Gatty she also painted large pictures in oil, Maxwell, 1949, 107.

41 Laura Wilson Barker (1817–1905), composer and poet, married the writer Tom Taylor in 1855. Her musical compositions were usually performed for charitable fund-raising but in 1900 she conducted a programme of her orchestral pieces in Birmingham.

42 Nead, 1988, 26.

43 Jane Beckett and Jo Lambert, 'Private lives/public property', *Feminist Arts News*, 3 (2), 1989, 17–24.

44 Karen Jones and Kevin Williamson, 'The birth of the schoolroom', *Ideology and Consciousness*, 1979, 59–110. These thoughts about the city have greatly benefited from conversations with Lubaina Himid.

45 J. Ruskin, *Sesame and Lilies*, 1864, in E.T. Cook and A. Wedderburn (eds), *The Works of John Ruskin*, London, Allen, 1905, 18, 122. Ruskin lived with his parents in the London suburb of Dulwich.

46 L. Davidoff and C. Hall, 'The architecture of public and private life: English middle-class society in a provincial town', in D. Fraser and A. Sutcliffe, eds. *In Pursuit of Urban History*, London, Arnold, 1983, 326–46.

47 Lynne Walker, 'Vistas of pleasure: women consumers of urban space in the west end of London, 1850–1900', in *Cracks in the Pavement: Gender, Fashion, Architecture*, London, Sorella, 1993.

48 *Art Journal*, 1863, 105. J. Ruskin, in Cook and Wedderburn (eds), 1905, 122.

49 Christies, 26 July 1974, lot 181. The title may not be the artist's.

50 Sotheby Belgravia, 8 March 1977, lot 162; Roy Miles Fine Paintings, London.

51 From 1862 Jane Bowkett exhibited seaside pictures; her sister Eliza Martha Bowkett showed views of Hastings, 1862–7 and of Eastbourne, 1865. It seems likely that the two sisters worked together on the Sussex coast.

52 Griselda Pollock, 'Difference: women/art/history', *Art Monthly*, February 1988, 27, writes, 'a careless governess preoccupied with a novel while the unregarded children make havoc is as imaginable as an image of a woman with her children caught up in her own intellectual concerns . . .'. However, the woman is not represented with the visual signs for the governess, for which see chapter 8.

53 Ruskin, 1864, in Cook and Wedderburn (eds), 1905, 18, 123.

54 Painting untraced. [Bessie Rayner Parkes], 'The Society of Female Artists', *English Woman's Journal*, May 1858, 207–8.

55 Harriet Taylor, 'The enfranchisement of women', *Westminster Review*, July 1851, in A. Rossi, *Essays on Sex Equality: John Stuart Mill and Harriet Taylor Mill*, Chicago, University of Chicago Press, 1970, 91–121.

56 Bessie Rayner Parkes, 'A year's experience in women's work', *English Woman's Journal*, October 1860.

57 Painting untraced. Margaret Tekusch, *Portrait of Miss Fox*, Society of British Artists, 1848.

58 W. Meynell, 'Our living artists', *Magazine of Art*, 3, 1879–80, 307; Sotheby Belgravia, 25 March 1975.

59 Private collection, London.

60 Victoria and Albert Museum, London; Roy Brindley, London.

61 Sotheby Belgravia, 22 September 1981, lot 276.

62 Helene Roberts, 'Marriage, redundancy or sin: the painter's view of women in the first twenty-five years of Victoria's reign', in M. Vicinus (ed.), *Suffer and Be Still: Women in the Victorian Age*, London, Methuen, 1980, 45–76

63 With thanks to Marion Maule for information on the use of fans.

64 Forbes Collection, New York; Southampton Art Gallery. Edith Hayllar showed twelve works at the RA 1882–97, Jessica thirty-two works 1880–1902.

65 Susan Casteras, *The Substance and the Shadow: Images of Victorian Womanhood*, New Haven, Yale Center for British Art, 1982, 77.

66 *A Coming Event* is in the Forbes Collection, New York; other works by the Hayllar sisters are known from photograph albums recording their paintings.

67 C.R. Leslie, *Queen Victoria Receiving the Sacrament at her Coronation, 1838*, RA 1843, Royal Collection, engraved S. Cousins, 1843.

68 I. Beeton, *Household Management*, London, Ward Lock, 1888.

69 The new traditions and rituals of bourgeois femininity are not considered in J. MacKenzie, *Propaganda and Empire: The Manipulation of British Public Opinion, 1880–1960*, Manchester University Press, 1984, nor in E. Hobsbawm and T. Ranger (eds.), *The Invention of Tradition*, Cambridge, Cambridge University Press, 1983.

70 R. Hennessy and R. Mohan, 'The construction of woman in three popular texts of empire: towards a critique of materialist feminism', *Textual Practice*, 3, 1989, 323–39.

71 ibid.

72 See Lucy Bland, 'The married woman, the "New Woman" and the feminist: sexual politics of the 1890s', in J. Rendall (ed.), *Equal or Different: Women's Politics 1800–1914*, Oxford, Blackwell, 1987, 141–63.

8 WORKING WOMEN

1. H. Martineau, 'Female industry', *Edinburgh Review*, 109, April 1859, 294. One of the meanings of the word 'work' which was specific to and for bourgeois women, was handwork, that is the kinds of fancy needlework done in company; it is used in this sense in the novels of Charlotte Brontë and Elizabeth Gaskell in the 1850s.

2 M. Foucault, *Surveiller et punir: La naissance de la prison*, Paris, Gallimard, 1975, trans. A. Sheridan, as *Discipline and Punish, The Birth of the Prison*, Harmondsworth, Penguin, 1982. M. Foucault, *La volonté de savoir*, Paris, Gallimard, 1976, trans. R. Hurley, *The History of Sexuality: Volume I, An Introduction*, Harmondsworth, Penguin, 1981.

3 Foucault, 1981, 136.

4 ibid., 147.

5 Foucault, 1982, 191.

6 ibid., 187.

7 Lucy Bland, 'The domain of the sexual, a response', *Screen Education*, no. 39, 1981, 56–67.

8 Foucault, 1981, 149–50, 140; Foucault, 1982, 218–22. Profitable durations and docile bodies are discussed in Foucault, 1982, 135ff.

9 Beverley Brown and Parveen Adams, 'The feminine body and feminist politics', *m/f*, 3, 1979, 35–50.

10 E. Chadwick, *Report from the Poor Law Commissioners on an Enquiry into the Sanitary Condition of the Labouring Population of Great Britain*, 1842, ed. M.

W. Flinn, Edinburgh, Edinburgh University Press, 1965. See F. Mort, *Dangerous Sexualities: Medico-Moral Politics in England since 1830*, London, Routledge, 1987, for the shifting alliances of reformists.

11 Parliamentary Papers, 1843, XIV, *Childrens' Employment Commission, First and Second Reports*, 1842–3, especially 'Medical evidence on London dress-makers and milliners', 622.

12 A. John, *By the Sweat of their Brow: Women Workers at the Victorian Coalmines*, London, Routledge, 1983, 135–59.

13 A. Davin, 'Imperialism and motherhood', *History Workshop Journal*, 5, 1978, 9–65. Rosemary Hennessy and Rajeswari Mohan, 'The construction of woman in three popular texts of empire: towards a critique of materialist feminism', *Textual Practice*, 3, 1989, 323–39.

14 Ziggi Alexander, 'Let it lie upon the table: the status of Black women's biography in the UK', *Gender and History*, 2 (1), 1990, 22–33; Z. Alexander and A. Dewjee, *Wonderful Adventures of Mrs Seacole in Many Lands*, Bristol, Falling Wall Press, 1984.

15 R. Visram, *Ayahs, Lascars and Princes: Indians in Britain, 1700–1947*, London, Pluto, 1986, 30.

16 There were numerous portraits of actresses in character roles, about 1880–1900, as for example Louise Jopling's portrait of Ellen Terry as Portia or Anna Lea Merritt's *Scene from Romeo and Juliet* with Ellen Terry as Juliet and Mary Ann Stirling as Nurse, 1883, Garrick Club, London.

17 Emily Crawford, 'Great Britain: Art', in Maud Howe Elliott, *Art and Handicraft in the Woman's Building of the World's Columbian Exposition, Chicago*, Chicago, Rand McNally, 1894. The British contribution emphasised philanthropy and nursing.

18 *Needlework* was reproduced in Florence Fenwick Miller, 'Art in the women's section of the Chicago Exhibition', *Art Journal*, 1893, p. xvi.

19 Foucault, 1981, 45.

20 *The Art Journal* consistently promoted art as a teacher of morality, noting of Richard Redgrave that he 'has employed a noble art in the spirit of a true philanthropist', 1850, 49, and making similar claims for Emily Osborn, 1860, 170.

21 F. Prochaska, *Women and Philanthropy in Nineteenth-Century England*, Oxford, Clarendon, 1980.

22 *A Sister of Mercy* portrayed a visit to 'the bedside of a poor woman' near death, *Art Journal*, 1856, 164. The other three works are discussed later in this chapter.

23 C. Yeldham, *Women Artists in Nineteenth-century France and England*, New York, Garland, 1984, 3, 166–8. There were sharp contrasts between the flower-seller with a pert smile and hour-glass figure depicted by Maude Goodman in *Rival Blossoms* (RA 1886) and the heavy-featured contained women portrayed in Maria Brooks's *Down Piccadilly* (RA 1883).

24 While this depiction of a prima donna in the footlights was admitted to the Royal Academy, the *Art Journal* deplored it as 'not specifically suited for pictorial treatment' (1873, 202).

25 E. O'Donnell (ed.), *Mrs E.M. Ward's Reminiscences*, London, Pitman, 1911, 118, 129; I. McAllister (ed.), *Henrietta Ward: Memories of Ninety Years*, London, Hutchinson, 1924, 125–8.

26 Census entries, 1871 for 4 Constitution Crescent, Gravesend, and 1881, 18 Melbury Road.

27 Jane Lewis, *Women in England 1870–1950*, Brighton, Wheatsheaf, 1985, 56; L. Davidoff, 'Mastered for life, servant and wife in Victorian and Edwardian England', *Journal of Social History*, 7, 1974.

28 M. Forster, *Lady's Maid*, London, Chatto, 1990.

29 Jane Hales, housemaid, sat to Evelyn Pickering de Morgan when she lived at her parental home. A.M.W. Stirling, *William de Morgan and his Wife*, London, Thornton Butterworth, 1922, 177.

30 Works not traced. *Spectator*, 3 April 1858, 380; *Art Journal*, 1860, 85, 169; *Athenaeum*, 19 May 1860, 688.

31 Works not traced. See *Art Journal*, 1855, 176.

32 Lavender Sweep was Laura and Tom Taylor's address in Clapham.

33 Reproduced in D. Cherry, *Painting Women*, Rochdale, Rochdale Art Gallery, 1987, 13, 14.

34 I. Beeton, *Household Management*, London, Ward Lock, 1888, 22, 28, 1485.

35 L. Davidoff, 'Class and gender in Victorian England: the diaries of Arthur J. Munby and Hannah Cullwick', *Feminist Studies*, 5 (1), 1979, 87–141. H. Dawkins, 'The diaries and photographs of Hannah Cullwick', *Art History* 10 (1), 1987, 154–87.

36 Liz Stanley, *The Diaries of Hannah Cullwick*, London, Virago, 1984. Hannah Cullwick also noted the contrast between her own hands, 'very coarse and hardish', and Mrs J.'s very white hands, 111.

37 *Spectator*, 4 July 1857, 715, my italics. The picture, untraced, showed a woman with crossed arms leaning out of a window.

38 *Athenaeum*, 11 May 1861, 635. The *Illustrated London News* commended the 'womanly delight in her subject' while not commenting on the servant, 27 July 1861, 87. The artist's careful working of her subject is shown by her numerous compositional and figure studies in pencil and in oil, private collections, UK.

39 John Tagg, *The Burden of Representation: Essays on Photographies and Histories*, London, Macmillan, 1988.

40 Works untraced but reproduced in Hayllar family photographic albums.

41 Mary Braddon, *Aurora Floyd*, London, Tinsley, 1863, 149.

42 R. Visram, 1986.

43 See *A History of the Black Presence in London*, London, Greater London Council, 1987, 10; R. Visram, 1986, plates 2 and 3. A watercolour of a beach scene with an ayah is reproduced in Ina Taylor, *Helen Allingham's England*, Exeter, Webb & Bower, 1990, 58.

44 Little is known of the picture's history. It was shown at the Winter Exhibition, London, in 1861 then sent to Liverpool in 1862, priced £84. P.G. Nunn, 'Rebecca Solomon's "A Young Teacher" ', *Burlington Magazine*, 130, 1988, 769.

45 *Critic*, 23 November 1861, 524.

46 Decorations for the East India Company House in London included Rysbrack's chimney piece *Britannia Receiving the Riches of the East*, 1728–30, and Roma's ceiling painting of the same subject, 1778; see Mildred Archer, *India and British Portraiture, 1770–1825*, Oxford, Oxford University Press, 1979, plates 1 and 3.

47 *Punch*, 11 September 1858. See K. Vadgama, *India in Britain: The Indian Contribution to the British Way of Life*, London, Royce, 1984, 17. After the Indian National Uprising of 1857 a *Punch* cartoon contrasted a white woman as Justice taking reprisals, with a group of cowering Indian women. Vadgama, 1984, 23.

48 For Mary Ellen Best's portrait of Isabella Pauli, 'A Portuguese Hindoo', see C. Davidson, *The World of Mary Ellen Best*, London, Chatto, 1985, plate 13. Asian women may have modelled for pictures with subjects such as *The Hindoo Girl*, or Elizabeth Siddall's drawing *The Lovers*, 1854, Ashmolean Museum, Oxford. Rebecca Solomon's illustration to Mrs Gatty's story 'The Double Tie' in the *Churchman's Magazine*, 1864, depicted a travelling ayah in an envelop-

ing shawl cradling a child on her lap. These portrayals may have drawn on illustrations in travel books rather than study from a model.

49 *Joanna Mary Boyce: Memorial Exhibition*, London, Tate Gallery, 1935, nos 7 and 22. It is not known whether the artist and sitter/s were friends or professional acquaintances. For Eliza Fox see chapter 10.

50 Reproduced in J. Marsh and P. Nunn, *Women Artists and the Pre-Raphaelite Movement*, London, Virago, 1989, plate 4. The subject is from the novel by Harriet Beecher Stowe.

51 Michelle Cliff, 'Object into subject: some thoughts on the work of Black women artists', in H. Robinson (ed.), *Visibly Female: Feminism and Art: An Anthology*, London, Camden, 1987, 140.

52 Thomas Hood's 'The Song of the Shirt', first published in *Punch*, December 1843, was printed as catchpennies and on handkerchiefs and set to music. It was quoted in exhibition catalogues throughout the period, as Flora Reid, *The Seamstress*, 'With fingers weary and worn', Institute of Oil Painters 1883–4; Lily Rose, *The Song of the Shirt*, statuette, RA 1886; or Margaret Bird, *The Song of the Shirt*, RA 1891.

53 Society of British Artists, 1854. Engraved in *Illustrated London News* with a campaign for a memorial to Thomas Hood, 15 July 1854, 36.

54 T.J. Edelstein, 'They sang the song of the shirt', *Victorian Studies*, 1980, 183–200.

55 For a more extensive discussion see D. Cherry, 'Surveying seamstresses', *Feminist Arts News*, 9, 1983, 27–9. The Film and History Project's film *The Song of the Shirt*, 1979, drew on the plethora of texts on seamstresses to reconstruct the needlewomen's positions in the contexts of the 1840s.

56 Parliamentary Papers, 1843, XIV, *Children's Employment Commission*, 1843, op. cit.; 'Milliners' apprentices', *Fraser's Magazine*, 1846, 308–16; T. Mills, 'The seamstress', *Penny Illustrated News*, 2, 1851, 34.

57 It was frequently reiterated that needlewomen worked all night. Parliamentary Papers, 1843, XIV, *Children's Employment Commission*, 1843, op. cit.; 'Milliners' apprentices', *Fraser's Magazine*, 1846, 308–16; T. Mills, 'The seamstress', *Penny Illustrated News*, 2, 1851, 34. Christian meanings for light and dark were often used to reinforce the irregularity of night work.

58 C. Walkley, *The Ghost in the Looking Glass*, London, Peter Owen, 1981, plate 44.

59 'Milliners' apprentices', *Fraser's Magazine*, 1846, 308–16.

60 S. Alexander, *Women's Work in Nineteenth-century London: A Study of the Years 1820–50*, London, Journeyman, 1983.

61 PP, 1843, op cit.; 'Juvenile and female labour', *Edinburgh Review*, 79, 1844, 130–56; and *Fraser's*, op. cit. Links between needlework and prostitution were made in the *Children's Employment Commission*, Kingsley's *Alton Locke*, 1850 and in visual images such as Millais, *Virtue and Vice*, 1853, private collection, in which a needlewoman is being tempted to prostitution. In Elizabeth Gaskell's *Ruth* of 1853, the seamstress works her way, through her sewing, to redemption.

62 Lynda Nead, 'The Magdalen in modern times', in Rosemary Betterton (ed.), *Looking On: Images of Femininity in the Visual Arts and Media*, London, Pandora, 1987, 73–92.

63 Henry Mayhew, *The Morning Chronicle Survey of London Labour and the Poor*, London, Caliban, 1980, I, 151ff., 165.

64 ibid., 228.

65 ibid., 159.

66 PP, 1843, op. cit.; *Fraser's*, op. cit; 'The seamstress', *Eliza Cook's Journal*, 11

May 1850, 17–19

67 Jane Coral Hurlstone (fl. 1846–56, d. 1858) exhibited *The Women of England in the Nineteenth Century* at the Society of British Artists in 1852. According to the *Art Journal*, 1852, 137, 'in the most abject misery we see a creature starved and in rags drudging for bread which is served to her in crumbs'. This shirtmaker is contrasted to a lavishly dressed woman in an opera-box. For other images of unrepaired attic rooms, see T. Mills, 1851; G. Reynolds, 'The slaves of England', *Reynolds' Miscellany*, 4 March 1850; Eliza Meteyard, 'Lucy Dean, the noble needlewoman', *Eliza Cook's Journal*, 16 March 1850; and Redgrave's *The Seamstress*, 1844.

68 G. Stedman-Jones, *Outcast London: A Study of the Relationship between Classes in Victorian Society*, Oxford, Clarendon, 1971; R.Q. Gray, *The Aristocracy of Labour in Nineteenth-Century Britain*, London, Macmillan, 1981.

69 Anna Blunden's family owned property in Exeter; her sisters retailed Berlin wool. See V. Surtees, *Sublime and Instructive: Letters from John Ruskin to Louisa Marchioness of Waterford, Anna Blunden, and Ellen Heaton*, London, Michael Joseph, 1972; *Edgbastonia*, 18, 1898, 205–9.

70 *Manchester Guardian*, 21 February 1933.

71 M.J. Peterson, 'The Victorian governess: status incongruence in family and society', in M. Vicinus (ed.), *Suffer and Be Still: Women in the Victorian Age*, Methuen, London, 1980, 3–19.

72 Elizabeth Eastlake, '*Vanity Fair*, *Jane Eyre* and the Governesses Benevolent Institution', *Quarterly Review*, 84, 1848, 176–85. To 'pass through the gazette' was to become bankrupt.

73 *Art Journal*, 1854, 167.

74 The painting is known through a photograph of Queen Victoria's present table for Christmas 1860; see H. and A. Gernsheim, *Queen Victoria, A Biography in Word and Picture*, London, Longman, 1959, plate 177. I am indebted to Susan Casteras for this reference. A replica is now at the Yale Center for British Art, New Haven, Conn.

75 *Saturday Review*, 2 June 1860, 709; *Athenaeum*, 19 May 1860, 689; *Art Journal*, 1860, 170; *Blackwood's*, 88, 1860, 68. The painting and its reviews provide interesting representations not only of the vulgar lady but also of the bad mother.

76 *Art Journal*, 1864, 262.

77 *Art Journal*, 1860, 170.

78 Several articles on governessing appeared in the *English Woman's Journal* in its first two years but by April 1859 Harriet Martineau dismissed the governess as an out-of-date stereotype of women's work in 'Female industry', *Edinburgh Review*, 1859, 294. Reviewers criticised Emily Mary Osborn's 'most hackneyed theme'. See note 75. Louisa Starr's *Hardly Earned* (RA 1875) depicted a daily governess or music teacher, *Academy*, 1875, 591.

79 Lynda Nead, *Myths of Sexuality: Representations of Women in Victorian Britain*, Oxford, Blackwell, 1988, 181.

80 O. Doughty and J.R. Wahl (eds.), *Letters of Dante Gabriel Rossetti*, Oxford, Clarendon, 1965, I, 214.

81 Nead, 1988, 196–212, and plate 46.

82 *Athenaeum*, 18 March 1854, 346; *Spectator*, 18 March 1854; see also *Critic*, May 1854, 163; *Illustrated London News*, 1854, 278.

83 *Athenaeum*, 18 March 1854, 346.

84 Doughty and Wahl (eds), 1965, I, 214. Rossetti held back his design for *Found* from the circulating portfolio. A finished drawing for the composition of *Found* in the British Museum could have been misdated to 1853. Rossetti started

painting in September 1854 but by 1856 only the wall and the calf had been painted.

85 Doughty and Wahl (eds), 1965, I, 274. Three versions exist, one at the Ashmolean and another in a private collection. They may have been included in the Pre-Raphaelite exhibition at Russell Place in London in 1857 as 'Sketches from Browning . . .'.

86 [Anna Mary Howitt], 'A house of mercy', [London Diocesan Penitentiary for Fallen Women], *English Woman's Journal*, 1, 1858, 13–27.

87 Ruskin called her Ida after Tennyson's poem 'The Princess', W.M. Rossetti (ed.), *Ruskin, Rossetti, Pre-Raphaelitism, Papers 1854 to 1862*, London, Allen, 1899, 89ff. Letter to Bessie Parkes [1854], Parkes Papers, V, 173, Girton College, Cambridge.

88 For popular cultural images of the prostitute see Nead, 1988; Elizabeth Siddall was certainly aware of Hunt's painting as she visited the Royal Academy; see Anna Mary Howitt to Bessie Parkes, Parkes Papers, VII, 2, Girton College. For artisan respectability see R.Q. Gray, *The Labour Aristocracy in Victorian Edinburgh*, Oxford. Clarendon, 1976.

89 Urania Cottage, Shepherds Bush, West London, funded by Angela Burdett-Coutts was opened in 1847 as a reformatory or 'home for homeless women'. By 1853 of the 57 admitted, 10 had been expelled, 14 had left of their own accord, and 33 had been required by the home to emigrate. See C. Dickens, 'Home for homeless women', *Household Words*, 23 April 1853 and E. Johnson (ed.), *Letters from Charles Dickens to Angela Burdett-Coutts*, London, Cape, 1953. A. Burdett-Coutts, *Woman's Mission: A Series of Congress Papers on the Philanthropic Work of Women by Eminent Women*, London, Sampson, Low, 1893.

90 *Athenaeum*, 25 March 1854, 380.

91 In 1856 Thomas Plint requested F.M. Brown to include in *Work* 'a quiet, earnest, holy-looking' female tract distributor because he was interested in this work. See Deborah Cherry, 'Selected letters and journals of Ford Madox Brown 1850–70', PhD thesis, University of London, 1978.

92 C. Arscott, 'Employer, husband, spectator: Thomas Fairbairn's commission of the Awakening Conscience', in J. Wolff and J. Seed (eds), *The Culture of Capital: Art, Power and the Nineteenth-century Middle Class*, Manchester, Manchester University Press, 1988, 159–190. It is significant that James Leathart, Newcastle industrialist, commissioned Rossetti's *Found* in 1859.

93 Several studies, some depicting Gretchen combing her long hair, survive in the artist's sketchbooks in a private collection.

94 Nead, 1988, 182–91

95 See Wilkie Collins, *No Name*, 1862.

96 *Athenaeum*, 11 May 1861, 635. This critic complained at its 'rather superfluous neglect of beauty'. *Saturday Review*, 25 May 1861, 121, compared it to Bellini and noted the 'vengeful expression which is not pleasant to contemplate'. The picture was destroyed, but is reproduced in J. Marsh and P.G. Nunn, 1989, plate 54.

97 F.G. Stephens described *Venus Verticordia* as 'victorious and indomitable', *Athenaeum*, 21 October 1865, 546. Rossetti chose not to exhibit his works, but to show them to a select group of visitors to his studio and to sell them directly to northern collectors. An old ally from the Pre-Raphaelite Brotherhood, Stephens publicised Rossetti's work in the *Athenaeum* where he was art critic from 1861.

9 FROM TOWNS TO COUNTRYSIDE AND SEASIDE

I am particularly grateful to Susanna Wade Martins for reading and commenting on a earlier version of this chapter which was published as 'Paradise lost: histories regained', *Art History*, 12 (3), 1989, 374–81.

1 'Pictures by railway', *Eliza Cook's Journal*, 18 October 1851, 385–7.

2 John Linnell and George Cole both bought country estates. Cole's income in 1864 was £1,000, rising to £2,580 in 1873 and averaging £2,000 from 1874 to 1881. See T.J. Barringer, *The Cole Family of Painters*, Bradford, Cartwright Hall Art Gallery, 1988.

3 Linnell's *Harvesting* of 1857, representative of mid-century prosperity, was engraved in Copeland's *Agriculture Ancient and Modern* of 1866, a handbook of high-farming.

4 G. Mingay (ed.), *Rural Life in Victorian England*, London, Heinemann, 1977, 27; his figures are for England.

5 B.A. Holderness, 'Agriculture and industrialisation in the Victorian economy', in G.E. Mingay (ed.), *The Victorian Countryside*, London, Routledge, 1981.

6 S. Marriner, *The Economic and Social Development of Merseyside*, London, Croom Helm, 1982.

7 *Lord Leverhulme*, London, Royal Academy of Arts, 1980, 11.

8 P. Razzell and R.W. Wainwright, *The Victorian Working Class: Selections from Letters to the Morning Chronicle*, London, Frank Cass, 1973.

9 Letter from Ellen Clacy, 4 May 1913. Her painting and letter are in the Walker Art Gallery, Liverpool. Thanks to Jane Sellars for documentation. In 1885 Ellen Clacy's address was 93 Fitzroy Road, Primrose Hill, London NW.

10 N.P. Green, *The Spectacle of Nature: Landscape and Bourgeois Culture in Nineteenth-century France*, Manchester, Manchester University Press, 1990, 11, 94.

11 Raymond Williams, *The City and the Country*, London, Chatto, 1973. In the eighteenth century pictorial landscapes were based on and compared to the works and style of named individual artists such as Claude Lorrain.

12 R. Chignell, *Life and Paintings of Vicat Cole, RA*, London, Cassell, 1896, I, 133.

13 *Louisa Paris, Watercolours of the South East of England in the 1850s*, Eastbourne, Towner Art Gallery, 1982, 16. I am indebted to my mother Joan for sharing her enjoyment of these works with me.

14 Letters from Barbara Bodichon to Bessie Rayner Parkes, (1847–50), V, 167; 11 September 1851, V, 57; Bessie Rayner Parkes to Annie and Belle Leigh Smith, 1850, VI, 64, 65; 3 September 1854, VI, 66. Parkes Papers, Girton College, Cambridge. The drawings are all in Girton College, Cambridge; see Kate Perry, *Barbara Leigh Smith Bodichon, 1827–1891*, Cambridge, Girton College, 1991, no. 38. I am most grateful to Kate Perry for all her help with this material.

15 O. Doughty and J.R. Wahl (eds.), *The Letters of D.G. Rossetti*, Oxford, Clarendon Press, 1965, I, 163.

16 Sarah Sophia Beale, *Recollections of a Spinster Aunt*, London, Heinemann, 1908, 123.

17 L. Jopling, *Twenty Years of My Life, 1867–87*, London, John Lane, 1925, 53.

18 Painting in the open air was not necessarily a comfortable experience for bourgeois men. In 1826, after attracting a large crowd while sketching in a London park, the French artist Delecluze resolved to dress as a workman. I am indebted to Marcia Pointon for the information and for numerous helpful and incisive comments on this chapter. See Marcia Pointon, *The Bonington Circle*, Brighton, Hendon Press, 1985, 101.

19 *Nearing the Frontier* is in Wolverhampton Art Gallery; *Four Miles More* see *Queen*, 2 November 1889, 615.

20 Reproduced in *Queen*, 13 April 1889, 475. For discussion of the representation of towns by women artists such as Louise Rayner see D. Cherry, *Painting Women*, Rochdale, Rochdale Art Gallery, 1987, 22ff.

21 Compare Helen Allingham's cover 'Fashion repeats itself', *Graphic*, 7 September 1872 with Herkomer's 'Low lodging house St Giles, a study from life', *Graphic*, 3 August 1872. When women portrayed comparable themes, the subject was philanthropic as in Mary Ellen Edwards's 'Children's Hospital', *Graphic*, 18 December 1869.

22 Reproduced in Cherry, 1987, 22.

23 *Art Journal*, 1882, 210. *Rushcutters* is in Sheffield City Art Gallery; *They Homeward Wend . . .* in the National Museum of Wales, Cardiff.

24 *Magazine of Art*, 1882, 252; *Athenaeum*, 23 May 1885, 667; *Art Journal*, 1881, 215. *Blanchisseuses* is in the Walker Art Gallery; other works untraced.

25 M. Newman, London, May 1966, no. 26, undated.

26 For example, Emily Mary Osborn, *God's Acre*, repr. *Art Journal*, 1868, 148.

27 *Art Journal*, 1874, 201.

28 According to F. Haskell and N.B. Penny, *Taste and the Antique*, London, Yale University Press, 1981, 194. This seated figure of a woman resting her head on her hand was usually called Dacia and occasionally referred to as a Province or Germania. My thanks to Melva Croal here.

29 Agnews sold the painting to Menelaus in May 1876, having the previous month acquired the artist's three Royal Academy exhibits, which they titled *Youth and Age*, *Apple Blossoms* and *Goosey, Goosey, Gander*. It was bequeathed by Menelaus to the Museum in 1882. With thanks to Alison Winter of Agnews, Fiona Pearson and Dr M.L. Evans for information.

30 Information provided by Jane Sellars. Jill Morgan kindly provided a wealth of documentation on Heape and his collection which formed the basis of Rochdale Art Gallery's holdings. The catalogue price for *The Belle of the Village* was £300, but according to Anthony Wray the archives at Southport Art Gallery indicate that the picture was purchased for £100.

31 *Studio*, Special Number, 8, 1899, 31; *Studio*, 24, 1901–2, 300.

32 'Mrs Alice Mary Morgan', *Dictionary of National Biography*, XIII, 1917, 908–9. The picture is in the Castle Museum, Norwich.

33 M.B. Huish, *Happy England as Painted by Helen Allingham*, London, Black, 1903, reprinted as *The Happy England of Helen Allingham*, London, Bracken Books, 1985, 194.

34 *Art Journal*, 1881, 26.

35 Helen Allingham and S. Dick, *The Cottage Homes of England*, London, Arnold, 1909, reprinted London, Bracken Books, 1984, 11.

36 Ina Taylor, *Helen Allingham's Happy England*, Exeter, Webb & Bower, 1990.

37 For example, *Harvest Field near Westerham Kent*, Manchester, Whitworth Art Gallery. Agricultural labour was less frequently depicted in later works; the Kent setting may argue for a date after 1889.

38 The record of her palette indicates that of the nine colours used, five were yellows. Huish, 1985, 194.

39 ibid., 194.

40 Helen Allingham to M.H. Spielmann, 18 January 1890, John Rylands University Library, Manchester, English, Mss. 1303.

41 Huish, 1985, 99, 180.

42 Helen Allingham and D. Radford (eds), *William Allingham: A Diary, 1828–89*, 1907, reprinted Harmondsworth, Penguin, 1985, 338.

43 M.H. Spielmann and G.S. Layard, *Kate Greenaway*, 1905, reprinted New York, Blom, 1968, 173.

44 Private collection, repr. in P.G. Nunn, *Victorian Women Artists*, London, Women's Press, 1987, plate IV.

45 *Census of Surrey*, 1871, 7. The artist Frank Holl commissioned a house by Shaw; Miles Birket Foster's house was decorated with papers and fabrics by Morris & Co, based in Merton in Surrey from 1881. For craft workers see Lynne Walker and C. Sanger, 'The Inval Weavers', *Craft Quarterly*, 1, 1981, 2–6.

46 *A Handbook for Travellers in Surrey*, 5th edition, London, John Murray, 1898, 16, 393, 397.

47 For example, 'Rambles in Surrey', *Illustrated London News*, 20 July 1889, 92; H.E. Ward, 'Out of doors in Surrey', *Magazine of Art*, 1883, 290–6.

48 *Illustrated London News*, 10 April 1886, 369.

49 Of the 61 works on seasonal themes shown at the Fine Art Society in 1886, 50 were of spring and summer.

50 Helen Allingham and D. Radford (eds), 1985, 345.

51 Taylor, 1990, 43.

52 I an indebted here in my thinking to discussions with Lynne Walker and to her path-breaking research on women and architecture. For a discussion of the relations between women and the vernacular see 'Bricks and daughters: women and architecture 1835–1935', in W. Schutte and M.Wilke (eds), *The Wise Woman Buildeth Her House: Architecture, History, Gender*, Groningen, 1992, 12–50.

53 G. Jekyll, *Wood and Garden*, London, Longmans, 1899, 4, 193.

54 G. Jekyll, *Old West Surrey*, London, Longmans, 1904, 159, viii.

55 W. Allingham, *Surrey Cottages*, London, Fine Art Society, 1886.

56 *Illustrated London News*, 10 April 1886, 369.

57 Huish, 1985, 126.

58 Judith Tankard and M.R.V. Valkenburgh, *Gertrude Jekyll: A Vision of Garden and Wood*, London, John Murray, 1989.

59 E. Gauldie, 'Country homes', in Mingay (ed.), 1981, II, 531–2.

60 Mary Augusta Ward, *Robert Elsmere*, London, Smith Elder, 1888, 158, 202–3. Related to this position were women's philanthropic activities of building new cottages.

61 Huish, 1985, 146.

62 M. Kaufman, *The Housing of the Working Classes and the Poor*, 1907, reprinted Wakefield, E.P. Publishing, 1975, 59. Some of these debates are discussed in Jan Marsh, *Back to the Land: The Pastoral Impulse in England from 1880 to 1914*, London, Quartet, 1982.

63 C. Holme (ed.), *Old English Country Cottages*, London, Studio, 1906, iii.

64 L. Davidoff, J. L'Esperance and H. Newby, 'Landscape with figures: home and community in English society', in J. Mitchell and A. Oakley (eds), *The Rights and Wrongs of Women*, Harmondsworth, Penguin, 1976, 139–75.

65 W. Lever, *Art and Beauty and the City*, Port Sunlight, Lever Bros [1915], 6; J. Sellars, *Women's Works*, Liverpool, Walker Art Gallery, 1987.

66 A. Davin, 'Imperialism and motherhood', *History Workshop Journal*, 5, 1978, 9–65. Anna Davin also points out the restructuring of the workforce in the later nineteenth century.

67 C. Fox and F. Greenacre, *Artists of the Newlyn School, 1880–1900*, Newlyn, Orion Gallery, 1979; C. Fox and F. Greenacre, *Painting in Newlyn, 1880–1930*, London, Barbican Art Gallery, 1985; for the artist see also G. Crozier, *Art Journal*, 1904, 382; *Queen*, 18 October 1890, 576 and Mrs Lionel Birch, *Stanhope A. Forbes and Elizabeth Stanhope Forbes*, London, Cassell, 1906.

68 N. Green, 1990, 118.

69 For Stanhope Forbes's recollection in 1900 that 'every corner was a picture and . . . the people seemed to fall naturally into their places and to harmonise with their surroundings', see Fox and Greenacre, 1985, 59.

70 Birch, 1906, 25–6.

71 Caroline Burland Yates Gotch, fl. 1880–1902, was one of the first artists to visit Newlyn in 1879 after training at the Slade and Heatherley's in London; following a period in Paris and London and marriage to Thomas Gotch, she settled in Newlyn in 1887. See Fox and Greenacre, 1979, 251.

72 Marianne Preindlsberger worked at Pont Aven in 1885, and with her husband Adrian Stokes at St Ives, 1889–94.

73 Griselda Pollock and Fred Orton, 'Les Données Bretonnantes, La Prairie de la représentation', Art History, 3 (3), 1980, 314–44.

74 Alice Meynell, 'Newlyn', Art Journal, 1889, 98.

75 Birch, 1906, 33.

76 Eve Blantyre Simpson, 'The paintings and etchings of Elizabeth Stanhope Forbes', Studio, 4, 1894, 187. It is not clear how extensively male artists actually worked on the canvas out of doors. For A Fish Sale on a Cornish Beach (RA 1885) Stanhope Forbes rented a studio previously converted by an artist-tenant from an old sail loft, and although he noted the reluctance of two young women to model for him, two such figures are prominent in the foreground of this painting. See Fox and Greenacre, 1979, 58. In 1900 he claimed that 'to plant one's easel down in full view of all, and to work away in the midst of a large congregation needs a good deal of courage; but it takes even more to boldly ask some perfect stranger to pose for one under such very trying conditions.' Fox and Greenacre, 1979, 20.

77 Elizabeth Forbes, 'On the slopes of a southern hill', Studio, 18, 1899, 25–34.

78 Birch, 1906, 63.

79 Fox and Greenacre, 1985, no. 50.

80 Joyce S. Pedersen, 'School mistresses and head mistresses: elites and education in nineteenth-century England', Journal of British Studies, 15 (1), 1975, 135–62.

81 Carol Duncan, 'The Moma's hot mamas', Feminist Arts News, 3 (4), 1990; Griselda Pollock, Vision and Difference: Femininity, Feminism and the Histories of Art, London, Routledge, 1988, 50–90.

10 CULTURAL COLLISIONS

1. Spectator, 7 June 1856, 614, asserted that Boadicea is 'meditating vengeance' in a forest. According to Mary Howitt, the picture depicted 'Boadicea brooding over her wrongs', Amice Lee, Laurels and Rosemary: The Life of William and Mary Howitt, Oxford, Oxford University Press, 1955, 216.

2 Critic, 27 July 1861, 109.

3 Athenaeum, 7 June 1856, 718.

4 Lee, 1955, 217.

5 Margaret Howitt (ed.), Mary Howitt: An Autobiography, London, Isbister, 1889, II, 117.

6 Letter dated c. 1848–50, transcript in Barbara Stephen's notebook, Add. Ms. 7621, Cambridge University Library.

7 Charles Harrison, English Art and Modernism, 1900–39, London, Allen Lane, 1981, 14–18.

8 V. Surtees, Sublime and Instructive, London, Michael Joseph, 1972, 115; see also Ruskin to Sophia Sinnett, 1858, in E.T. Cook and A. Wedderburn, The Collected Works of John Ruskin, London, George Allen, 1904, 14, 308n.; P.G.

Nunn, 'Ruskin's patronage of women artists', *Woman's Art Journal*, 2 (2), 1981, 8–13. Ruskin's views on sexual difference were elaborated in *Sesame and Lilies*, 1864.

9 Anna Mary Howitt exhibited at the Society of Female Artists in 1858, but not, so far as is known, thereafter.

10 O. Doughty and J.R. Wahl (eds), *The Letters of Dante Gabriel Rossetti*, Oxford, Clarendon Press, 1965, I, 200; for an extended discussion see Deborah Cherry and Griselda Pollock, 'Woman as sign in Pre-Raphaelite literature: a study of the representation of Elizabeth Siddall', *Art History*, 7 (2), 1984, 206–27.

11 Kate Perry, *Barbara Leigh Smith Bodichon, 1827–91*, Cambridge, Girton College, 1991, 22; J. Marsh and P.G. Nunn, *Women Artists and the Pre-Raphaelite Movement*, London, Virago, 1989, 184; *Rossetti's Portraits of Elizabeth Siddal*, Oxford, Ashmolean, 1991.

12 Barbara Bodichon to Bessie Rayner Parkes [1854], Parkes Papers, Girton College, Cambridge, V 173, 172.

13 While frailty and invalidism were signs of bourgeois femininity, physical health was promoted by egalitarian feminists as signifiers of women's independence. Their philanthropy parallels Ruskin's.

14 Doughty and Wahl (eds), 1965, I, 108. R.C. Lewis and M. S. Lasner (eds), *Poems and Drawings of Elizabeth Siddal*, Wolfville, Canada, Wombat Press, 1978.

15 See *The Pre-Raphaelites*, London, Tate Gallery, 1984, no. 198. Between 1853 and 1857 Elizabeth Siddall made several drawings for Tennyson's poems, none of which were included in Moxon's edition of 1857. As early as 1853 she was preparing a subject from Tennyson for exhibition at the Royal Academy; Doughty and Wahl (eds), 1965, I, 59.

16 *Elizabeth Siddal: Pre-Raphaelite Artist, 1829–62*, Ruskin Gallery, Sheffield, 1991, nos 27–9, and my entries in *William Morris and the Middle Ages*, Manchester, Whitworth Art Gallery, 1984, nos 40, 43–8.

17 *Elizabeth Siddal: Pre-Raphaelite Artist, 1829–62*, nos 38, 37, 30, 31; Maud Sulter, *Echo: Works by Women Artists*, Liverpool, Tate Gallery, 1991, 42; my entry, *The Pre-Raphaelites*, 1984, no. 222.

18 Two volumes of Scott's *Minstrelsy* (1802), inscribed 'Eliz*th*. E. Siddall' are in the Fitzwilliam Museum, Cambridge. In 1854 the artist was preparing designs for a volume of Scottish ballads.

19 Elizabeth Siddall inspected medieval manuscripts at Ruskin's and the Bodleian, see Doughty and Wahl (eds), 1965, I, 258; Jennifer Harris, *Antique Collector*, December 1984, 68–71, and J. Marsh, *The Legendary Elizabeth Siddal*, London, Quartet, 1989.

20 The phrase 'to-be-looked-at-ness' is Laura Mulvey's, from her analysis of 'Visual pleasure and narrative cinema', *Visual and Other Pleasures*, London, Macmillan, 1989, 14–26. Siddall's designs for *La Belle Dame Sans Merci* or *The Gay Goshawk* address men's looking at women.

21 Anna Jameson, *A Commonplace Book of Thoughts, Memories, and Fancies*, London, Longmans, 1855, 331, 356, 362.

22 Agnes Strickland, *The Lives of the Queens of Scotland and English Princesses*, Edinburgh and London, Blackwell, 1850, I, vii, written in collaboration with her sister. Their predilections for upper-class and royal heroines were shared by women artists of the period.

23 ibid., I, 3; V, 264.

24 ibid., V, 264.

25 ibid., V, 221.

26 Roy Strong, *And When Did You Last See Your Father? The Victorian Painter and British History*, London, Thames & Hudson, 1978, 128–35.

27 *Illustrated London News*, 11 July 1863, 54; *Art Journal*, 1863, 97, 106.

28 *Illustrated London News*, 6 May 1865, 439.

29 Henrietta Ward, *Scene in the Louvre in 1649* (RA 1862), depicting Henrietta Maria; *Sion House, 1553* (RA 1868), depicting Lady Jane Gray, Christie's sale catalogue, 14.7.1972, lot 24; *The First Interview of the Divorced Empress Josephine* (RA 1870).

30 J.A. Froude, *History of England from the Fall of Wolsey to the Defeat of the Spanish Armada*, London, 1856–70.

31 Hugh Trevor-Roper, 'The Highland tradition of Scotland', in E. Hobsbawm and T. Ranger (eds), *The Invention of Tradition*, Cambridge, Cambridge University Press, 1983, 15–41. Dian Kriz has investigated the relations between evicting landowners and art collecting in her unpublished paper 'The Highland landscape', Vancouver, 1990.

32 *Illustrated London News,* 11 July 1863, 54; *Art Journal*, 1863, 97.

33 Cherry, 1987, 17–18 ; *Art Journal*, 1861, 169; *Athenaeum*, 11 May 1861.

34 *Spectator*, 1 May 1852, 422.

35 *Art Journal*, 1869, 184; see also *The Times*, 24 May 1862, 10; *Saturday Review*, 24 May 1862, 592; *Builder*, 24 May 1862, 367.

36 *Illustrated London News*, 21 June 1862, 641; 31 May 1862, 564.

37 Sarah Flower Adams, *Vivia Perpetua. A Dramatic Poem in Five Acts. With a Memoir of the Author by Eliza Bridell Fox*, privately printed, 1893. *Art Journal*, 1859, 83–4.

38 *English Woman's Journal*, March 1861, 59–60; *Art Journal*, 1861, 72.

39 Eliza Bridell-Fox, 'Memories', *Girl's Own Paper*, 19 July 1890, 657–61. The painting was shown with a quotation from Anna Jameson.

40 Julia Margaret Cameron's photographs of Marie Spartali include *Imperial Eleanor*, 1868; *Hypatia*, 1868, the neo-platonist philosopher and mathematician; *La Donna Maria*, *The Spirit of the Vine* and studio portraits. The string of beads which appears in several photographs belonged to the sitter. The argument here departs from Amanda Hopkinson's view that the photographer was 'unpredictable and unsystematic in her sources'; it does not concur with her interpretation of the literary references. See Amanda Hopkinson, *Julia Margaret Cameron*, London, Virago, 1986, 125, 110.

41 See J. Nicoll, *Rossetti*, London, Studio Vista, 1975, for Rossetti's patrons.

42 Elizabeth Cowie, 'Woman as sign', *m/f*, 1978, 1, 49–63.

43 Emma Sandys's works are in the Castle Museum, Norwich. For Rebecca Solomon see *Solomon: A Family of Painters*, London, Geffrye Museum, 1985.

44 Wilmington, Delaware Art Museum.

45 'Sophia [Wisdom] is holding a sheaf of corn', with thanks to Rosemary Ind and Anna Lazou-Voutou for the translation. A drawing in black and red chalks of the figure without attributes was at Phillips, London, 3 November 1986, lot 72. Nicole Murray of Phillips kindly provided a reproduction.

46 Annotation by W.M. Rossetti to Marie Spartali's list of current works in a letter to him in preparation for his article 'English painters of the present day', *Portfolio*, 1870, 113–19, University of British Columbia, Vancouver.

47 D.G. Rossetti's translation of Boccaccio's poem in *Dante and His Circle*, in W.M. Rossetti (ed.), *The Collected Works of Dante Gabriel Rossetti*, London, Ellis, 1887, 229. This watercolour and *The Last Sight of Fiammetta* (1876) predate Marie Spartali's sitting to Rossetti as Fiammetta in 1878.

48 For the significance of Boccaccio's *De Claris Mulieribus*, c. 1370, and Castiglione's *Il Cortegiano*, 1528, see L. Nochlin and A. Sutherland Harris,

Women Artists, 1550–1950, Los Angeles, Los Angeles County Museum of Art, 1976, 24.

49 Griselda Pollock, 'Woman as sign: psychoanalytic readings', *Vision and Difference: Femininity, Feminism and Histories of Art*, London, Routledge, 1988, 120–54, explores the ways in which masculine fantasies are negotiated and positioned through representations of the blank, unseeing and petrified female face.

50 Untraced. An oil sketch survives in a private collection. See R. Treble, *Great Victorian Pictures: Their Paths to Fame*, London, Arts Council of Great Britain, 1978, 95. Henry Blackburn, *Royal Academy Notes*, London, 1894, 19, gives the colours. The vast scale compares to Eliza Melville's eight-foot by five-foot painting *He Shall Gather the Lambs with His Arm*, 1889; see *Queen*, 23 February 1889, 260. By this date women artists were executing large-scale paintings which exceeded the moderate dimensions of their works in the 1860s and rivalled men's academic productions.

51 F. Rinder, 'Henrietta Rae', *Art Journal*, 1901, 303–9; A. Fish, *Henrietta Rae*, London, Cassell, 1905.

52 Jane Sellars, *Women's Works*, Liverpool, National Museums and Galleries on Merseyside, 1988, 4–5.

53 *The Times*, 5 May 1894, 16.

54 *Magazine of Art*, 1894, 274.

55 *Athenaeum*, 2 June 1894, 716.

56 ibid., 5 May 1894, 583.

57 Maud Sulter, *Echo: Works by Women Artists, 1850–1940*, Liverpool, Tate Gallery, 1991, 38.

58 *Athenaeum*, 23 May 1885, 667.

59 R. Parker and G. Pollock, *Old Mistresses: Women, Art and Ideology*, London, Routledge, 1981; Lynda Nead, 'Representation, sexuality and the female nude', *Art History*, 6 (2), 1983, 227–36.

60 Sheila Jeffreys, *The Spinster and Her Enemies: Feminism and Sexuality, 1880–1930*, London, Pandora, 1985; Judith Walkowitz, *Prostitution and Victorian Society. Women, Class and the State*, Cambridge, Cambridge University Press, 1980.

61 F. Mort, *Dangerous Sexualities: Medico-Moral Politics in England since 1830*, London, Routledge, 1987, 134.

62 *The Times*, 20 May 1885, 10ff.

63 Martin Bernal, *Black Athena: The Afro-Asiatic Roots of Classical Civilisation*, London, Free Association Books, I, 1987.

64 Artist's form, Tate Gallery archives, London.

65 Edward W. Said, *Orientalism: Western Conceptions of the Orient*, London, Routledge, 1978. Margaret Murray Cookesley was one of several women artists to make a reputation with North African and particularly harem scenes.

66 J. Burkhauser (ed.), *Glasgow Girls: Women in Art and Design, 1880–1920*, Edinburgh, Canongate, 1990.

67 Pamela Reekie Robertson, *Margaret Macdonald Mackintosh*, Glasgow, Hunterian Art Museum, 1983, appendix no. xvii; Burkhauser (ed.), 1990, 84; *Dekorative Kunst*, 2, 1898, 74.

68 *Studio*, 1896, 90.

69 *Dekorative Kunst*, 1, no. 1, October 1897, quoted in Burkhauser (ed.), 1990, 92; and 'Die Schottischen Kunstler, Margaret Macdonald, Frances Macdonald . . .', *Dekorative Kunst* 3, 1898, 48–9, kindly translated by my father.

70 Their work was regularly included in *Dekorative Kunst*, featured in *Ver Sacrum* in 1900 and 1901, and in *Deutsche Kunst and Dekoration* in September

1902 (with a cover design by Margaret Macdonald Macintosh), discussed in several publications by Hermann Muthesius, and included in Julius Meier-Graefe's *Encyclopaedia of Modern Art*, 1904–5.

71 G. White, 'Some Glasgow designers and their work', *Studio*, 11, 1897, 89–90. Thereafter this journal became a consistent supporter.

72 'The Arts and Crafts Exhibition', *Studio*, 9, 1896, 202–4.

73 *Bailie*, 14 November 1894, *Quiz*, 15 November 1894. See also Liz Bird, 'Ghouls and gas pipes: public reaction to the early work of the Four', *Scottish Art Review*, 14 (4), 1975.

74 Considerable research has yet to be done in what would be fruitful interconnections suggested by the outline of the 'new philosophy' by Lafcadio Hearn in *Kokoro: Hints and Echoes of Japanese Inner Life*, London, 1896. Glasgow artists were certainly aware of Belgian symbolist art; they may have attended lectures by Max Muller on eastern philosophies and religions and perhaps been in contact with a group of Rosicrucians in the city.

75 Works of this period are reproduced in Burkhauser (ed.), 1990, 84–7. The figural forms become more rounded after 1896–7.

76 *Glasgow Evening News*, 25 January 1896.

77 ibid., 13 November 1894, 4.

78 *Liverpool Courier*, 29 August 1896. This watercolour and *The Sleeping Princess* were illustrated in *The Yellow Book*, 10, 1896, 175, 177.

79 Bridget Elliott, 'Poseurs and voyeurs in Beardsley's Covent Garden Masquerades', *Oxford Art Journal* 9 (1), 1986, 38–49; E. Showalter, *Sexual Anarchy: Gender and Culture at the Fin de Siècle*, London, Virago, 1992.

80 Reproduced Burkhauser (ed.), 1990, 120.

81 Janice Helland, 'Gender and opposition in the art of Frances Macdonald', in Burkhauser (ed.), 1990, 129.

82 Louise Jopling, *Twenty Years of My Life, 1867–87*, London, John Lane, 1925, 32. The subject from the Old Testament Book of Esther was cited in Tennyson's poem 'The Princess'.

83 Cherry, 1987, 26–30.

84 Henrietta Ward, *Newgate, 1818* (RA 1876) is untraced, but a study of the two main figures is in the Library of the Religious Society of Friends, London.

85 Whitney Chadwick, *Women, Art and Society*, London, Thames & Hudson, 1990, 167, is clearly mistaken on this point.

86 The double portrait of William and Mary Howitt is in the Castle Museum, Nottingham, repr. Cherry, 1987, 9; the drawing of Sarah Flower Adams is at Conway Hall, London; others untraced, but see *People's Journal*, 1846.

87 Margaret Gillies to Leigh Hunt [1838–9], University of Iowa Library, Iowa, Leigh Hunt Collection, Ms L/G 48h.

88 R. Garnett, *The Life of W.J. Fox*, London, John Lane, 1910, 310. Eliza Fox, *Mme Bodichon* (RA 1868), untraced.

89 Reproduced as frontispiece, L. G. Anderson, *Elizabeth Garrett Anderson, 1836–1917*, London, Faber, 1936; *Paintings by Mrs Swynnerton*, Manchester, City Art Gallery, 1923, no. 51.

90 I am indebted to Kate Perry for pointing out that the watercolours were based on the photograph of C.A. Biggs, 1875, and of L. Becker, 1889, repr. H. Blackburn, *Women's Suffrage*, London, Williams & Norgate, 1902, facing 125 and facing 180.

91 Untraced. *Englishwoman's Review*, April 1903, repr. 72. The portrait was then hanging in the Women Students' Room at University College, Bristol along with Helen Blackburn's collection of portraits.

92 *Comus*, 1877, repr. R. Strachey, *The Cause: A Short History of the Women's*

Movement in Great Britain, 1928, London, Virago, 1978.

93 Girton College, Cambridge, with thanks again to Kate Perry for discussing these points.

94 *Illustrated London News*, 2 August 1890, 154–5.

95 *Englishwoman's Review*, 15 January 1892, 11.

96 ibid., 15 January 1891, 55. Susan Dacre, Annie Swynnerton and Emily Ford quickly forwarded their names for the committee.

97 *Description of Portraits*, 5, no. 11, National Portrait Gallery archives, London; for *Barbara Bodichon*, see chapter 6.

98 Letters from the curator, 1919–20, stipulating the reduction and new dimensions. I am grateful to Sandra Martin for making the archival material at the City Art Gallery, Manchester, available. A photograph of the original painting is in *Descriptions of Portraits*, 5, no. 11, National Portrait Gallery archives.

99 Jill Liddington and Jill Norris, *One Hand Tied Behind Us: The Rise of the Women's Suffrage Movement*, Virago, London, 1978.

100 *Englishwoman's Review*, 15 May 1880, 216; *Women's Suffrage Journal*, June 1880, 101.

101 *Englishwoman's Review*, 14 July 1883, 317. Frances Mary Stirling recollected that at a meeting in St James Hall held before 1890 Lydia Becker was on the platform 'holding up a long banner with a noble sentiment on it'; letter to Ray Strachey, n.d., Fawcett Collection, London.

102 *Women's Suffrage Journal*, July 1883, 122.

103 *Womens Suffrage Journal*, April 1884, 63; May 1884, 97.

104 Lisa Tickner, *The Spectacle of Women: Imagery of the Suffrage Campaign, 1907–1914*, London, Chatto, 1987.

EPILOGUE

1 Lubaina Himid, 'Afterward', *The Thin Black Line*, Urban Fox Press reissue, 1989, 12.

2 Teresa de Lauretis, *Technologies of Gender: Essays on Theory, Film and Fiction*, Bloomington, Indiana University Press, 1987.

SELECT BIBLIOGRAPHY

Alexander, Z. (1987) 'Preface', in M. Ferguson (ed.), *The History of Mary Prince, a West Indian Slave, Related by Herself*, London, Pandora.

—— (1990) 'Let it lie upon the table: the status of Black women's biography in the UK', *Gender and History* 2 (1).

Allthorpe-Guyton, M. (1982) *A Happy Eye: A School of Art in Norwich, 1845–1982*, Norwich, Jarrolds.

Architectural Association (1981) *Miss Gertrude Jekyll, 1843–1932, Gardener*, London.

Askwith, B. (1969) *Lady Dilke: A Biography*, London, Chatto.

Baldwin, A. (1960) *The Macdonald Sisters*, London, Peter Davies.

Beale, S.S. (1908) *Recollections of a Spinster Aunt*, London, Heinemann.

Beckett, J. and Cherry, D. (eds) (1987) *The Edwardian Era*, Oxford, Phaidon.

—— and —— (1987) 'Art, class and gender, 1900–1910', *Feminist Arts News* 2 (5).

—— and —— (1988) 'Women under the banner of Vorticism', *ICSAC Cahiers*, Brussels, 8/9.

Beckett, J and Lambert, J. (1989) 'Private lives: public property', *Feminist Arts News* 3 (2).

Birch, Mrs Lionel (1906) *Stanhope A. Forbes and Elizabeth Stanhope Forbes*, London, Cassell.

Birkenhead, S. (1943) *Against Oblivion*, London, Cassell.

Blackburn, H. (1902) *Women's Suffrage*, London, Williams & Norgate.

Bland, L. (1981) 'The domain of the sexual: a response', *Screen Education*, 39.

—— (1985) 'Cleansing the Portals of Life: the venereal diseases campaign in the early twentieth century', in M. Langan and B. Schwarz (eds) *Crises in the British State, 1880–1930*, London, Hutchinson.

—— (1986) 'Marriage laid bare', in J. Lewis (ed.) *Labour and Love: Women's Experience of Home and Family, 1850–1940*, Oxford, Blackwell.

—— (1987) 'The married woman, the New Woman and the feminist', in J. Rendall (ed.) *Equal or Different: Women's Politics, 1800–1914*, Oxford, Blackwell.

Brown, B. and Adams, P. (1979) 'The feminine body and feminist politics', *m/f*, 3.

Buckley, C. (1990) *Potters and Paintresses: Women Designers in the Pottery Industry, 1870–1955*, London, Women's Press.

Burkhauser, J. (ed.) (1990) *Glasgow Girls: Women in Art and Design, 1880–1920*, Edinburgh, Canongate.

Burne-Jones, G. (1904) *Memorials of Edward Burne-Jones*, London, Macmillan.

Burton, H. (1949) *Barbara Bodichon*, London, John Murray.

Butler, E. (1922) *An Autobiography*, London, Constable.

Callan, A. (1979) *Angel in the Studio: Women in the Arts and Crafts Movement*, London, Astragal.

Canziani, E.S. (1939) *Round About Three Palace Green*, London, Methuen.

Casteras, S. (1982) *The Substance and the Shadow: Images of Victorian Womanhood*, New Haven, Conn., Yale Center for British Art.

—— (1987) *Images of Victorian Womanhood in English Art*, London, Associated University Press.

Castle Museum (1982) *The Women's Art Show, 1550–1970*, Nottingham.

Charteris, E. (1931) *The Life and Letters of Sir Edmund Gosse*, London, Heinemann.

Cherry, D. (1983) 'Surveying seamstresses', *Feminist Arts News*, 9.

—— (1984) 'The Pre-Raphaelites', *Marxism Today* (May).

—— (1987) *Painting Women: Victorian Women Artists*, Rochdale, Rochdale Art Gallery.

Cherry, D. and Pollock, G. (1984) 'Woman as sign in Pre-Raphaelite literature: a study of the representation of Elizabeth Siddall', *Art History*, 7 (2).

Clayton, E. (1876) *English Female Artists*, London, Tinsley.

Clement, C.E. (1904) *Women in the Fine Arts*, Boston, Houghton Mifflin.

Cliff, M. (1987) 'Object into subject: some thoughts on the work of Black women artists', in H. Robinson (ed.) *Visibly Female: Feminism and Art: An Anthology*, London, Camden Press.

Cowie, E. (1978) 'Woman as sign', *m/f*, 1.

Craik, D.M. (1858) *A Woman's Thoughts about Women*, London, Hurst & Blackett.

Crawford, A. (ed.) (1984) *By Hammer and Hand: The Arts and Crafts Movement in Birmingham*, Birmingham, City Museum and Art Gallery.

Davidoff, L. (1973) *The Best Circles: Society, Etiquette and the Season*, London, Croom Helm.

Davidoff, L and Hall, C. (1987) *Family Fortunes: Men and Women of the English Middle Class, 1780–1850*, London, Hutchinson.

Davidoff, L., L'Esperance, J. and Newby, H. (1976) 'Landscape with figures: home and community in English society', in J. Mitchell and A. Oakley (eds) *The Rights and Wrongs of Women*, Harmondsworth, Penguin.

Davidson, C. (1985) *The Art of Mary Ellen Best*, London, Chatto.

Davin, A. (1978) 'Imperialism and motherhood', *History Workshop Journal* 5.

Day, H.E. (1969) *East Anglian Painters*, Eastbourne, Eastbourne Fine Art.

Doane, M.A. (1987) *The Desire to Desire: The Woman's Film of the 1940s*, London, Macmillan.

Duncan, C. (1973) 'Happy mothers and other new ideas in French art', in N. Broude and M.D. Garrard (eds) (1982) *Feminism and Art History: Questioning the Litany*, New York, Harper & Row.

—— (1990) 'The Moma's hot mamas', *Feminist Arts News*, 3 (4).

Eastbourne, Towner Art Gallery (1982) *Louisa Paris: Watercolours of the South-east of England in the 1850s*.

Ellet, E. (1859) *Women Artists in All Ages and Countries*, London, Bentley.

Fish, A. (1905) *Henrietta Rae (Mrs Ernest Normand)*, London, Cassell.

Fisher, J.F. (1986) 'The world of Jane Maria Bowkett', *The Lady* (18 December).

—— (1988) 'Jane Maria Bowkett', *Women Artists Slide Library Journal* 20.

Foucault, M. (1979) 'What is an author?', *Screen* 20 (1).

—— (1981) *The History of Sexuality. Volume I: An Introduction*, Harmondsworth, Penguin.

—— (1982) *Discipline and Punish, The Birth of the Prison*, Harmondsworth, Penguin.

Fox, C. and Greenacre, F. (1985) *Painting in Newlyn, 1880–1930*, London, Barbican Art Gallery.

Gamman, L. and Marshmont, M. (eds) (1988) *The Female Gaze: Women as Viewers of Popular Culture*, London, Women's Press.

Garnett, R. (1910) *The Life of W.J. Fox: Public Teacher and Social Reformer*, London, John Lane.

Geffrye Museum (1985) *Solomon: A Family of Painters*, London.

Green, N.P. (1990) *The Spectacle of Nature: Landscape and Bourgeois Culture in Nineteenth-century France*, Manchester, Manchester University Press.

Hall, C. (1979) 'The early formation of Victorian domestic ideology', in S. Burman (ed.) *Fit Work for Women*, London, Croom Helm.

Hare, A. (1893) *The Story of Two Noble Lives, being Memorials of Charlotte Countess Canning and Louisa Marchioness of Waterford*, London, Allen.

Hennessy, R. and Mohan, R. (1989) 'The construction of woman in three popular texts of empire: towards a critique of materialist feminism', *Textual Practice*, 3.

Himid, L. (1987) 'We will be', in R. Betterton (ed.) *Looking On: Images of Femininity in the Visual Arts and Media*, London, Pandora.

—— (1990) 'Mapping: a decade of Black women artists, 1980–90', in M. Sulter (ed.) *Passion: Discourses on Blackwomen's Creativity*, Hebden Bridge, Urban Fox Press, distributed by Bookspeed, 48 Hamilton Place, Edinburgh, EH3 5AX.

Holcomb, A and Sherman, C.R. (1981) *Women as Interpreters of the Visual Arts, 1820–1979*, Westport, Conn., Greenwood.

Hopkinson, A. (1986) *Julia Margaret Cameron*, London, Virago.

Howitt, A.M. (1853) *An Art Student in Munich*, London.

Howitt, M. (ed.) (1889) *Mary Howitt: An Autobiography*, London, Isbister.

Huish, M.B. (1985) *The Happy England of Helen Allingham*, London, Bracken Books.

Hutchison, S. (1968) *The History of the Royal Academy, 1768–1968*, London, Chapman and Hall.

Israel, K.A.K. (1990) 'Writing inside the kaleidoscope: re-representing Victorian women public figures', *Gender and History* 2 (1).

Jeffreys, S. (1985) *The Spinster and Her Enemies: Feminism and Sexuality, 1880–1930*, London, Pandora.

Jekyll, F. (1934) *Gertrude Jekyll: A Memoir*, London, Cape.

Jopling, L. (1925) *Twenty Years of My Life: 1867–87*, London, John Lane.

Knight. L. (1936) *Oil Paint and Grease Paint: Autobiography of Laura Knight*, London, Nicholson.

Lauretis, T. de (1987) *Technologies of Gender: Essays on Theory, Film and Fiction*, Bloomington, Indiana University Press.

—— (ed.) (1988) *Feminist Studies/Critical Studies*, London, Macmillan.

Lee, Amice (1955) *Laurels and Rosemary: The Life of William and Mary Howitt*, London, Oxford University Press.

Levine, P. (1987) *Victorian Feminism, 1850–1900*, London, Hutchinson.

Levy, A. (1991) *Other Women: The Writing of Class, Race and Gender, 1832–98*, Princeton, Princeton University Press.

Lewis, R.C. and Lasner, M.S. (eds) (1978) *Poems and Drawings of Elizabeth Siddal*, Wolfville, Canada, Wombat Press.

Liddington, J. and Norris, J. (1978) *One Hand Tied Behind Us: The Rise of the Women's Suffrage Movement*, London, Virago.

McAllister, I. (ed.) (1924) *Henrietta Ward: Memories of Ninety Years*, London, Hutchinson.

Mackenzie, T. (1895) *The Art Schools of London*, London, Chapman and Hall.

Marsh, J. and Nunn, P.G. (1989) *Women Artists and the Pre-Raphaelite Movement*,

London, Virago.

Martineau. H. (1877) *Autobiography*, London, Smith Elder.

Maxwell. C. (1949) *Mrs Gatty and Mrs Ewing*, London, Constable.

Merritt, A.L. (1879) *Henry Merritt: Art Criticism and Romance*, London, Kegan Paul.

Minh-ha, Trinh T. (1989) *Women, Native, Other: Writing Postcoloniality and Feminism*, Bloomington, Indiana University Press.

Mort, F. (1987) *Dangerous Sexualities: Medico-Moral Politics in England since 1830*, London, Routledge.

Mulvey, L. (1989) *Visual and Other Pleasures*, London, Macmillan.

National Army Museum (1988) *Lady Butler, Battle Artist*, London.

Nead, L. (1983) 'Representation, sexuality and the female nude', *Art History* 6 (2).

—— (1987) 'The Magdalen in modern times', in R. Betterton (ed.) *Looking on: Images of Femininity in the Visual Arts and Media*, London, Pandora.

—— (1988) *Myths of Sexuality: Representations of Women in Victorian Britain*, Oxford, Blackwell.

Nochlin, L. (1989) *Women, Art and Power and Other Essays*, London, Thames & Hudson.

Nochlin, L. and Harris, A.S. (1976) *Women Artists, 1550–1950*, Los Angeles, Los Angeles County Museum of Art.

Nunn, P.G. (ed.) (1986) *Canvassing: Recollections by Six Victorian Women Artists*, London, Camden Press.

—— (1987) *Victorian Women Artists*, London, Women's Press.

—— (1988) 'Rebecca Solomon's "A Young Teacher"', *Burlington Magazine*, 130.

O'Donnell, E. (ed.) (1911) *Mrs E.M. Ward's Reminiscences*, London, Pitman.

Parker, R. and Pollock, G. (1981) *Old Mistresses: Women, Art and Ideology*, London, Routledge.

Pearce, L. (1991) *Woman, Image, Text: Readings in Pre-Raphaelite Art and Literature*, Hemel Hempstead, Harvester Wheatsheaf.

Perry, K. (1991) *Barbara Leigh Smith Bodichon 1827–1891*, Cambridge, Girton College.

Pollock, G. (1988) *Vision and Difference: Femininity, Feminism and the Histories of Art*, London, Routledge.

Poovey, M. (1988) *Uneven Developments: The Ideological Work of Gender in Mid-Victorian England*, London, Virago.

Rendall, J. (ed.) (1987) *Equal or Different: Women's Politics, 1800–1914*, Oxford, Blackwell.

Reynolds, J. (1973) *The Williams Family of Painters*.

Rich, A. (1986) *Of Woman Born: Motherhood as Experience and Institution*, New York, Norton.

Roberts, H. (1972) 'Marriage, redundancy or sin: the painter's view of women in the first twenty-five years of Victoria's reign', in M. Vicinus (ed.) (1980) *Suffer and Be Still: Women in the Victorian Age*, London, Methuen.

Robertson, P.R. (1983) *Margaret Macdonald Macintosh*, Glasgow, Hunterian Art Gallery.

Roget, J.L. (1891) *A History of the Old Water-colour Society*, London, Longmans.

Ruskin Gallery (1991) *Elizabeth Siddal: Pre-Raphaelite Artist*, Sheffield.

Sanders, V. (1989) *The Private Lives of Victorian Women: Autobiography in Nineteenth-century England*, New York, St Martins Press.

Sellars, J. (1988) *Women's Works*, Liverpool, National Museums and Galleries on Merseyside.

Smith-Rosenberg, C. (1985) *Disorderly Conduct: Visions of Gender in Victorian America*, New York, Knopf.

Sparrow, W.S. (1905) *Women Painters of the World*, London, Hodder & Stoughton.

Spielman, M.H. and Layard, G. (1968) *Kate Greenaway*, New York, Blom.

Stirling, A.M.W. (1922) *William de Morgan and his Wife*, London, Thornton Butterworth.

Sulter, M. (1991) *Echo: Works by Women Artists, 1850–1940*, Liverpool, Tate Gallery.

Swanson, V. (1990) *The Biography and Catalogue Raisonné of the Paintings of Sir Lawrence Alma-Tadema*, Aldershot, Scolar.

Tankard, J. and Valkenburgh, M.R.V. (1989) *Gertrude Jekyll: A Vision of Garden and Wood*, London, John Murray.

Tanner, A. (1982) *The Glasgow Society of Lady Artists, 1872–1971*, Glasgow, Collins Gallery.

Taylor, I. (1990) *Helen Allingham's England*, Exeter, Webb & Bower.

Thwaite, A. (1984) *Edmund Gosse: A Literary Landscape 1849–1928*, London, Secker & Warburg.

Tickner, L. (1987) *The Spectacle of Women: Imagery of the Suffrage Campaign, 1907–1914*, London, Chatto.

Treble, R. (1978) *Great Victorian Pictures: Their Paths to Fame*, London, Arts Council of Great Britain.

Vicinus, M. (1985) *Independent Women: Work and Community for Single Women, 1850–1920*, London, University of Chicago Press.

Visram, R. (1986) *Ayahs, Lascars and Princes: Indians in Britain, 1700–1947*, London, Pluto.

Walker, L. (1993) 'Vistas of pleasure: women consumers of urban space in the west end of London, 1850–1900', in *Cracks in the Pavement: Gender, Fashion, Architecture*, London, Sorella Press.

—— (1992) 'Bricks and daughters: women and architecture, 1835–1935', in W. Schutte and M. Wilke (eds) *The Wise Woman Buildeth Her House: Architecture, History, Gender*, Groningen.

Watt, N. (1985) *The Norfolk and Norwich Art Circle, 1885–1985*, Norwich, Norfolk Museums Service.

Weedon, C. (1987) *Feminist Practice and Post-structuralist Theory*, Oxford, Blackwell.

Wolff, J and Seed, J. (eds) (1988) *The Culture of Capital: Art, Power and the Nineteenth-century Middle Class*, Manchester, Manchester University Press.

Wood, C. (1974) 'The artistic family Hayllar', *The Connoisseur* (May).

Woodring, C.R. (1952) *Victorian Samplers: William and Mary Howitt*, Lawrence, University of Kansas Press.

Yeldham, C. (1984) *Women Artists in Nineteenth-Century France and England*, New York, Garland.

INDEX

Numbers in **bold** refer to plate numbers